The works of

WILLIAM BLAKE

in the Huntington Collections

Cover: "The Conversion of Saul"

THE WORKS
OF WILLIAM BLAKE
in the Huntington Collections

A Complete Catalogue by Robert N. Essick

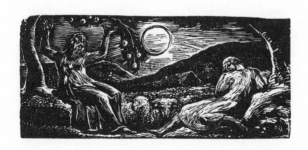

THE HUNTINGTON LIBRARY, ART COLLECTIONS,
BOTANICAL GARDENS

Library of Congress Cataloging in Publication Data

Henry E. Huntington Library and Art Gallery.
 The works of William Blake in the Huntington collections.

 (Huntington Library publications)
 1. Blake, William, 1757–1827—Bibliography—Catalogs.
2. Blake, William, 1757–1827—Manuscripts—Catalogs.
3. Blake, William, 1757–1827—Catalogs. 4. Henry E. Huntington Library and
Art Gallery—Catalogs. I. Blake, William, 1757–1827. II. Essick, Robert N.
III. Title. IV. Series.
Z8103.H46 1985 [PR4146] 016.760'092'4 85-10689
ISBN 0-87328-084-9

Title Page: "Thenot," one of Blake's wood engravings for
R. J. Thornton's edition of *The Pastorals of Virgil*

CONTENTS

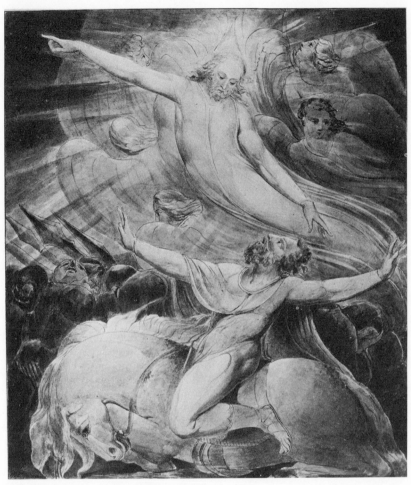

Frontispiece. The Conversion of Saul

LIST OF ILLUSTRATIONS

This project is supported by a grant from the
National Endowment for the Arts.

INTRODUCTION

The Collection

William Blake's work as a painter, poet, and printmaker challenges conventional ways of separating the arts into different disciplines. Over the last few decades, scholars have come to realize that the understanding of any one facet of Blake's *oeuvre* requires us to attend to all others. The Huntington Library and Art Gallery serve the needs of this expanding vision of Blake, for the diversity of the collections covers the full range of his inter-related productions.

The Huntington Gallery's collection includes examples of Blake's pictorial art in three of his major media—pencil sketches, watercolor drawings, and tempera paintings. With but one exception, all these works date from the nineteenth century when Blake's technical abilities had matured. The collection includes two of the large number of illustrations to the Bible Blake prepared for Thomas Butts, one in tempera and one in watercolors; a representative group of the "Visionary Heads" Blake sketched at the behest of John Varley; and the illustrated Genesis manuscript, left incomplete at Blake's death. But the centerpiece of the collection is the group of watercolor illustrations to three of John Milton's poems. The designs for *Comus*, *Paradise Lost*, and "On the Morning of Christ's Nativity" constitute the largest collection in any single institution of Blake's pictorial responses to the most important poet in his literary heritage.

Blake's training as a reproductive printmaker provided him both with a profession and with a means of publishing his designs and poems. The Huntington Library has an extensive collection of Blake's work as an engraver of book illustrations designed by other artists, as well as the original prints he designed and executed to illustrate Edward Young's *Night Thoughts*, the Book of Job, and Dante's *Inferno*. Blake's innovative graphics have deservedly attracted more attention than the prints he created through traditional techniques, and these too are well represented at the Huntington. The collection includes

ten of the illuminated books printed from plates etched in relief and several examples of Blake's special methods of relief color printing (*Songs of Innocence and of Experience* and *The Song of Los*) and planographic printing from unetched surfaces (*The Song of Los* and "Hecate") and from plates originally incised for intaglio printing ("Albion rose" and "Lucifer and the Pope in Hell").

The Library's collection of Blake's writings offers an equally representative diversity. Although very few of Blake's works were published in conventional typography during his life, the Huntington has two copies of *Poetical Sketches*, Blake's first book of poems, a copy of the *Descriptive Catalogue* for his 1809 exhibition of paintings, and the only known copy of *The French Revolution*. Blake published most of his poems as illuminated books which unite the literary and the pictorial in a composite form of expression. The Huntington collection includes the unique copy of what may be Blake's first illuminated book, *All Religions are One*, three copies of his lyric collections, *Songs of Innocence* and *Songs of Experience*, both of his political poems *America* and *Europe*, and one of only four extant copies of the epic *Milton*. Blake's energetic annotating of books he read is represented by three important examples, including the first volume he is known to have annotated (Lavater's *Aphorisms*) and the last (Thornton's *The Lord's Prayer*). The Huntington also has the single largest collection of Blake's letters, including a remarkable group of fifteen written to John Linnell and his wife in the last two years of Blake's life.

Almost all the important Blake materials in the collection were acquired by the institution's founder, Henry E. Huntington (1850–1927). Though he did not consistently compile information on purchases and sources, dealer and auction records indicate that Huntington began to buy Blake materials in 1911. At the Robert Hoe auction in April of that year, Huntington made numerous important purchases, including *Songs of Innocence*, *Songs of Experience*, *Milton*, and the annotated copy of Lavater's *Aphorisms*. His agent at the Hoe sale was the New York book dealer George D. Smith, who continued to act in that capacity until his death in 1920. His last bidding for Blake items on Huntington's behalf was at the John Linnell auction of March 1918. That sale provided Huntington with *All Religions are One*, *The French Revolution*, the illustrated Genesis manuscript, and the collection of Blake's letters to Linnell. During this same period,

Huntington made extensive purchases from the great dealer A.S.W. Rosenbach, beginning with most of the *Paradise Lost* drawings in 1911. Blake's illustrations to *Comus* and "On the Morning of Christ's Nativity" followed in 1916 from the same source. Another Philadelphia bookman, Charles Sessler, provided the "Visionary Heads," "Moses Placed in the Ark of the Bulrushes," and "Lucifer and the Pope in Hell" in the early 1920s. Several important Blakes came to Huntington as part of large collections of books, including *Songs of Innocence and of Experience* in the Beverly Chew library acquired in 1912, the richly color-printed copy of *The Song of Los* in the Frederic R. Halsey collection (1915), and "The Conversion of Saul" in the extra-illustrated Kitto Bible purchased in 1919. By 1923, Huntington had gathered almost all the important works now in the Blake collection. The most significant acquisitions since his day are a title-page design for Robert Blair's *The Grave*, given to the Gallery in 1946, and the color-printed drawing of "Hecate," purchased by the Library in 1954. Yet the Library's own stacks can yield unexpected treasures, such as the happy discovery in 1982 of the previously untraced pencil sketch of Blake's "Pestilence," found among a group of uncatalogued drawings.

The Catalogue

In 1938, the Huntington published C. H. Collins Baker's illustrated catalogue of Blake's drawings and paintings in the Huntington collection. This work was revised by Robert R. Wark and reprinted in 1957. In 1978, *Blake: An Illustrated Quarterly* (volume 11, pages 236–59) published a brief handlist of the collection which includes books and manuscripts as well as pictures. Although I am much indebted to these predecessors, and in particular to Dr. Wark's edition of the Baker catalogue, the present volume is not a revision of any previous publication. It includes all original Blake materials at the Huntington and is based on a new examination of them and all relevant documents I have been able to locate. My major goal has been to provide scholars and students with basic facts about the physical properties of the works recorded. The extent of additional information varies according to the importance of the works. For example, books

with Blake's commercial copy engravings are listed with only brief notes on condition of the plates and standard catalogue references, whereas the illuminated books are described in more detail with information on binding, provenance, variations in design, and preliminary drawings and drafts. For some works, I have been able to correct or add to the information offered in the standard catalogue of Blake's paintings and drawings (Butlin 1981–see Bibliography) and the standard bibliography of his writings (Bentley 1977). Notes on iconography and interpretation are reserved for the drawings and paintings in Part I. The emphasis in these brief essays is on the direct relationships between Blake's designs and the texts illustrated, the major sources for motifs, and the differences among works at the Huntington and Blake's other illustrations of the same texts. Some of the drawings have already been the objects of extensive analysis, as noted in the *Literature* recorded for each series or image; but others, such as the Genesis manuscript, have not previously received as much commentary as is offered here. I hope that these discussions and the accompanying illustrations will help the general reader, as well as the scholar, toward a greater understanding and appreciation of Blake's art.

The variety of Blake's works at the Huntington has necessitated the division of this catalogue into several parts and sections. Most of these divisions are preceded by brief comments on the nature of the works included and the way they are catalogued. The organization of this volume and its individual entries are usually self-explanatory, but the following general points may be helpful to readers.

All of Blake's writings in the collection are printed in the following standard editions:

> *Blake Complete Writings.* Ed. Geoffrey Keynes. London: Oxford Univ. Press, 1966, reprinted with revisions 1979.
>
> *William Blake's Writings.* Ed. G. E. Bentley, Jr. Oxford: Clarendon Press, 1978. 2 volumes. With bibliographical information, not independently cited here, reprinted for the most part from Bentley 1977.
>
> *The Complete Poetry and Prose of William Blake.* Ed. David V. Erdman. Newly Revised Edition. Berkeley: Univ. of California Press, 1982. All quotations from Blake's writings are taken from this text, cited as "Blake 1982."

References under *Literature* for each series or work are selective. Only Part I ranges beyond standard catalogues and bibliographies to include commentary and criticism. Books and articles with only brief references to materials at the Huntington are not included. Complete lists of reproductions are provided only for the illuminated books (Part II, section A).

All dimensions record height followed by width in centimeters.

Blake's works are housed in two divisions of the Huntington, the Gallery and the Library. Almost all the works in the former are designated by accession numbers, recorded here. Library materials in the rare book and manuscript collections are designated by call numbers; those in the reference collection are cited by classification numbers.

The Blake collection is available for study by qualified scholars upon application in advance to the Reader Services Librarian or to the Curator of the Art Collections.

<p style="text-align:center">* * *</p>

I could not have written this catalogue without the generous assistance of the Huntington staff. Shelley Bennett, Associate Curator of Art, and Diana Wilson, Art Gallery Librarian, have been particularly helpful with materials in their care. Among the many members of the Library staff who have so kindly assisted me, I cannot fail to mention Daniel Woodward, Huntington Librarian, Valerie Franco, Huntington Archivist, and Alan Jutzi, Susan Naulty, Virginia Renner, Mary Robertson, Robert Schlosser, Linda Williams, and Mary Wright. Jane Evans has contributed her editorial expertise throughout all stages of the production of this volume. Thomas Lange, Assistant Curator of Rare Books, has made available to me his great knowledge in matters bibliographic and chalcographic and has survived my persistent inquiries with remarkable grace. My greatest debt is to Robert R. Wark, Curator of Art Collections, for asking me to write this catalogue, for the example of his scholarship, and for his dedication to an institution which has meant so much to us both.

Robert N. Essick
The Huntington Library and Art Collections
December, 1984

BIBLIOGRAPHY

Standard works cited by author and date (title and date for collections of essays). Works listed under *Literature* in Part I are similarly cited.

Baker, C. H. Collins. *Catalogue of William Blake's Drawings and Paintings in the Huntington Library.* Enlarged and revised by R. R. Wark. San Marino: The Huntington Library, 1957.

Bentley, G. E., Jr. *Blake Records.* Oxford: Clarendon Press, 1969.

Bentley. *Blake Books.* Oxford: Clarendon Press, 1977. Plate numbers and copy designations of Blake's illuminated books follow this standard bibliography.

Bindman, David. *Blake as an Artist.* Oxford: Phaidon Press, 1977.

Bindman. *The Complete Graphic Works of William Blake.* [London]: Thames and Hudson, 1978.

Binyon, Laurence. *The Engraved Designs of William Blake.* London: Ernest Benn, 1926.

Blake, William. *The Complete Poetry and Prose of.* Ed. David V. Erdman. Newly Revised Edition. Berkeley: Univ. of California Press, 1982.

Blake in His Time. Ed. Robert N. Essick and Donald Pearce. Bloomington: Indiana Univ. Press, 1978.

Butlin, Martin. *The Paintings and Drawings of William Blake.* New Haven: Yale Univ. Press, 1981. All references are to volume 1 only. Unless noted otherwise, all works at the Huntington for which this book is cited are reproduced in monochrome in volume 2.

Easson, Roger R., and Robert N. Essick. *William Blake: Book Illustrator. Volume I: Plates Designed and Engraved by Blake.* Normal: American Blake Foundation, 1972. *Volume II: Plates Designed or Engraved by Blake 1774–1796.* Memphis: American Blake Foundation, 1979.

Essick, Robert N. *William Blake, Printmaker.* Princeton: Princeton Univ. Press, 1980.

Essick. *The Separate Plates of William Blake: A Catalogue.* Princeton: Princeton Univ. Press, 1983.

Hagstrum, Jean H. *William Blake, Poet and Painter.* Chicago: Univ. of Chicago Press, 1964.

Keynes, Geoffrey. *A Bibliography of William Blake.* New York: Grolier Club, 1921.

Keynes and Edwin Wolf 2nd. *William Blake's Illuminated Books: A Census*. New York: Grolier Club, 1953.

Keynes. *Engravings by William Blake: The Separate Plates*. Dublin: Emery Walker, 1956.

Keynes. *Blake Studies: Essays on His Life and Work*. 2d ed. Oxford: Clarendon Press, 1971.

Paley, Morton D. *William Blake*. Oxford: Phaidon Press, 1978.

Rossetti, William Michael. "Annotated Lists of Blake's Paintings, Drawings, and Engravings." In Alexander Gilchrist, *Life of William Blake*. London: Macmillan, 1863. 2:202-61. Revised and reprinted in Gilchrist, *Life of Blake*. London: Macmillan, 1880. 2:207–83.

Russell, Archibald G. B. *The Engravings of William Blake*. London: Grant Richards, 1912.

Wittreich, Joseph Anthony, Jr. "Blake in the Kitto Bible." *Blake Studies* 2 (1970): 51–54.

EXHIBITIONS

Burlington Fine Arts Club, 1876. *Exhibition of the Works of William Blake*. Introductory Remarks [and catalogue] by William B. Scott. London, 1876.

Carfax & Co., 1904. *Exhibition of Works by William Blake*. January 1904. [Catalogue by A. G. B. Russell, London, 1904.]

Carfax & Co., 1906. *Exhibition of Works by William Blake*. 14 June–31 July 1906. London, [1906].

Edinburgh Museum of Science and Art, 1878. *Catalogue of Loan Collection of Water Colour Drawings*. 2d ed. Edinburgh, 1878.

Fogg Art Museum, 1924. *Works by William Blake Lent to the Fogg Art Museum*. [Cambridge, Mass., 1924]. Typescript of a handlist, without item numbers, in the British Museum, Department of Prints and Drawings.

Grolier Club, 1905. *Catalogue of Books, Engravings Water Colors & Sketches by William Blake*. 26 January–25 February 1905. [New York], 1905.

Grolier Club, 1919–20. *William Blake an Exhibition*. 5 December 1919–10 January 1920. New York, 1919.

Grosvenor Gallery, 1877–78. *Winter Exhibition of Drawings by the Old Masters and Water-Colour Drawings by Deceased Artists of the British School*. London, 1877.

Huntington Art Gallery, 1936. *An Exhibition of William Blake's Water-Color Drawings of Milton's "Paradise Lost."* 12 May–31 July 1936. Catalogue by C. H. Collins Baker. San Marino, 1936.

Huntington Art Gallery, 1940. "William Blake's Water-Color Drawings of Milton's 'Paradise Lost'." *Calendar of the Exhibitions*, July–August–September 1940.

Huntington Art Gallery, 1953. "William Blake." *Calendar of the Exhibitions*, November–December 1953.

Huntington Art Gallery, 1965–66. *William Blake and His Circle*. November 1965–February 1966. Catalogue by Robert R. Wark. [San Marino, 1965.]

Huntington Art Gallery, 1972. Robert Wark, "The Bodman Collection: Four Hundred Years of Fine Prints." *Calendar of Exhibitions*, June 1972.

Huntington Art Gallery, 1972–73. *The Followers of William Blake*. 1 November 1972–31 January 1973. Catalogue by Larry Gleeson. [San Marino, 1973.]

Huntington Art Gallery, 1974, 1983. No catalogues.

Huntington Art Gallery, 1978. Robert R. Wark, "Prints by Blake." *Huntington Calendar*, May–June 1978.

Huntington Art Gallery, 1979. *English Book Illustration circa 1800*. January–February 1979. Catalogue by Shelley Bennett and Patricia Crown. [San Marino, 1979.]

Huntington Art Gallery, 1984. "Blake Exhibit." *Huntington Calendar*, September–October 1984.

Little Museum of La Miniatura, 1936. *A Descriptive Hand-List* [by Mrs. George Madison Millard] *of a Loan Exhibition of Books and Works of Art by William Blake*. 16–28 March 1936. Pasadena, [1936].

Manchester Whitworth Institute, 1914. *Catalogue of a Loan Collection of Works by William Blake*. February–March 1914. London, 1914.

National Gallery [of] British Art, 1913. *Catalogue* [by A. G. B. Russell] *of Loan Exhibition of Works by William Blake*. October–December 1913. 2d ed. London, 1913.

National Gallery of Scotland, 1914. *Catalogue of Loan Exhibition of Works by William Blake and David Scott*. 22 May–4 July 1914. Edinburgh, [1914].

Nottingham Art Museum, 1914. *Catalogue of a Loan Exhibition of Works by William Blake*. April 1914. Nottingham, 1914.

I. DRAWINGS AND PAINTINGS

A. Illustrations to Milton's Poetry

The poetry of John Milton was second only to the Bible as an influence on Blake's writings. In 1800, Blake wrote that "Milton loved me in childhood & shewd me his face,"[1] but this early interest probably increased during Blake's sojourn in Felpham, 1800–1803. There he worked, and frequently chafed, under the patronage of William Hayley, author of a then-standard life of Milton (1796) and a contributing editor of a sumptuous edition of Milton's poetry (1794–97). Blake's indebtedness to his great English precursor as a religious poet in an age of political revolution culminates in the illuminated book *Milton*, composed and etched ca. 1804–1808.[2] In addition to his importance as a contributor to the Miltonic tradition in poetry, Blake is one of Milton's greatest illustrators. Beginning in 1801, and extending to at least 1816, Blake received commissions to execute watercolor illustrations to Milton's *Comus* (two series of eight designs each), "On the Morning of Christ's Nativity" (two series of six designs), *Paradise Lost* (two series of twelve designs and at least three designs for a third suite), "L'Allegro" and "Il Penseroso" (a single group of twelve designs), and *Paradise Regained* (one group of twelve designs). The Huntington has one of the series for each of the first three of these poems, plus one design from the other complete group of illustrations to *Paradise Lost*.

Blake's Milton designs, like most of his illustrations to the works of other poets, generally follow their textual sources with remarkable fidelity, even in the minor details of verbal description and imagery. Some differences between designs and their texts may be accidental, but most seem to be purposeful attempts to visualize thematic or symbolic patterns underlying literal statements. Like all artists, Blake inherited a tradition of representational and iconographic conventions, but these he combined and extended to form pictorial commentaries on Milton's poems. Further, many of the motifs Blake used in his Milton illustrations appear elsewhere in his art where they take on identifiable meanings within Blake's own vocabulary of symbols, both visual and verbal. Thus, modern scholars have studied the Milton designs as presentations of Blake's own concepts of creation, fall, redemption, and other themes common to both poets.

It is not known which edition(s) of Milton's poems Blake read. All quotations and line numbers given here are based on John Milton, *Complete Poems and Major Prose*, ed. Merritt Y. Hughes (New York: Odyssey Press, 1957).

General Studies of Blake's Milton Illustrations:

Geoffrey Keynes, notes in Milton, *Poems in English with Illustrations by William Blake* (London: Nonesuch Press, 1926), 1:271-79, 2:355-59; Huntington *Comus* and "Nativity Ode" designs reproduced.

Marcia R. Pointon, *Milton & English Art* (Manchester: Manchester Univ. Press, 1970), Chap. III (iii), "William Blake and Milton."

David Bindman, *William Blake*. Catalogue of an exhibition, Hamburger Kunsthalle and Staedelsches Kunstinstitut, Frankfurt am Main, 1975 (Munich: Prestel-Verlag, 1975), 192–205.

Joseph Anthony Wittreich, Jr., *Angel of Apocalypse: Blake's Idea of Milton* (Madison: Univ. of Wisconsin Press, 1975), Chap. 2, " 'The House of the Interpreter': Blake's Milton Illustrations."

Bindman 1977, Chaps. 21, "*Comus* and *Paradise Lost*," and 22, "Illustrations to Milton's Minor Poems."

Milton Klonsky, *William Blake: The Seer and His Visions* (New York: Harmony Books, 1977), 79–87.

Martin Butlin, *William Blake*. Catalogue of an exhibition, The Tate Gallery, 1978 (London: Tate Gallery, 1978), 112–23.

Paley 1978, Chap. 8.

Pamela Dunbar, *William Blake's Illustrations to the Poetry of Milton* (Oxford: Clarendon Press, 1980), all series reproduced.

David Bindman, *William Blake: His Art and Times*. Catalogue of an exhibition, Yale Center for British Art, 1982, and Art Gallery of Ontario, 1982–83 (London: Thames and Hudson, 1982), 149–55.

Stephen C. Behrendt, *The Moment of Explosion: Blake and the Illustration of Milton* (Lincoln and London: Univ. of Nebraska Press, 1983), Huntington *Paradise Lost* designs reproduced in misleading color.

a. Illustrations to Comus. Ca. 1801. Illus. 1–8.

Eight designs in pen and watercolors with some evidence of pencil underdrawing, each approx. 21.5 x 18 cm. and signed "WB inv" lower left or right. Each design is pasted down to a 55.7 x 45.4 cm. mat and the group housed in a quarter blue leather slip case with "WILLIAM BLAKE DESIGNS FOR MILTON'S COMUS EIGHT WATER COLOR DRAWINGS EXHIBITED AT THE BURLINGTON FINE ARTS' CLUB 1876" stamped in gold on two panels of the spine. A photocopy of Rosenbach's receipt (see provenance, below) is pasted to the inside front cover.

In a letter to William Hayley of 31 July 1801, John Flaxman included a postscript addressed to Blake, stating in part that the "Rev.d Joseph Thomas of Epsom desires you will at your leisure, make a few sketches of the same size, which may be any size you please from Milton's Comus for Five Guineas."[3] Blake acknowledged the commission in a letter of 19 October 1801 to Flaxman: "Mr Thomas your friend to whom you was so kind as to make honourable mention of me, has been at Felpham & did me the favor to call on me. I have promis'd him to send my designs for Comus when I have done them, directed to you."[4] There is no record of when Blake finished the designs. Stylistic characteristics, as well as the history of ownership leading back to Thomas' grandson,[5] indicate that the *Comus* illustrations at the Huntington are this group begun in 1801. The eight smaller (approx. 15 x 12 cm.) *Comus* designs in the Museum of Fine Arts, Boston (Butlin 1981, No. 528) illustrate the same scenes as the Huntington series. Their style suggests a much later date of composition, ca. 1815. The Boston group was first owned, and probably commissioned, by Thomas Butts, Blake's chief patron for his pictorial works.[6]

In contrast to the Huntington set, the Boston group is more delicate in coloring and less somber in general tone. Blake used more and

shorter brush strokes in the later group to develop greater detail in modeling and richer surfaces. These qualities, replacing the slightly broader washes of the Huntington designs, may result in part from Blake's having learned the traditional techniques of miniature portraiture by 1802. Although the Huntington series has more prominent and continuous outlines, it also gives a stronger impression of atmospheric effects, including chiaroscuro shading in the landscape backgrounds of the first, second, fourth, and sixth designs in response to the consistently crepuscular imagery of Milton's descriptions of the "ominous Wood" (line 61) where most of the masque takes place. Keynes 1926, 1:277, finds the Huntington designs "much more beautiful," but Bindman 1977, 186, emphasizes the artistic development exemplified by the later series. Major differences between the two series in motifs and composition are briefly noted below for each design. The poem is cited by line number.

Provenance: Joseph Thomas, inherited by his grandson Drummond Percy Chase; sold anonymously at Sotheby's, 2 August 1872, lot 157 (£20.10s. to Ellis and Green); Alfred Aspland by 1876, sold Sotheby's, 27 January 1885, lots 94 (£4.10s. to Colnaghi), 95 (£4.8s. to Colnaghi), 96 (£4.8s. to Colnaghi), 97 (£5 to Colnaghi), 98 (£5.17s.6d. to Dr. Edward Riggall), 99 (£3.3s. to Colnaghi), 100 (£4 to Colnaghi), 101 (£5.5s. to Colnaghi); reunited by Crawford J. Pocock, offered Christie's, 14 May 1891, lot 567 (bought in at £47.5s.); Frank T. Sabin by 1913; offered in Rosenbach's catalogue 24 of 1916, item 17, with "original designs for 'America', Dante's 'Inferno', Blair's 'Grave', etc., etc." in a second "morocco folio" case ($29,000); both groups acquired December 1916 by Henry E. Huntington for $17,200 (according to Rosenbach's receipt of 1 January 1917 in the Huntington archives).

Exhibition: Burlington Fine Arts Club, 1876, Nos. 10, 12–17, 20; National Gallery [of] British Art, 1913, Nos. 50i-viii; Manchester Whitworth Institute, 1914, Nos. 62i-viii; Nottingham Art Museum, 1914, Nos. 46i-viii; Grolier Club, 1919–20, No. 44; Huntington Art Gallery, 1965–66 (Nos. 13–20), 1984.

Literature:
Rossetti 1880, 246, "another set" of *Comus* designs noted under No. 230a-h (the Boston set).
Darrel Figgis, Preface to *Comus: A Mask* (London: Ernest Benn, 1926), xxi-xviii, Boston series reproduced.
Baker 1957, 32–37, Huntington series reproduced.
Angus Fletcher, *The Transcendental Masque: An Essay on Milton's Comus* (Ithaca: Cornell Univ. Press, 1971), 253–56, both series reproduced in color.

Irene Tayler, "Blake's *Comus* Designs," *Blake Studies* 4 (1972):45–80, Hunting-
ton series reproduced; revised and expanded into "Say First! What Mov'd
Blake? Blake's *Comus* Designs and *Milton*," in *Blake's Sublime Allegory*, ed.
Stuart Curran and Joseph Anthony Wittreich, Jr. (Madison: Univ. of
Wisconsin Press, 1973), 233–58, Huntington series reproduced.
Stephen C. Behrendt, "*Comus* and *Paradise Regained*: Blake's View of Trial in
the Wilderness," *Milton and the Romantics* 3 (1977):8–13.
Behrendt, "The Mental Contest: Blake's *Comus* Designs," *Blake Studies* 8
(1978): 65–88.
Karl Franson, "The Serpent-Driving Females in Blake's *Comus* 4," *Blake: An
Illustrated Quarterly* 12 (1978–79):164–77, both series reproduced.
Butlin 1981, No. 527, both series reproduced in color.
Janet A. Warner, *Blake and The Language of Art* (Kingston and Montreal: McGill-
Queen's Univ. Press, 1984), 169–76.
All color reproductions of the Huntington series suffer from poor color
fidelity.

1. "Comus and His Revellers" (Illus. 1). Accession No. 000.20. 21.6 x
18.1 cm. Lightly foxed, with a small nick in the left elbow of the ani-
mal-faced figure second from the left.

The design incorporates images from at least three different pas-
sages in the poem: the opening speech of the attendant Spirit (1–91),
the stage directions following line 91 that introduce Comus and his
debauched retinue, and the entry and first speech of the Lady (170–
229). The representation of the attendant Spirit, placed upper left
"Before the starry threshold of *Jove's* Court" (1), may be indebted both
to the brief description of his "sky robes" (83) and to Milton's later
personification of Hope as a "hov'ring Angel girt with golden wings"
(214). The attendant Spirit describes the setting—a "drear Wood"
with "shady brows" (37–38)—and the habits of Comus and his band
of revellers who, although human, have become brutish, as their ani-
mal faces reveal. They are pictured, left to right, according to the
attendant Spirit's description: a "hog" (71), a "Wolf" (70), and an
"Ounce" (i.e., a lynx, 71). The right arm and hand of a fourth victim of
Comus' spells emerge from behind the large tree trunk along the right
margin. The upraised and overlapping arms of the troupe, similar in
general pattern to Blake's representation of the personified Morning
Stars in his Job designs,[7] evoke Comus' later descriptions of their
"Tipsy dance" and "wavering Morris move" (104, 116). Comus, a na-

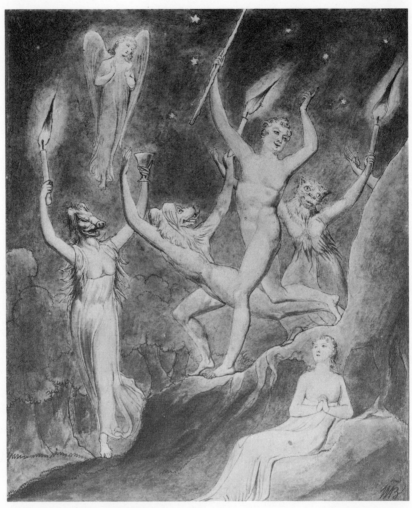

1. Comus and His Revellers

ked and rather fleshy youth, strides in front of the group. None of these figures, however, actually appears in the masque until the conclusion of the attendant Spirit's opening speech, at which point he becomes "viewless" (92). The stage direction introduces Comus' "Charming Rod," pictured in his right hand, the "Torches," and the "Glass," placed in Comus' hand in the text but given by Blake to the monster farthest to the left. The stage direction indicates that the group includes both "Men and Women." In the design, at least the

holder of the glass, and perhaps also the lynx-headed creature, seem to have female bodies. The Lady, pictured lower right before tentacle-like roots, does not enter the masque until some seventy-six lines later, after Comus and the monsters have left the stage. Her appearance and demeanor throughout the illustrations, and her role as a passive center of considerable activity, recall the virginal heroine of Blake's *The Book of Thel* (1789), an illuminated poem which may have been influenced by *Comus*.[8]

By combining figures and details from three parts of the masque, Blake introduces us to the three main antagonists in the poem, each representing a different state of organic and spiritual existence: the angelic, the beastly, and the human. This type of "epitome" design had been used for frontispieces or first illustrations in books since the early Renaissance, but had become less fashionable by Blake's time. Yet this traditional technique gave Blake a way of visualizing the psychological implications of Milton's poem. By placing the pensive and troubled Lady in the lower right corner and arraying Comus and his band above her head, Blake suggests that they are among the "thousand fantasies" and "calling shapes and beck'ning shadows dire" (205, 207) conjured up by the Lady's imagination in response to her "misbecoming plight" (372) and the revelry she hears but cannot see (170–81). The presence of the attendant Spirit violates the literal sequence of events, but emphasizes his omniscience and continual guardianship over the Lady.

In the Boston version, there are four beasts, each holding a torch, including humans (left to right) with the head of a hog, wolf or dog (wearing a collar), bull, and bird (see the fifth design). Neither of the last two is named in the text. Comus, with right foot forward, is dressed and slippered, holds his glass (as in the stage directions), and stands between the first and second monsters from the right. Only a small part of the tree trunk on the right margin is pictured, but the hillock behind the Lady has been enlarged and roughly formed into the quarter section of a circle. She turns to her left with hands extended, palms outward, in a gesture suggesting fright or protest. The attendant Spirit has been replaced by additional stars in the upper left sky. The upper outline of the tree foliage extends well above the heads of the first three revellers from the left.

2. "Comus, Disguised as a Rustic, Addresses the Lady in the Wood"
(Illus. 2). Accession No. 000.21. 21.9 x 18.5 cm. Remargined with a
narrow sliver of paper along the right margin extending for about 6
cm. up from the bottom corner.

Comus, who has now assumed the appearance of a "harmless Vil-
lager/Whom thrift keeps up about his Country gear" (166–67),
addresses the Lady (265–330). Her face and gesture express her con-

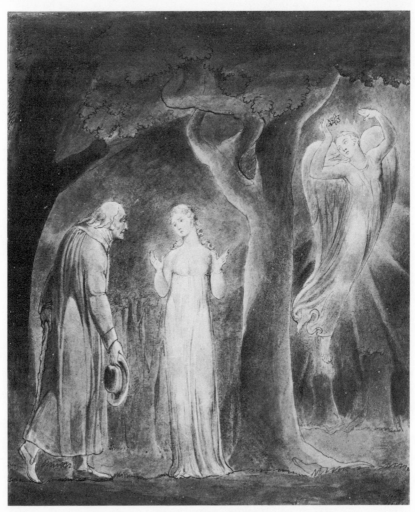

2. Comus, Disguised as a Rustic, Addresses the Lady in the Wood

fused and unhappy plight, for she is lost in the "rough shades" and "leavy Labyrinth" of the "tall Wood" (266, 270, 278). Comus hides his magic wand (see the first design) behind his back, even though it now takes on the character of a gnarled walking stick. His long coat and broad-brimmed hat are typical accouterments of travelers in Blake's art.[9] The attendant Spirit is not present in this scene in the text (244–330), but has a prominent role in the design. Rays of light emanate from his angelic form. Much later in the masque, the Spirit describes the magical root of "Haemony" (629–47) he gives the Lady's Brothers to protect them from Comus' spells. In "another Country," Heamony "Bore a bright golden flow'r, but not in this soil." A flower, even one specifically described as absent from the "soil" of this masque, has an obvious pictorial superiority over an "unsightly root" (629), and thus Blake places a small yellow flower in the Spirit's right hand. Once again, Blake has taken a motif named in a later scene and introduced it into an early illustration as an emblem prophetic of the Lady's eventual salvation.

In the Boston version, the attendant Spirit hovers closer to the ground, with wings extended upwards, and wears a transparent gown indicated only by a collar and a few filmy lines around his legs and right hip. A halo, arching over his head, replaces the more encompassing radiance of the Huntington design. His hands, palms outward, echo the Lady's gesture, but suggest disapproval as much as surprise. There is no flower. The Lady's hands are farther from her shoulders; her face expresses more confusion than sadness. Comus' disguise is much the same, but he looks younger and is slightly less stooped. There are now three trees immediately behind the Lady and Comus and two in the middle distance behind the Spirit. The changes in the trees, Comus' posture, and the Spirit's wings give the Boston version a much stronger vertical axis. The tree trunks are more columnar, branching into a canopy only at the top of the design.

3. "The Brothers Seen by Comus Plucking Grapes" (Illus. 3). Accession No. 000.22. 21.7 x 18 cm. Evidence of rubbing-out indicates that Blake changed slightly the size or the position of the ox's head.

In Comus' dialogue with the Lady, he describes how he came upon her Brothers "plucking ripe clusters from the tender shoots" of a

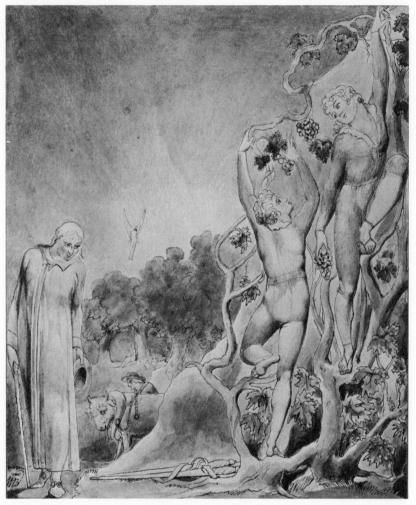

3. The Brothers Seen by Comus Plucking Grapes

"green mantling vine/That crawls along the side of yon small hill"
(294–96; see also the "cooling fruit," 186). Blake's portrayal of the
Brothers recalls similar scenes of climbing and gathering fruit in "The
School Boy" and the second plate of "The Ecchoing Green" among
the *Songs of Innocence*. As in these designs of 1789, the graceful bodies
of the youths harmonize with the shapes of the vines as they pluck
clusters of grapes. The Brothers' garb is also similar to the clothing

worn by boys and shepherds in *Songs of Innocence*. Their vulnerability is stressed by their having left their swords (mentioned 601 and 611) at the foot of the hill (lower center). They are distinguished in the text as the "elder" and the "second" Brother, but Blake gives no clear indication of their relative ages anywhere in the series. The Lady compares her Brothers to "Narcissus" (237), and some interpreters have found something narcissistic, even homoerotic, in their nearly identical lineaments, their rapt gaze at each other, and the intertwined straps of their swords.[10]

Although this scene in the masque is a flashback, Comus is pictured in the villager's costume he does not assume until he addresses the Lady (265). His expression of feigned humility does not disguise evil intent.[11] In the middle distance are the "labor'd Ox/In his loose traces" and the farmer ("swink't heger") mentioned by Comus (291–93), even though the latter is described as sitting "at his Supper." In the background are the tiny figures of the Lady, seated by a tree, and the attendant Spirit hovering protectively above. Radiance illuminates the sky just above the trees. A few jagged pencil lines 4.2 cm. above and slightly to the left of the Spirit's head may indicate a single star. The small mark 5 cm. above the Spirit's head is a flaw in the paper.

In the Boston version, the youth upper right places a cluster of fruit in his brother's extended right hand. The same action is pictured on the second plate of "The Ecchoing Green" (*Songs of Innocence*, 1789) and the second plate of *The Marriage of Heaven and Hell* (ca. 1790–93). The vines are smaller and do not extend to the left of the lower Brother. The swords are omitted. Comus' face, raised a little and tilted to the right, is less obviously malevolent. There are two oxen and the Spirit is much larger. His wings touch above his head and a spiky radiance surrounds his entire form. The trees are placed higher in the design, with the result that there is greater distance between the farmer and the Lady but less sky.

4. "The Brothers Meet the Attendant Spirit in the Wood" (Illus. 4). Accession No. 000.23. 22.2 x 18.1 cm. A few fragmentary lines indicate that the toes of the left foot of the figure on the right were first drawn farther to the left. Butlin 1981, No. 527.4, notes a 3 mm. strip of paper added to the bottom edge, but I can find no evidence of such remargining.

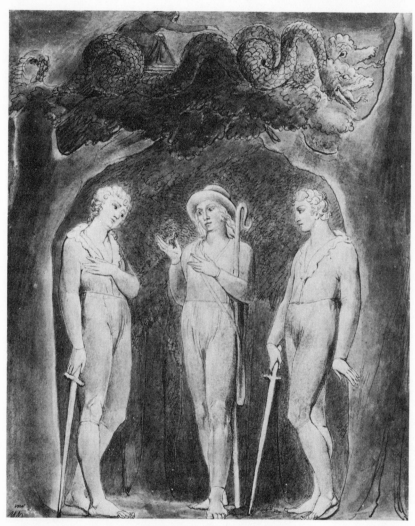

4. The Brothers Meet the Attendant Spirit in the Wood

The design illustrates the entry of the attendant Spirit and his con-
versation with the Brothers (stage direction and 490–658). The former
is now "habited like a Shepherd," with a satchel hanging at his left
side, its strap crossing over to his right shoulder, and a crook balanced
by his left upper arm. The two gentle youths now hold their swords, if
somewhat limply, as they are armed by the Spirit with knowledge of

Comus' evil powers and their sister's peril. The attendant Spirit, who the Brothers believe to be Thyrsis, their "father's Shepherd" (493), holds the golden flower of haemony (see the second design).

In his conversation with the Brothers, the Spirit refers to the moon goddess "Hecate" (535). This would seem to be the most direct prompting for Blake's introduction of the dark and heavily draped figure and serpents in the sky, but another relevant passage is Comus' apostrophe to "Dark veil'd Cotytto" and Hecate, who ride together in a "cloudy Ebon chair" as nocturnal allies in debauchery and sorcery (128–44). Blake's picturing of the serpents, apparently pulling Hecate (or a composite figure of Hecate/Cotytto) in a "chair," is indebted to a Roman frieze, showing Ceres pursuing Proserpine in a snake-drawn chariot, reproduced in Bernard de Montfaucon's *Antiquity Explained*.[12] This borrowing is given iconographic justification by the identification of Hecate and Cotytto with each other, and with Proserpine, in contemporary handbooks of classical mythology.[13] Further, the story of Proserpine and Ceres centers, like *Comus*, on a struggle between the forces of darkness and of light over a young woman's fate.

In the Boston version, the Brother on the right turns his back to the viewer; the Brother on the left gestures palm outward with his left hand. Two foreground tree trunks have been added immediately left and right of the Spirit/shepherd, whose left hand reaches down to grasp his crook. The foliage above these figures is wider and the serpents and their driver are smaller. The short and faint lines extending from the draped figure's hand in the Huntington version have become clearly drawn reins leading to the neck of each serpent. A crescent moon has been added just to the right of the driver's head, unmistakably identifying her with the moon. Her long hair is pictured, for she is no longer hooded. Because of these changes, Franson 1978–79, 167–71, argues that the figure in the sky is Cotytto in the Huntington design and Hecate in the Boston version.

5. "The Magic Banquet with the Lady Spell-Bound" (Illus. 5). Accession No. 000.24. 22.1 x 17.9 cm.

The Lady is "set in an enchanted Chair" before a table "spread with all dainties" in Comus' "stately Palace" (stage direction following 658). The three large lamps hanging from above may have been prompted by the Lady's earlier reference to the stars as "Lamps/With

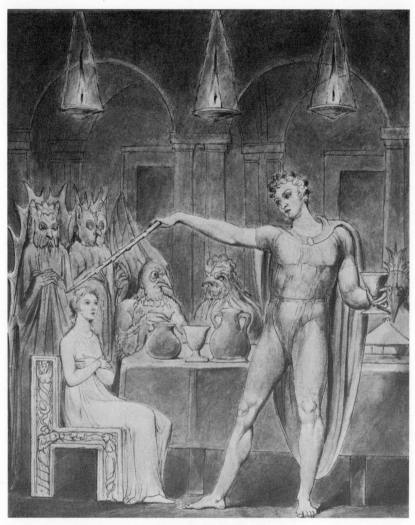

5. *The Magic Banquet with the Lady Spell-Bound*

everlasting oil" (198–99). The Lady's arms, crossed over her bosom, suggest both her bound condition and her attempts to protect the "freedom" of her mind (664). Her peril is underscored by the decorations on the chair: three figures, at least two of whom are female, encircled by serpents. Comus holds, in his left hand, his "Glass" (stage direction), filled just below the rim with "orient liquor" (65); his

"wand" (659) is in his right hand. Five members of "his rabble" (stage direction) with the heads of birds stand or sit behind the main adversaries. The Second Brother refers to a "village cock" (346), thereby providing a possible suggestion for the cock's head below Comus' right elbow, but there are no further textual references to birds. The representation of these avian monsters may have been influenced by several pictures of Osiris in Montfaucon's *Antiquity Explained* and by engravings of sculpted owls in the third volume (1794) of James Stuart and Nicholas Revett, *The Antiquities of Athens*, a work for which Blake engraved three plates.[14] The threatening unnaturalness of the banquet is underscored by Comus' rose-purple cape and blue hair, and by the greenish-yellow light suffused through the entire scene.

In the Boston version, Comus' band, from left to right, have the heads of a bald man with an idiotic expression, a cat, an elephant, a lion or some such shaggy beast, a boar with protruding tongue (just to the right of Comus), and a long-beaked bird similar to the one in the Huntington design. The first two monsters stand holding a jar and a pitcher respectively; the remainder are seated and seem to be busy eating from plates or a cup (far right). Both the elephant and the lion have animal bodies to match their heads. A semi-transparent snake twists upward from the jar, held by the figure far left, to which Comus points his wand. He is slenderer, his blue cloak less full, and he holds the cup at shoulder level. The outline of a cloud or smoke arches over the snake, the Lady (whose hands rest on her thighs), and the first three monsters on the left. The side of the Lady's chair is decorated with a shaft of grain. The simple Doric columns of the Huntington design have been replaced by a different arrangement of Ionic columns. For his architectural setting, as with the moon goddess of the fourth design, Blake has turned to classical sources and motifs, much as Milton has filled his text with classical allusions. There are no rectangular portals beyond the archway in the background.

6. "The Brothers Driving out Comus" (Illus. 6). Accession No. 000.25. 22.5 x 17.8 cm. Evidence of rubbing out to the right and above Comus' left arm and around his left thigh indicates that Blake changed slightly their size or position.

"The Brothers rush in with Swords drawn, wrest [Comus'] Glass

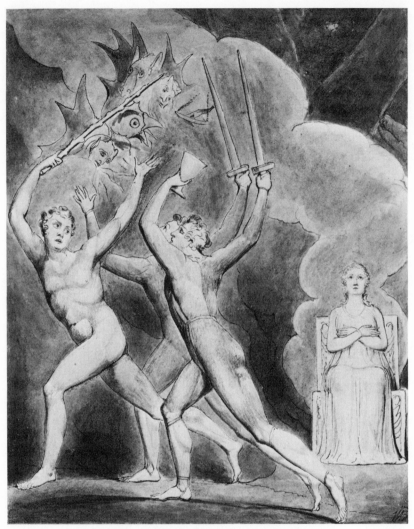

6. *The Brothers Driving out Comus*

out of his hand," and disperse his "rout" (stage direction following 813). Comus' palace, for which the lamp just left of the Brothers' swords serves as a visual synecdoche, and the monsters literally go up in smoke to be replaced by two trees and the night sky with two stars, upper right. Although no smoke is named in this scene, elsewhere in

the text it is associated with the dark forest (5) and with Comus' crew (655). The heads of Comus' remaining cohorts are pictured, bottom to top, as a devil with pointed ears and prominent lumps or short horns on his forehead, a bird with open beak, a bearded man with short horns, and a horse with large nostrils and ears. Three bat-like wings, similar to those given to the owl-faced creatures in the fifth design, are clustered behind them. The horned figures recall two heads of the Whore of Babylon's beast in Blake's watercolor design of ca. 1795–97 for the title page to "Night the Eighth" of Edward Young's *"Night Thoughts"* (British Museum; Butlin 1981, No. 330.345). The Brothers seem to be looking up at the four heads rather than at Comus. The Lady, still spellbound, sits in what appears to be the same rectilinear chair shown in the previous design, although its sketchy decorations do not clearly picture humans or snakes. Comus is nude, as he was in the first design, and still holds his wand even though the attendant Spirit had specifically instructed the Brothers to "seize" it (653). Much of the smoke seems to be billowing from behind the Lady's chair. This suggests that Comus' conjurations are made possible by the Lady's own troubled state of mind—a theme first suggested in the opening design. Thus the dispersal of Comus' band indicates a change in the Lady's psychological condition.

In the Boston version, the forest has replaced all but a column of flames (lower left) and smoke behind Comus and the Lady, who now sits on a ledge between her Brothers and their enemy. We see her in three-quarter view facing to the right. The heads of the four creatures above are arranged differently; all seem reasonably human. Comus is clothed and turns more toward us. The rear-most Brother is placed slightly to the right of his companion; he too turns his face toward us. The Lady's hands rest on her thighs, as in the fifth design of the Boston series. There is no lamp.

7. "Sabrina Disenchanting the Lady" (Illus. 7). Accession No. 000.26. 21.7 x 18 cm. There is a small nick in the paper in the crotch of the trees slightly above and to the left of the figure's hat, far left.

Sabrina, goddess of the River Severn, "rises, attended by water-Nymphs," to "sprinkle...drops...from [her] fountain pure" on the Lady to free her from Comus' spell (stage direction following 889 and 911–12). Sabrina's stylish coiffure may have been prompted by the

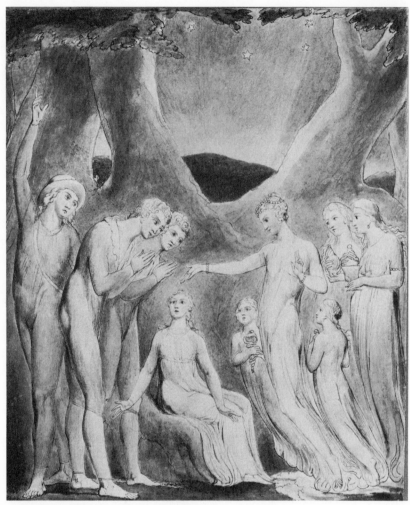

7. Sabrina Disenchanting the Lady

"twisted braids" in the attendant Spirit's song to her (863), although her hair is described as a "loose train" in the next line. The Spirit, still in his shepherd's costume, points heavenward, a gesture appropriate for his words at the end of this scene: "Come let us haste, the Stars grow high,/But night sits monarch yet in the mid sky" (956–57). We can still see the strap of his satchel crossing his chest, but he no longer has a crook. The Lady's Brothers bow toward Sabrina and hold their hands palm to palm as if in prayer. The Lady, seated in the center of

action, holds her arms and hands in a gesture hinting at astonishment, but also showing a freedom she lacked in the previous two designs. As heavenly magic replaces beastly forces, Sabrina's four attendants constitute a virtuous counterpart to Comus' rout. The nymph far right holds a covered cup or a vase, perhaps containing "vial'd liquors" (847), her adult companion holds a conch shell, and the child left of Sabrina clasps a turbinate shell, perhaps a whelk, with both hands. The top of a shell can be seen just above the left shoulder of the remaining nymph. These aquatic forms may have been suggested to Blake by "Triton's winding shell" (873). The beads in Sabrina's hair, around her wrists, and on the left arm of the figure far right are hinted at by "their pearled wrists" (834) described by the attendant Spirit. These jewels are similar to those worn by the finny woman swimming underwater on plate 11 of *Jerusalem* (ca.1804–20). The nymph far right and the girl right of Sabrina each wears a small circular earring. The waters of the Severn lap gently below their feet. The burst of radiance above the distant hills fails to dispel four "Stars" (956).

In the Boston version, there are no tree trunks or stars and Sabrina has only two diminutive attendants, at least one of which holds a large spiral shell. Sabrina has no jewels, but holds a large clam or oyster shell in her left hand. She sprinkles the magical water with her right hand directly on the Lady's "breast" (as the text directs, 911) rather than above her head as in the Huntington version. The Lady's arms extend up and out from the elbow, but her open hands express much the same emotion as in the Huntington design. She sits on a large rock rather than a grassy bank. Sabrina's hair is "loose" (864) and she bends at the knees closer to the Severn than in the Huntington version. Only the more distant Brother holds his hands in prayer; the other is pictured in profile with his right arm at his side. A rainbow extends from the Lady to the right margin, arching just above Sabrina's head. This prominent motif is given textual precedent by the attendant Spirit's references to "Iris' Woof" (83) and "humid bow" (992) and Comus' to "the colors of the Rainbow" (300).

8. "The Lady Restored to Her Parents" (Illus. 8). Accession No. 000.27. 22.4 x 18.3 cm. Lightly foxed in the sky, hill, and on several figures.

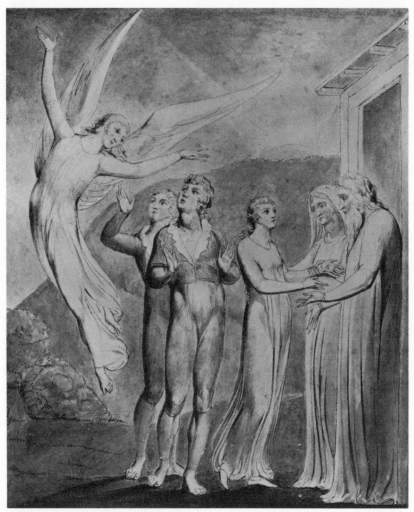

8. The Lady Restored to Her Parents

The Lady and her Brothers have left the dark wood to return to the
house of their aged parents (947 and stage direction following 957).
Their humble house on the right contrasts with Comus' palace pic-
tured in the fifth design. The Brothers look to the left with gestures of
surprise as they see the attendant Spirit *in propria persona* as a soaring
winged figure. The Lady's mother, with a mantle over her head, re-
calls similar figures elsewhere in Blake's art, such as the old woman in

the illustration on page 35 of Edward Young's *Night Thoughts*, engraved by Blake 1796–97. Such figures are associated with Vala, the goddess of fallen nature in Blake's mythology, and with other mysterious females like the hooded moon goddess in the fourth design. It is far from certain that this iconography is pertinent to the Lady's mother in *Comus*, but the format of the design does suggest a juxtaposition between the Lady's spiritual guardian on the left and her earth-bound natural parents on the right. While the masque ends in joyous dance and song, Blake's illustrations end on a far more serious note emphasized by the facial expressions of all six figures.

In the Boston version, the disc of the sun above the distant hill is smaller but more prominently outlined and colored. The large shaft of light in the Huntington design is replaced by many smaller rays. Trees and their heavy foliage fill the middle distance. We now see the pitch of the roof on the far right. The front-most Brother turns his back to us, with arms down but hands spread out; the other Brother holds his hands in prayer. We also see the attendant Spirit from behind; his extended hands reach toward the top right corner. The Lady is pictured in profile and with a happier expression on her face. Her parents, however, look even more careworn. Her mother raises her right hand in greeting, rather than reaching it around her daughter's waist as in the Huntington design.

b. Illustrations to Paradise Lost. 1807. Illus. 9–20.

Twelve designs in pen and watercolors, each approx. 25.5 x 21 cm. Most designs appear to have been trimmed slightly—see the notes on signatures and the fragments of the borders around the sixth, eighth, ninth, and eleventh illustrations. Each design is pasted down to a card the same size as the image, which is in turn attached to a backing mat taped at the corners to a larger (approx. 60 x 48 cm.) front mat with window. The group is housed in a blue quarter-leather case with "BLAKE DRAWINGS FOR PARADISE LOST" in gilt on the spine.

Designs number 4, 9, 11, 12, and perhaps 3 bear the date "1807," and this is in all probability the date of composition for the entire series. There is no record of any commission or original purchaser; but W. M. Rossetti, in his annotated copy of his 1863 catalogue (210–11), noted the existence of a set of *Paradise Lost* illustrations belonging to

Alfred Aspland and associated with "Chase."[15] These references strongly suggest that the Huntington series, like the *Comus* illustrations, was first acquired (and commissioned?) by Chase's grandfather, the Rev. Joseph Thomas.

Many of the scenes Blake chose to picture were well-established subjects for illustrators of *Paradise Lost*, but "Christ Offers to Redeem Man," "The Creation of Eve," and "Michael Foretells the Crucifixion" are most uncommon.[16] Further, Blake emphasizes Christ's role in the epic far more than most previous illustrators. In *The Marriage of Heaven and Hell* of ca. 1790–93, Blake wrote a brief but radical re-reading of *Paradise Lost* in which the Devil claims for himself the role of hero. There is no evidence of such a Satanic perspective in these watercolor illustrations, but rather one consistent with Blake's Christo-centric theology in his own epics, *Milton* (ca. 1804–1808) and *Jerusalem* (ca. 1804–20). The iconography of the designs is expanded and intensified through the many parallel motifs, including the proleptic appearance of signs of the fall in early illustrations and parodic recastings of prelapsarian imagery in later ones, which link scenes separated by the linear narrative. Throughout the series, we encounter images prophetic of salvation through Christ. These foreshadowings and echoes provide a visual equivalent to the typological structures in Milton's poem.

Blake completed another series of twelve *Paradise Lost* illustrations dated 1808 (Butlin 1981, No. 536). These larger designs, all approx. 49.5 x 39.5 cm., were first acquired, and probably commissioned, by Thomas Butts. They represent the same scenes, except that the fourth design has been replaced by "Adam and Eve Asleep." Nine of the Butts set are now at the Museum of Fine Arts, Boston; the first is in the Victoria and Albert Museum, London, the second is in the Huntington (described below as No. c), and the tenth is in the Houghton Library, Harvard University, Cambridge, Massachusetts.[17] The Butts set is somewhat more highly finished and monumental than the Huntington group, with stronger interior modeling on the figures and more facial details. The figures are larger, in relation to the total pictorial space, than in the Huntington series. Blake began another series, approx. 51 x 38 cm. and based on the Butts group, for John Linnell in 1822, but the only designs known from this set are versions of the fifth, eighth, and eleventh illustrations (Butlin 1981, No. 537). The

major differences between the Huntington series and these other illustrations, as well as information about preliminary and closely related works, are briefly noted below for each design. The poem is cited by book and line number.

Provenance: Joseph Thomas; inherited by his grandson Drummond Percy Chase; sold anonymously at Sotheby's, 2 August 1872, lot 156 (£100 to Ellis and Green); Alfred Aspland by 1876, sold Sotheby's, 27 January 1885, lots 77–88 (dispersed, as noted for each design below); reunited in 1914 by Henry E. Huntington.

Exhibition: Burlington Fine Arts Club, 1876, Nos. 114–19, 160–65; Grosvenor Gallery, 1877–78, Nos. 353–55, 358, 361, 362, 381, 386, 387, 389–91; Edinburgh Museum of Science and Art, 1878, Nos. 146–57; Carfax & Co., 1906, Nos. 51a–l; Grolier Club, 1919–20, No. 45; Huntington Art Gallery, 1936 (Nos. 1, 2a, 3–12), 1937, 1940, 1965–66 (Nos. 1–12), 1953, 1984.

Literature:

William Bell Scott, *William Blake: Etchings from His Works* (London: Chatto and Windus, 1878), 7–8, with four etchings by Scott based on the fifth, eighth, ninth, and eleventh designs in the Huntington series.

Rossetti 1880, 218, no. 85.

Anon., "*The Creation of Eve* by William Blake," *Burlington Magazine* 10 (1907): 290–91.

Darrell Figgis, *The Paintings of William Blake* (London: Ernest Benn, 1925), 67–69, Boston series reproduced.

C. H. Collins Baker, *An Exhibition of William Blake's Water-Color Drawings of Milton's "Paradise Lost"* (San Marino: Huntington Library, 1936), series reproduced.

Baker, "William Blake, Painter," *Huntington Library Bulletin* 10 (1936):144–46.

Baker, "The Sources of Blake's Pictorial Expression," *Huntington Library Quarterly* 4 (1940–41):359–67; reprinted in *The Visionary Hand*, ed. Robert N. Essick (Los Angeles: Hennessey & Ingalls, 1973), 117–26.

Morse Peckham, "Blake, Milton, and Edward Burney," *The Princeton University Library Chronicle* 11 (1950):107–26.

Baker 1957, 15–26, Huntington series reproduced.

John Beer, *Blake's Humanism* (Manchester: Manchester Univ. Press, 1968), 194–96, 257.

Edward J. Rose, "Blake's Illustrations for *Paradise Lost, L'Allegro,* and *Il Penseroso*: A Thematic Reading," *Hartford Studies in Literature* 2 (1970):40–67, Huntington series reproduced.

Robert R. Wark, *Ten British Pictures* (San Marino: Huntington Library, 1971), Chap. VII, "Blake's 'Satan, Sin, and Death'."

Joseph Anthony Wittreich, Jr., "William Blake: Illustrator-Interpreter of *Para-*

dise Lost," in *Calm of Mind,* ed. Wittreich (Cleveland: Press of Case Western Reserve Univ., 1971), 99–103.

Martin Butlin, "A Minute Particular Particularized: Blake's Second Set of Illustrations to *Paradise Lost," Blake Newsletter* 6 (1972–73):44–46.

David Wagenknecht, *Blake's Night* (Cambridge: Harvard Univ. Press, 1973), 173–81.

Butlin 1981, No. 529, all designs reproduced, the three series in color.

Irene H. Chayes, "Blake's Ways with Art Sources: Michelangelo's *The Last Judgment," Colby Library Quarterly* 20 (1984):71–3, 79, 88.

1. "Satan Calling Up His Legions" (Illus. 9). Accession No. 000.1. 25 x 21.1 cm. Signed lower right "18[trimmed off]/ WB." Small scratches in cloud upper right; Satan's loins lightly stained. Touches of blue along the bottom edge, now covered by the mat, suggest that this color has faded from other areas of the design.

Provenance: As for the series to 1885, lot 77 (£6 to Pincott); Sydney Style, sold Sotheby's, 15 December 1906, lot 481, with all but the fifth and sixth designs (£2000 to Frank T. Sabin); Rosenbach Company, sold 1911 to Henry E. Huntington ($17,000 for all but the fifth and sixth designs).

Satan is pictured "on the Beach/Of inflamed Sea" as he attempts to rouse his rebel angels (1:299–334). Blake had previously painted two temperas of this scene, one ca. 1799–1800, now in the Victoria and Albert Museum, and the other ca. 1800–1805, now at Petworth House, Sussex (Butlin 1981, Nos. 661 and 662). In both, Satan stands in the upper center of the composition with arms raised, but the action is pictured from a more distant point of view with many more figures less symmetrically arranged than in the Huntington watercolor. A slight pencil drawing (ca. 1805–10?) may be a sketch for Satan with alternative positions for his arms (Robert N. Essick collection; Butlin 1981, No. 591).

Satan's troubled visage with "baleful eyes" (1:56) and the slight suggestion of scales over his genitals, like those given to Satan in Blake's sixth Job watercolor of ca. 1805–1806 (Pierpont Morgan Library; Butlin 1981, No. 550.6), indicate his fallen condition; but his heroic physique suggests residual potency. His dramatic stance and arm gesture recall illustrations of this scene by Thomas Lawrence (exhibited at the Royal Academy in 1799) and Henry Fuseli (painted and engraved in 1802), as well as Blake's own personification of "Fire"

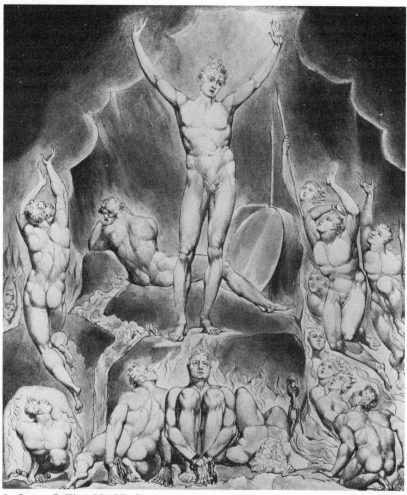

9. *Satan Calling Up His Legions*

in *For Children: The Gates of Paradise*, plate 5 (1793).[18] Satan's "ponderous shield" and "Spear" (1:284, 292) rest on the rock behind and to the right of him. The clouds and streaks in the sky in the background suggest one half of Milton's interwoven water and flame imagery descriptive of the "fiery Deluge" of hell (1:68). Some of Satan's minions are beginning to "rouse and bestir themselves" (1:334) and rise from their "Dungeon horrible" and "Adamantine Chains and penal Fire" (1:48, 61). Their bodies, like many similar figures throughout

Blake's art, testify to his great indebtedness to Michelangelo. The chained figure immediately below Satan's feet is a familiar Blakean type, with notable versions on the frontispiece and plate 3 of *America* (1793), plate 22 of *The Book of Urizen* (1794), and in the lower left corner in both tempera versions of "Satan Calling Up His Legions." The upside-down figure just to the right has numerous parallels, including the victim in "The Poison Tree" in *Songs of Experience* (1794), two personifications of Death in Blake's *Night Thoughts* watercolors of ca. 1795–97 (British Museum; Butlin 1981, Nos. 330.434 and 330.435), one of the dead sons in the third Job design (Pierpont Morgan Library; Butlin 1981, No. 550.3), and one of the fallen figures in the lower right corner of "The Fall of Man," a watercolor of 1807 (Victoria and Albert Museum; Butlin 1981, No. 641). A generally similar upside-down male with cascading hair, but no beard, appears in Edward Burney's illustration of the same scene in an edition of *Paradise Lost* published in 1799. The crouching devil in the lower left corner is reminiscent of the imprisoned figure on plate 9 of *The Book of Urizen*; he is repeated in a small niche in the lower right quarter of "The Last Judgment" pencil drawing of ca. 1809 (National Gallery of Art, Washington; Butlin 1981, No. 645). The seated figure behind Satan is pictured below his leader in both tempera versions. His melancholic posture suggests classical sculptures of fallen soldiers or a traditional river god.[19] The latter association is particularly apt because of the infernal river of "liquid fire" (1:229, and see 2: 575–76) cascading from behind his left hip. The rising figure on the left is a slightly modified version of one of the saved just below the left corner of Christ's throne in Blake's "The Day of Judgment" illustration to Robert Blair's *The Grave*, drawn in 1805 but now known only through Louis Schiavonetti's engraving of 1808.

The format of the whole design, with rising and crouching bodies symmetrically arranged about a vertical central axis defined by a single dominant figure, also reminds us of a Resurrection or Last Judgment scene.[20] Blake's use of this compositional formula suggests that he found a typological relationship between Satan's rousing of the fallen angels and Christ's resurrection of fallen man, the former event a satanic parody of the latter, both predicting and necessitating it.

There are only eight figures pictured in the Butts version, now in the Victoria and Albert Museum. Satan, the recumbent figure behind

him, and the crouching figure lower left are positioned much as in the Huntington design, but the upside-down and bearded man has been moved to the lower center of the composition. His manacled arms and hands are pictured in a cruciform position; the head of another tortured follower of Satan emerges above his right arm. The bound figure with prominent knees drawn up to his chest, placed immediately below Satan in the Huntington design, has been moved to the right corner. Two heads appear above his left shoulder. There is no fiery river; flames appear only around Satan's feet and the two figures below him, and above the group lower right. There is only one spear. The streaks in the sky behind Satan are more prominent.

2. "Satan, Sin, and Death: Satan Comes to the Gates of Hell" (Illus. 10). Accession No. 000.2. 24.7 x 20.8 cm. Signed lower right "W Blake."

Provenance: As for the series to 1885, lot 78 (£5.5s. to Pincott); as for the first design.

Satan, in his flight to the earth, enters from the left to be challenged by his incestuous offspring, Death (2:645–734). Sin, Satan's daughter and mate, interposes herself between father and son (2:726). The basic arrangement of the figures follows the tradition established by William Hogarth's painting of ca. 1735–40 and continued by many illustrators of the scene.[21] In Blake's first known attempt at the subject, a pencil and wash drawing of ca. 1780 (University of Texas, Austin; Butlin 1981, No. 101), Satan and Death are pictured much as in this Huntington design, but Sin is on the right. A pencil drawing at Johns Hopkins University (Butlin 1981, No. 530) is closely related to the finished watercolors and is probably of about the same date. It is close in size to the Thomas/Huntington version with the figures similarly proportioned, but Satan and Death stand as in the Butts/Huntington design. This drawing may be transitional between the two watercolors, with Sin's arms arranged in an intermediate position. Rossetti 1863, 249, No. 99, and 1880, 268, No. 127, lists an uncolored work he titles "Death shaking the dart" in the collection of "Mr. Harvey." This untraced drawing may be related.

Satan brandishes the shield and spear pictured at his side in the first design, even though neither is mentioned in the passage illustrated.

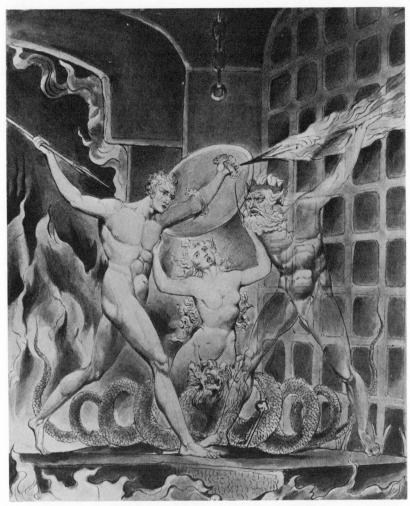

10. Satan, Sin and Death: Satan Comes to the Gates of Hell

The adversaries "frown" and take "horrid strides" toward each other
(2:676, 713–14). Death, wearing a "kingly Crown," raises his flaming
"Dart" with both hands and levels "his deadly aim" at Satan's head
(2:672–73, 711–12). Milton describes Death as a "shadow," a figure
"that shape had none" (2:667, 669). Most illustrators of the scene pic-
tured him as a skeleton, but Blake indicates Death's insubstantiality
by drawing his body in outline but revealing the background through

his transparent flesh. Blake has thereby remained true to the text without turning away from his characteristic linear style and toward chiaroscuro techniques indicative of the "obscurity" which, for Edmund Burke, made Milton's description of Death an exemplar of the sublime.[22]

The strong diagonals formed by the combatants' weapons give linear expression to their conflict and focus attention on Sin, who rises to separate them. She is pictured with a voluptuous torso, but below her loins are the tails of two serpents coiling "in many a scaly fold/Voluminous and vast" and the heads of three "Hell Hounds.../ With wide *Cerberean* mouths" (2:650–51, 654–55). Her "fatal Key" to "Hell Gate" (2:725) dangles to the right of Death's right calf. Above and behind Satan are two archways, suggesting that he has already passed through two groups of the "thrice threefold" gates and has come to the last set "of Adamantine Rock" (2:645–46). Although the rectilinear gateway on which the figures stand suggests rock, the barrier on the right is, as in Hogarth's painting, a "huge Portcullis.../ Of massy Iron" (2:874, 878) with vertical bars terminating at the bottom in points like Death's dart. The chain descending above the center of Blake's illustration also recalls the chain hanging from the portcullis in Hogarth's picture, as well as the chains in Blake's first design.

In the Butts version, also at the Huntington, Satan has his left leg forward and is turned more toward the viewer. His genitals are scaled. Death, now without a beard, has his left foot advanced and shows us his back. Sin's left arm is almost fully extended to touch Death's left elbow. The scaly coils on each side terminate in crested serpents' heads similar to the snake's in the ninth design. Their open mouths and forked tongues recall Milton's image of "a Serpent arm'd/ With mortal sting" in the scene illustrated (2:652–53). The same detail appears, rather obscurely represented, in Burney's illustration published in 1799. The head of a fourth hellhound now appears just left of Satan's left knee. All three figures stand on uneven ground rather than cut stone. The vertical bars of the portcullis no longer end in spear-points. There are numerous minor changes in the figures' hair, the architectural background, and in the position of the flames.

For further information on the Butts version, see Part I, section A, No. c, below.

3. "Christ Offers to Redeem Man" (Illus. 11). Accession No. 000.4.
25.7 x 20.9 cm. Signed lower right "180 [cut off, except for what may
be the bottom of a 7]/ WB." Evidence of scratching-out below Satan's
left shin, right thigh, and around his head.

Provenance: As for the series to 1885, lot 79 (£4 to Pincott); as for the first
design.

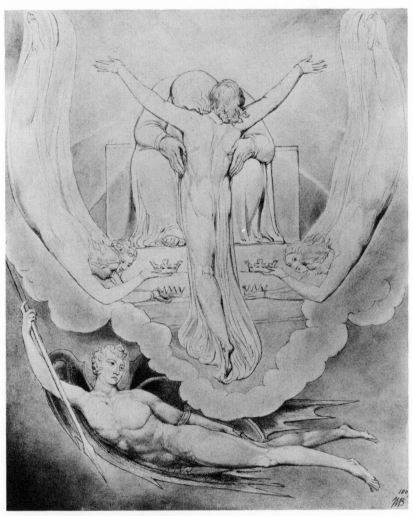

11. Christ Offers to Redeem Man

Christ is shown in the act of offering to atone through His incarnation and death for man's sins (3:222-65). Blake drew a very similar image of Christ in "The Ascension," a watercolor of ca. 1803–1805 (Fitzwilliam Museum; Butlin 1981, No. 505). Christ's gesture, contrasting sharply with the enclosed and static posture of the Father "High Thron'd" but "bent down" (3:58), foreshadows the crucifixion we see in the eleventh design. The hiding of God's face and the placement of Christ before Him may be Blake's pictorial literalization of Milton's description of the Son as He through whom "th' Almighty Father shines,/ Whom else no Creature can behold" (3:386–87). On both sides of the rectilinear throne, similar to the one bearing a heavy, despairing figure on plate 51 of Blake's *Jerusalem*, angels descend to "cast/ Their Crowns" before God (3:349–52). A similar descending figure, but with arms outstretched, appears in one of Blake's *Night Thoughts* watercolors he also engraved (British Museum; Butlin 1981, No. 330.17, page 40 of the 1797 edition). Below, Satan is "Coasting the wall of Heav'n on this side Night/ In the dun Air sublime" (3:71–72). He holds his spear and shield and his genitals are again covered with scales, but he now has wings (3:73) with bat-like trailing edges. He is similarly armed and winged, but pictured in a somewhat different hovering posture, in Blake's 1795 color printed drawing, "Satan Exulting over Eve" (Butlin 1981, Nos. 291–92). Milton's "wall" at the periphery of heaven becomes in Blake's illustration a parabolic cloud band. In the *Paradise Lost* series and in several of his Job illustrations of ca. 1805–1806, Blake used such clouds to indicate the boundary between higher and lower states of vision and being.[23]

"Christ Offers to Redeem Man" includes motifs from two preliminary drawings in Blake's *Notebook* (British Library; Butlin Nos. 201.104 and 201.110–11).[24] The pencil sketch on page 104 lacks the descending angels but includes the winged Holy Ghost hovering over the scene. The Father's arms overlap the Son's and reach down to His buttocks. The sketch on pages 110–11 is a somewhat different composition, with God's face and long beard visible and the Son standing prayerfully at the Father's left hand. Below, a figure one would expect to be Satan, yet with female breasts, twists within a web of curved lines.

In the Butts/Boston version, the larger figures fill almost all of the pictorial space. God slumps over slightly to His right and His hands are a little higher on Christ's back. Unlike the Huntington design,

there are no horizontal lines suggesting steps below God's throne. Christ's head is turned to the left so that we see a profile of His "conspicuous count'nance" (3:385) on which "Divine compassion visibly appear'd" (3:141). His hands overlap the ankles of the descending angels. On each side, the front-most angel completely covers the body of his companion, only a portion of whose face is pictured. The angels' crowns are "inwove with Amarant.../...a Flow'r which once/ In Paradise, fast by the Tree of Life/ Began to bloom..." (3:352–55). Satan holds his spear with the point at its top, just above his right hand. There are no scales over his loins. The cloud band is less symmetrical, particularly where it dips below Christ's feet, and there is a stronger contrast between the "dun Air" (3:72) around Satan and the light radiating from God.

4. "Satan Spying on Adam and Eve and Raphael's Descent into Paradise" (Illus. 12). Accession No. 000.5. 25.1 x 20.9 cm. Signed lower left "W Blake 1807." Slightly foxed.

Provenance: As for the series to 1885, lot 81 (£5 to Pincott); as for the first design.

The design is a composite of three separate events in the poem: Satan, "undelighted," watching Adam and Eve walking in the garden (4:285–324); God's instructions to Raphael (5:224–45); and the Seraph's descent to Eden (5:266–85). The temporal division of these episodes between two Books of the text is given pictorial expression by the dramatic, V-shaped cloud band separating Raphael and God from the terrestrial scene. On the left, Satan gestures in surprise or consternation, his face "dimm'd" (4:114) and brow knotted as he "falls into many doubts with himself, and many passions, fear, envy, and despair" ("The Argument" to Book 4). Blake captures this sense of self-division and degeneration into a lesser form of being by entwining Satan's winged body with the serpent he will become and placing the serpent's head in ascendancy over Satan's residually angelic countenance. This motif, nowhere indicated in the text, also visualizes Milton's description of the hell "within" Satan "and round about him" (4:20–21) wherever he goes. The perverse and restrictive embrace of Satan and serpent contrasts with the gentle companionship of Adam and Eve—as they walk "hand in hand" and gaze into

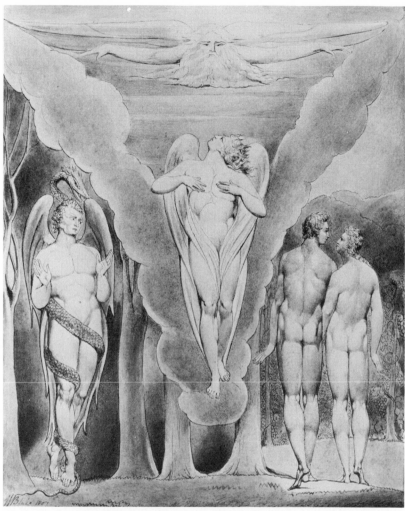

12. *Satan Spying on Adam and Eve and Raphael's Descent into Paradise*

each other's eyes as a prelude to "love's imbraces" (4:321–22)—and with the vines and clusters of "purple Grape" (4:259) twining around the two tree trunks behind the couple. This last motif suggests the traditional elm and vine *topos*, an emblem of ideal marriage, corporeal or spiritual, expressive of Adam and Eve's Edenic relationship.[25] The fruitful vegetation also contrasts with the barren tree left of Satan. Adam is pictured with "Hyacinthine Locks" (4:301) and Eve with the

"golden tresses" which Milton compares to a vine with curling tendrils (4:305–307).

Raphael, partly "veil'd with his gorgeous wings" (5:250), intercedes like a spear point between Satan and his intended victims. The angel looks above to "th' Eternal Father" (5:246) as though he were still receiving His instructions. The portrayal of God, with wings and arms "outspread" (1:20 and 7:235), is generally similar to His appearance in the sketch of "Christ Offers to Redeem Man" on page 104 of Blake's *Notebook* (see the third design, above) and to the rain god in Henry Fuseli's "Fertilization of Egypt," engraved by Blake in 1791 for Erasmus Darwin's *The Botanic Garden*. A common source of this image for both Fuseli and Blake may be an engraving of Jupiter Pluvius from the Antonine Pillar in Montfaucon's *Antiquity Explained*.[26] Variations on this figure type appear in many of Blake's designs, including the title-page to *Visions of the Daughters of Albion* (1793), the 1795 color printed drawing "The House of Death" (Butlin 1981, Nos. 320–22), and "Christ's Troubled Dream" in his illustrations to Milton's *Paradise Regained* of ca. 1816–20 (Fitzwilliam Museum; Butlin 1981, No. 544.8).

In the Butts/Boston group, the design is replaced by "Adam and Eve Asleep" (4:771–809; Butlin 1981, No. 536.5). Ithuriel and Zephon hover over the couple who recline on a bed of flowers while Satan, in the form of a toad, sits "close at the ear of *Eve*" (5:800).

5. "Satan Watching the Endearments of Adam and Eve" (Illus. 13). Accession No. 000.6. 25.7 x 21.8 cm. Signed lower right "W Blak [cut off]."

Provenance: As for the series to 1885, lot 80 (£10 to Gray); J. Annan Bryce by 1904; apparently sold privately to Henry E. Huntington in 1914.

The design illustrates the luxuriant scene in which Adam kisses Eve while Satan watches with "envy" (4:492–504), but Blake draws on other passages in Book Four to picture the couple's "happy nuptial League" (4:339). Several critics have associated the gentle sensuousness of the design with the state of "Beulah" in Blake's mythic poetry.[27] Adam and Eve sit on a "soft downy Bank damaskt with flow'rs" (4:334) over which large sprigs of "Laurel" and roses "without Thorn" form a "blissful Bower" (4:256, 690, 694, 698).[28] Below their feet are lily-like flowers, not mentioned in the poem. A some-

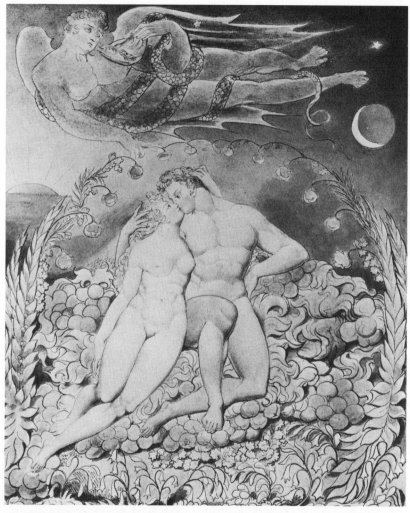

13. Satan Watching the Endearments of Adam and Eve

what exaggerated and stylized emphasis on the floral surroundings is also offered in engraved illustrations of Edenic scenes in *Paradise Lost* by Richard Westall (1795), Edward Burney (1799), and Henry Fuseli (ca. 1800–1810). Eve "half imbracing lean'd/ On our first Father," and looks on Adam "with eyes/ Of conjugal attraction unreprov'd" (4:492–95).[29] Her "loose tresses" (4:497) tumble over her right shoulder. Adam wears a wreath of flowers in his hair—a detail, not men-

tioned in the text, which foreshadows Christ's crown of thorns in the eleventh design. Above, Satan gazes at his serpent form twisted around him in a solipsistic parody of the kiss and embrace of Adam and Eve. His left hand, resting on the serpent's head, repeats the form of Eve's hand on the back of Adam's head. Satan's right forefinger points toward Adam's head or slightly above and beyond it. Satan's human form is little more than a ghostly presence; one of the two stars in the sky can be seen through his upper wing. Thus he has taken on one of Death's characteristics in the second design, while his serpentine self recalls Sin. Satan's posture may have its source in two engravings of wind gods in James Stuart and Nicolas Revett, *The Antiquities of Athens*, volume 1 (1762).[30] The sun has "declin'd" into "th' Ocean" (4:353–54) on the left, balanced by "the coming on/ Of grateful Ev'ning mild" and the "fair Moon" with "her starry train" on the right (4:646–49; see also 4:355, 540–41).

In 1806, Blake executed a watercolor of the same scene showing the serpent at the feet of Adam and Eve and Satan above grasping his head with both hands in jealous torment (Fogg Art Museum; Butlin 1981, No. 531). The torsos and heads of Adam and Eve are positioned as in the Huntington and Butts/Boston designs, but their arms and hands are arranged differently. A small pencil sketch (Fitzwilliam Museum; Butlin 1981, No. 532), picturing only Adam and Eve, would seem to be a preliminary for the 1806 design since both show Eve's legs crossed at the ankles. Another pencil drawing (British Museum; Butlin 1981, No. 533) is probably an intermediate composition between the 1806 design and the Huntington version. The lines delineating Satan are unclear in this sketch, but he may be holding the serpent in his extended right hand. The sun and moon are situated as in the Huntington design.

In the Butts/Boston version, Satan's position is reversed so that he now flies to the right. Consequently, we can now see a clear similarity between Adam's cradling of Eve's head in his right hand and Satan's caress of the serpent's head with his right hand. Satan's left forefinger points directly at Eve's right eye; she now seems to be gazing up at Satan as much as at Adam. All these changes strengthen the parodic relationship between the two couples and hint at Eve's later fascination with the serpent's seductive attentions. The sun is now on the right side of the composition with Adam; the moon is on the left with

Eve. If this reversal is meant to preserve the usual directional conventions of east and west, then the sun must be rising, as Eve describes it in 4:641–56. Satan is more solidly modeled than in the Huntington version, but two of the eight stars can be seen through (or on?) his upper wing. Eve holds a single rose in her left hand and Adam holds two lilies on one stem in his left hand, now extended to mid-thigh. There are no berries on the laurel on the left; both bordering sprigs now look more like palm fronds. There are numerous minor differences in the floral arrangements. The design in the incomplete series planned for Linnell closely follows the Butts/Boston version (National Gallery of Victoria, Melbourne; Butlin 1981, No. 537.1). There are three stars in the sky above Satan's feet, three on his legs, one bisected by the upper edge of his right wing, and one on his left wing to the right of his left shoulder.

6. "Raphael Warns Adam and Eve" (Illus. 14). Accession No. 000.7. 25.7 x 20.9 cm. Signed lower left on Eve's chair "W Blake." Traces of a border line along top edge.

Provenance: As for the series to 1885, lot 83 (£10 to Gray); as for the fifth design.

Raphael has joined Adam and Eve in their "Bow'r.../ With flow'rets deck't" (5:375, 379) to answer Adam's questions about creation and to deliver God's admonitions about sin (beginning at 5:451 and continuing into Book 8). Raphael's multifold wings (see 5:277–85) rise to form an ogee arch over his head. With his left hand he points above, probably in reference to the "Almighty" (5:469), and with his right to the "interdicted Tree" (7:46) in the middle distance.[31] The serpent twines around the tree and several beasts stand around it, much as Satan describes to Eve his first enounter with the tree and its "alluring fruit" (9:585–93). Thorny tendrils climb the trunk and thorns grow from the edges of some of its branches as indications of the dangers the tree poses to those who would eat its fig-like fruit. A very similar tree, with the serpent coiled around it, appears in Blake's 1807 watercolor, "The Fall of Man" (Victoria and Albert Museum; Butlin 1981, No. 641). The animals around the tree include a horse, a Renaissance symbol of lust, who looks back at the tree (with "Longing," as Satan says, 9:593?); an "elephant" (4:345), perhaps as a sign of concupiscence; a peacock, often associated with pride or vanity but also a

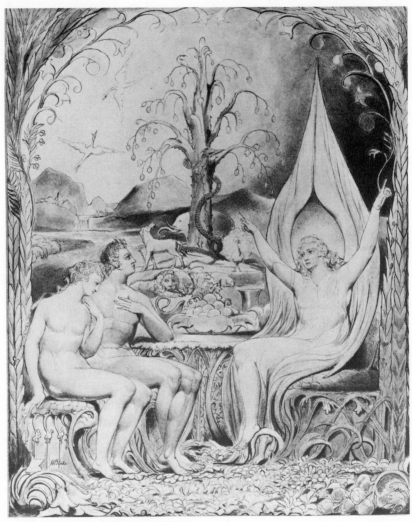

14. Raphael Warns Adam and Eve

traditional emblem of immortality; and a "lion" (4:343) who lies down with at least three sheep in this still peaceable kingdom. In the background on the left, "waters fall/ Down the slope hills" (4:260–61), to the right of which stands a "stag" (7:469) and another tiny beast which I cannot identify. Two large, long-necked birds soar left of the tree; another sits on the top-most branch on the left. This last motif recalls

the description of Satan sitting "Like a Cormorant"' on the Tree of Life (4:194–96).

Adam looks above, rather than directly at Raphael, suggesting that he is "attentive" (7:51) to the transcendental message rather than the angel's bodily appearance. Adam's gesture, left hand on breast, indicates the heartfelt impression Raphael's story is making. Eve leans toward her mate, seemingly more interested in Adam than the angel in accord with Milton's concepts of feminine subservience: "Hee for God only, shee for God in him" (4:299). Between the couple and Raphael stands the "Table" fringed with "grassy turf" and laden with "various fruits" in a leafy bowl, a goblet, and a large cup with a delicately twisted handle (5:390–91; see also 5:303–307). A few oak leaves can be seen behind the table legs. The base of the table and the "mossy seats" (5:392) are constructed of curving and interlaced vegetation reminiscent of Gothic tracery.[32] Branches of laurel leaves and berries frame the design on each side. Lilies and roses, growing on the same branches, complete the upper portions of the bower.

In a pencil sketch of the design, Adam and Eve sit on a couch-like bed of flowers with their forelegs drawn up under their thighs (British Museum; Butlin 1981, No. 534). Eve extends her right forearm toward the right with her hand raised, palm-outward. Raphael's wings are not raised but drop down his back. Many of the floral details, the table, all the animals, and the landscape are not pictured.

In the Butts/Boston version, Eve stands in the middle of the design, right foot striding forward. She separates Adam and Raphael much as her eating of the forbidden fruit will separate Adam from God. She is serving "at Table" (5:443–45), and thus the design pictures a slightly earlier scene than the Huntington illustration. She holds a cluster of purple grapes (see 5:307) in her right hand and the decorative cup in her left hand which, in the Huntington version, rests on the left side of the table. Her head leans toward Adam. Behind her are more fruit and two gracefully designed vessels on the table. The forbidden tree, smaller than in the Huntington design, is directly above Eve's head. It stands on a high hill on which are two horses and an ox. The serpent is pictured with two complete loops around the tree and his head rests in the crotch between the first limb on the left and the trunk. The waterfall is present, but there are many differences in the landscape. Two birds fly close to the ground in the middle-distance between

Adam and Eve. Above them are two palms, an ostrich, an elephant, and a peacock. A female lion, or some other large cat, is just above Adam's head; a flock of sheep graze to the right of Raphael's right hand. A stag leaps above the flock and in front of a clump of trees. Right of Eve's left shoulder is a tree entwined with a grape vine. Two similarly decorated trees appear above Adam's right shoulder. Clusters of purple grapes also grace the framing vegetation on each side. There are two oak leaves on the right like those behind the table legs. The laurel leaves look more palmlike, but their berries are still pictured. The arching vines have only lilies and bare but delicately curled tendrils. We see Adam's face in three-quarter view. His brow is knitted, his eyes are downcast, and he gestures in surprise or consternation with palms turned upward. Raphael is crowned and his wings do not extend as high as in the Huntington version. The bases of their chairs are even more elaborate and now include pointed Gothic arches. The foreground leaves and flowers are considerably smaller in relation to the size of the figures.

7. "The Rout of the Rebel Angels" (Illus. 15). Accession No. 000.8. 25.8 x 20.8 cm. Signed lower right "W Blake." There is some evidence of rubbing-out on and to the left of the left thigh of the large falling figure just right of center.

Provenance: As for the series to 1885, lot 82 (£5 to Pincott); as for the first design.

The final battle in heaven is described in 6:834–66. Christ, all but His left arm circumscribed by the disc of the sun, bends His great "Bow" (6:713, 763) and aims one of seven "arrows" (6:845) at the rebellious angels now "Hurl'd headlong flaming from th' Ethereal Sky" (1:45).[33] Two groups of three loyal angels hover on each side of the circle. The front-most angel in each group gestures in awe at the spectacle below. Blake drew similar groups of gesturing angels, but without wings, around God in his fifth Job watercolor of ca. 1805–1806 (Pierpont Morgan Library; Butlin No. 550.5). Christ's face is taut and "severe," but does not strongly express the "wrath" Milton describes (6:825–26). Blake also pictures a heroically proportioned figure leaning on one knee and reaching down from a great circle in his famous "Ancient of Days," the frontispiece to *Europe* (1794); but there

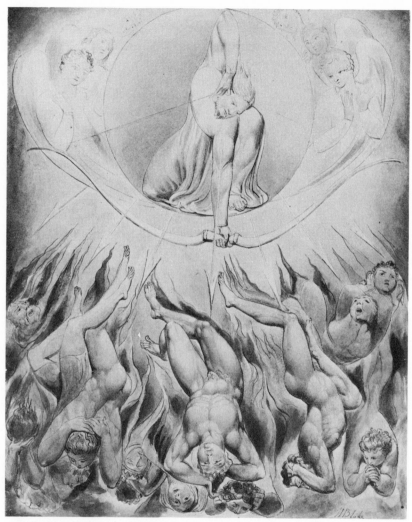

15. *The Rout of the Rebel Angels*

the figure is Urizen in the act of delimiting material creation with giant compasses. Blake's sixth design to Thomas Gray's "The Progress of Poesy," executed ca. 1797–98, is an even closer analogue (collection of Mr. and Mrs. Paul Mellon; Butlin 1981, No. 335.46). In the Gray illustration, Hyperion stands before the flaming disc of the sun and points his bow and arrow to the left. Specters of the night descend headlong

below shafts of light in the form of arrowheads, much as in this *Paradise Lost* illustration. A similar format and visual pun on Son/sun also appear in John Flaxman's thirty-first illustration to Dante's *Paradiso*, in which Christ sits enthroned on the sun surrounded by lines of radiance and worshipful (but not winged) figures.[34]

The falling angels, like Satan's companions in the first design, have many forerunners in Blake's works featuring Michelangesque figures. The central figure, with scales already covering part of his loins, may be Satan, for he is shown in much the same posture in Blake's sixteenth Job watercolor of ca. 1805–1806 (Pierpont Morgan Library; Butlin 1981, No. 550.16). Blake first used this figure type on plate 7 of *America* (1793). Just below the left forearm of this central figure is one of the "helmed heads" mentioned by Milton (6:840). The next head to the left is crowned. The large figure on the left, with his hands over his head, falls like the victim on the left in plate 6 of *The Book of Urizen* (1794). Three large watercolors contemporary with the Huntington *Paradise Lost* series include several similar damned and descending figures: "A Vision of the Last Judgment" of 1806 (Pollock House, Glasgow; Butlin 1981, No. 639), "The Fall of Man" of 1807 (Victoria and Albert Museum; Butlin 1981, No. 641), and "The Vision of the Last Judgment" of 1808 (Petworth House, Sussex; Butlin 1981, No. 642).

In a group of three interrelated drawings of ca. 1780, Blake pictures the battle in heaven between Satan and Michael in *Paradise Lost* (untraced, Philadelphia Museum of Art, and Bolton Museum; Butlin 1981, Nos. 103–104A). Blake developed this design in a pencil sketch of ca. 1795 and in one of his *Night Thoughts* watercolors of ca. 1795–97 (both British Museum; Butlin 1981, Nos. 105, 330.452). Although these compositions are closely related in subject to the Huntington *Paradise Lost* design, none bears any compositional similarities to it.

In the Butts/Boston version, Christ's face is milder, perhaps touched by "Divine compassion" (3:141). Both His knees touch the lower rim of the sun's circle. There is a large arrowhead below His bow hand, but there is no shaft, as though Christ's straight left arm had replaced it. There are four arrows of light descending from the sun. Below are thirteen (rather than fourteen) falling angels, some indicated only by their heads. The three largest, front-most figures are variations on those in the Huntington version, with the left and right figures exchanging places. There are many differences between the two designs in the postures and positions of the other bodies and

heads. None are helmeted or crowned in the Butts/Boston version.

8. "The Creation of Eve" (Illus. 16). Accession No. 000.9. 25.3 x 20.8 cm. Signed lower right "1807/ WB." Traces of a border line just below the signature and along the right edge. Slight foxing along the left edge.

Provenance: As for the series to 1885, lot 84 (£7 to Pincott); as for the first design.

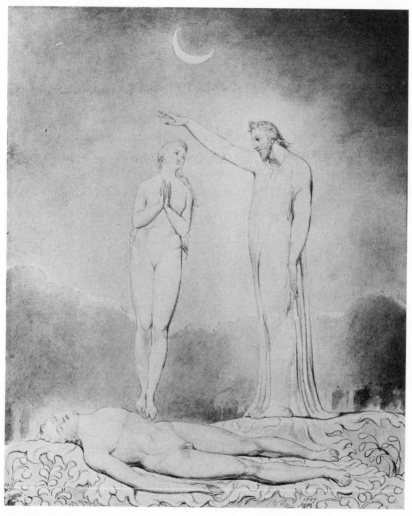

16. The Creation of Eve

Under the "forming" hand of Christ, Eve rises from Adam's side, her hands together in prayer (8:452–77). In the poem, Adam relates this event which he saw "as in a trance.../ Though sleeping" (8:462–63). His condition may account for Blake's atmospheric indefiniteness in the delineation of the aura around Christ and the hazy background. The moon, traditionally a celestial representative of the feminine, is poised directly above Eve. Beginning in *The Book of Urizen* (1794), Blake treated the separation of the sexes in his mythic poetry as a fall into division. In this context, Adam's sleep can be viewed as a decline into a lower level of consciousness. Similarly, the giant leaf on which Adam lies and Christ stands suggests a diminution from a spiritual to a vegetative state. Yet this can also be a fortunate fall, a necessary step toward ultimate reunification and the salvation of both sexes. As Blake writes in *Jerusalem* (ca. 1804–20), "...when Man sleeps in Beulah, the Saviour in mercy takes/ Contractions Limit, and of the Limit he forms Woman: That/ Himself may in process of time be born Man to redeem."[35] The creation of Eve is also pictured in *Jerusalem*, plate 35, showing Eve just emerging from Adam's side and Christ soaring above in flames, and in Blake's Genesis manuscript (see Part I, section C, Nos. 10 and 11).

In Adam's recounting of this scene, he does not specifically refer to Christ's presence. However, Milton consistently attributes the creation of the world to Christ as the Father's "effectual might" (3:170) and the performative embodiment of His creative "Word" (7:163; see also "The Argument" to Book 7). Accordingly, Blake pictures Christ as Eve's creator even though the tradition established by Renaissance portrayals of the Biblical event, such as Michelangelo's Sistine fresco, gives this role to God the Father. An important precedent for the presence of Christ in Blake's design is Henry Fuseli's 1793 painting of the same subject (Hamburg, Kunsthalle). The godly creator in the background is somewhat ambiguously characterized; but in a letter of 14 August 1795, Fuseli wrote that some viewers supposed "that the aerial figure may perhaps aim at being a representation of the Supreme Being: no Such thought entered my head—for Believers, let it be the Son, the Visible agent of His Father; for others it is merely a Superior Being entrusted with [Eve's] Creation."[36]

Blake's preliminary pencil drawing for "The Creation of Eve" is in the British Museum (Butlin 1981, No. 535). Only the three figures and

the moon are indicated in sketchy outline. In the Butts/Boston version, Adam's body is turned a little more toward us, his feet touch each other, and his left hand and part of his left forearm are pictured. Eve's face is less turned toward Christ and her brow and mouth are more relaxed, expressing reverence rather than worry. Her eyes look upward rather than toward Christ's face. His hair is longer and He stands on a giant leaf clearly distinct from the one beneath Adam. A diffuse halo surrounds His head; the aura around His body is narrower than in the Huntington version and does not reach to His feet. The tree trunks and foliage in the background are clearly outlined. The foreground vegetation has been rearranged, with lily-like flowers lower right. The design in the incomplete series planned for Linnell closely follows the Butts/Boston version (National Gallery of Victoria, Melbourne; Butlin 1981, No. 537.2). Christ's halo is larger and more clearly defined than in the earlier versions. There is a diffused aura around Eve's head, but none around Christ's body.

9. "The Temptation and Fall of Eve" (Illus. 17). Accession No. 000.10. 25.4 x 20.8 cm. Signed lower right "1807/ WB." Traces of a border line along right edge.

Provenance: as for the series to 1885, lot 85 (£6 to Pincott); as for the first design.

Blake pictures both Eve's fall and Adam's sudden consciousness of a profound disturbance in Eden. Eve stands before the the Tree of the Knowledge of Good and Evil and eats of its fruit (9:780–84). In the poem, she plucks the fruit from the tree, but Blake shows her accepting it from the serpent's mouth in a satanic parody of the innocent kiss of Adam and Eve in the fifth illustration. Eve's left hand, gently cradling the serpent's head as it had embraced Adam's in the fifth design, contributes to the strong sexual implications of this unholy union of woman and beast. Blake closely follows Milton's description of the serpent, balanced on a "Circular base of rising folds.../ Fold above fold a surging Maze, his Head/ Crested aloft, and Carbuncle his Eyes;/ With burnisht Neck of verdant Gold, erect/ Amidst his circling Spires" (9:499–502). Entwining the serpent around Eve's body is Blake's own addition to the scene, one that recalls Satan's serpent-bound form in the fourth and fifth designs. Blake first used this striking motif in the 1795 color printed drawing "Satan Exulting over Eve"

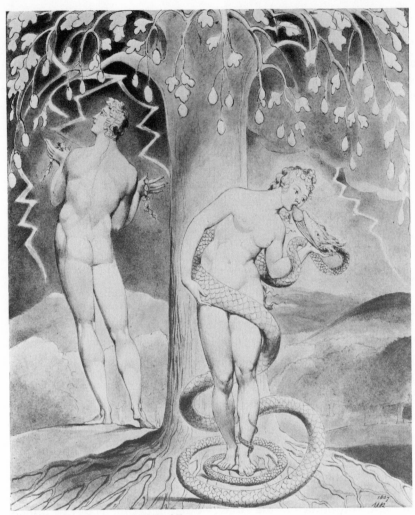

17. *The Temptation and Fall of Eve*

(Butlin 1981, Nos. 291–92). The tree is "Loaden with fruit of fairest colors mixt,/ Ruddy and Gold" (9:577–78). Its tentacle-like roots contribute to the sense of entrapment and repeat in their jagged outline the lightning streaking through the stormy sky. This last motif is not necessarily implied by the text until the "Thunder" after Adam's fall (9:1002); but the dark clouds, roots, and lightning offer a visual correlative to Milton's statement, in the main passage illustrated, that

"Earth felt the wound, and Nature from her seat/ Sighing through all her Works gave signs of woe" (9:782–83). Adam and Eve had parted shortly before her fall ("The Argument" to Book 9). He stands in the middle distance with the "Garland" he had been making for Eve's "Tresses" draped over each hand (9:840–41). His gesture of surprise and visage show that "hee the falt'ring measure felt" (9:849). The rendering of Adam's back may be based on plate 23 in Alexander Browne's *Ars Pictoria*.[37]

Blake's pencil sketch of a woman encircled by a serpent may be a preliminary version of Eve (Victoria and Albert Museum; Butlin 1981, No. 589). The woman in this drawing stands rigidly upright and is seen full face with the serpent touching her mouth; a few sketchy lines in the background suggest two or three trees. The sketch, and through it perhaps Eve in this *Paradise Lost* illustration, may have been adopted from a statue of Isis entwined with a snake, reproduced in Montfaucon's *Antiquity Explained*.[38] In Blake's tempera of ca. 1799–1800, "Eve Tempted by the Serpent" (Victoria and Albert Museum; Butlin 1981, No. 379), Adam sleeps while the gigantic snake coils behind and above Eve with the fatal fruit in its mouth. The portrayal of the serpent in this painting is clearly indebted to Milton's description, and the placement of the fruit is an important prelude to this watercolor, but the composition is otherwise unlike the Huntington illustration.

In the Butts/Boston version, the tree trunk is formed of clustered branches spread out into roots at its base. The large thorns on trunk and roots recall the appearance of the tree in both versions of the sixth illustration. The hillock beneath the roots is no longer bare, but covered with grassy vegetation. Adam has dropped the garland (9:892–93) which now lies on the ground just left of his left foot. The three bolts of lightning are larger and seemingly closer to the figures. The two bolts on the left pass behind Adam's hands; one points toward his right foot.[39] The background foliage is lower and more clearly outlined.

10. "The Judgment of Adam and Eve: 'So Judged He Man'" (Illus. 18). Accession No. 000.11. 25 x 20.2 cm. Signed lower right "W Blake." Slight foxing lower right and left of Adam's back.

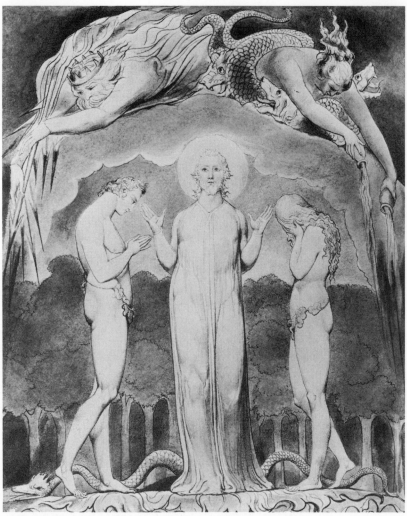

18. The Judgment of Adam and Eve: "So Judged He Man"

Provenance: As for the series to 1885, lot 86 (£7 to Pincott); as for the first design.

Christ, a haloed "mild Judge and Intercessor both" (10:96), stands between Adam and Eve and gestures toward each as He delivers His judgment on them and the serpent (10:163–208). Eve, "with shame nigh overwhelm'd" (10:159), buries her face in her hands, while

Adam bows and clasps his hands in prayer. Both have covered their loins with "broad smooth Leaves" (9:1095; see also 9:1110–15) of a shape typical of Blake's representations of oak leaves. All three figures stand on an enormous leaf like the one beneath Adam in the eighth illustration. The serpent, whose penalty is to move on his "Belly groveling" (10:177), undulates just behind and below the raised heels of Adam and Eve, for "Her Seed shall bruise thy [the serpent's] head, thou bruise his heel" (10:181).

Sin and Death, allowed to pass through the "Gates of Hell" (9:230) as a consequence of the fall, dominate the top of the design. They are not present during the judgment scene in Milton's text, and thus Blake has pictured in one composition two consecutive events in the narrative, much as he does in the previous design. A cloud band— perhaps a reminder of the "Bridge" (9:301) they had built to earth— separates Sin and Death from the trio below but does not stop the descent of Death's darts on the left or the diseases Sin pours from two vials on the right (see 11:471–93). Blake, following the imagery of Revelation Chap. 16, pictured vials with liquid pouring from them to symbolize disease in his engraving on page ten of the 1797 edition of Edward Young's *Night Thoughts*, and included both darts and a single vial in "Satan Smiting Job with Boils," first executed as part of the Job watercolor series of ca. 1805–1806 (Pierpont Morgan Library; Butlin 1981, No. 550.6). Death, bearded and crowned, is recognizably the same figure portrayed in the second design; but he is no longer transparent, for the fall has given him physical embodiment. Sin's hellhounds and two serpentine tails surround her torso. The two figures seem to join at the waist, thereby picturing Milton's comment that "Death from Sin no power can separate" (10:251).

In the Butts version, now in the Houghton Library, Harvard University, Adam's head is upright rather than bowed and his right heel is poised above the serpent's head. Christ's halo is less clearly defined around its circumference. Death has three rather than eight darts, but he is otherwise pictured much as in the Huntington design even though he does not have a beard in the Butts version of the second illustration. The malevolent visages of Sin and Death are more strongly characterized, and we see more of their faces, than in the Huntington version. The hellhounds are differently arranged, with two above Sin's head and none beneath her right arm. Both of her

scaly tails extend toward the right margin. Individual leaves are clearly outlined in the shrubbery between the background tree trunks.

11. "Michael Foretells the Crucifixion" (Illus. 19). Accession No. 000.12. 25.2 x 20.3 cm. Signed lower right "1807/WB." Traces of a border line along the right edge.

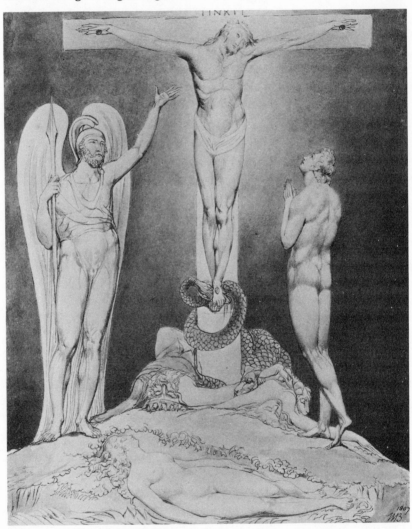

19. Michael Foretells the Crucifixion

Provenance: As for the series to 1885, lot 87 (£6 to Pincott); as for the first design.

In his lengthy description of mankind's future, the warrior angel Michael tells of Christ's crucifixion (12:401–35). Michael, wearing a "Helm" like a centurion's and holding his "Spear" (11:245, 249), points and looks toward Christ "nail'd to the Cross" (12:413) below the traditional Latin motto INRI (Jesus of Nazareth, King of the Jews). Christ's lineaments, loin cloth, and crown of thorns are very similar to those in Blake's watercolor of ca. 1800–1803, "Christ Crucified between the Two Thieves" (Fogg Museum; Butlin 1981, No. 494). Adam, no longer wearing leaves around his loins, holds his hands in prayer and gazes up at Christ's face. The cross is raised on a small hill, as is conventional for representations of Calvary. The landscape also accords with the "Hill/ Of Paradise" (11:377–78) from which Michael shows Adam this vision of the future.

At the foot of the cross are Sin and Death, for Christ's sacrifice has defeated them (see 12:415–17, 431).[40] Sin's hellhounds, three of whose heads lie on her torso, have also been stilled forever. The up-side-down cruciform posture of Sin and Death, foreshadowed by the bearded devil in the first design, indicates that they are "with him [Christ] there crucifi'd" (12:417). The serpent coils just above the fallen pair, his head pierced by the nail through Christ's feet. This early Christian motif is suggested by Michael's prophecy that the crucifixion "Shall bruise the head of Satan" (12:430). Blake also used this symbol in "The Everlasting Gospel" of ca. 1818: "And thus with wrath he did subdue/ The Serpent Bulk of Natures dross/ Till he had naild it to the Cross."[41]

Just as Adam slept while Eve "to life was form'd" (11:369), she now sleeps "below while thou [Adam] to foresight wak'st" (11:368). She lies in a shallow depression in the ground which suggests burial, or close identification with the earth, as much as sleep. Blake may have used this odd motif to suggest his own ideas about the annihilation of a separate female will, or emanation, necessary for spiritual renewal.

In the Butts/Boston version, Michael is larger in proportion to the other figures and his left arm is more bent at the elbow. His right arm descends down the shaft of his spear. Adam, Eve, and Michael are closer to the cross. The Latin motto does not appear at the top of the

cross. Christ's crown of thorns is more prominent. As in plate 76 of *Jerusalem* (ca. 1804–20), His loin cloth is knotted in front and its loose end hangs between His thighs. Only the serpent's head, rather than his head and a loop of his body, is pierced by the nail. His head is now crowned with a comb as in both versions of the ninth illustration. A spiral form, not colored like the rest of his body, replaces the serpent's coils heaped above Sin in the Huntington version. The depression in which Eve lies is accentuated by its brown coloring which contrasts with the surrounding yellow-green hillside. There are more individually outlined tufts of vegetation than in the Huntington version, but no fringe of small plants around Eve's resting place. The design in the incomplete series planned for Linnell (Fitzwilliam Museum; Butlin 1981, No. 537.3) follows the Butts/Boston version, but is illuminated by a great suffusion of light emanating from Christ's head.

12. "The Expulsion" (Illus. 20). Accession No. 000.13. 24.9 x 20.5 cm. Signed lower left "1807/WB." Slight foxing, most noticeably on Eve's right thigh and chest.

Provenance: As for the series to 1885, lot 88 (£7 to Pincott); as for the first design.

"In either hand the hast'ning Angel caught/ Our ling'ring Parents" and leads them "down the Cliff" from Eden (12:637–39). The angel Michael is dressed much as he is in the previous design, but he now wears a plumed crown less reminiscent of a centurion's helmet. These slight changes, plus the absence of his spear, make him less militant. Adam and Eve are once again clothed with leaves around their loins. "Looking back" (12:641) and up, they see a great coiling form representing the "Sword of God.../ Fierce as a Comet" (12:633–34) that leads them out of Eden and will become the "flaming Brand" (12:643) that bars them from returning. At the top of the design are four of the guardian "Cherubim.../ With dreadful Faces throng'd and fiery Arms" (12:628, 644).[42] Milton makes no mention of their mounts, the addition of which suggests the four horsemen of the Apocalypse. This allusion is appropriate because of Michael's earlier references to "this world's dissolution" and last judgment (12:459–60). Neither the lightning bolts nor the serpent below Michael's feet is named in the passage illustrated. The foreground thistles and thorny branches are not

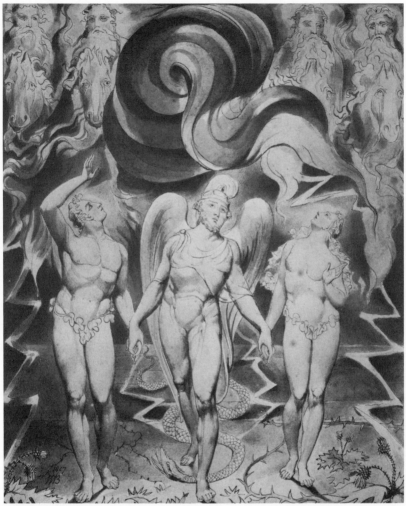

20. The Expulsion

mentioned in Book 12, but receive textual precedent from Christ's ear-
lier judgment of Adam ("Thorns also and Thistles," 10:203). Yet even
these images of fallen nature are not devoid of redemptive signifi-
cance, for the thorns remind us of Christ's crown in the previous
design.[43]

Blake pictured the expulsion of Adam and Eve on the title page of
Songs of Innocence and of Experience (1794) and in a pencil drawing of ca.

1820–25 (Alice M. Kaplan collection; Butlin 1981, No. 1026). Neither is related compositionally to this *Paradise Lost* illustration. In Blake's watercolor of 1807, "The Fall of Man" (Victoria and Albert Museum; Butlin 1981, No. 641), Christ holds Adam and Eve by their hands and guides them out of Paradise much as Michael guides the pair in this illustration. "The Fall of Man" includes steps behind the trio much like those indicated by horizontal lines in the Huntington design. See also Blake's Genesis manuscript, Part I, section C, No. 9.

In the Butts/Boston version, the Cherubim are more prominent. The ears of their horses touch at their tips to form ogee arches. Adam and Eve look down at the serpent. Their hand gestures are generally the same as in the Huntington design, but Eve's open mouth underscores the expression of surprise. Michael holds Eve by the wrist rather than the hand. His crown has become a simple skullcap surmounted by a great flowing plume. There is only one thistle plant (left margin) and the thorns are placed differently. There are no steps behind the foreground figures.

c. "Satan, Sin, and Death: Satan Comes to the Gates of Hell" (Illus. 21). Accession No. 000.3.

Pen and watercolor, with touches of liquid gold (now tarnished). 49.6 x 40.3 cm. Signed lower left with Blake's monogram, "inv./WB." Traces of rubbing out indicate that Satan's shield was originally drawn much larger. There is also evidence of reworking below Sin's upper arms and between her lower torso and Death's left leg. Pasted down to a backing mat and framed. According to Butlin 1981, 384, the verso (now covered) is inscribed, not in Blake's hand, "drawn for Mr. Butts from whom it passed to Mr. Fuller."

Provenance: Thomas Butts, Thomas Butts, Jr.; Mr. Fuller by 1863; H. A. J. Munro, sold Christie's, 24 April 1868, lot 500 (£3.12s. to Cuff); R. P. Cuff by 1876; Charles De C. Cuff, sold anonymously at Christie's, 19 July 1907, lot 46 (£99.15s. to F. T. Sabin); Rosenbach Company, sold October 1916 to Henry E. Huntington, with the illustrations to Milton's "On the Morning of Christ's Nativity" ($10,000, according to Rosenbach's receipt in the Huntington archives).

Exhibition: Burlington Fine Arts Club, 1876, No. 45; Huntington Art Gallery, 1936 (No. 2b), 1940, 1965–66 (No. 27), 1974, 1983, 1984.

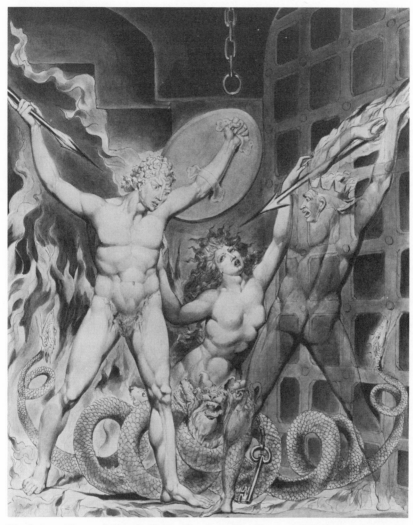

21. *Satan, Sin, and Death: Satan Comes to the Gates of Hell* (from the Butts series)

Literature:
Rossetti 1863, 225, No. 18; 1880, 247, No. 234.
Butlin 1981, No. 536.2, reproduced in color.
See also *Literature* for the *Paradise Lost* series, item b, above.

This version of "Satan, Sin, and Death" became detached from the other designs in the Butts series of illustrations to *Paradise Lost* when the group was dispersed at auction in 1868. Ten of the other eleven Butts illustrations are signed "W Blake" and are dated 1808; but it is possible that this design was executed as an independent work at a slightly earlier date, perhaps even before the other version in the Huntington. Blake rarely used the distinctive monogram appearing on this design after 1806.[44] "Satan, Sin, and Death" is the only design in the series with this monogram, and the only one touched with liquid gold. A lapse of time might also explain the inconsistency of picturing Death without a beard, for he is shown with a long, flowing beard in the tenth and eleventh designs of the Butts series.

For a discussion of motifs and comparisons with other versions, see the other "Satan, Sin, and Death" at the Huntington, Part I, section A, No. b.2, above.

d. Illustrations to "On the Morning of Christ's Nativity." Ca. 1814–16. Illus. 22–27.

Six designs in pen and watercolors, each approx. 16 x 12.5 cm., signed "W Blake" lower left or right. Each design is pasted down to a backing mat with three edges gilt, approx. 35.5 x 24 cm., with a framing line approx. 1 cm. from the image. Below each image, written in golden brown ink in a fine italic script, are lines from the poem noted for each design below. Each backing mat is pasted to a surrounding top mat, approx. 60 x 48 cm., and the group housed in a blue quarter-leather case with "BLAKE DRAWINGS FOR THE NATIVITY" in gilt on the spine.

Another set of six larger designs (approx. 25.5 x 19 cm.) by Blake illustrating the same scenes in Milton's "Nativity Ode" (as the poem is usually called) are in the Whitworth Art Gallery, University of Manchester.[45] Two of these are dated by Blake "1809" and three others bear fragments of what was probably the same date before the designs were trimmed. This is no doubt the date of composition of the entire Whitworth series, first owned (and probably commissioned by) the Rev. Joseph Thomas. The Whitworth group is notable for the thorough subordination of color to firm pen and ink outlines. In contrast, the Huntington series has simpler and more relaxed outlines and less

interior modeling of facial features, but a much greater emphasis on coloristic effects and delicate surfaces built with small brush strokes as in miniature portraiture. These characteristics associate the Huntington group with Blake's illustrations to Milton's *Paradise Regained*, "L'Allegro," and "Il Penseroso," all of which include designs on paper watermarked 1816. The lapidary surfaces of these works (dated ca. 1816–20 by Butlin 1981, Nos. 543 and 544) are more highly wrought than in the "Nativity Ode" designs, and thus a date of ca. 1814–16 seems likely for the Huntington designs. They were first owned, and probably commissioned, by Thomas Butts.

Typically, Blake follows Milton's text closely, particularly in the earlier, Whitworth series. Yet the "Nativity Ode" is a fairly short poem containing allusions to many figures and events not described in any detail. Nor was there a well-developed tradition for the illustration of the poem, there being no recorded series of "Nativity Ode" designs prior to Blake's. Thus, Blake was able to invent complex visualizations of only a few lines without violating the letter of the text or pictorial details associated with it.

At its auction in 1852, the Huntington series was sold "with the poem in MS," according to the catalogue. Butlin 1981, 393, reports (on the basis of evidence unknown to me) that these were "transcripts of Milton's verses in Blake's hand," now lost. The quotations of the poem on the backing mounts, recorded for each design below, may be based on these earlier transcriptions. The order of the designs indicated by these quotations is followed here and in Butlin 1981, No. 542. Numbers on the back of the old mats on which the Whitworth designs are still mounted record the same sequence—but see the third design for an alternative arrangement. Major differences in motifs and composition among the Huntington and Whitworth series and all extant preliminary sketches are noted for each design. The poem is cited by line number.

Provenance: Thomas Butts; Thomas Butts, Jr., sold Sotheby's, 26 March 1852, lot 147 (£6.12s.6d. to Henry G. Bohn); B. G. Windus; his daughter Mrs. J. K. de Putron by 1863, sold anonymously at Christie's, 16 March 1912, lot 6 (£336 to Frank T. Sabin); offered by Rosenbach Company, December 1912 catalogue, item 11, "bound in large 4to green morocco, gilt, g.e. [i.e., gilt edges of the present backing matts]," not priced, and in catalogue 17 of 1913, item 61, same binding ($9500); sold October 1916 to Henry E. Huntington, with the Butts

version of "Satan, Sin, and Death" ($10,000, according to Rosenbach's receipt
in the Huntington archives).

Exhibition: Grolier Club, 1919–20, No. 42; Huntington Art Gallery, 1953, 1965–
66 (Nos. 21–26), 1984.

Literature:
Rossetti 1863, 234, No. 207.
Geoffrey Keynes, "Note on the Illustrations," in *On the Morning of Christ's
 Nativity* (Cambridge: Univ. Press, 1923), 31–32, Whitworth series
 reproduced.
Baker 1957, 26–31, Huntington series reproduced.
Stephen C. Behrendt, "Blake's Illustrations to Milton's *Nativity Ode,*" *Philologi-
 cal Quarterly* 55 (1976):65–95, both series reproduced. Some of Behrendt's
 observations are questionable because he reverses the chronology of com-
 position of the two series.
Butlin 1981, No. 542, both series reproduced in color.
Butlin, "Note on the Illustrations," in *On the Morning of Christ's Nativity*
 (Andoversford: Whittington Press, 1981), 21–24, Whitworth series repro-
 duced in color.

1. "The Descent of Peace" (Illus. 22). Accession No. 000.14. 15.9 x 12.6
cm. Lines 29–34 inscribed on mount.

Blake begins the series with a Nativity scene clearly implied by, but
not described in, the introductory stanzas (1–21) and the first three
stanzas of "The Hymn" (20–52). We see the traditional stable as
though in cross section, framed by beams in the form of a Gothic arch-
way or the outline of a stained-glass window. The stable provides an
architectural equivalent to the "House of mortal Clay" (14), the
human body in which Christ is incarnate. Within, the infant Jesus
springs into the air with a suffusion of light around His entire form.
His energetic posture associates Him with "Albion rose," an intaglio
plate Blake first executed ca. 1793 (see Part III, section A, No. 5), and
with Orc, a representative of revolution in Blake's poetry of the 1790s
who like Jesus brings a new dispensation to mankind.[46] To the right
are the "Virgin Mother" (3) and Joseph, both with halos. Mary kneels
on some straw and leans back against her husband as though swoon-
ing with exhaustion or ecstasy after the divine birth. On the left are
the young John the Baptist and his mother, St. Elisabeth, both with
arms outstretched to welcome the Saviour. The bearded figure behind
them is probably John's father, Zacharias. Two oxen stand in the back

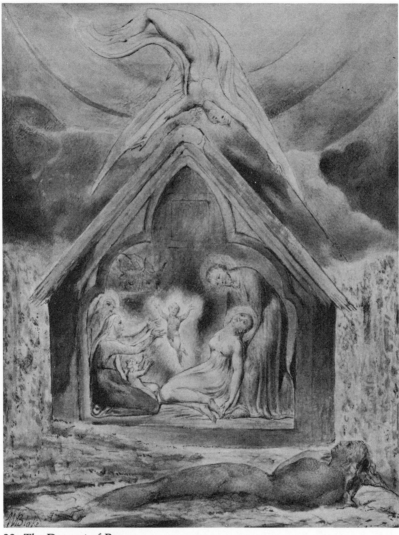

22. The Descent of Peace

of the stable, their muzzles hidden in what may be hay or straw. The presentation of the Holy Family, St. Elisabeth, the oxen, and even the square window at the back of the stable is based closely on Blake's tempera of ca. 1799–1800, "The Nativity" (Philadelphia Museum of Art; Butlin 1981, No. 401), with right and left reversed and some

minor changes in positions, costumes, and faces. The infant John sits in his mother's lap in the tempera, but he holds his hands close to his chin in prayer and Zacharias is not pictured.

Personified "Peace" (46) descends from a tripartite "turning sphere" (48), her arms and each "Turtle wing... dividing" (50) the clouds and complementing the triangular roof line of the stable. In her left hand she holds "her myrtle wand" (51). Her wings and outstretched arms are similar to those of the humanized bird in "Night Startled by the Lark" among Blake's illustrations of ca. 1816–20 to Milton's "L'Allegro" (Pierpont Morgan Library; Butlin 1981, No. 543.2). Below the stable is the female form of "Nature" (32). Although Milton describes her as "in awe" before "the Heav'n-born child" (30, 32), Blake pictures Nature looking, and perhaps raising her head, toward Peace. "Innocent Snow" (39) covers the foreground and frosts what is presumably vegetation (trailing over poles?) on each side of the stable.

In the earlier, Whitworth version, the position of Peace is reversed so that her feet are on the right and the myrtle wand is in her left hand. She is "crown'd with Olive green" (47), a headdress only vaguely suggested, if present at all, in the Huntington version. A prominent cloud band separates the three concentric circles from the stable and descends around Peace's wand (see 50). There are only three people in the stable: Mary, seated on a pile of straw and holding the infant Jesus in her arms, and Joseph standing behind them and leaning over—but not supporting—Mary. Spiky rays emanate from Christ's head, a halo graces Mary's, and a gentle light glows around Joseph's head. On the left are two oxen eating from a large "manger" (31). There is no window in the back wall of the stable. This detail, as well as the positioning of all figures, indicates that Blake borrowed from his tempera "Nativity" only for the later, Huntington, version. Nature's position is reversed, with her head on the left. She holds her hands in prayer but does not raise her head from the snow-covered ground. "Innocent Snow" (39) also covers her backside. The background on each side of the stable is filled with an abstract pattern of enlarged snowflakes or frost-covered leaves.

A pencil sketch of the design is in the National Gallery of Art, Washington (Butlin 1981, No. 539). Peace descends with her feet on the

right, as in the Whitworth design. Other features link the sketch to the later version: Christ's position, the presence of John and Elizabeth, and Nature's position with her head on the right (but lifted higher than in either watercolor). Zacharias is not pictured. Mary's head was first outlined in an upright position, but then moved back to lean against Joseph, as in the Huntington design. Thus, the sketch would appear to be a transition between the two watercolors.

2. "The Annunciation to the Shepherds" (Illus. 23). Accession No. 000.15. 15.8 x 12.4 cm. Slight nick in upper left arm of center shepherd in foreground. Lines 85–87 inscribed on mount.

The "helmed Cherubim/ And...Seraphim/ Are seen in glittering ranks with wings display'd" (112–14). The Cherubim stand within "A Globe of circular light" (110) with their arms raised and crossing in a symmetrical pattern like the "Chorus of the Skies" in one of Blake's *Night Thoughts* watercolors of ca. 1795–97 (British Museum; Butlin 1981, No. 330.437) and the personified Morning Stars in the fourteenth Job design of ca. 1805–1806.[47] The circumference of the "Angel Choir" (27) is formed by the Seraphim, two blowing trumpets (perhaps foreshadowing the "trump of doom," 156) and several with timbrels (see the fifth design). Below are "The Shepherds on the Lawn/ ...in a rustic row," their gestures expressing the "blissful rapture" with which they receive the announcement of the incarnation (85–6, 98). The eight foreground figures suggest a family group composed of men, women (far left, and probably third from left and second from right), and at least one child (held by the woman far left). Their "sheep" (91) and a dog (left of the second figure from the right) rest behind them. A second dog (left corner) and a ram (right corner) are similar to those sleeping in the foreground of the first and last Job watercolors of ca. 1805–1806 (Pierpont Morgan Library, Butlin 1981, Nos. 550.1 and 550.21). Behind the flock on the right are the outlines of two, or perhaps three, tents. On the horizon above the center shepherd is the stable of the Nativity, now (and in both its later appearances) with lateral extensions on each side of the rectangular building introduced in the first design. The crossing form of this structure in which Jesus is born foreshadows the structure on which He will be crucified. The outline of a human form is barely visible within the stable.

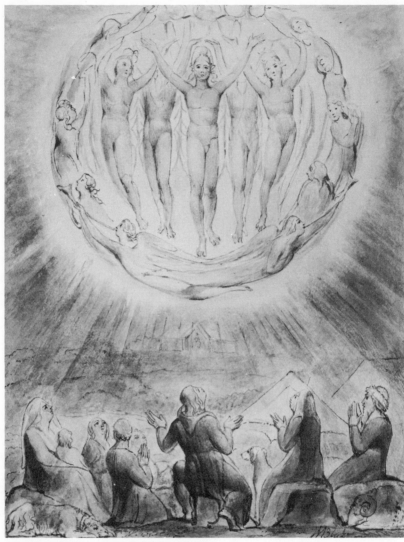

23. *The Annunciation to the Shepherds*

In the earlier, Whitworth version, the circle of angels includes eight (rather than nine or more) wingless Seraphim forming the circumference. Four of them hold lyres and one, upper left, plays "stringed noise" (97) on a lute. Within the circle are five Cherubim, as in the Huntington version, but with the central angel part of the group

rather than standing in front of it. The Cherubim wear long gowns, their swords (see 113) hang at their left sides, and their raised wings are more prominent than in the Huntington version. The shepherds are more symmetrically arranged, with two aged and bearded men on the left, both praying, and two younger figures on the right. The central figure turns to the left, and between him and the group of two adults on the left is a child with his left hand resting on the head of a dog. The dog and ram in the lower corners of the Huntington design are not pictured. There is a prominent hill in the background on the right, but no tents. The stable is much larger. We can clearly see two figures within, no doubt Joseph and Mary, the latter perhaps holding the infant Jesus.

3. "The Old Dragon" (Illus. 24). Accession No. 000.16. 15.8 x 12.3 cm. Lines 165–72 inscribed on the mount.

Blake has drawn images from at least two parts of the ode to epitomize the pagan gods sent to hell by the coming of Christ. They are all pictured "under ground,/ In straiter limits bound" (168–69). Later in the ode, Milton describes their imprisonment in "th' infernal jail" (233) as happening when the sun is "in bed" (229). Accordingly, Blake has colored this design in tones that suggest a moonlit (see 236) night scene. The largest, central demon is very probably "Th' old Dragon" (168) who "Swinges the scaly Horror of his folded tail" (172). His seven heads (at least two of which seem female) and the way his tail joins a band of stars associate him with the "great red dragon" whose "tail drew the third part of the stars of heaven" in Revelation 12:3–4. Blake has returned to one of Milton's own sources for a fuller description of the old Dragon. Blake had earlier pictured this Biblical beast, associated with "that old serpent, called the Devil, and Satan" in Revelation 12:9, in three watercolors of ca. 1803–1805: two versions of "The Great Red Dragon and the Woman Clothed with the Sun" (Brooklyn Museum and National Gallery of Art, Washington; Butlin 1981, Nos. 519–20), and "The Great Red Dragon and the Beast from the Sea" (National Gallery of Art, Washington; Butlin 1981, No. 521). The Dragon in this "Nativity Ode" design holds a heavy Roman sword in his left hand and in his right a staff topped by a finial in the shape of a pomegranate, a fruit associated with hell.[48] Snakes twine around the monster's ankles.

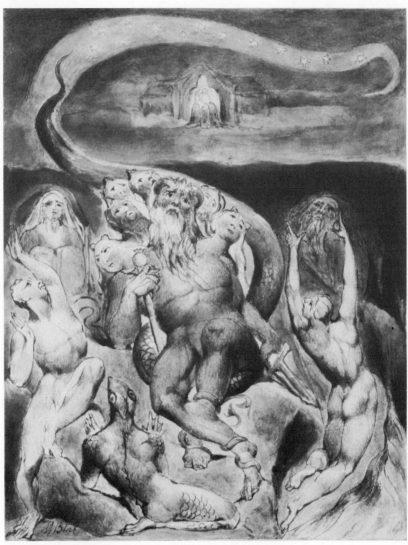

24. *The Old Dragon*

Below the old Dragon sits a scaly creature with webbed hands. This is probably Dagon, referred to in the ode as "that twice-batter'd god of Palestine" (199).[49] The old woman upper left may be "Ashtaroth" (200), another name for the Phoenician moon goddess Astarte. Her posture and face associate her with the figure on plate 16 of Blake's *For*

Children: The Gates of Paradise (engraved 1793); the veil over her head suggests Vala, a nature goddess in Blake's own mythology. The two writhing bodies, lower right and left, recall the fallen angels in Blake's first and seventh illustrations to *Paradise Lost* (see Part I, section A, Nos. b.1 and b.7). The figure on the left margin is close to a mirror image of the devil on the right margin of the first *Paradise Lost* design. Hellish flames rise just below the figure in the lower right corner. The company of fallen gods is completed by the bearded face and shadowy body upper right.

On the horizon in the upper, above-ground portion of the design is the stable, a humble reminder of a godly presence stronger than all the fearsome devils below. The three figures kneeling before the light-filled center of the stable immediately suggest the three wise men, although the events of the poem take place before the arrival of the "Star-led Wizards" (23). Two large angels stand in profile (see 244) on either side of the central portal, their wings extended over the pitch of the roof. The slight outlines of two standing figures, probably Mary and Joseph, appear within.

In the earlier, Whitworth version, the faces of the old gods are more strongly characterized. Some look like ghoulish caricatures or the physiognomic portraits among Blake's "Visionary Heads" (see Part I, section B). The old Dragon has only six heads, similar in their exaggerated features to the heads of the beast in Blake's "The Whore of Babylon," a watercolor of 1809 (British Museum; Butlin 1981, No. 523). His large tail coils in front of his shins, undulates into the sky on the right, and merges with a band of stars extending from right to left above the stable. His left hand, swordless, points directly at the stable door above his central two heads; his right hand grasps a staff with a fleur-de-lis finial, the central bowl of which resembles a pomegranate. To the right is a human figure grasping his head in anguish, and below him a man with scales covering his loins (see Satan in the third and seventh *Paradise Lost* designs, Part I, section A, Nos. b.3 and b.7). Upper left, but still below the surface of the earth, are a head, a woman's torso with scales below her breasts, and a seated devil with a grotesque masculine face but female breasts. Below and to the left of this last figure are four heads, two apparently female and one bearded. The raised right hand of the bearded figure grasps a small bag; the lowest figure holds a dagger. A large devil in the lower left

corner leans on a sword and shield decorated with lightning bolts terminating in spear points. To the right is a human figure, seen from the back, reaching upward with his right arm. The stable is much larger, in relation to the land and sky, than in the Huntington version. Within the portal we see the Virgin holding the infant Jesus on the right and a kneeling figure (Joseph?) on the left. Sheep rest on each side of the central bay.

A pencil sketch of the design in the British Museum (Butlin 1981, No. 540) shows the old Dragon with seven heads, as in the Huntington version, but is in all other respects much closer to the Whitworth version. Although the other extant sketches for the "Nativity Ode" watercolors (see the first and fifth designs) are transitional between the two series, this drawing may be a preliminary for the earlier set. The Dragon's left hand was first sketched to the right of his knees, and perhaps grasping the scepter, but then moved over his head as in the Whitworth design.

Behrendt 1976, 86–89, places this design as the fifth in both series, apparently as an illustration of the jailing of the old gods, 229–36. This ordering creates a symmetrical pattern, with the first and last designs showing the stable close up, the second and penultimate designs showing it in the distance, and the two central designs the only ones without the Nativity scene.

4. "The Overthrow of Apollo and the Pagan Gods" (Illus. 25). Accession No. 000.17. 15.7 x 12.3 cm. A few delicate lines suggest that the head of the descending figure, upper left, was first sketched in a lower position. Small nick in lower left corner. Lines 173–80 inscribed on mount.

The lack of symmetry in this design and its rather cluttered appearance bespeak the disarray that the birth of Christ has brought to paganism. The "parting Genius" (186) of Apollo, his mouth open slightly in a "shriek" (178), dives down in an arc of pale flames and leaves behind his now spiritless statue (173–78). Below and in front of the statue is an altar in the shape of an Ionic column. Its flames point downward, as though the sacrificial fires are now becoming hellish and destructive. Below are four worshipers, perhaps "Flamens" (194) and/or the "Tyrian Maids" who "their wounded Thammuz mourn"

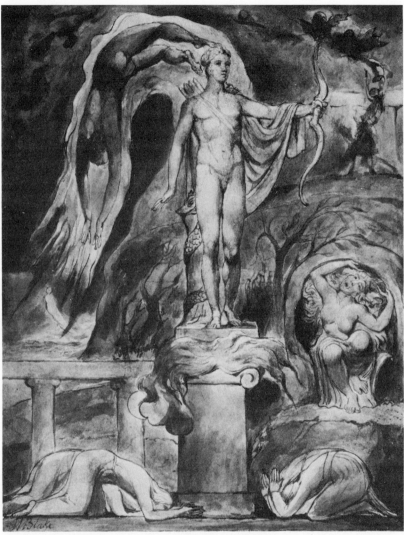

25. *The Overthrow of Apollo and the Pagan Gods*

(204), bowing in prayer and "lament" (183). To the right of the statue, a woman wails within a confining cavern in the "steep of Delphos" (178) rising in the background. She may be a personification of the "breathed spell" which "Inspires the pale-ey'd Priest from the prophetic cell" (179–80) or one of the "Nymphs" who "in twilight shade

of tangled thickets mourn" (188). Her expression and hair are similar to those of "the Delphic Priestess" Blake portrays in one of his watercolors of ca. 1795–97 illustrating Young's *Night Thoughts* (British Museum; Butlin 1981, No. 330.302). The small trees to the left of this woman and left of the statue evoke the "poplar pale" (185) and the thicket of the Nymphs. On the top of Delphos and in front of a colonnade are a band of undefined outlines and washes that suggest departing spirits, as in the more clearly drawn Whitworth version. Two forms at the top have bat wings. Between the colonnade lower left and the descending Genius, a ghostly figure hovers over the sea, probably as a visualization of "A voice of weeping heard" over "the resounding shore" (182–83).

In 1815, Blake engraved a reproduction of the Apollo Belvedere to illustrate John Flaxman's essay on "Sculpture" in Abraham Rees, *The Cyclopaedia* (plates volume 4, dated 1820). Like the "Laocoön" pictured on the same plate, Blake probably based his Apollo on a plaster cast then in the drawing school of the Royal Academy.[50] The statue of Apollo in this "Nativity Ode" design is clearly based on this same restoration of the Apollo Belvedere. In comparison to the *Cyclopaedia* plate, the "Nativity Ode" design differs in the addition of the bow, the absence of sandals, the turning of the statue's face from profile to three-quarter view, and the enlargement and repositioning of the Python around the tree stump behind and to the left of Apollo. The importance of Blake's necessarily close study of the statue for the engraving is indicated by the fact that Apollo in the earlier, Whitworth watercolor, although based in general outline and posture on the Apollo Belvedere, lacks all the details (quiver, cloak, tree stump with serpent) directly linking the Huntington version to the *Cyclopaedia* illustration and its source. The story of Apollo killing the Python made him a type of Christ; but in the context of the "Nativity Ode" designs, the classical myth is replaced by the Christian truth it prefigures. Further, the visual allusion to what was in Blake's day one of the most highly regarded monuments of classical civilization transforms the design into an expression of Blake's criticism of the derivative, even destructive, nature of Greek and Roman art.[51]

In the Whitworth version, the statue of Apollo holds the neck of the open-mouthed (and dead?) serpent in the left hand; the right hand grasps a lower part of the snake, whose body ends in coils at Apollo's

feet. The parting Genius has his mouth open wide. Between him and the statue is a large, many-pointed star—no doubt the star of Bethlehem (see 240). Two triangular shapes, probably the sails of ships, sink into the sea lower left. A gowned figure stands on the shore, looking to the left and gesturing with her hands to the right. In the lower left foreground are two bearded men (Flamens?) looking up in anguish at the statue. The man closest to the base of the statue wears a wreath of leaves; both gesture in fear. In front of them is a woman bent low in prayer, as are her two companions (Tyrian Maids?) lower right. The woman in the cave sits on a low stool, her body more upright than in the Huntington version. There are no trees on the hill, but on its level summit are a small altar and five figures, one of which is probably another statue with its Genius escaping upwards in flame. Above are three bolts of lightning and a band of clouds containing a winged circle entwined with two serpents; a dog-headed figure ("Anubis," 212); a bull-headed figure ("Osiris," 213); and two more or less human forms, one bearded, soaring just below the top center and top left edge of the image.[52] The colonnade upper right is Doric and that on the lower left is Ionic. There is no capital beneath the fire on the altar in front of the central statue.

5. "The Flight of Moloch" (Illus. 26). Accession No. 000.18. 15.7 x 12.4 cm. Evidence of scratching out above the winged figure's head. A few lines suggest that the head of the figure farthest to the left may have been first sketched higher and more to the left. Lines 205–12 inscribed on mount.

The center of the composition is dominated by the "burning Idol all of Blackest hue" of "sullen Moloch" (205, 210). The devil-god himself flies away in dark smoke above the crowned and sceptered idol, much as the Genius departs the statue of Apollo in the previous design. The bat wings and posture of this figure are similar to Satan's on plate 19 of Blake's *For the Sexes: The Gates of Paradise* (ca. 1818) and recall the visual and verbal images of the Spectre in *Milton* (ca. 1804–1808) and *Jerusalem* (ca. 1804–20). On each side of the design are worshipers who "dance about the furnace blue" (210). Bearded men are on the left, youthful females on the right. These dancers and the timbrels (see 219) in their raised hands are fallen parodies of the chorus of angels

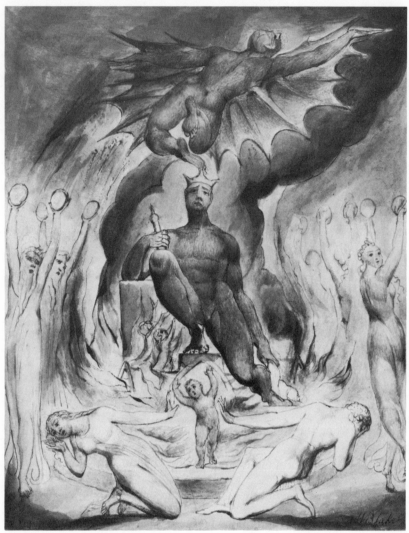

26. The Flight of Moloch

and their instruments in the second design. Below the idol is his "Ark" (220) in the form of a furnace raised slightly on a circular plinth. Its arched mouth is just under the giant's foot. Two similarly arched mouths or vents also belch flames from the ends of the transverse extensions. This cruciform structure mimics its spiritual opposite–the

stable as pictured in the second, third, and sixth designs. The fires of the furnace reach upward toward the idol and would seem to be about to consume it.

In *Paradise Lost*, Milton describes the child sacrifices practiced by the followers of Moloch.[53] No such rites are described in the "Nativity Ode," but this would seem to be the activity Blake pictures in the lower part of this illustration. Two children reach toward the idol just below his right foreleg; a third dangles limply from his left hand. The saddened man (right) and horrified woman (left) in the foreground have apparently cast their child into the furnace. But this babe strides miraculously out of the flames in an energetic posture that recalls Jesus in the first design.[54] As with the triumph of Christ over paganism, this innocent child is more powerful than the forces of evil now literally going up in flames.

In the earlier, Whitworth, version the posture of the idol and the positions of the male and female dancers are reversed. Some of the dancers in the background play large pipes. We can see the saddened faces of both the man (left) and the woman (right) in the foreground. The left hand of the man and right hand of the woman touch the babe, who leans to the right and looks at the woman. The furnace and its circular plinth are larger, in relation to the adult figures and idol, than in the Huntington design. Its large, transverse roof reaches to the idol's waist and its three portals are steeply pointed. The general effect is that of a black giant squatting on top of a cruciform church. Two children reach upward on each side of the idol's left leg. In his left hand he holds a scepter topped by a fleur-de-lis ornament like the old Dragon's staff in the third Whitworth design. We can see the face of the (dead?) child dangling from the idol's right hand. His crown has five (rather than three) points, he is bearded, and there are flames above the furnace's roof right and left of the idol's upper arms. We see only the back of the bat-winged monster's head and his right foot is partly obscured by his left calf. Jagged mountains fill the distant horizon.

A pencil sketch for the design (David Bindman collection, London; Butlin 1981, No. 541) shows the major figures in the postures they have in the Huntington version. A few faint lines indicate that Blake had first sketched at least the foreground couple and the babe

between them in a position closer to the Whitworth watercolor, and thus the drawing appears to be a transition between the two series.

6. "The Night of Peace" (Illus. 27). Accession No. 000.19. 15.7 x 12.3 cm. The head of the angel upper left was first sketched more to the right. There is an old horizontal crease on the right margin, starting

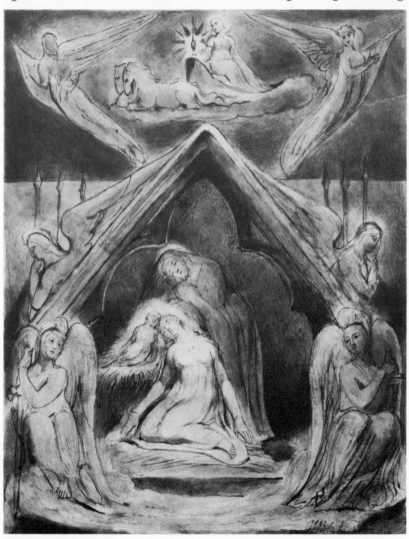

27. The Night of Peace

2.5 cm. from the top right corner and extending approx. 1.5 cm. into the design. Lines 237–44 inscribed on mount.

Blake and Milton return us to the "Courtly Stable" (243) where we began. The coloring of the design and the closed eyes of the Holy Family indicate that this is a night scene. The "Virgin.../ Hath laid her Babe to rest" (237–38), and He is now "sleeping" (242) on a bed of straw, perhaps placed on a manger. His mother also rests on straw and leans her head toward the babe in mutual support. Joseph, with a mantle over his head, stands behind with closed eyes and rests on his arms. White and yellow light glows around the child and small halos curve above the heads of Mary and Joseph. At each side of the portal is a guardian angel, "helmed" like the Cherubim of the second design but also "sworded" like Milton's Seraphim (112–13). They "sit in order serviceable" (244) on what appears to be a cloud, or perhaps snow, curving below the stable. Just behind are the two angels introduced in the third design, with their large wings extended along the roof, but now they hold spears. Four more spears suggest the presence of additional heavenly protectors. Two angels playing harps (see 115) are symmetrically arranged in the sky above the roof line of the transverse extensions of the stable. Between them is a personification of "Heav'n's youngest-teemed Star," the star of Bethlehem, sitting in "her polisht Car" (240–41). Her resting steeds and chariot are supported by a bed of clouds. She holds a "Handmaid Lamp" (242) with rays of light forming a star-like pattern around it.

In the earlier, Whitworth, version the angel in the sky on the right (rather than left) turns his head away from us. There is a diagonal cloud band in front of each angel in the sky and seventeen stars. The chariot has a spoked wheel and the figure holding the lamp turns her head to the right and smiles. The horses turn their heads toward us. Diagonal lines indicate that the transverse roof of the stable is thatched. There is only one spear on the left, held by the standing angel. The right margin of the design is trimmed, perhaps by as much as 1 cm., but the arm position of the standing angel on the right suggests that he too held a spear. The seated guardians do not curve inward toward the portal. The ground below them is decorated with a few lines indicating grass rather than a cloud or snow. The base of the stable shows prominent wood grain. Within, the babe sleeps on a

"manger" (31) and his mother rests on an enormous pile of straw, her head supported by her right arm. Joseph stands behind, eyes open, and leans protectively over his family. Only Jesus has a halo, emanating spiky rays of light, but both Joseph and Mary wear mantles over their heads. Two oxen stand behind the straw on the left.

B. The Visionary Heads

In 1819, Blake's new friend and patron John Linnell introduced him to the landscape painter John Varley (1778–1842). Varley, deeply interested in the pseudo-sciences of astrology and physiognomy, was apparently attracted to Blake because of his purported visionary abilities. By October 1819 (the date on four of the sketches), Blake began to draw for Varley a number of portraits of various historical and imaginary personages (including the anthropomorphic "ghost" of a flea) Blake would call up before his mind's eye. These séance-like drawing sessions continued over a number of years, as indicated by a date of 1825 on a portrait of Achilles (untraced since 1942; Butlin 1981, No. 707). Many of these pencil drawings, now generally referred to as "Visionary Heads" even though a few include the entire body, were composed in a small notebook, then containing some 66 leaves and now called the "Blake-Varley" sketchbook (dispersed; Butlin 1981, No. 692). Other portraits were drawn on larger, separate sheets of paper. From these, Varley and Linnell made facsimile copies, tracings, and counterproofs, the last by placing the original face down on a dampened sheet of paper and rubbing on the back of the original or passing both sheets through a rolling press to transfer some of the graphite from one to the other. Some of the copies with right and left in the same direction as the originals may have been produced with the aid of the graphic telescope, a device invented by John Varley's brother, Cornelius, for projecting images on paper so that their outlines could be traced (see Butlin 1973 under *Literature*, below). Many of these copies were probably made in preparation for their engraving in John Varley's projected series of publications entitled *A Treatise on Zodiacal Physiognomy Illustrated by Engravings of Heads and Features*, only the first part (1828) of which appeared (see Part III, section B, No. 49). About 75 of the original pencil "Visionary Heads" on separate sheets,

and replicas of them, are now extant or have been recorded by trustworthy authorities. Most of the drawings bear pencil inscriptions by John Varley or Linnell recording the subject.

It is difficult to determine the degree of seriousness Blake brought to these unusual drawings. According to Linnell, "Varley beleived [sic] in the reality of Blakes visions more than even Blake himself— that is in a more literal & positive sense that did not admit of the explanations by which Blake reconciled his assertions with known truth."[55] Some scholars have suggested that Blake merely "humoured the credulous Varley's beliefs,"[56] but Blake's own concepts of the unity of imaginative conception and artistic execution provide the basis for an epistemology justifying visionary portraiture as a serious activity without requiring a belief in the bodily reappearance of the dead. As Blake wrote in his letter to Dr. John Trusler of 23 August 1799, "I know that This World Is a World of Imagination & Vision I see Every thing I paint In This World, but Every body does not see alike."[57]

Some of the sketches, such as the "Socrates" (No. 2, below), are clearly derived from conventional portraits or appear to be responsive to the legendary characteristics of the subject. Blake wrote that "Chaucer's characters, as described in his Canterbury Tales," are "the physiognomies or lineaments of universal human life."[58] In his "Visionary Heads," as in his painting and engraving of Chaucer's pilgrims, Blake seems to have been striving for a similar expression of individualized, yet universal, human types. Many portraits were probably conceived as physiognomic portraits, and those with careful interior modeling on forehead and skull may have been influenced by phrenological theories (see Mellor 1978 under *Literature*, below). By the late 1780s, Blake was familiar with the most famous theory of physiognomy through his engraving of four plates for J. C. Lavater's three-volume *Essays on Physiognomy* (1789–98). Blake also owned at least one book, the *Observations on the Deranged Manifestations of the Mind* (1817), by the phrenologist J. G. Spurzheim.

The Huntington collection includes nine "Visionary Heads" on separate sheets, none of which is from the Blake-Varley sketchbook. The first eight listed here are bound together in that order in a full tan leather volume by Riviere & Son with gilt framing lines and all edges gilt. "A SERIES OF VISIONARY HEADS–ORIGINAL DRAWINGS BY WILLIAM BLAKE" is stamped in gold on the front cover and

spine. The first leaf is a carefully hand-written title page in black and red: "A SERIES OF VISIONARY HEADS—ORIGINAL DRAWINGS BY WILLIAM BLAKE FROM THE COLLECTION OF JOHN LINNELL WHO OBTAINED THEM DIRECT FROM THE ARTIST." The next leaf is headed "A WONDERFUL SERIES OF VISIONARY HEADS" followed by a passage from Gilchrist's *Life of Blake* (see *Literature*, below). Each drawing is hinged along the left margin to a mat approx. 43 x 30.5 cm. The purchase and sale records of the Philadelphia book dealer Charles Sessler indicate that the eight drawings were bound at a cost of £26.10s. when Sessler acquired the group from E. Parsons in June 1920. The first and fifth portraits appear to be counterproofs; the fourth may be a replica by Linnell or Varley. The inscribed numbers in the lower left corner of each sheet record the present binding order.

Literature:
John Varley, *A Treatise on Zodiacal Physiognomy* (London: the author, 1828), 54–55.
Allan Cunningham, *The Lives of the Most Eminent British Painters, Sculptors, and Architects* (London: John Murray, 1830) 2:167–71.
Jane Porter, *The Scottish Chiefs*, Revised Edition (London: George Virtue, [1841]), 2:466–70.
Alexander Gilchrist, *Life of William Blake* (London and Cambridge: Macmillan, 1863), 1:249–56.
William Bell Scott, "A Varley-and-Blake Sketch-Book," *The Portfolio* 2 (1871):103–105.
Alfred T. Story, *James Holmes and John Varley* (London: Bentley and Son, 1894), 259–65.
Pencil Drawings by William Blake, ed. Geoffrey Keynes (London: Nonesuch Press, 1927), Pls. 40–49 (fifth Huntington drawing reproduced).
Adrian Bury, *John Varley of the "Old Society"* (Leigh-on-Sea: F. Lewis, 1946), 49–61.
Blake's Pencil Drawings, Second Series, ed. Geoffrey Keynes (London: Nonesuch Press, 1956), Pls. 32–38 (seventh, eighth, and ninth Huntington drawings reproduced).
Baker 1957, 46–49.
Joseph Burke, "The Eidetic and the Borrowed Image: An Interpretation of Blake's Theory and Practice of Art," in *In Honour of Daryl Lindsay: Essays and Studies*, ed. Franz Philipp and June Stewart (Melbourne: Oxford Univ. Press, 1964), 110–27; reprinted in *The Visionary Hand*, ed. Robert N. Essick (Los Angeles: Hennessey & Ingalls, 1973), 253–302.
The Blake-Varley Sketchbook of 1819, introduction and notes by Martin Butlin

(London: Heinemann, 1969), 1:1–18, third Huntington drawing repro-
duced. Volume 2 is a reproduction of the sketchbook.

Bentley 1969, 257–65, 296–97 (extract from Anon., "Nativity of Mr. Blake,
The Mystical Artist," *Urania* 1 [1825]: 70–72), 496–99 (from Cunningham
1830).

Drawings of William Blake, ed. Geoffrey Keynes (New York: Dover, 1970), Pls.
60–74 (third, seventh, and ninth Huntington drawings reproduced).

Ruthven Todd, *William Blake the Artist* (London: Studio Vista, 1971), 112–17
(fourth and ninth Huntington drawings reproduced).

Martin Butlin, "Blake, The Varleys, and the Graphic Telescope," in *William
Blake: Essays in Honour of Sir Geoffrey Keynes*, ed. Morton D. Paley and
Michael Phillips (Oxford: Clarendon Press, 1973), 294–304.

Butlin, *William Blake*. Catalogue of an exhibition, The Tate Gallery, 1978 (Lon-
don: Tate Gallery, 1978), 133–36.

Anne K. Mellor, "Physiognomy, Phrenology, and Blake's Visionary Heads,"
in *Blake in His Time* 1978, 53–74 (second Huntington drawing reproduced).

G. Ingli James, "Some Not-so-Familiar Visionary Heads," *Blake: An Illustrated
Quarterly* 12 (1979):244–49, tracings (by Linnell?) of the first and second
Huntington designs reproduced.

Butlin 1981, Nos. 495–531. All extant drawings on separate sheets repro-
duced. Butlin's entry numbers are given for each drawing, below.

1. "Caractacus," a counterproof from Blake's original of ca. 1819.
Accession No. 000.45. Image 16.5 x 12.4 cm. on wove sheet 29.4 x 20.2
cm. Inscribed in pencil (by Varley?) "Caractacus" top center; also
"(1)" lower left, "10" lower right. Inscribed below the drawing on the
mount, "VISIONARY HEAD OF CARACTACUS," followed by a
quotation from "Gilchrist."

Provenance: John Linnell; trustees of the Linnell estate, sold Christie's, 15
March 1918, lot 165 with sixteen other drawings, including the third, seventh,
eighth, ninth, and perhaps the sixth Huntington drawings (£46.4s. to E. Par-
sons); sold Parsons to Sessler, June 1920 (£12.12s.); sold with all but the ninth
drawing to Henry E. Huntington, 12 September 1922 ($1000, according to
Sessler's letter of 15 August 1922, now in the Huntington archives, offering
the drawings).

Literature:
Rossetti 1863, 245, No. 53; 1880, 260, No. 42 (apparently the Blake-Varley
sketchbook version).
Butlin 1981, No. 719.

The right-left relationships and the flatness of the lines indicate that

this is a counterproof of the "Caractacus" from the Blake-Varley sketchbook of ca. 1819.[59] There is also a tracing of the portrait, probably by Linnell, in the collection of G. Ingli James, Cardiff (reproduced James 1979). Henry Fuseli painted a generally similar head of Caractacus in three-quarter view, with prominent eyes, brow ridges, and mustache, in 1792.[60] Blake's visionary head may have been influenced by a recollection of his friend's work.

Caractacus (flourished ca. 50 A.D.) led the Britons in their struggle against Roman domination. In this full-frontal portrait of a powerful, block-like face, Blake represents the indomitable character for which the warrior king was famous. Blake could have learned about Caractacus from such popular works as Rapin de Thoyras, *The History of England*, where he is presented as a heroic fighter for British freedom, or from Charles Allen's *New and Improved History of England* (1798), for which Blake engraved four plates. There are also plays about Caractacus by William Mason (1759) and William Monney (1816). Thus, Blake may have considered Caractacus as a precursor to his own struggles against "the silly Greek & Latin slaves of the Sword."[61]

2. "Socrates." Ca. 1819–20. Accession Nos. 000.50 (recto) and 000.51 (verso). Image on recto 22 x 14.8 cm. on wove sheet 31.3 x 20.1 cm. Inscribed in pencil (by Varley?) "Socrates," below image; also "(2)" lower left, "6" lower right. Three heads in profile on verso, probably by Varley. Inscribed below drawing on the mount, "VISIONARY HEAD OF SOCRATES," followed by a brief quotation from "Gilchrist."

Provenance: John Linnell; trustees of the Linnell estatè, sold Christie's, 15 March 1918, lot 163 with fifteen other drawings, including the fourth, fifth, and perhaps the sixth Huntington drawing (£44.2s. to E. Parsons); offered by Parsons, June 1918 catalogue 282, item 445 (£12.12s.); sold to Sessler, June 1920 (£12.12s.); as for the first drawing.

Literature:
Rossetti 1863, 243, No. 30; 1880, 260, No. 38.
Butlin 1981, No. 713.

Blake's drawing in near profile looking to the left is generally similar to traditional portraits of Socrates, such as the sculpted bust in the

Farnese Gallery (reproduced in a mid-eighteenth-century engraving by George Vertue) and a profile engraved by Michael Van Der Gucht (1660–1725). There is also a group of eight outline profiles of Socrates in Lavater's *Essays on Physiognomy*, 1:*175, some quite similar to Blake's drawing except for his distinctive treatment of the eyelid. Mellor 1978, 67–69, has analyzed the prominent segmentation of the forehead of Blake's "Socrates" as a response to Lavater's comments on the philosopher's physiognomy and to Spurzheim's phrenological principles.

Blake's several written references to Socrates (469–399 B.C.) offer a mixture of criticism for the Athenian philosopher's analytical rationalism and praise for his intellectual independence. Blake seems to have identified with Socrates as a fellow victim of malicious critics. On plate 93 of *Jerusalem* (ca. 1804–20), Blake pictured three figures, each inscribed with the name of one of Socrates' accusers, as an historical parallel to the trinity of false accusers (Hand, Hyle, Scofield) in Blake's reconstitution of his own life into myth. Such associations were supported by what Blake believed to be a similarity between his physiognomy and Socrates'. In 1825, Henry Crabb Robinson asked Blake, "What resemblance do you suppose is there between your Spirit & the Spirit of Socrates?" Blake replied, " 'The same as between our countenances.' He paused & added: 'I was Socrates.' And then as if correcting himself: 'a sort of brother—I must have had conversations with him—so I had with Jesus Christ—I have an obscure recollection of having been with both of them.' "[62] One of the physical resemblances Blake refers to was a snub nose, prominent in the "Visionary Head" and several of the profiles in Lavater. Blake also believed that Christ shared this feature: "The Vision of Christ that thou dost see/ Is my Visions Greatest Enemy/ Thine has a great hook nose like thine/ Mine has a snub nose like to mine."[63]

One of the profiles on the verso of this "Visionary Head" is similar to a face, also probably by Varley, on page 12 of the Blake-Varley sketchbook (private collection, England; Butlin 1981, No. 692.12). Two of the verso sketches also bear some resemblance to a portrayal of "Conceit" in Varley's *Zodiacal Physiognomy*. Another visionary head of Socrates, drawn ca. 1820, is in the Yale Center for British Art.[64] This portrait is very similar to the Huntington drawing, but shows the face in full profile, without the brow ridge of the right eye, and with a

smaller left eye. A tracing, probably by Linnell, of the Huntington version is in the collection of G. Ingli James, Cardiff (reproduced in James 1979).

3. "Queen Eleanor." Ca. 1819–20. Accession No. 000.46. Image 18.4 x 15.4 cm. on wove sheet 19.7 x 15.5 cm., slightly foxed. Inscribed in pencil "(3)" lower left, "11" lower right. Inscribed below drawing on the mount, "VISIONARY HEAD OF QUEEN ELEANOR."

Provenance: As for the first drawing to March 1918; offered by E. Parsons, June 1918 catalogue 282, item 451 (£15.15s.); sold to Sessler, June 1920 (£15.15s.); as for the first drawing.

Exhibition: Huntington Art Gallery, 1984.

Literature:
Rossetti 1863, 244, No. 46; 1880, 260, No. 46.
Butlin 1981, No. 726.

This drawing of a crowned and noble-looking woman, her eyes turned upward, is presumably the "Visionary Head" described by Rossetti in 1863 and 1880 as "Queen Eleanor. Handsome: not very interesting" and sold under the same title in the Linnell auction at Christie's in 1918. There are two queens of that name important in English history: Eleanor of Aquitaine (1122?–1204), wife of Henry II; and Eleanor of Castile (died 1290), wife of Edward I. In 1783, Blake engraved a plate after Thomas Stothard, "The Fall of Rosamond," which pictures the first of these queens. In about 1815, Blake executed a pencil sketch, apparently of the same subject although differing in design (George Goyder collection; Butlin 1981, No. 607). In at least one passage in *Jerusalem* (ca. 1804–20), Blake alludes to the subject of these designs and the play—Thomas Hull's *Henry the Second*—illustrated by the engraving.[65] Finally, the Blake-Varley sketchbook includes a drawing of "Falconbridge Taking Leave of King John and Queen Eleanor" (Private collection, Great Britain; Butlin 1981, No. 692.57). But Blake's pictorial works indicate an equal interest in Eleanor of Castile. While an apprentice, ca. 1774, Blake copied her head and shoulders from Eleanor's tomb effigy in Westminster Abbey (Bodleian Library; Butlin 1981, No. 25), and may have had a hand in its engraving for Richard Gough, *Sepulchral Monuments in Great Britain*

(1786), 1:Pl. XXIII*. The long, flowing hair in this portrait offers the only distinctive similarity between the "Visionary Head" and any of the other designs noted here. In 1793, Blake designed and engraved a large plate of "Edward & Elenor" (1793), showing the Queen saving her husband's life by sucking the poison from his wound. For other visionary heads related to this legendary incident, see the sixth Huntington drawing, below.

There is a counterproof of the drawing in a Swiss private collection (Butlin 1981, No. 727) inscribed "Queen Eleanor" in a hand which can not be identified with Blake's, Varley's, or Linnell's.

4. "Canute," a replica (?) of Blake's original of ca. 1819–20. Accession No. 000.44. Image 23.5 x 19 cm. on wove sheet 25.4 x 19.4 cm. Evenly browned (except for an uneven strip along the bottom), probably by the residual effect of a fixative applied to the paper. Slightly damp-stained along right margin. Inscribed in pencil (by Linnell?) "Canute" below image and "Dark Hair & Eyes" lower right; also "(4)" lower left, "9" lower right, and "77" upside-down in the lower right corner of the verso. Inscribed below drawing on the mount, "VISIONARY HEAD OF KING CANUTE," followed by a brief quotation from "Gilchrist."

Provenance: As for the second drawing to March 1918; sold to Sessler, June 1920 (£15.15s.); as for the first drawing.

Exhibition: Huntington Art Gallery, 1965–66, No. 30, reproduced.

Literature:
Rossetti 1863, 245, No. 52; 1880, 260, No. 43 (perhaps not the Huntington version); 1880, 262, No. 74 (perhaps the counterproof).
Blake: An Illustrated Quarterly 11 (1978):241, Huntington version reproduced.
Butlin 1981, No. 722.

An almost identical, but slightly larger, head of Canute is in the National Gallery of Art, Washington (Butlin 1981, No. 721). A good many lines in the Huntington drawing have been strengthened in a rather mechanical and studied manner, suggesting that it was copied from the other version, perhaps with the aid of the graphic telescope. There is also a counterproof, made from the National Gallery draw-

ing, in the collection of Jonathan Wordsworth, Oxford (Butlin 1981, No. 723).

Canute (or Cnut, 994?–1035), greatest of the Danish kings of ancient Briton, is remembered in most chronicles as a brave warrior, a fierce but just ruler, and a patron of the church and of poets. The elaborate crown he wears in this "Visionary Head" may be Blake's response to the legend that Canute once placed his crown on a statue of Christ as a sign of humility. Blake's portrayal emphasizes Canute's nobility, and perhaps even a visionary glimmer in his upturned eyes.

5. "Solomon," a counterproof from Blake's original of ca. 1819–20(?). Accession No. 000.52. Image 22.2 x 18.5 cm. on laid paper (sheet 25.8 x 21.1 cm.) with chain lines 2.5 cm. apart and a Britannia watermark. Slight foxing. Inscribed "SOLOMON" in block letters in pencil below image, "(5)" lower left, "8" lower right. Inscribed below drawing on the mount, "VISIONARY HEAD OF SOLOMON," followed by a quotation from "Gilchrist."

Provenance: As for the second drawing to March 1918; sold to Sessler, June 1920 (£15.15s.); as for the first drawing.

Literature:
Rossetti 1863, 244, No. 43; 1880, 260, No. 35 (probably one of the originals rather than the Huntington counterproof).
Butlin 1981, No. 702.

The right-left relationships and the over-drawing of light lines indicate that this is a much improved counterproof from either the drawing in the Courtauld Institute, University of London, or the one in the collection of Edwin Wolf 2nd, Philadelphia.[66] Either may be Blake's original; the latter, inscribed "J Linnell from Mr Blake," is "heavily gone over" (according to Butlin 1981, 509).

Rossetti 1863, 244, describes Blake's near-profile of Solomon: "Age about forty; a piercing, reflective, sensuous Jewish head, the eye exceedingly far back from the line of the nose, the chin blunt and very large. Admirable." Solomon's nose is the stock Jewish type used by contemporary caricaturists, a motif Blake also used for one of the rabbis in "Christ Crucified between the Two Thieves" of ca. 1800–1803 (Fogg Art Museum; Butlin 1981, No. 494) and for one of the Roman(?)

soldiers in "The Soldiers Casting Lots for Christ's Garment" of 1800 (Fitzwilliam Museum; Butlin 1981, No. 495). There is also a profile by Blake or Varley with nose and eye similar to Solomon's in the Blake-Varley sketchbook (untraced; Butlin 1981, No. 692.72). See also Blake's verses on "a great hook nose," quoted above in the discussion of the second drawing. Blake's tempera painting of ca. 1799–1800, "The Judgment of Solomon" (Fitzwilliam Museum; Butlin 1981, No. 499), shows a very youthful monarch looking nothing like the "Visionary Head."

6. "Saladin, and the Assassin," two drawings on one sheet, ca. 1819–20. Accession No. 000.49. Top image (the Assassin) 9 x 16.8 cm., bottom image (Saladin) 16.3 x 13.3 cm., on a wove sheet 31.3 x 20 cm. watermarked "SMITH & ALLNUTT/ 1815." Inscribed in pencil by Linnell, "The Assasin laying dead at the feet of Ed.wd 1st in the holy land," top right, "Saladin" lower left, and "Blake fecit" lower right. Also inscribed in pencil "6)" lower left, "13" lower right. The two portraits are divided by a horizontal pencil line. The top of Saladin's head was first drawn higher on the sheet, then partly erased. Inscribed below drawings on the mount, "VISIONARY HEAD OF SALADIN AND FIGURE OF THE ASSASSIN LYING DEAD," followed by a quotation from "Gilchrist."

Provenance: John Linnell; trustees of the Linnell estate, sold Christie's, 15 March 1918, in lot 162, 163, or 165 (£16.16s., £44.2s., £46.4s., all to E. Parsons); offered by Parsons, June 1918 catalogue 282, item 461 (£16.16s.); sold to Sessler, June 1920 (£16.16s.); as for the first drawing.

Literature:
Rossetti 1863, 244, Nos. 37 and 38; 1880, 261, Nos. 50 and 54.
Butlin 1981, No. 728.

In 1272, an Assassin stabbed Prince Edward, later King Edward I, with a poisoned dagger. Blake had long been interested in this incident—see the third "Visionary Head," above. He may have been attracted to legends concerning Edward I as a result of his having drawn two pictures of the King's corpse when his tomb in Westminster Abbey was opened on 2 May 1774 (Society of Antiquaries, London; Butlin 1981, Nos. 1, 2). As Rossetti 1863, 244, notes, the bust of

the would-be assassin is oddly "leonine." Indeed, Blake would seem to be using the animal transformation technique of caricaturists and cartoonists to visualize literally a "beastly" character.

The profile of Saladin (1138–93), famous for his chivalry, is that of a noble youth. As Rossetti 1863, 244, suggests, it is the "kind of head that might do for John the Evangelist." Although the great Moslem leader fought against the Crusaders in the Holy Land and was an enemy of the secret society of Assassins, there is no direct historical connection between Saladin and Edward I.

7. "Uriah and Bathsheba," two profiles on one sheet, ca. 1819–20. Accession No. 000.53. Left image (Uriah) 15 x 12.2 cm., right image (Bathsheba) 17 x 10.4 cm., on wove sheet 20.3 x 32.6 cm. watermarked JH(?) in monogram and "1818." Inscribed by Varley in pencil "Uriah the Husband/ of Bathsheba," lower left, "Bathseba" lower left of the right image; also "7" in pencil, sideways, lower left corner. Title inscriptions written very lightly, then reinforced with pencil. Slightly foxed, with an old crease line running vertically between the two portraits. Inscribed below drawing on the mount, "VISIONARY HEADS OF BATHSHEBA AND URIAH, THE HUSBAND OF BATHSHEBA," followed by a quotation from "Gilchrist."

Provenance: As for the first drawing to March 1918; offered by E. Parsons, June 1918 catalogue 282, item 462 (£15.15s.); sold to Sessler, June 1920 (£15.15s.); as for the first drawing.

Literature:
Rossetti 1863, 244, Nos. 40, 41; 1880, 259–60, Nos. 33, 34.
Butlin 1981, No. 699.

Rossetti 1863, 244, describes Blake's Uriah as "a heavy, stupid man, with a huge cerebellum and enormous bull-neck," and Bathsheba as "sweet, soft, yielding, witty." The story of Uriah, his wife Bathsheba, and King David is told in II Samuel 11. The woman's face in Blake's tempera painting of ca. 1799–1800, "Bathsheba at the Bath" (Tate Gallery; Butlin 1981, No. 498) is of the same general type as her visionary portrait, but neither rendering shows clearly individualized features. Blake also drew a visionary head of "David"—apparently the Biblical king as a rather feminine youth (collection of F. Bailey Vanderhoef,

Jr., Ojai, California; Butlin 1981, No. 698).

8. "Joseph and Mary, and the Room They were Seen in," two portrait busts with an interior scene between them, ca. 1819–20. Accession No. 000.47. Image 17 x 25.1 cm. on wove sheet 20 x 31.4 cm., slightly foxed with stains in the top corners. Inscribed in pencil by Linnell on verso, "Joseph & Mary & the room they were seen in." Recto inscribed in pencil "1 No"(?) and "12," lower left, and "(8)" top left. Inscribed below drawing on the mount, "VISIONARY SCENE OF JO-SEPH AND MARY AND THE ROOM THEY WERE SEEN IN," followed by a quotation from "Gilchrist."

Provenance: As for the first drawing to March 1918; offered by E. Parsons, June 1918 catalogue 282, item 460 (£18.18s.); sold to Sessler, June 1920 (£18.18s.); as for the first drawing.

Literature:
Rossetti 1863, 245, No. 50; 1880, 260, No. 37.
Butlin 1981, No. 705.
Mary Lynn Johnson, "Observations on Blake's Paintings and Drawings (Based on Butlin's Catalogue Raisonne)," *Blake: An Illustrated Quarterly* 16 (1982):6, suggesting that the young man may be Jesus and that the bearded man in the interior scene may be Joseph.

Joseph and Mary are shown as adolescents in both the large busts and the interior scene. The room looks contemporary, with what may be a mantel on the right and a bed with canopy and bolsters behind Mary. Thus, the room may be the actual one in which Blake saw the figures before his mind's eye rather than a recreation of a Biblical bedroom. A tall, bearded, and perhaps haloed man stands behind Joseph, holding the boy's right hand and left arm and apparently guiding him off to the left. The children are shown in the same head and arm posture in the larger busts. Mary holds her hands demurely over her chest. A few sketchy lines on Joseph's left arm in the larger portrait indicate the location of the bearded man's left hand in the interior scene.

The nose, mouth, and heavy-lidded eyes of Blake's Mary are similar to these features in one of Raphael's Madonnas reproduced in an unsigned engraving in Lavater's *Essays on Physiognomy* (1792), 2:334. A portrait of the Virgin with some of the same characteristics, plus

thin, arched eyebrows like those in this "Visionary Head," faces page 390 in volume 3 (1798) of Lavater.

9. "Old Parr When Young," 1820 (Illus. 28). Accession No. 000.48. Image 28.4 x 16.5 cm. on the right half of a sheet 29.8 x 36.8 cm., the left half folded over to form a cover leaf for the drawing. Laid paper, chain lines 2.5 cm. apart, with a crown and shield watermark and a countermark of "1810" in a circle. Slight mildew staining over the upper part of the drawing. Inscribed in pencil on recto of cover leaf, "Old Parr/ when young," near top edge, and "Saturday/ Mr Pepper Called/ Vincent-/ Mr Sneyd-," lower right corner. Inscribed in pencil by Varley on the recto of leaf bearing the drawing, "old Parr/ when young/ Viz 40," lower left, and "Aug 1820-/ W. Blake. fect.," lower right. The drawing is hinged in a mat approx. 38 x 26.5 cm., which in turn is bound in tan leather by Riviere & Son matching the binding for the first eight drawings. On the front cover and spine, stamped in gold, is "VISIONARY PORTRAIT OF OLD PARR AT THE AGE OF FORTY—AN ORIGINAL DRAWING BY WILLIAM BLAKE." The hand-written title page begins "VISIONARY PORTRAIT OF OLD PARR" and ends "FROM THE COLLECTION OF JOHN LINNELL WHO OBTAINED IT DIRECT FROM THE ARTIST." The drawing was bound for £15.15s. shortly before its acquisition in June 1920 by Sessler (according to his business records).

Provenance: As for the first drawing to March 1918; offered by E. Parsons, June 1918 catalogue 282, item 459 (£15.15s.); sold to Sessler, June 1920 (£15.15s.); sold to Henry E. Huntington, 5 September 1923 ($2500, perhaps with un-identified works not by Blake, according to Sessler's business records).

Exhibition: Huntington Art Gallery, 1984.

Literature:
Rossetti 1863, 245, No. 59; 1880, 262, No. 62.
Butlin 1981, No. 748.

Thomas, or "Old," Parr died on 15 November 1635 at what he claimed to be the age of 152 years 9 months. Blake may have learned of this legendary hero of longevity from John Taylor's popular essay and poem, *The Old, Old, Very Old Man: or, The Age and Long Life of Thomas Par.*[67] There are a number of seventeenth and eighteenth-cen-tury engraved portraits of Parr, but all those I have seen show him in

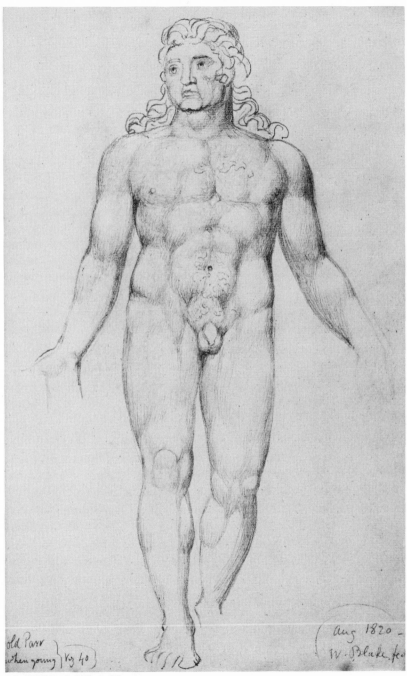

28. *Old Parr When Young*

age and look nothing like Blake's full-length portrayal.

Rossetti 1863, 245, describes Blake's drawing as "a perfectly naked figure, aiming probably to represent a man admirably constituted for vital strength and endurance. Carefully drawn, with the short thorax characteristic of Blake's figures." Parr was famous for his physical vitality, even as a centenarian, and Blake's visionary figure of him at the youthful age of 40 would seem to be a muscular representative of the "Strong Man," one of the "three general classes of men" Blake pictured in "The Ancient Britons" (untraced since 1809; Butlin 1981, No. 657) and discussed in *A Descriptive Catalogue* of 1809.[68] Blake drew a very similar figure, with alterations in the positions of the limbs, to portray "The Symbolic Figure of the Course of Human History Described by Dante" in one of his watercolors of ca. 1824–27 illustrating the *Divine Comedy* (National Gallery of Victoria, Melbourne; Butlin 1981, No. 812.28).

C. Illustrated Manuscript of Genesis.
Ca. 1826–27. Illus. 29–39.

Blake's Genesis manuscript contains eleven leaves, including two alternative title pages. The condition of the designs (described for each leaf, below) and the text clearly indicate that the manuscript was left at Blake's death in a fairly early state of development. Many parts of the designs exist as only pencil sketches even on the second title page, by far the most finished leaf. Leaves 3 through 11 contain the text of Genesis, from the first verse through 4:15, written in a modified Gothic script on rectos only. The hand is similar to the lettering on the title page of Blake's Job engravings (1825) and on the small name card Blake engraved at the end of his life for George Cumberland. The text is in pencil, with all verses through the first ten words of 2:5 written over in green, and in some cases red, watercolor. Many leaves, most noticeably the sixth, show light, preliminary pencil inscriptions of the same text offset slightly from the darker pencil letters. Each leaf, approx. 38 x 28 cm., is wove paper with two contiguous deckled edges. Leaves 1, 2, and 7 (q.v.) show a Whatman watermark. These features strongly suggest that all leaves are quarters of a sheet approx. 76 x 56 cm., corresponding to Whatman's "Imperial" size paper.[69]

According to Alexander Gilchrist, the Genesis manuscript was "commenced... for Mr. Linnell" and was the beginning of a projected "MS. Bible."[70] Gilchrist consulted Linnell while writing his biography of Blake, and thus his statements may be based on information given by the man who he claims commissioned the work. A similar level of possible authority pertains to Rossetti's statement (1863, 246) that the manuscript was executed "in the year of Blake's death." The 1826 watermarks on the second and seventh leaves provide a *terminus a quo* for most of the work. The 1821 watermark on the first leaf allows for the possibility that Blake began work on a title page some years earlier, but it is far more likely that the whole work was conceived and executed ca. 1826–27. Blake's increasing illness in those years may have interfered with his progress on this ambitious project, begun when he was already engaged in preparing a large number of illustrations to Dante's *Divine Comedy* for Linnell. All evidence indicates that the manuscript was begun with the intention of creating a unique work, not a preliminary for a subsequent letterpress and/or engraved publication.

At the beginning of each chapter, Blake added his own interpretive headings. These are as follows:

[leaf 3] Chap: 1
The Creation of the Natural Man. [Written in watercolor below two partly erased headings in pencil, the higher ending "... & the Earth" and the lower ending "... & the Spirit"]

[leaf 6] Ch. 2 Chap 2 [partly erased]
The Natural Man divided into Male & Female & of the Tree of Life & of the Tree/ of Good & Evil [written over illegible chapter heading]

[leaf 8] Chap. 3 [cancelled?]
Ch 3 Of the Sexual Nature & its Fall into Generation & Death

[leaf 10] Chap IV [cancelled?]
Ch–V [sic] How Generation & Death took Possession of the Natural Man/ & of the Forgiveness of Sins written upon the Murderers Forhead

The radical reinterpretation of the Bible is a central concern in Blake's writings throughout his working life. At the end of *The Marriage of Heaven and Hell* (1790–93), Blake announced his projected publication of "The Bible of Hell: which the world shall have whether they will or no."[71] Although the Genesis manuscript is not a clearly hellish testament, it does constitute Blake's final attempt to give the world a Bible incorporating his own exegesis. The chapter headings stress his concept of the fall of man not as a single historical event but as a complex and continuing process implicit in material creation. Spiritual man has already fallen into a limited condition when he becomes the "Natural Man" (chapter 1). The binary division of Adam into male and female, and the division of his world between the two trees of life and law (chapter 2), lead to a further fall into the natural cycles of "Generation" and mortality (chapter 3). Man becomes dominated by these restrictive forces, one consequence of which is the first murder (chapter 4). At this point, Blake swerves most dramatically even from the traditions of Gnostic exegesis by interpreting the "mark upon Cain" (4:15) as a "written" sign "of the Forgiveness of Sins." This act of divine inscription prefigures its spiritual opposite, the writing of the Mosaic tablets, and prophesizes its fulfillment in the self-sacrifice of Christ. Through his chapter headings, Blake suggests a reading of the Bible much like his own story of "The Universal Man" in *The Four Zoas* (ca. 1796–1807): "His fall into Division & his Resurrection to Unity/ His fall into the Generation of Decay & Death & his Regeneration by the Resurrection from the dead."[72]

Comments on the designs follow the description of each leaf. Blake's text of Genesis follows the King James version, except for many changes in accidentals (not recorded here) and the substantive revisions listed in the table at the end of this section of the catalogue.

Provenance: John Linnell; trustees of the Linnell estate, sold Christie's, 15 March 1918, lot 192 (£157.10s. to George D. Smith on behalf of Henry E. Huntington, according to Smith's invoice of 25 July 1918 in the Huntington archives).

Exhibition: Grolier Club, 1919–20, No. 50; Huntington Art Gallery, 1984, leaves 1 and 2 only.

Literature:
Rossetti 1863, 246, No. 66; 1880, 264, No. 88 (only leaves 1–3, 5, 7, 11 listed). Keynes 1921, No. 12.

S. Foster Damon, *William Blake: His Philosophy and Symbols* (London: Constable, 1924), 220–21. The order of the first two leaves is reversed.

Piloo Nanavutty, "A Title-Page in Blake's Illustrated Genesis Manuscript," *Journal of the Warburg and Courtauld Institutes* 10 (1947):114–22; reprinted in *The Visionary Hand*, ed. Robert N. Essick (Los Angeles: Hennessey & Ingalls, 1973), 127–46, second leaf reproduced.

Baker 1957, 40–43, first and second leaves reproduced.

S. Foster Damon, *A Blake Dictionary* (Providence: Brown Univ. Press, 1965), 151–52,459, second leaf reproduced (which Damon considers the earlier version). For some corrections of Damon's description, see John E. Grant's review, *Philological Quarterly* 45 (1966):534–35.

John Beer, *Blake's Visionary Universe* (Manchester: Manchester Univ. Press, 1969), 268–69.

Blake Complete Writings, ed. Geoffrey Keynes (London: Oxford Univ. Press, 1969), 933 (chapter headings and major variants in text of Genesis).

John E. Grant, footnotes in *Blake's Visionary Forms Dramatic*, ed. David V. Erdman and Grant (Princeton: Princeton Univ. Press, 1970), 333–34, 350.

Bentley 1977, 217–18.

Bindman 1977, 219–20, second leaf reproduced.

Paley 1978, 181, second leaf reproduced.

Leslie Tannenbaum, "Blake and the Iconography of Cain," in *Blake in His Time* 1978, 30–31, drawings on tenth and eleventh leaves reproduced.

William Blake's Writings, ed. G. E. Bentley, Jr. (Oxford: Clarendon Press, 1978), 2:1344–45, 1740 (chapter headings and most substantive variants in text of Genesis).

Butlin 1981, No. 828, first and second leaves reproduced in color.

Blake 1982, 688, 891 (chapter headings and major variants in text of Genesis).

1. First Title Page (Illus. 29). Accession No. 000.32. Pencil, pen, gouache, and watercolors. Image 34.1 x 23.9 cm. on sheet 38.2 x 27.5 cm., watermarked "J WHATMAN/ TURKEY MILL/ 1821." Inscribed in pencil on verso, "57447" (the former call number for the entire manuscript).

The composition is a carefully balanced integration of the letters of GE/ NE/ SIS with four major figures arranged around it. This structure is placed above a convex arc, apparently the circumference of the earth, complemented by a concave arc formed by four seated or kneeling figures. Rossetti 1863, 246, describes seven of the figures as "God the Father and Son, the four living creatures used as the Evangelical Symbols, and Adam." These identifications, perhaps based on information supplied by Linnell, have been accepted by most modern authorities. The bearded figure in a mandorla on the right is very

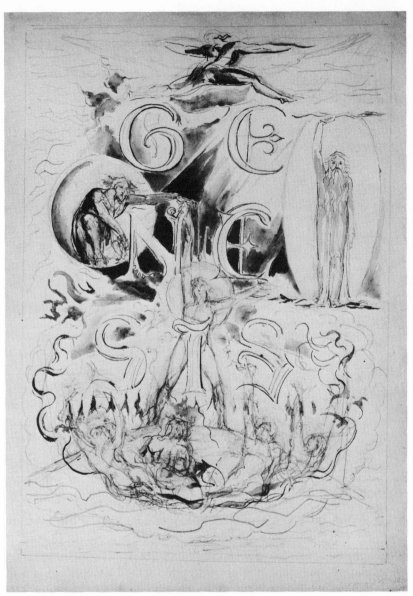

29. Genesis Manuscript: First Title Page

probably God the Father, and His opposite on the left the Son kneeling
in a sphere.[73] One of Blake's most characteristic motifs is a figure

within, or reaching out from, a circle or ellipse–most famously in "The Ancient of Days" (the frontispiece to *Europe*, 1794), but also a prominent feature in several designs illustrating Dante's *Divine Comedy* Blake drew at about the same time he was working on the Genesis manuscript. Wavy blue lines above and below the Father, widened and colored black in the second title page, and the counterbalanced position of His arms suggest that He is dividing "the waters which were under the firmament from the waters which were above the firmament" (1:7). The Son reaches out with His left hand toward the raised right hand of Adam, standing like a colossus on the rim of the earth. Their touching, or almost touching, hands suggest that the Son is in the act of creating Adam—a role traditionally given to the Father, as in Michelangelo's Sistine fresco—or at least illuminating prelapsarian man with the divine consciousness emblemized by the large halo around Adam's head and upper torso. A few sketchy lines emanating from it suggest that the halo is also the sun, as is made clear by the more prominent rose-colored rays in the second title page. The letter "I" serves as a garment for Adam's loins, literally clothing him in the Word of God. His left arm repeats the Son's gesture.

The symmetry of the design suggests that the symmetry of the Trinity is completed by the figure at the top of the design.[74] The giant wings, lightly sketched in pencil, associate him with the traditional representation of the Holy Ghost as a dove. He strides energetically to the right, with arms extended, in a posture very similar to, but the reverse of, the figure striding in flames on plate 3 of *The Book of Urizen* (1794). In an annotation on one of his Dante drawings, Blake identified the Holy Ghost with the "Imagination,"[75] always an energetic and creative faculty for Blake. Thus, the Holy Ghost may be engaged in acts of creation like the other members of the Trinity. Two flames (of inspired activity?) rise near his left foot. They are tinted the same red as the body of the Holy Ghost. Slight diagonal lines descending from the top right corner may be the beginnings of rain or rays of light.

The figures near the bottom of the design are too sketchy to identify.[76] Rossetti's reasonable proposal that they represent the four Evangelists may be based on their development in the second title page (q.v.). They sit on clouds or waves with tongues of (hellish?) flame above their heads. Three reach upward with extended arms,

perhaps in anguish or in hopeful expectation of receiving the divine contact granted Adam.

2. Second Title Page (Illus. 30). Accession No. 000.33. Pencil, pen, watercolors, and liquid gold on first four letters of GE/ NE/ SIS. Image 33 x 23.5 cm. on sheet 38 x 28 cm., watermarked "J WHATMAN/ 1826." Inscribed on verso like first leaf.

Blake repeats the same basic design, and at least the same four uppermost figures, in this more highly developed version of the title page. All authorities except Damon (1924 and 1965) take this to be a replacement for the other version; but since leaf 2 is also an unfinished design, it is possible (although unlikely) that Blake set it aside and later began work on leaf 1. In spite of basic similarities in format, the tone shifts dramatically: the black, tomato red, and strong blue colors of leaf 1 are replaced by pastel green, pink, blue, yellow and rose. Adam and the halo/sun are smaller; his gestures, particularly the left arm, are less dramatic. The general effect is more peaceful and decorative and less dominated by taut and theatrical postures. The Holy Ghost looks to the right, rather than turning back to the left as in leaf 1. The Son now wears a billowing, diaphanous robe and stands (among clouds?) much as He is pictured in one of Blake's illustrations of ca. 1824–27 to Dante's *Paradiso* (National Gallery of Victoria, Melbourne; Butlin 1981, No. 812.90). A scroll cascades from His left hand and falls into Adam's upraised right hand. In light of the Son's cruciform posture, this scroll suggests a written covenant of man's eventual salvation.

The first four letters of the title spring into vegetative life. Blake first used interwoven natural and calligraphic forms on the title page to *Songs of Innocence* (1789), where it also suggests a union of world and word (or, in the Genesis manuscript, world and God's creative Word). Blake was familiar with symbolic interpretations of plants and flowers from at least the early 1790s, when he engraved several plates for Erasmus Darwin's *Botanic Garden*. Blake probably also knew the *Temple of Flora* (1799–1807) by Robert John Thornton, for whose school text of Virgil's *Pastorals* (1821) Blake designed and executed his only wood engravings. Thus it seems likely that the plants decorating GENESIS are botanically specific and emblematically significant. Nanavutty

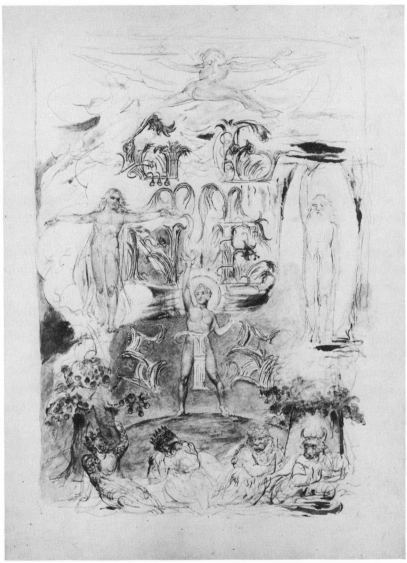

30. *Genesis Manuscript: Second Title Page*

1947 has interpreted them accordingly. The three funnel-shaped forms dangling from the "G" are the seed pods of *nelumbo nucifera,* or sacred lotus, which Thornton describes as an ancient Egyptian sym-

bol associated with Ceres (Nanavutty, 130 of the 1973 reprint). A similar significance pertains to the ears of grain growing from the terminal of the letter, converting its vertical form into a sheaf. The diagonal of the "N" supports the pencil outline of a serpentine stem ending in five petals which Nanavutty identifies as *nymphaea caerulea*, the flower of the blue lotus. These emblems of fruitfulness on the left side of the design contrast with the flowers on the right. The first "E" bears three red roses, traditional emblems of martyrdom. The center horizontal of the second "E" is covered by a large blossom identified by Nanavutty as the *lilium martagon*, or lily of Calvary, also pictured on plate 23 of Blake's *Jerusalem* (ca. 1804–20). However, it is very similar to the two flowers on the title page to Blake's *The Book of Thel* (1789), usually identified as the *anemone pulsatilla*, or pasqueflower, described by Darwin.[77] In either case, the flower is associated with Christ's sacrifice and resurrection. Between the first and second line of letters are two trees, perhaps the feathery date palm (*phoenix dactylifera*), emblems of "salvation and victory as well as the martyr's sacrifice," but also of marriage when pictured in pairs (Nanavutty, 136 of the 1973 reprint). Blake pictures a palm with similarly descending fronds on plate 37 of *Jerusalem*.[78] Nanavutty (132–33 of the 1973 reprint) and Butlin 1981, 597, suggest the presence of two snakes above the left-most rose on the first "E" and rising from the blossom on the second "E," but these may simply be tendrils. The last two letters are formed of clusters of grass or grain, complemented by the light green coloring highlighting all letters.

Blake places two large, fruit-bearing trees at the lower corners of his composition. These are undoubtedly the "Tree of Life" and the "Tree of Good & Evil" Blake names in his heading to the second chapter of Genesis. Nanavutty (138 of the 1973 reprint) notes that the Tree of Life is on the left, presumably because it stands just below Christ, but the trees are otherwise not clearly differentiated. Both have the thick, short trunks of the oak, a tree Blake associated with the Druidic errors of fallen religion.

The four figures in the lower margin can be seen, in this second title page, as more or less human bodies with the heads (right to left) of an ox, a lion, a bird, and a reptilian creature with only residual human characteristics. A few lines below them, particularly on the right, may indicate water into which the feet of the two central figures disappear.

The two on the right gesture, palms outward, in fear or surprise. The two on the left are crowned. The bizarre figure far left, with arm raised (in fear?), sticks out his tongue. Multi-colored scales cover his left arm and right shoulder. The animal heads associate these figures with three of the Evangelists: the lion of St. Mark, the eagle of St. John, and the ox of St. Luke. No single beast is traditionally allied with St. Matthew, but the beast on the left may complete the group of four Evangelists, as Rossetti suggests (see leaf 1). Blake's figures also evoke the typological parallels to the Evangelical beasts: the vision of the four faces in Ezekiel 1:10 (man, lion, ox, eagle) and the four creatures, called "zoa" in the original Greek, of Revelation 4:7 (lion, calf, man, eagle). Blake may have further associated all these foursomes with the river parted into "four heads" in Genesis 2:10.

The equivalents to these Biblical quaternaries in Blake's mythological poetry are the four Zoas, each an embodiment of a fundamental attribute of humanity. Several passages in *The Four Zoas*, Blake's long manuscript poem of ca. 1796–1807, associate Luvah with the bull, Urizen with the lion, and Tharmas with the eagle.[79] The fourth Zoa, Urthona (also called Los), is not identified with a particular animal, but like St. Matthew he may be implied by the creature far left. In their separate, beastly forms, as presented on this title page, the Zoas indicate man's fall into a degraded and contentious state of division. Thus, the whole design, moving from top to bottom, represents a descent from imaginative creativity to the fallen nature of the two trees and the Zoas, a descent that parallels the plot outlined by Blake's chapter headings. The course of human history encompasses all these "states," as Blake calls them in *Milton* and *Jerusalem*, and thus Adam stands at the decisive midpoint in the composition. His feet are firmly planted in the material world, but his right hand is in touch with divinity through the medium of a written document. Thus, Adam is also a portrait of the reader, whose position is the same as he opens the Book of Genesis.

3. "God the Father in the Act of Creation" (Illus. 31). Accession No. 000.34. Pencil, pen(?), and watercolors. Image (including text of Genesis 1:1–18) 29.4 x 23.5 cm.; headpiece 8 x 23.5 cm. Sheet 37.7 x 27.5 cm. Text in green and red over pencil, with liquid gold on the initial "I."

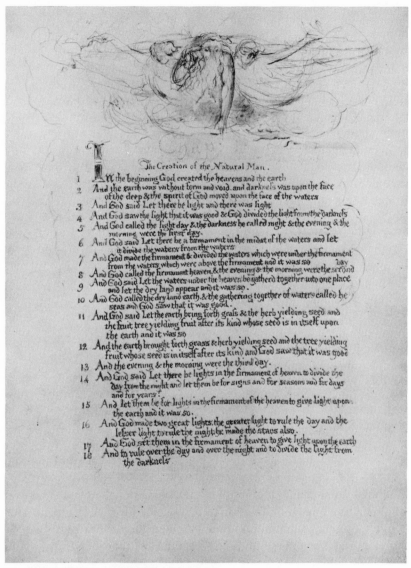

The Creation of the Natural Man.

1 In the beginning God created the heavens and the earth
2 And the earth was without form and void. and darkness was upon the face
 of the deep & the spirit of God moved upon the face of the waters
3 And God said Let there be light and there was light
4 And God saw the light that it was good & God divided the light from the darkness
5 And God called the light day & the darkness he called night & the evening & the
 morning were the first day.
6 And God said Let there be a firmament in the midst of the waters and let
 it divide the waters from the waters
7 And God made the firmament & divided the waters which were under the firmament
 from the waters which were above the firmament and it was so day
8 And God called the firmament heaven & the evening & the morning were the second
9 And God said Let the waters under the heaven be gathered together unto one place
 and let the dry land appear and it was so.
10 And God called the dry land earth, & the gathering together of waters called he
 seas and God saw that it was good.
11 And God said Let the earth bring forth grass & the herb yielding seed and
 the fruit tree yielding fruit after its kind whose seed is in itself upon
 the earth and it was so
12 And the earth brought forth grass & herb yielding seed and the tree yielding
 fruit whose seed is in itself after its kind and God saw that it was good
13 And the evening & the morning were the third day.
14 And God said Let there be lights in the firmament of heaven to divide the
 day from the night and let them be for signs and for seasons and for days
 and for years?
15 And let them be for lights in the firmament of the heaven to give light upon
 the earth and it was so.
16 And God made two great lights: the greater light to rule the day and the
 lesser light to rule the night: he made the stars also.
17 And God set them in the firmament of heaven to give light upon the earth
18 And to rule over the day and over the night and to divide the light from
 the darkness

31. God the Father in the Act of Creation

In the design above the text, a bearded figure—no doubt God the
Father—reaches down with His left hand in an act of creation. This
gesture is similar to the demiurge in Blake's "Ancient of Days," the
frontispiece to *Europe* (1794). The sinister implications of the compari-

son are somewhat mitigated by the Father's right hand, raised with palm outward in blessing. If Blake's chapter heading also serves as a caption for the headpiece, then the Father is creating Adam, "the Natural Man." Close to each side of the Father is a winged angel, with outer arm extended slightly above the horizontal, to form a symmetrical pattern. Pencil outlines define billowing clouds, some extending down both margins of the text.

4. "The Fourth and Fifth Days of Creation" (Illus. 32). Accession No. 000.35. Pencil, pen(?), and watercolors. Image (including text of Genesis 1:19–24) 27 x 17.8 cm.; vignette below verse 19, 8.9 x 16.5 cm.; vignette below verse 21, 7 x 16.8 cm.; vignette below verse 24, 2.6 x 14.9 cm. Sheet 37.9 x 27.3 cm. Verses 19 and 20 in green and red over pencil, remainder in green over pencil.

The design below verse 19 includes three winged figures with extended arms standing on "the waters" (1:20). The man on the right faces forward, the central figure shows us his back, and we see the figure on the left from the side or in a three-quarter view. A convex arc behind the figures' knees probably represents the earth. Just above the horizon and between the figures are two circles, the "two great lights" (1:16) of the firmament. A few sketchy lines on the circle left of the central figure suggest crescent phases of the moon. There are four "stars" (1:16) in the sky, arranged in two pairs around the heads of the figures left and right. The man on the right, with a pointed chin or goatee and spiky hair, looks a good deal like Christ on leaf 1. Thus, the three figures may be the Trinity creating the earth, the firmament, and the waters. Their three positions relative to the viewer underscore the triune nature of their being and acts.

The design between verses 21 and 22 shows two billowing waves with a bottlenose dolphin (illustrating "whales," 1:21?) sporting between them. Above are three winged figures, their heads and bodies close together in a recessional diagonal from left to right. The front-most head looks like Christ's on leaf 1, and thus once again Blake would seem to be picturing the Trinity. They soar above the waves like "the Spirit of God" who "moved upon the face of the waters" (1:2). Just above the water are a few pencil lines, perhaps clouds, on the left; and, on the right, a very sketchy outline of a "winged fowl" (1:21).

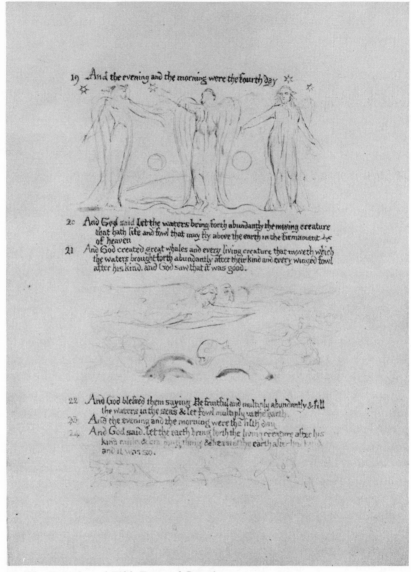

32. The Fourth and Fifth Days of Creation

The decoration at the bottom of the leaf consists of three clusters of pencil squiggles. These may be the first thoughts for "the living

creature... cattle, and creeping thing, and beast of the earth" (1:24) of the verse immediately above.

5. "The Creation of Adam" (Illus. 33). Accession No. 000.36. Pencil, pen(?), and watercolors. Image (including text of Genesis 1:25–31) 28.3 x 21.3 cm.; tailpiece 15.4 x 21.3 cm. Sheet 37.8 x 27.5 cm. Verses 25–27 in green and red over pencil, remainder in green over pencil. Design in pencil only.

In the illustration, a figure on the left, probably Adam, strides with arms raised toward three figures on the right arranged in a recessional diagonal from right to left. Their arms are raised in parallel to form three strong diagonals rising from left to right. Blake used similar arrangements of aligned figures with complementary gestures to picture the accusatory friends in his Job illustrations, first executed as watercolors ca. 1805–1806 (Butlin 1981, No. 550) and engraved ca. 1823–26. A few lines suggest clouds right and left of the four figures. Partly erased lines indicate that Blake first drew a somewhat larger version of Adam. The central figure in the group of three appears to be bearded like God the Father on leaves 1–3. The group may be either the Father, accompanied by wingless versions of the attendants given Him on leaf 3, or the Trinity just after having "created man in his own image" (1:27).[80]

6. "Adam and Eve in the Garden of Eden" (or "The Creation of Adam and Eve"?) (Illus. 34). Accession No. 000.37. Pencil and pen or brush. Image (including text of Genesis 2:1–13) 29.5 x 20 cm.; headpiece 9.5 x 20 cm. Sheet 38.2 x 28 cm. Verse 1 through first ten lines of verse 5 in green over pencil; design and remainder of text in pencil only.

Blake's chapter heading seems to serve as a caption for the design above it. In the center is Adam, seated on the surface of the earth and with hands raised as if in surprise or bewilderment. Behind him is the bearded figure of God the Father. To the left is a figure hovering in the sky with his legs drawn up as if seated, and with slight suggestions of large wings. Even the basic features of his face are not defined; he may be another member of the Trinity, an angelic attendant like those on leaf 3, or even an adumbration of Satan. The fourth figure, on the right, is Eve, "divided" from a presumably androgynous Adam to cre-

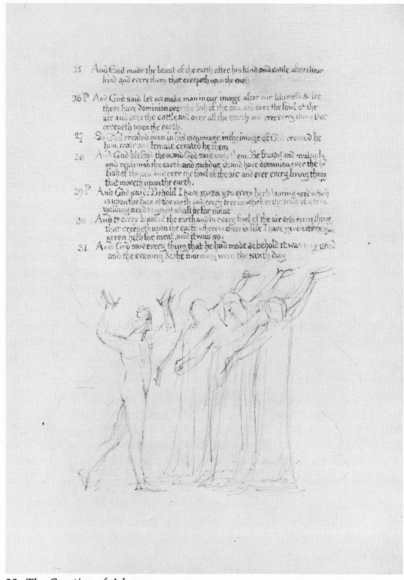

33. The Creation of Adam

ate the two sexes (see chapter headings, above). She appears to rise in
a diagonal line toward the top right corner with her feet hidden by, or

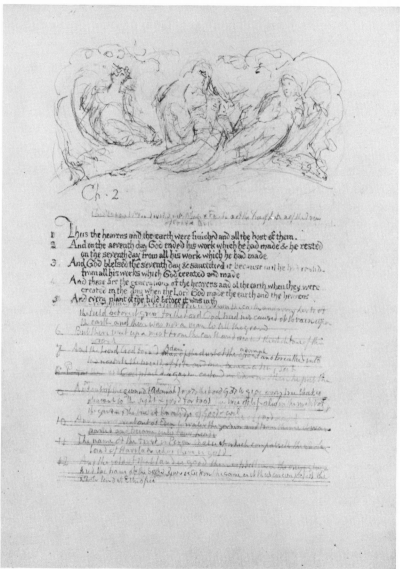

34. *Adam and Eve in the Garden of Eden*

just emerging from, Adam's left hip and thigh. A few long and twist-
ing pencil strokes on each side and partly over the figural group

roughly suggest the two trees of Eden Blake names in his chapter heading as another indication of the fall into division. A few circular shapes above the figures right and left may be fruit dangling from branches.

7. "The Creation of Eve" (Illus. 35) Accession No. 000.38. Pencil. Image (including text of Genesis 2:14–25) 29.7 x 20.5 cm.; tailpiece 12 x 20.5 cm. Sheet 38.2 x 28 cm., watermarked "J WHATMAN/ 1826."

The design is surrounded by a framing line at the bottom and each side. Adam lies prone on the ground, his head on the left and his neck stretched back as if in agony. Several dark lines cross his chest to indicate either a restrictive band or an incision. Eve hovers just above him, with her head on the right and her feet touching. She appears to have just emerged from Adam's chest. We see the front of Eve's torso, but her head may be awkwardly twisted and her left arm, bent at the elbow, reaches up and to the right. Above her is God the Father, bearded and winged, soaring to the right with His hands at His side. Behind God, and offset in a recessional line to the right, are two further faces—either the remaining members of the Trinity or angelic attendants. Blake first lightly drew Adam's head and torso farther to the left, and Eve's head and left arm farther to the right, and then redrew the figures in darker lines. A few wavy lines at the bottom suggest vegetation, water, or perhaps even flames just below Adam's knee. Lines below and above Eve delineate the outlines of clouds.

The basic format of the design—one horizontal figure suspended above another—was a favorite of Blake's. It appears in such major works as the 1795 color printed drawings "Elohim Creating Adam" and "Satan Exulting over Eve" (Butlin 1981, Nos. 289–92), and in "Job's Evil Dream," first executed as a watercolor ca. 1805–1806 (Pierpont Morgan Library; Butlin 1981, No. 550.11) and engraved by Blake ca. 1823–26 as the eleventh plate in his Job illustrations.

The Book of Genesis is a composite of at least two creation myths, as indicated by the two names given God in the Hebrew text: "Elohim" in Chapter 1, and "Jahweh" in Chapter 2. There are, for example, two versions of the creation of Eve, one in which "male and female" are created together (1:27), and the familiar tale of Adam's rib (2:21–22). Accordingly, Blake provides two illustrations of Eve's creation, the

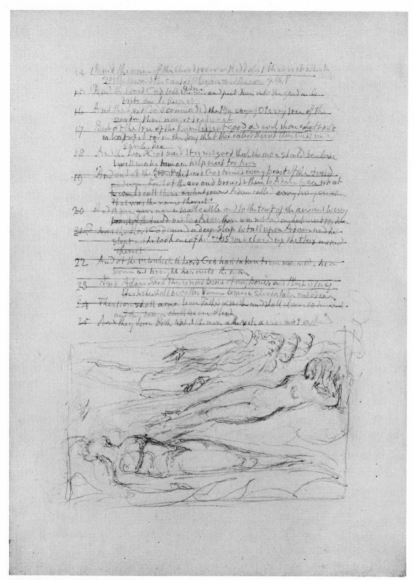

35. *The Creation of Eve*

first as the headpiece to Chapter 2 (leaf 6), in which God may be creating man and woman together as in the Elohim version, and the second on leaf 7, corresponding to the Jahweh version. Blake seems to

have known about the composite structure of Genesis as early as 1794 when he used a dual creation plot in _The Book of Urizen_.[81] See also comments on textual variants, below.

For another version of the creation of Eve, see Blake's _Paradise Lost_ designs, Part I, section A, No. b.8.

8. "Adam and Eve at the Tree of Knowledge" (Illus. 36). Accession No. 000.39. Pencil. Image (including text of Genesis 3:1–14) 29.7 x 20.2 cm.; headpiece 11 x 19.9 cm. Sheet 38.1 x 27.7 cm.

The design at the top, surrounded by framing lines, directly illustrates Blake's chapter heading and the text of Genesis below it. Adam kneels on the far left, his arms apparently behind his back. To the right, the fallen Eve kneels with her left hand over her breasts and her right hand covering her vulva in a version of the Venus Pudica posture.[82] A few dark lines on the ground between the pair may be a partly-eaten fruit from the tree of the knowledge of good and evil. Its thick trunk dominates the right half of the design, with a few swirling lines suggesting foliage and fruit above. At its base is the serpent, already cursed by God and going on his "belly" (3:14). His large head is extended toward Eve. Blake lightly sketched all the major motifs— Adam, Eve, the tree, and the serpent—farther to the left, then redrew them in darker pencil.

9. "The Expulsion from Eden(?)" (Illus. 37). Accession No. 000.40. Pencil. Image (including text of Genesis 3:15–24) 24.2 x 18.5 cm.; tailpiece 9.2 x 17 cm. Sheet 37.9 x 27.8 cm. Inscribed in pencil on verso, "X57447" (the former call number for the entire manuscript).

The tailpiece is little more than a few undefined shapes (lower left), large curving lines (upper center and right), and more tightly-curled lines (top right). Yet these first thoughts in pencil are enough to suggest an expulsion scene illustrating verse 24, written just above it. On the title page for _Songs of Innocence and of Experience_ (1794), Blake pictured the expulsion (see Illustration 46). The basic format of this relief etching would seem to be repeated here on leaf 9, with Adam and Eve cowering on the left and the flames of divine wrath on the right. Alternatively, the swirling lines might indicate a whirlwind, like the one in which God appears in the thirteenth plate of Blake's _Job_

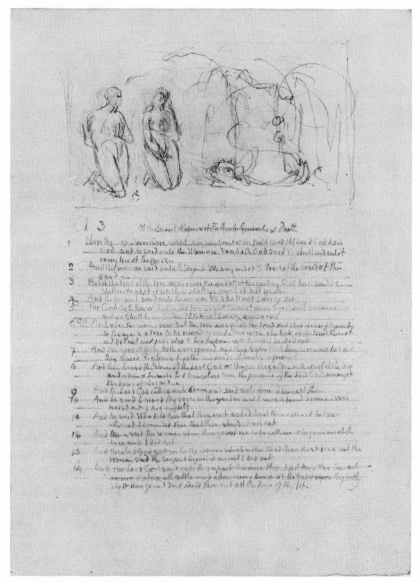

36. *Adam and Eve at the Tree of Knowledge*

engravings, ca. 1823–26. See also Blake's *Paradise Lost* illustrations, Part I, section A, No. b.12.

37. The Expulsion from Eden

10. "Cain Fleeing from the Body of Abel" (Illus. 38). Accession No. 000.41. Pencil. Image (including text of Genesis 4:1–14) 29.8 x 20.5 cm.; headpiece 11.2 x 20.5 cm. Sheet 38 x 27.8 cm.

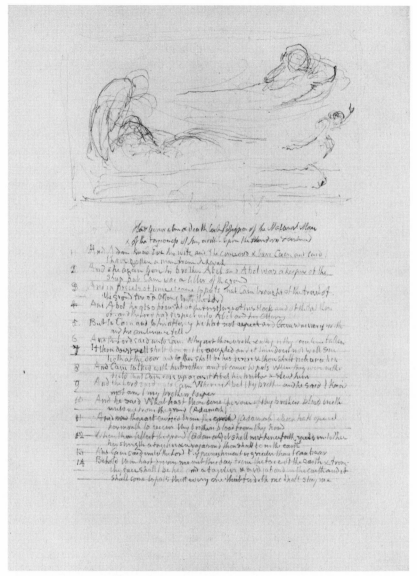

38. Cain Fleeing from the Body of Abel

The design, within framing lines above the text, pictures events following the death of Abel and illustrates the first line of Blake's chapter heading. In about 1826, Blake painted a tempera of the same subject,

showing Cain fleeing from his brother's grave, with Eve lamenting over Abel's body and Adam kneeling behind her, his gestures indicating shock at the horror of the first murder.[83] The sketch on leaf 10 would seem to be a variant of this design. A few lines in the lower part of the design may indicate an open grave or the first sketchy indications of Abel's body. Behind the horizontal lines on the left is a prone figure whose head is supported by a kneeling figure. It is unclear whether this is Adam comforting the distraught Eve, as Damon notes (1924, 221, and 1965, 152), or one of Abel's parents lamenting over his body. A few curved lines below the head of the kneeling figure may be an alternative position for his head or an indication of another figure behind the first. On the far right, the small (and distant?) figure of Cain flees to the right. Above him hovers a much larger figure, apparently in pursuit. This may be God, as in many traditional portrayals of the scene, or a personification of "The Voice of Abels Blood," a phrase based on Genesis 4:10 Blake wrote on a generally similar hovering figure in the tailpiece to *The Ghost of Abel* (1822).[84]

11. "God the Father Marking Cain's Forehead" (Illus. 39) Accession No. 000.42. Pencil. Image (including text of Genesis 4:15 and 20 ruled lines drawn in anticipation of further text) 29.8 x 20.2 cm.; tailpiece 15 x 20.2 cm. Sheet 38 x 28.1 cm.

The design at the bottom of the leaf directly illustrates the single verse written above it ("And the Lord set a mark upon Cain"), but in such a way as to visualize Blake's interpretation of the event set forth in the second line of his chapter heading on leaf 10 ("& of the Forgiveness of Sins written upon the Murderers Forhead"). God the Father, on the left, kneels to embrace the much smaller figure of Cain and to kiss his forehead in an act of tender forgiving and blessing more than marking. Cain turns his face up toward God and touches His right upper arm with his left hand. The composition follows the conventions used in many illustrations of the return of the prodigal son in Christ's parable (Luke 15:11-32), such as the engraving by Marten de Vos (1531–1603) and Rembrandt's famous etching of 1636. Through this visual allusion, Blake establishes a typological relationship between the marking of Cain and the forgiving of another wayward

39. God the Father Marking Cain's Forehead

son, itself a foreshadowing of Jesus on the cross forgiving His murderers (Luke 23:34).

A cottage with steeply-pitched roof stands in the background on the

right. Two bending, perhaps kneeling, forms in front of the dwelling are probably Adam and Eve. Curving lines outline clouds on each side of God and Cain.

**

Listed below are the substantive differences between Blake's Genesis manuscript and the King James Version.

	Blake	*King James Version*
leaf 3		
1:1	the heavens and	the heaven and
10	together of waters	together of the waters
11	grass & the herb	grass, the herb
	fruit after its kind	fruit after his kind,
12	herb yielding seed and the tree	herb yielding seed after his kind, and the tree
	whose seed is	whose seed was
	after its kind	after his kind
14	firmament of heaven	firmament of the heaven
	and for years	and years
17	firmament of heaven	firmament of the heaven
18	from the darkness [end]	from the darkness: and God saw that it was good.
leaf 4		
1:20	in the firmament	in the open firmament
22	multiply abundantly & fill	multiply, and fill
leaf 5		
1:25	creepeth upon the ear [remainder partly rubbed out]	creepeth upon the earth after his kind: and God saw that it was good.
26	over everything that creepeth	over every creeping thing that creepeth
29	face of the earth	face of all the earth
	every tree in which	every tree, in the which
leaf 6		
2:3	because in it	because that in it
	all his works	all his work
4	And these are the	These are the

Adam
7 formed Man of the dust of the formed man of the dust of the ground
adamah
ground
9 ground (Adamah) made ground made
13 [verse number partly erased]
encompasseth compasseth

leaf 7

2:14 and the name of the P [end] And the fourth river is Euphrates.
Adam
15 took the m-- took the man
into the garden into the garden of Eden
to dress and to dress it and
17 thou shalt surely[?] surely die thou shalt surely die
Adamah
19 And out of the ground And out of the ground
them to Adam them unto Adam
22 And of the rib And the rib
24 leave Father & mother leave his father and his mother
shall cleave to shall cleave unto
they twain[?] shall be they shall be

leaf 8

3:1 field that the field which the
5 thereof your eyes thereof, then your eyes
as Gods (Elohim) knowing as gods, knowing
6 also to her husband also unto her husband
12 And Adam said And the man said
gavest me to be gavest to be
14 thou art accursed thou art cursed

leaf 9

3:15 her seed he shall bruize her seed; it shall bruise
16 And unto the woman Unto the woman
thy sorrows thy sorrow
in sorrow shalt though in sorrow thou shalt
17 hearkened to the hearkened unto the
18 thistles it shall bring forth thistles shall it bring forth
unto thee to thee
19 sweat of the face thou shalt sweat of thy face shalt thou
ground (Adamah) for dust ground; for out of it wast thou taken:
thou art for dust thou art
dust thou shalt return dust shalt thou return

21 And to Adam	Unto Adam
22 Behold Adam is become	Behold, the man is become
23 forth at the garden of Eden	forth from the garden of Eden
ground (Adamah) from	ground from
24 drove out Adam	drove out the man
sword to keep the way	sword which turned every way, to
	keep the way

leaf 10

4:1 from Jehovah	from the Lord
2 keeper of the sheep	keeper of sheep
3 ground for an offering	ground an offering
4 Abel and his offering	Abel and to his offering
5 But to Cain	But unto Cain
7 and to thee shall	And unto thee shall
8 talked with his brother	talked with Abel his brother
10 from the ground (Adamah)	from the ground.
11 And now thou art cursed	And now art thou cursed from
from the ground (Adamah)	the earth, which
which	
12 ground (Adamah) it	ground, it
vagabond thou shalt be	vagabond shalt thou be
14 and a fugitive	and I shall be a fugitive

leaf 11

4:15 said unto Cain Therefore	said unto him, Therefore
taken of him	taken on him
and the Lord set a mark upon	And the Lord set a mark upon Cain,
Cains forehead [end]	lest any finding him should kill him.

The most significant alteration of the King James version is Blake's addition of "Adamah," the Hebrew word for "ground" in the English text, to indicate that Adam was made "of the dust of the ground" (2:7) and named accordingly. Blake uses the Hebrew word in only one other place in his writings, the "Laocoön" inscriptions of ca. 1820, where he explains that God repented that "he had made Adam (of the Female, the Adamah)."[85] Blake thereby suggests that the man created in Genesis 2:7 was originally a synthesis of masculine spirit and female matter, an internal dualism externalized in the creation of Eve. To underscore the nature of such a man, Blake also substitutes (albeit not consistently) "Adam" for "man." It may be significant that he makes no such changes in the "Elohim" creation myth of chapter 1 (see

comments on leaf 7). However, Blake complicates the Elohim/Jahweh distinction by adding "Elohim" (a plural) after "Gods" in Genesis 3:5, apparently to contrast the creator of the material world with "Jehovah," his substitute for "Lord" in Genesis 4:1.[86]

Blake introduced another group of revisions to eliminate a possible inconsistency in the King James text. In 2:8, Adam and Eve are located in "a garden eastward of Eden," but by 2:15 this becomes "the garden of Eden." Blake does not emend 2:8, but deletes "Eden" from 2:15. The change of "from the garden of Eden" to "at the garden of Eden" in 3:23 may have been made for a similar reason since "at" does not require the prior presence within necessitated by "from." In 4:15, Blake added "forehead" in accord with his own chapter heading on leaf 10 and illustration of God marking Cain and forgiving him, leaf 11. Even the change of "his" to "its" in 1:11–12, and the deletion of "his kind" in 1:12, would appear to have been made for the sake of consistency with "itself" in the same verses. Similarly, Blake converts to the genderless pronoun in reference to "seed" at the end of 3:15 to be consistent with "it" earlier in the same sentence. Other revisions may be simple errors, but it is possible that even the most trivial changes are Blake's response to the Hebrew text.[87]

D. Other Drawings and Paintings

1. "Pestilence" (Illus. 40). Ca. 1793–97. Accession No. 82.36. Pencil, 22.5 x 28.5 cm., on laid paper 24.2 x 29.9 cm. with chain lines 2.6 cm. apart and a fleur-de-lis watermark. Inscribed in ink, lower left, "cker[?]," cut by the edge of the sheet on the left. Minor repairs on top and left edges.

Provenance: Mrs. Blake?; perhaps Frederick Tatham, sold Sotheby's, 29 April 1862, with 33 "other" items in lot 200 or 201 (2s. and 3s., both to Francis Harvey); offered by Harvey, catalogue of ca. 1865, as "Plague," with 16 other "sketches in ink and pencil" (£3.3s.); Frederick Locker-Lampson by 1886; E. Dwight Church, who acquired numerous works from Locker-Lampson through Dodd, Mead, & Co., ca. 1905; sold from the Church estate at Anderson Galleries, 29 March 1916, lot 983, laid into a copy of Blake's *Illustrations of Dante* ($110); removed from the Dante portfolio and acquired, probably as part of a large group of miscellaneous drawings, at an unknown time prior to 1982 by the Huntington Library and Art Gallery.

Exhibition: Huntington Art Gallery, 1983.

Literature:
Rossetti 1863, 241, No. 18 ("Plague," located in the collection of "Mr. Harvey"); 1880, 257, No. 20 ("Plague," no ownership given).

The Rowfant Library. A Catalogue of the Printed Books, Manuscripts, Autograph Letters, Drawings and Pictures Collected by Frederick Locker-Lampson (London: Bernard Quaritch, 1886), 140, "original drawing of the Plague... inserted" in a copy of Blake's *Illustrations of Dante* in "original green cloth boards."

Shelley M. Bennett, "A Newly Discovered Blake in the Huntington," *Huntington Calendar* (July–August 1983):2–4, reproduced.

Bennett, "A Newly Discovered Blake at the Huntington," forthcoming in *Blake: An Illustrated Quarterly,* reproduced.

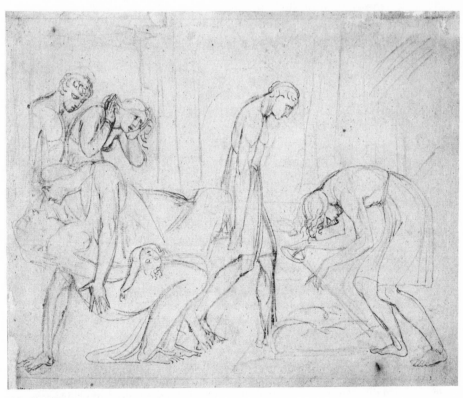

40. Pestilence

The theme of this pencil sketch and its basic compositional elements attracted Blake's attention from ca. 1779 to ca. 1805. Listed below are the seven related works.

Butlin 1981, No. 184. "Pestilence, Probably the Great Plague of London." Pen and watercolor, ca. 1779–80. Collection of Robert Tear.

No. 185 "Pestilence." Pen and watercolor, ca. 1780–84. Collection of Robert Essick.

No. 201.25. Pencil sketch for an emblem series in Blake's *Notebook*, ca. 1790–92. British Library.

Europe, plate 7. Full-page design, relief and white line etching, 1794.

No. 190. "Pestilence." Pen and watercolor, ca 1790–95. Estate of Gregory Bateson.

No. 192. "Pestilence." Pen and watercolor, ca. 1795–1800. City Art Gallery, Bristol.

No. 193. "Pestilence." Pen and watercolor over pencil, ca. 1805. Museum of Fine Arts, Boston.

The first two, clearly early, works are associated with Blake's execution of a group of small watercolors illustrating scenes in English history.[88] All the later versions are not specifically related to the London plague of 1665 but embody universal themes with revolutionary and apocalyptic implications. The left side of the composition in both early versions is dominated by a seated man supporting a stricken woman with a bellman in the background. Blake used the first two figures in his *Notebook* sketch of ca. 1790–92 and all three in the design in *Europe*, 1794. When he reworked the full "Pestilence" composition at about the same time (No. 190), he left these three figures out and moved the standing man holding a stricken woman from the right side of the design to fill the vacated left side. The remainder of the design was completely reconstituted with new figures and architectural background along the lines we can see in the pencil sketch.

Rossetti 1863, 241, describes the Huntington drawing as a "reasonably careful sketch for" the final version of ca. 1805, which seems unlikely. Bennett (1983 and forthcoming) suggests that the drawing may be the first in the 1790s group, a preliminary to No. 190. Yet a third hypothesis is prompted by the major compositional development among the last three watercolors: the shift from showing the faces of all figures in profile (no. 190) to showing two figures on the left in

three-quarter view. The companion drawings to Nos. 190 and 192, two versions of "A Breach in a City, the Morning after the Battle" (Carnegie Institute, Pittsburgh, and Ackland Art Center, University of North Carolina; Butlin 1981, Nos. 189 and 191), show the same progression from profile to three-quarter view in the two standing figures on the right. The unfinished character of the Huntington sketch, and the hesitant and studied nature of its lines, suggest that it is Blake's first experiment at changing some figures to three-quarter view to develop the expressive potential of their faces. He tried showing more of the faces of both figures standing behind the litter, but this disturbs the symmetrical, frieze-like relationship between the two men carrying the shrouded body. Consequently, in the last two versions, Blake retained the three-quarter view of the standing woman, returned the standing man to profile, and turned the face of the man holding the woman on the left toward us. The last two watercolors are somewhat tighter compositions than No. 190, with less distance between the standing figures. A similar disposition in the pencil sketch allies it with the later group. Thus, the Huntington drawing may fit into the "Pestilence" sequence as a transition between Nos. 190 and 192.

There is no record of the existence of this drawing between its sale in 1916 to an unknown purchaser and its rediscovery at the Huntington in 1982 in a pile of miscellaneous drawings. The provenance is problematic and has in the past been confused with that of Butlin's No. 192. When found at the Huntington, a printed label, "450 Blake The Plague," was pasted just below the top right margin. This is very probably a clipping from a sale or exhibition catalogue, but no one has yet been able to identify its source. The label has been removed, for reasons of conservation, but retained. The suite of Blake's Dante engravings, with which the drawing was associated in the *Rowfant Library* catalogue of 1886 and in the 1916 auction catalogue, can not be identified with any of the Dante sets now at the Huntington Library (see Part III, section B, No. 10).

2. "Lot and His Daughters" (Illus. 41). Ca. 1799–1800. Accession No. 000.55. Pen and tempera on canvas, framed to 26 x 37.5 cm. Signed lower right, "inv/WB" in monogram. Butlin 1981, 319, reports that the painting is inscribed "on back 'Genesis XIX c. 31 & 32v'." The painting

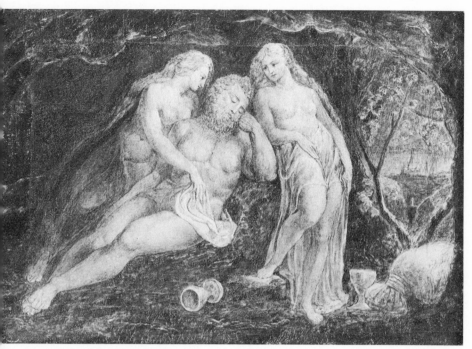

41. Lot and His Daughters

is now backed by a thick paper mat and I can not confirm Butlin's information. Housed in a full green leather case, stamped in gold on the front cover "WILLIAM BLAKE—ORIGINAL PAINTING 'LOT AND HIS DAUGHTERS' " and on the spine "ORIGINAL PAINTING BY WILLIAM BLAKE." A leather label on the inside front cover reads "THIS PAINTING WAS FORMERLY IN THE COLLECTIONS OF THOS. BUTTS, ESQ. AND DANTE GABRIEL ROSSETTI." A rectangular indentation in the canvas extends around the figures approx. 2.7 cm. from the inner lip of the present frame. This appears to have been caused by a previous frame used to cover damaged areas, now restored, around the periphery of the image. Since the present dimensions of the work are given in the 1876 Burlington exhibition catalogue, the restrictive framing and subsequent restoration probably occurred before that date.

Provenance: Thomas Butts; Dante Gabriel Rossetti by 1863; William Bell Scott by 1876, sold Sotheby's, 21 April 1885, lot 186* (£6 to Gray); Alfred Aspland(?);

J. Annan Bryce by 1904; acquired by Henry E. Huntington, 26 May 1917 (according to Baker 1957, 52).

Exhibition: Burlington Fine Arts Club, 1876, No. 88; Carfax & Co., 1904, No. 33 (from "Butts, Aspland" collections), and 1906, No. 7; Grolier Club, 1919–20, No. 51.

Literature:
Rossetti 1863, 223, No. 111 (located in the collection of "Mr. Rossetti, from Mr. Butts"); 1880, 235, No. 134.
Baker 1957, 52, reproduced.
Geoffrey Keynes, *William Blake's Illustrations to the Bible* (Clairvaux: Trianon Press, 1957), 6, No. 22, reproduced.
Anthony Blunt, *The Art of William Blake* (Morningside Heights: Columbia Univ. Press, 1959), 65-66.
Bindman 1977, 120.
Milton Klonsky, *William Blake: The Seer and His Visions* (New York: Harmony Books, 1977), 71, reproduced.
Paley 1978, 55.
Butlin 1981, No. 381.
Robert N. Essick, review of Butlin 1981 in *Blake: An Illustrated Quarterly* 16 (1982):41.

In 1799 and 1800, Blake executed a series of tempera paintings, all with Biblical subjects, for Thomas Butts. These fall into two groups: twenty-six extant and twenty-four untraced works, all about 27 x 38 cm., with both Old and New Testament subjects; and five larger paintings (approx. 32 x 50 cm.) on the life of Christ. "Lot and His Daughters," based on Genesis 19:30-35, is part of the former group. The figures are shown "in a cave" (19:30) with the daughter on the left just lifting her father's loin cloth. The wineskin and two cups on the ground remind us of Lot's drunkenness. In the middle distance beyond the grape vines on the right stands a small, white figure facing left—no doubt Lot's wife turned to "a pillar of salt" (19:26). The burning of Sodom and Gomorrah (19:24) is pictured as one or two buildings in flames on the horizon above Lot's wife.

The scene suggests Blake's concepts of the limited senses and consciousness of the natural man and his fall into degraded forms of sexuality. Bindman 1977, 120, notes that Lot "is pictured as a slumbering Farnese Hercules, and the composition perhaps makes a satirical reference to the well-known Baroque composition of *Hercules between Vice*

and Virtue."[89] He also compares Lot to Blake's "type of Strong Man described in *The Descriptive Catalogue"* — see comments above on "Old Parr When Young," Part I, section B, No. 9. Paley 1978, 55, notes that the painting "may owe something to Rubens," apparently because of the sensuous proportions and disposition of the figures.

Blake's so-called "tempera" medium does not have egg yolk as an emulsion vehicle, but rather includes glue or a low-solubility gum as the binder. Contemporary handbooks on painting sometimes called this medium "size-color" or "distemper."[90]

3. "The Conversion of Saul." Ca. 1800. Accession No. 000.29. Reproduced facing page vii and in color on the cover. Pen and watercolor, perhaps over pencil. Image, including framing line, 40.9 x 35.8 cm. on a heavy wove sheet 42.3 x 37.1 cm. Signed lower left in ink within image, "inv/ WB" in monogram; inscribed by Blake below image on right, "Acts IX c. 6 v."

Provenance: Thomas Butts; Thomas Butts, Jr., sold Sotheby's, 26 March 1852, lot 152 (19s. to Colnaghi's); Lt.-Col. Francis Cunningham, sold Sotheby's, 11 May 1876, lot 651 (£8.8s. to Noseda); inserted as leaf 10173 in volume 56 of the extra-illustrated Kitto Bible by either J. (John?) Gibbs or Theodore Irwin; Theodore Irwin, Jr., sold to Henry E. Huntington in 1919 as part of the Kitto Bible, from which now removed.

Exhibition: Perhaps Grolier Club, 1919–20, in No. 46, "A Collection of Miscellaneous Water-colours"; Huntington Art Gallery, 1953, 1965–66 (No. 29, reproduced), 1984.

Literature:
Rossetti 1863, 229, No. 167; 1880, 242, No. 191.
Baker 1957, 38–9, reproduced.
Geoffrey Keynes, *William Blake's Illustrations to the Bible* (Clairvaux: Trianon Press, 1957), 46, No. 154, reproduced.
Robert R. Wark, *The Huntington Art Collection* (San Marino: Huntington Library, 1970), 56, reproduced in color.
James Thorpe, *William Blake: The Power of the Imagination* (San Marino: Huntington Library, 1979), 21; reprinted in Thorpe, *Gifts of Genius* (San Marino: Huntington Library, 1980), 127, reproduced in color in both.
Butlin 1981, No. 506, reproduced in color.
Janet A. Warner, *Blake and The Language of Art* (Kingston and Montreal: McGill–Queen's Univ. Press, 1984), 39-42.

Between ca. 1800 and 1805, Blake executed over eighty watercolors with Biblical subjects for Thomas Butts. These can be seen as one of Blake's most important visual commentaries on the Bible, but the extent to which they embody concepts Blake develops in his poetry has yet to be explored fully. Nor has it been determined if the group was planned in advance as a carefully structured series or simply evolved over the years as Butts commissioned additions to his collection. "The Conversion of Saul" is a member of this large group and has been dated by Butlin 1981, 364, to the early years of production because of the bold watercolor washes and dramatic lighting effects, including chiaroscuro, typical of Blake's work ca. 1800–1802.

Saul's dramatic conversion is told in Acts 9:3–7. Christ, surrounded by angels and a suffusion of "light from heaven" (9:3), directs Saul toward "the city" (9:6) of Damascus. Rather than falling "to the earth," as the Bible describes Saul (9:4), Blake shows him astride a great horse which has gone to ground. Saul looks up to Christ in rapt awe and extends his arms in a cruciform gesture, perhaps as a foreshadowing of his acceptance of Christ's crucifixion as a cornerstone of his new faith. On the left, one of "the men which journeyed with" Saul looks upward, his face illuminated by divine light, but the remainder of the helmeted soldiers bow their heads, "hearing a voice, but seeing no man" (9:7). This configuration stresses the physical presence of Christ rather than His being an insubstantial vision given to Saul alone. The soldiers' failure to see Christ (with one telling exception) is a result of their own perceptual and spiritual limitations expressed by their enclosed, earth-bound postures.

4. "A Title Page for *The Grave*" (Illus. 42). 1806. Accession No. 000.30. Pen and blue watercolor. On paper cut to the image of 23.8 x 20 cm. and pasted to a backing sheet 34.8 x 27.5 cm. Inscribed by Blake on the tomb, "*A Series of Designs:/ Illustrative of/ The Grave./ a Poem/ by Robert Blair./ Invented & Drawn by William Blake/ 1806.*" Inscribed in pencil on the backing sheet, lower left, "Drawing by Blake for title to Blairs Grave not published." Slightly foxed.

Provenance: Robert Cromek; his son, Thomas Hartley Cromek until at least 1865[91]; Bernard Buchanan Macgeorge by 1892, inserted in a copy of Robert Blair's *The Grave*, 1808, with a pencil and wash portrait of Blake (see Part III, section B, No. 4B, and Part V, No. 1), sold Sotheby's, 1 July 1924, lot 123,

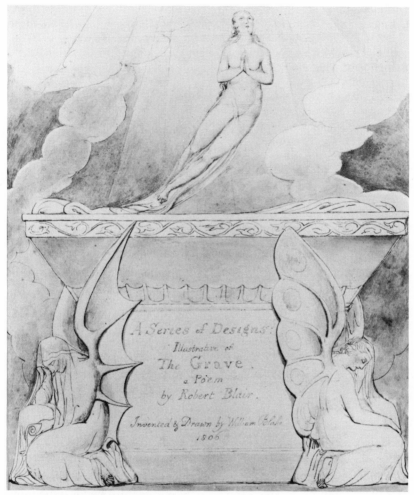

42. A Title Page for The Grave

"loosely inserted" in *The Grave* (£98 to Francis Edwards); offered by Edwards, December 1924, for £150 "with other items" (according to Butlin 1981, 457— probably the portrait and book); Mrs. George Millard; George Clinton Ward; Mrs. Louise Ward Watkins by 1936; given to the Huntington Library in July 1946 by Keith Spalding (both drawings and the copy of *The Grave*).

Exhibition: Little Museum of La Miniatura, 1936, No. 2 (apparently removed from *The Grave*); Philadelphia Museum of Art, 1939, No. 121; Huntington Art Gallery, 1979, No. 22.

Literature:
Catalogue of the Library of Bernard B. Macgeorge (Glasgow: James Maclehose, 1892), 10, "original drawing inserted [in a copy of Blair's *Grave*, 1808] of a title page which was not adopted, formerly belonging to Mr. Cromek."
Russell 1912, 125.
Keynes 1921, 220.
C. H. Collins Baker, "A Gift of Blake Material," *The Friends of the Huntington Library* 3 (1 October 1946):1–3, reproduced.
Baker, "William Blake's Designs for *The Grave*," *Huntington Library Quarterly* 10 (1946):111–15, reproduced.
Baker 1957, 39, reproduced.
Bentley 1977, 213–14.
Bindman 1977, 146.
Paley 1978, 178, reproduced.
Butlin 1981, No. 616.
Robert N. Essick and Morton D. Paley, *Robert Blair's* The Grave *Illustrated by William Blake: A Study with Facsimile* (London: Scolar Press, 1982), 50, 71–3, 223, reproduced.
Essick, review of Butlin 1981 in *Blake: An Illustrated Quarterly* 16 (1982):49.

In September 1805, the engraver and publisher Robert H. Cromek commissioned Blake to design and engrave a series of designs to illustrate Robert Blair's popular "Graveyard" poem, *The Grave*, first published in 1743.[92] Blake appears to have begun work with vigor and high spirits, but by November 1805 Cromek had decided to employ the fashionable engraver Louis Schiavonetti to engrave twelve of Blake's designs, thereby removing from Blake's hands the most lucrative part of the project. The Schiavonetti plates appear in the volume first published in 1808. The role of the unpublished Huntington title page, with its 1806 date, in this endeavor is difficult to ascertain. Blake may have dated the design in anticipation of publication in 1806 at a time when he believed the book would feature his designs more than Blair's text.[93] Yet the title makes no reference to designs *engraved* by Blake, a fact that Butlin 1981, 458, explains by proposing that the drawing was inscribed after Blake learned that Schiavonetti would be executing the plates. Baker 1946, 112, was the first to suggest that the title page was prepared for "an album that should contain a set of prints engraved by Blake" rather than an edition of the poem. Essick and Paley 1982, 72, reiterate this thesis and suggest alternatively that such an album may have been planned as late as 1806 as a means for Blake to sell his own drawings (hence, *"Invented & Drawn"*) which had

not been acquired by Cromek for publication. But the recent discovery that the Huntington drawing was originally owned by the Cromek family strongly suggests that it was not for any independent project of Blake's but part of Cromek's own publication schemes. We know that Cromek exhibited Blake's "original Drawings," including a group of the "beautiful designs" shown in Birmingham in July 1806.[94] The Huntington drawing would have made a suitable title page for a portfolio containing Blake's drawings which Cromek could use to advertise his forthcoming book. Another drawing, also dated 1806, may be related to the same series of designs. This highly finished work, now in the British Museum (Butlin 1981, No. 613), shows the resurrection of the dead around an empty panel, apparently prepared in anticipation of a (title-page?) text of some sort.

The Huntington design does not illustrate any specific passage in Blair's poem but, like Blake's other designs for *The Grave*, stresses the theme of resurrection. The inscription is placed as though chiseled in the side of the large tomb, scalloped and decorated around its top with tendril and lily motifs. On either side of the base sit female figures like funerary statues. The veiled woman on the left holds a scroll. Her sinister qualities are underscored by the bat-like wings, very similar to those given to Death in the unpublished *Grave* design of "Death Pursuing the Soul through the Avenues of Life" (Robert Essick collection; Butlin 1981, No. 635) and to Satan in one of Blake's Job watercolors of ca. 1805–1806 (Pierpont Morgan Library; Butlin 1981, No. 550.3). Her companion on the right seems equally saddened, but her veil does not cover her face or hair. Her butterfly wings are of the type traditionally associated with Psyche. The two figures together suggest contrary destinies: the death of the body and the immortality of the soul. Above the tomb, a praying woman—or female personification of the soul—leaves her shrouds behind as she rises heavenward between clouds and through rays of light.

5. "Moses Placed in the Ark of the Bulrushes" (Illus. 43). Ca. 1824(?). Accession No. 000.28. Pen and watercolor over pencil. Laid paper, chain lines 2.7 cm. apart, cut to the image of 28.6 x 39.7 cm. The work is unfinished, for Moses and his ark are only sketched in pencil.

Provenance: John Linnell; trustees of the Linnell estate, sold Christie's, 15

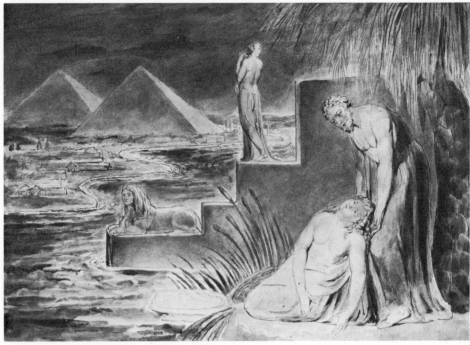

43. Moses Placed in the Ark of the Bulrushes

March 1918, lot 156 (£120.15s. to Robson & Co.); purchased by Charles Sessler from Robson, July 1920 ($726); purchased by Henry E. Huntington, with twelve letters from Charles Lamb to Samuel Taylor Coleridge, November 1920 ($7000).

Exhibition: Grolier Club, 1919–20, No. 46; Huntington Art Gallery, 1953, 1965–66 (No. 28), 1984.

Literature:
Russell 1912, 102.
Keynes 1921, 215, reproduced.
Baker 1957, 37–38, reproduced.
Geoffrey Keynes, *William Blake's Illustrations to the Bible* (Clairvaux: Trianon Press, 1957), 10, No. 34, reproduced.
Albert S. Roe, "The Thunder of Egypt," in *William Blake: Essays for S. Foster Damon,* ed. Alvin H. Rosenfeld (Providence: Brown Univ. Press, 1969), 179–80, 452–53, reproduced.
Keynes 1971, 143–46.
Ruthven Todd, *William Blake the Artist* (London: Studio Vista, 1971), 126–27, reproduced.

Bindman 1977, 120–21, 127–28, reproduced.
Milton Klonsky, *William Blake: The Seer and His Visions* (New York: Harmony Books, 1977), 68, reproduced.
Butlin 1981, No. 774, reproduced in color, and comments under No. 482.

Rossetti 1863, 224, No. 114, and 1880, 236, No. 137, describes a tempera painting of this scene, probably executed ca. 1799–1800 (untraced since 1863; Butlin 1981, No. 385). Some twenty-five years later, Blake engraved a small plate of the same design as the Huntington watercolor for an annual, probably edited by Robert John Thornton, titled *Remember Me! A New Years Gift or Christmas Present* (London, 1825).[95] The watercolor would appear to be related to this later project, perhaps as a preliminary to the engraving, in spite of the enormous differences in size, or as a separate, unfinished rendering of the same design commissioned by Thornton or Linnell. As Butlin 1981, 538, points out, "the relatively loose technique, particularly the dappled brush-strokes of the water and the robe of Moses' father, suggests a latish date."[96] A proof of the engraving in the Rosenwald Collection, National Gallery of Art, Washington, with an image 7 x 11.1 cm. and inscribed "The Hiding of Moses," does not extend quite as far on the left margin. There are a number of differences between it and the watercolor, including changes in the buildings beneath the pyramids and the addition of smoking chimneys on the left, more bulrushes around Moses, a burst of radiance in the sky above and to the left of the man's head, and vegetation at the base of the palm on the right. The image was further trimmed, along the left and bottom margins, to 6.8 x 9.7 cm. for publication in the small duodecimo volume.

The design illustrates the events of Exodus 2:1–4. Moses' mother, Jochebed, has already placed the infant in "an ark of bulrushes,... and laid it in the flags by the river's bank" (2:3). She sinks against her husband, Amram, in weariness and concern for the child's fate. As Baker 1957, 37, indicates, the postures of Moses' parents are very similar to those of Joseph and Mary in "The Descent of Peace" among Blake's illustrations to Milton's "Nativity Ode" (see Part I, section A, No. d.1, and illustration 22). This visual echo follows the traditional typological relationship between the beginning of Moses' life and Christ's. In this context, the large palm near the right margin may have its customary significance as an emblem of resolve in the midst of adversity (see note 78) and Christ's entry into Jerusalem. Moses'

sister, Miriam, stands like a statue on the wall extending into the Nile, "to wit what would be done to him" (2:4).

In Blake's mythological poetry, Egypt is cast as a place of slavery and its culture a fallen and perverted form of rational materialism. Although neither the sphinx nor the distant pyramids seem obviously sinister in the watercolor, most scholars have interpreted the scene in the light of Blake's written statements about Egypt. Roe 1969, 179, states that the "subject" of the design is "the commencement of Man's journey through the Fallen World of Generation" and treats it as an illustration of Blake's own poetry on that theme. Bindman 1977, 121, places the design in the context of Blake's other pictorial treatments of Moses (see Butlin 1981, Nos. 49, 111–15, 385–87, 440–41, 445, 447, 449, perhaps 757) and takes its central theme to be "the fate of prophecy." Bindman also suggests (127–28) the influence of Poussin's "Exposition of Moses," exhibited in London in 1799 (i.e., at about the same time Blake probably painted the lost tempera version). Butlin 1981, 538, notes that some of the low buildings across the river are "brick-kilns" in the engraving. This detail associates the design with Blake's image of "Minute Particulars in slavery... among the brick-kilns/ Disorganiz'd, & ... Pharoh in his iron Court."[97]

6. "The Six-Footed Serpent Attacking Agnolo Brunelleschi" (Illus. 44). Ca. 1826–27. Accession No. 000.43. Pencil, 24.2 x 33 cm. on wove paper 24.6 x 33 cm. Recently removed from the backing mat, thereby revealing on the verso a pencil inscription, "8/16," and a hitherto unrecorded pencil sketch by Blake of a standing woman, 17.5 x 5.5 cm. Recto stained and rubbed.

Provenance: Mrs. Blake(?); Frederick Tatham(?); Joseph Hogarth, sold Southgate and Barrett's, 20 June 1854, lot 5082, with 21 other works not described (16s. to Edsall); perhaps the drawing sold from the Richard Johnson collection at Platt's, 25 April 1912, lot 712, with 15 other works, most not described; probably the design for "Dante's 'Inferno' " offered by Rosenbach, catalogue 18 of 1916, item 17, in a group of drawings (see Part IV, No. 2) accompanying Blake's illustrations to *Comus* (see Part I, section A, No. a for further provenance).

Exhibition: Huntington Art Gallery, 1953, 1984.

Literature:
Russell 1912, 117 note, referring to "a pencil study of the two [central] figures" in the Johnson sale.

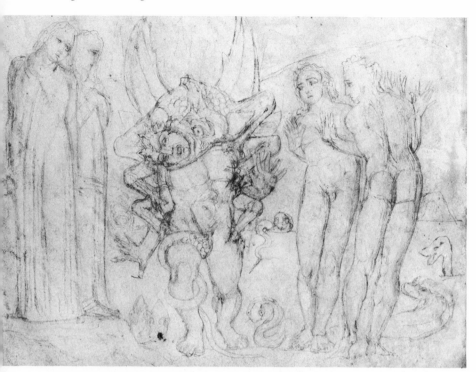

44. The Six-Footed Serpent Attacking Agnolo Brunelleschi

Albert S. Roe, *Blake's Illustrations to the Divine Comedy* (Princeton: Princeton Univ. Press, 1953), 108 note, Melbourne watercolor reproduced.
Blake's Pencil Drawings, Second Series, ed. Geoffrey Keynes (London: Nonesuch Press, 1956), Pl. 54, reproduced.
Baker 1957, 46, reproduced.
Ursula Hoff, *The Melbourne Dante Illustrations by William Blake* (Melbourne: National Gallery of Victoria, 1961), 2, 4, watercolor reproduced.
Drawings of William Blake, ed. Geoffrey Keynes (New York: Dover, 1970), Pl. 89, reproduced.
Milton Klonsky, *Blake's Dante* (New York: Harmony Books, 1980), 78, 149, Melbourne watercolor reproduced.
Butlin 1981, No. 822.

In 1824, John Linnell commissioned Blake to design a series of illustrations to Dante's *Divine Comedy,* apparently with the intention of issuing a series of engravings. Blake prepared a main series of 102 drawings, approx. 37 x 53 cm., left at his death in various stages of completion but most including some watercolors. He also began,

probably in 1826, to engrave seven of the illustrations, including the subject of this pencil sketch, but these too are unfinished (see Part III, section B, No. 10). All three versions—the watercolor (National Gallery of Victoria, Melbourne; Butlin 1981, No. 812.51), the Huntington drawing, and the engraving—are very similar. At least two details, however, distinguish the sketch and engraving from the watercolor: the head and tail positions of the serpent in the middle distance just left of the thigh of the figure second from the right, and the scales on the back of the monster devouring the central figure. Thus, it seems likely that the sketch was made after the watercolor as a preliminary to the engraving. Comparative measurements indicate that the drawing may have been transferred facedown to the copper, with minor adjustments during the subsequent engraving process. Transfer might also explain the rather flat appearance of many of the pencil lines and the stained and oddly mottled condition of the paper. The framing lines below and to the right of the image (and trimmed from the top and left?) also associate the drawing with the engraving. No indentation from the edge of the plate is visible on the drawing, for the present size of the sheet is smaller than the copperplate, now in the Rosenwald Collection, National Gallery of Art, Washington. A somewhat freer pencil study, probably preliminary to the Melbourne watercolor, is in the collection of the Fondazione Horne, Florence (Butlin 1981, No. 821). Butlin 1981, No. 812.18, reports (but does not reproduce) another possible version on the verso of "Virgil Repelling Filippo Argenti from the Boat of Phlegyas" in the main series of watercolors (Fogg Art Museum).

The design illustrates *Inferno* 25:33–78. Dante stands on the far left, with Virgil slightly behind him with his hands on his breast. Both watch in awe as Cianfa de' Donati, in the form of a six-footed serpent, fastens on to his fellow thief Agnolo Brunelleschi and begins to merge with him. Blake closely follows Dante's detailed description of the monster's attack, including the tail thrust between the victim's thighs. On the right are two more Florentine thieves, Puccio Sciancato and Buoso (degli Abati or de' Donati). Their frightened gestures are complemented in the engraving by their hair which, like Agnolo's, stands out in sharp points. The Huntington sketch includes a few hellish flames in the background between the monster's wings.

The myth of Orc in Blake's poetry in the mid-1790s includes the

transformation of man into serpent. In his watercolor illustrations of ca. 1795–97 to Edward Young's *Night Thoughts*, Blake drew several half-human, half-serpent figures (British Museum; Butlin 1981, Nos. 330.296, 330.358, 330.361, 330.369). But none of these earlier examples captures the spirit of the horrific sublime as powerfully as this Dante illustration. Roe 1953, 107–108, interprets the watercolor version from the perspective of concepts in Blake's own writings. He suggests that the central theme is "Man in his Spectre's power" and accounts for the feminine appearance of the thief second from the right as an allusion to Blake's division of fallen man into male specter and female emanation.[98] Hoff 1961, 2, suggests a similarity between Blake's figure of Agnolo and Hendrik Goltzius' engraving after Cornelis van Haarlem's "The Dragon Devouring the Companions of Cadmus" (1588), a hero Dante mentions in line 97 of the same canto.

The woman lightly sketched on the verso strides to the right with right foot forward. Her body is turned toward us, but her face is shown in profile. Her hair seems to be gathered into a bun on top of her head; she may be holding something in her right hand. Martin Butlin has suggested to me in correspondence that this sketch may be a preliminary version of the woman second from the left in "Beatrice Addressing Dante from the Car" among the *Divine Comedy* watercolors of 1824-27 (Tate Gallery; Butlin 1981, No. 812.88). While the stance and right arm position of these two figures are similar, the hair and upturned face of the woman in the pencil sketch associate her with the second woman from the right in the "Beatrice" watercolor.

Notes

1. Letter to John Flaxman, 12 September 1800; Blake 1982, 707.

2. For a description of the Huntington copy of *Milton*, see Part II, section A, No. 13 of this catalogue.

3. The letter is now in the Folger Shakespeare Library, Washington, D.C. The postscript was first published in Marcia Allentuck, "Blake, Flaxman, and Thomas: A New Document," *Harvard Library Bulletin* 20 (1972): 318–19. For Thomas' life and patronage of Blake, see Leslie Parris, "William Blake's Mr. Thomas," *Times Literary Supplement* (5 December 1968): 1390.

4. Blake 1982, 718.

5. In his annotated copy of his 1863 catalogue of Blake's works (232), now in the Houghton Library, Harvard University, Rossetti noted the existence of "Chase's series" of *Comus* illustrations in addition to the Butts set, now at the Museum of Fine Arts, Boston. According to Parris (see note 3), this reference is to Thomas' grandson, Drummond Percy Chase (1820–1902).

6. The Boston series is described in Anon., *Catalogue of Paintings and Drawings in Water Color* (Boston: Museum of Fine Arts, 1949), 29–32, series reproduced; and Butlin 1981, No. 528. The Boston designs are also reproduced in *Illustrations of Milton's Comus: Eight Drawings by William Blake* (London: Quaritch, 1890), in color; Elisabeth Luther Cary, *The Art of William Blake* (New York: Moffat, Yard, 1907), Pls. XXIV–XXV; *Twenty-Seven Drawings by William Blake* (McPherson, Kansas: Carl J. Smalley, 1925); Helen D. Willard, *William Blake Water-Color Drawings* (Boston: Museum of Fine Arts, 1957); Butlin 1978.

7. First executed as a watercolor, ca. 1805–1806, for Thomas Butts (Pierpont Morgan Library; Butlin 1981, No. 550.14). See also the second illustration to Milton's "On the Morning of Christ's Nativity" (Part I, section A, No. d.2) and note 47 thereto.

8. S. Foster Damon, *A Blake Dictionary* (Providence, Rhode Island: Brown Univ. Press, 1965), 52, states that *"The Book of Thel* is best understood as a rewriting of Milton's *Comus."*

9. See for example the ninth and eleventh watercolor illustrations to Thomas Gray's "Elegy Written in a Country Church-Yard" (Paul Mellon collection; Butlin 1981, Nos. 335.113 and 335.115), the frontispiece to *Jerusalem*, and Blake's ninth wood engraving to Robert John Thornton, *The Pastorals of Virgil* (London, 1821).

10. Tayler 1973, 236, 245; Behrendt 1978, 80–81; Paley 1978, 62; Dunbar 1980, 19–20.

11. See Blake's criticism of mimickers of "humility & love" in his annotations to Lavater's *Aphorisms* (Blake 1982, 586).

12. (London: n.p., 1721), 1: Pl. 20. Blake may have studied the French edition (Paris, 1719) of this important work in William Hayley's library; see the auction catalogue of Hayley's books, Mr. Evans, 13–25 February 1821, lot 1854. Morton Paley has pointed to this same design in Montfaucon as a source for plate 46 of Blake's *Jerusalem*; see " 'Wonderful Originals'—Blake and Ancient Sculpture," in *Blake in His Time* 1978, 175. The association between Hecate and a serpent-drawn chariot is traditional; see Ovid, *Metamorphoses* Bk. 7 lines 290–92 of the Arthur Golding translation. Blake also pictures a moon goddess drawn by two serpents on plate 14 of his Job illustrations, first executed as a watercolor ca. 1805–1806 (Pierpont Morgan Library; Butlin 1981, No. 550.14).

13. See for example [J. Lempriere], *Bibliotheca Classica; or, A Classical Dictionary* (Reading: T. Cadell, 1788), entries for "Cotytto" and "Hecate." In the ninth edition (1815) of this standard handbook, Cotytto is also identified with Ceres.

14. Montfaucon 2: Pls. 39, 45 (pointed out in Paley, "Wonderful Originals," 177—see note 12); Stuart and Revett 3:19, 29 (pointed out in Dunbar 1980, 24).

15. Now in the Houghton Library, Harvard University; first recorded in Parris 1968 (see note 3).

16. See the catalogue of subjects in C. H. Collins Baker, "Some Illustrators of Milton's *Paradise Lost* (1688–1850)," *The Library* 3 (1948):1–21, 101–19.

17. The Butts series is described and reproduced in color in Butlin 1981, No. 536; and reproduced in Butlin 1978, Dunbar 1980, and Behrendt 1983, the last in color. The nine Butts designs in the Museum of Fine Arts, Boston, are described and reproduced in its 1949 catalogue (see note 6), 19–23. The Boston group is also reproduced in *Twenty-Seven Drawings* 1925 and Willard 1957 (see note 6); and in Milton, *Paradise Lost* (New York: Heritage Press, 1940), in color, *William Blake Paradise Lost*, intro. Henry P. Rossiter (New York: American Studio Books, 1947), a portfolio of unbound color illustrations, and Bindman 1975.

18. In the sketch of "Fire" in his *Notebook*, Blake quoted lines from *Paradise Lost* describing Satan: "Forthwith upright he rears from off the pool/ His mighty stature" (1:221–22).

19. Suggested in Dunbar 1980, 45.

20. Pointed out in Andrew Wilton, "Blake and the Antique," *The British Museum Yearbook 1: The Classic Tradition* (London: British Museum, 1976), 208.

21. See David Bindman, "Hogarth's 'Satan, Sin and Death' and Its Influence," *Burlington Magazine* 112 (1970): 153–58. Blake could have known Hogarth's design, now in the Tate Gallery, through any of three eighteenth-century engravings. The same format appears in the illustrations of the subject by James Barry and Henry Fuseli, two artists whom Blake admired. Butlin 1981, No. 529.2, suggests that Barry's Satan in his engraving of ca. 1792–95 influenced Blake's portrayal of Death, and that several of Fuseli's treatments of the subject influenced Blake's Satan.

22. See Burke, *A Philosophical Enquiry into the Origin of our Ideas of the Sublime and Beautiful*, ed. James T. Bolton (London: Routledge and Kegan Paul, 1958), 58–59.

23. Blake probably learned of this device from early German prints, such as the "Resurrection" in Dürer's *Large Passion* series of 1511.

24. For a complete reproduction, see *The Notebook of William Blake*, ed. David V. Erdman with the assistance of Donald K. Moore, Revised Edition ([New York]: Readex Books, 1977).

25. For a study of this *topos* and its explicit appearance in *Paradise Lost* 5:215–19, see Peter Demetz, "The Elm and the Vine: Notes Toward the History of a Marriage Topos," *PMLA* 73 (1958):521–32. Blake makes extensive use of intertwined trees and vines in *Songs of Innocence* (1789).

26. 1:Pl. 9; see note 12.

27. See Rose 1970, 40; Paley 1978, 63; Behrendt 1983, 145.

28. The large leaves on each side of the design have sometimes been described as palm fronds (see Baker 1957, 19, and Dunbar 1980, 57), but the small berries at the juncture of the leaves on the branch on the left identify them as laurel. The leaves and berries are similar to the laurel or bay wreaths around the portraits of Homer and Milton in Blake's "Heads of the Poets" he painted for William Hayley ca. 1800–1803 (City of Manchester Art Galleries; Butlin 1981, Nos. 343.1 and 343.11).

29. Behrendt 1983, 146, points out the similarity between the positioning of Adam and Eve in Blake's design and their embrace in Stephen Rigaud's illustration, engraved in 1801. Wilton 1976 (see note 20), 193, suggests that a drawing by Blake's friend George Cumberland of a classical group in the Borghese Gallery may be a source for Adam and Eve's eye-to-eye gaze, similar to the portrayal of Har and Heva in Blake's second illustration to his poem *Tiriel* of ca. 1789 (Fitzwilliam Museum; Butlin 1981, No. 198.2). Several scholars have suggested that this motif was influenced by James Barry's painting of "Jupiter and Juno on Mount Ida"—a most appropriate source for this *Paradise Lost* design because of Milton's explicit comparison of Adam and Eve to Jupiter and Juno in the passage illustrated (4:499–500). But the influence of Barry on at least the *Tiriel* design is uncertain because of difficulties in dating the painting, which Barry may have been working on as late as 1804. See William L. Pressly, *The Life and Art of James Barry* (New Haven and London: Yale Univ. Press, 1981), 148–51.

30. Pls. XIV and XV; suggested in Paley, "Wonderful Originals" (see note 12), 178. The first of these plates was engraved by James Basire, to whom Blake was apprenticed in the 1770s.

31. Raphael does not refer to the Tree of the Knowledge of Good and Evil in his remarks to Adam in Book 5, but Eve mentions it in the description of her dream at the opening of the Book and Milton refers to it in a recollection of the earlier conversation, 7:40–50.

32. Blake studied, and drew copies of, medieval sculpture and paintings in Westminster Abbey during his apprentice years in the 1770s. In his later writings on aesthetics, he praised the "Living Form" of Gothic Art (Blake 1982, 270).

33. Bows and arrows play an important role in the symbolic imagery of Blake's poetry— see particularly his letter to Thomas Butts of 22 November 1802 ("Los flam'd in my path, & the sun was hot/ With the bows of my Mind & the Arrows of Thought—") and plates 97–98 of *Jerusalem* (Blake 1982, 256–57, 722).

34. Not published in England until 1807, but Blake may have been shown the engravings of 1793 by his good friend Flaxman after his return from Italy in 1794. The similarities between the designs are pointed out in Collins Baker 1940, 124 of the 1973 reprint. Baker also notes a general similarity between "the falling figures in Flaxman's *Purgatorio*" (no doubt the sixteenth plate) and Blake's rebel angels. George Romney's drawing of the "Fall of the Rebel Angels" of ca. 1800–1802 (Fitzwilliam Museum) also pictures Christ standing before or within a circle emitting rays of light along its lower edge and surrounded by obeisant angels on each side.

35. Pl. 42, lines 32–34 (Blake 1982, 189). Blake's state of Beulah—" a Soft Moony Universe feminine lovely/ Pure mild & Gentle given in Mercy to those who sleep" (*The Four*

Zoas; Blake 1982, 303)—is also evoked by the visual qualities of this *Paradise Lost* illustration. Interpretations based on this and other passages in Blake's poetry are offered in Joseph H. Wicksteed, *Blake's Vision of the Book of Job*, 2d ed. (London: Dent, 1924), 227–28; Butlin 1978, 114–15; Dunbar 1980, 72–75; Behrendt 1983, 157–60.

36. Letter to William Roscoe; *The Collected English Letters of Henry Fuseli*, ed. David H. Weinglass (Millwood: Kraus, 1982), 138.

37. (London: Browne, 1669). This source is suggested by Baker 1940, 119–20 of the 1973 reprint.

38. Supplement 2:Pl. 46 (see note 12). This source is suggested in Wilton 1976, 198 (see note 20). See also the serpent-entwined women on the Lady's chair in the fifth *Comus* design (Part I, section A, item a.5). For more suggested sources of this motif, see Mary Jackson, "Blake and Zoroastrianism," *Blake: An Illustrated Quarterly* 11 (1977):72–85.

39. Butlin 1978, 115, takes this configuration as a foreshadowing of Christ's "Stigmata and . . . Man's eventual salvation through the Crucifixion."

40. Several scholars have identified Sin and Death in this design with figures in Blake's own mythology, including Urizen and the false goddesses Vala and Rahab. See Anne Kostelanetz Mellor, *Blake's Human Form Divine* (Berkeley: Univ. of California Press, 1974), 247; Jean H. Hagstrum, "Christ's Body," in *William Blake: Essays in Honour of Sir Geoffrey Keynes*, ed. Morton D. Paley and Michael Phillips (Oxford: Clarendon Press, 1973), 140.

41. Blake 1982, 524.

42. Pointon 1970, 143, and Butlin 1981, 381, associate these figures with the Four Zoas in Blake's mythology. See also *Jerusalem*, plate 13: "The Western Gate fourfold, is closd: Having four Cherubim/ Its guards . . ." (Blake 1982, 156).

43. The hopeful possibilities in the design, underscored by the serious yet mild expressions on all faces, are discussed in Kester Svendsen, "John Martin and the Expulsion Scene of Paradise Lost," *Studies in English Literature* 1 (1961):70–71; Merritt Y. Hughes, "Some Illustrators of Milton: The Expulsion from Paradise," *Journal of English and Germanic Philology* 60 (1961):673; Wittreich 1971, 102–103. For a comparison of Blake's design with Edward Burney's, see W. J. T. Mitchell, *Blake's Composite Art* (Princeton: Princeton Univ. Press, 1978), 19–20.

44. See Butlin 1972–73, 45–46; Butlin, "Cataloguing William Blake" in *Blake in His Time* 1978, 82–83; Butlin 1981, 385.

45. Described and reproduced in color in Butlin 1981, No. 538. The Whitworth series is also reproduced in Dunbar 1980 and Behrendt 1983.

46. See for example the babe in flames on Pl. 20 of *The Book of Urizen* (1794). The relationship between Orc and Blake's concept of Jesus in his nineteenth-century work is most complex; the figures are not equivalent. Yet the association of Orc with the infant Jesus

in these illustrations is supported by the fact that the beginning of Blake's _Europe_ (1794), a poem in which Orc is a major character, is based closely on the "Nativity Ode."

47. Pierpont Morgan Library; Butlin 1981, No. 550.14. See also "David Delivered out of Many Waters," a watercolor of ca. 1805 (Tate Gallery; Butlin 1981, No. 552). A likely source for this crossing pattern is a relief from Persepolis engraved in James Basire's shop for Jacob Bryant, _A New System of Ancient Mythology_ (London, 1774–75), 2: Pl. 2. Blake was one of Basire's apprentices at that time and may have helped with the Bryant plates. Blake refers to Bryant in his _Descriptive Catalogue_ of 1809 (Blake 1982, 543).

48. Noted in Dunbar 1980, 100.

49. Dagon is described as half man, half fish in _Paradise Lost_, 1:462–63, and as a "Sea Monster" in Blake's _Milton_ (Blake 1982, 138).

50. See Geoffrey Keynes, _William Blake's Laocoön_ (London: Trianon Press, 1976).

51. In the "Preface" to _Milton_ (ca. 1804–1808), Blake rejects "Greek or Roman Models" in favor of Christianity and "our own Imaginations" (Blake 1982, 95). In _A Descriptive Catalogue_ of 1809, he states that the "Apollo Belvidere" and other classical works were copied from patriarchal originals (Blake 1982, 531).

52. Blake probably learned of the ancient Near Eastern emblem of the winged disc with serpents from an engraving in Bryant, 1: Pl. 8 (see note 47). Osiris, but also "Moloch" (205), were often pictured with the head of a bull or ox. Both bull and dog-headed gods are also pictured in Richard Westall's illustration of the same lines, engraved in 1797.

53. 1:392–96. Blake names "Molech" in several of his works and refers to Moloch's "Furnaces" and "Victims of Fire" in _Milton_ (Blake 1982, 137).

54. Hagstrum 1964, 123, identifies the child with both Christ and Orc. See also note 46, above.

55. Linnell's manuscript _Autobiography_, quoted in Bentley 1969, 263.

56. Butlin 1981, 495.

57. Blake 1982, 702.

58. _A Descriptive Catalogue_ of 1809; Blake 1982, 532–33.

59. Keynes collection, Fitzwilliam Museum; Butlin 1981, No. 692.36. Reproduced in Keynes 1927, Pl. 46; _Blake-Varley Sketchbook_ 1969, 2:36; Keynes 1970, Pl. 64.

60. See Gert Schiff, _Johann Heinrich Füssli_ (Zürich: Verlag Berichthaus, 1973), 1:633, No. 1760 (reproduced in volume 2). This oil painting is the only extant fragment from a larger composition showing Caractacus as a prisoner in front of Emperor Claudius.

61. "Preface" to Blake's _Milton_ (ca. 1804–1808); Blake 1982, 95. For the relevant passages

in Rapin, see the translation by N. Tindal, 2d ed. (London: Knapton, 1732–33), 1:13–15.

62. Bentley 1969, 310.

63. "The Everlasting Gospel," ca. 1818; Blake 1982, 524. Five lines later, Blake mentions Socrates, again in the context of false accusation and martyrdom. For a discussion of these interconnections between Blake, Jesus, and Socrates, see David V. Erdman, " 'Terrible Blake in His Pride': An Essay on *The Everlasting Gospel*," in *From Sensibility to Romanticism*, ed. Frederick W. Hilles and Harold Bloom (New York: Oxford Univ. Press, 1965), 343–44.

64. Butlin 1981, No. 926. Also reproduced in Keynes 1927, Pl. 44.

65. Pl. 57, Lines 8–9; see also Pl. 63, lines 39–40 (Blake 1982, 207, 214–15).

66. Butlin 1981, Nos. 700, 701. The Courtauld drawing is also reproduced in Keynes 1927, Pl. 43; the Wolf version in *William Blake 1757–1827: A Descriptive Catalogue of an Exhibition* (Philadelphia: Philadelphia Museum of Art, 1927), 148.

67. First published London, 1635, and frequently reprinted. Parr is also mentioned by Rapin, 1:628 note 7, 2:294 (see note 61).

68. Blake 1982, 542–45.

69. See the mold sizes listed in Thomas Balston, *James Whatman Father & Son* (London: Methuen, 1957), 61.

70. *Life of William Blake* (London: Macmillan, 1863), 1:245–46.

71. Pl. 21; Blake 1982, 44.

72. Blake 1982, 301. Leslie Tannenbaum, *Biblical Tradition in Blake's Early Prophecies: The Great Code of Art* (Princeton: Princeton Univ. Press, 1982), 201–202, points out parallels between Blake's first three chapter headings and the structure of *The Book of Urizen* (1794). There would also seem to be an analogical but ironic relationship between Blake's interpretation of the mark of Cain in the Genesis manuscript and the "Marks of weakness, marks of woe" Blake "mark[s]"—i.e., observes and inscribes—in "London" (*Songs of Experience*, 1794; Blake 1982, 26).

73. Damon 1924, 221, and 1965, 151, asserts that the Father "uplifts the bow of spiritual warfare." My comments follow Grant's correction (review of Damon 1965 and Grant 1970, 334), but not his claim that the Father holds a bow in His left hand in the first title page and "Newtonian compasses" in the second (1970, 334). In both cases, these instruments are more probably folds of a diaphanous gown or cloak hanging behind the figure. There are also lines left of the Father's right leg indicating a garment.

74. Nanavutty 1949, 128 of the 1973 reprint, does not name this figure but suggests that it is "probably a woman." Damon 1924, 220, identifies him as "the Angel of Revelation"

(at least in the second title page) and the figure standing on the globe as the Holy Ghost. This last claim is repeated in Damon 1965, 151, and disputed by Grant in his review.

75. Blake 1982, 689.

76. Unaccountably, Damon 1924, 221, and 1965, 151, identifies them as "the twelve apostles."

77. See David V. Erdman, *The Illuminated Blake* (Garden City: Anchor Press/Doubleday, 1974). 34.

78. Probably associated with "the Palm of Suffering" referred to on Pl. 59 (Blake 1982, 208).

79. See Blake 1982, 318, lines 10 and 25 ("Bulls of Luvah" and "Lions of Urizen"); 331, line 10 (Tharmas compares himself to a "famishd Eagle"). These passages support neither Damon's identifications (1965, 151) of the figures on the Genesis title page as Luvah, Urthona, Urizen, and Tharmas, nor Nanavutty's list (139–40 in the 1973 reprint) of Urthona, Urizen, Luvah, Tharmas (both reading left to right). But Blake himself was not consistent in his associations of the Zoas with various animals. For example, "Luvah in Orc became a Serpent" (Blake 1982, 380, line 26), a statement supporting Damon's identification of the scaly figure far left as Luvah.

80. Damon 1924, 220, and 1965, 151, calls the group "the Trinity"; but Butlin 1981, 598, describes them as "God facing Adam, with two attendant figures."

81. Tannenbaum 1982 (see note 72), 201–204, argues convincingly for this influence. The multiple structure and authorship of Genesis are (first?) noted in Richard Simon, *A Critical History of the Old Testament*, trans. H.D. [Henry Dickinson] (London: Jacob Tonson, 1682). Simon comments specifically on the two stories of Eve's creation, page 41.

82. Blake may have learned of this pose, with the hand positions reversed, from the Medici Venus, a copy of which he engraved in 1815 for the third plate of "Sculpture" in Abraham Rees, *The Cyclopaedia* (plates volume 4, dated 1820). Eve is pictured with the same hand positions in Masaccio's "Expulsion" fresco, which Blake may have known through engraved copies.

83. Tate Gallery; Butlin 1981, No. 806. The tempera is based closely on a watercolor of ca. 1805–1809 (Fogg Art Museum; Butlin 1981, No. 664). There is also a pencil sketch (British Museum; Butlin 1981, No. 665), probably for the watercolor, and a miniature version, perhaps a replica by John Linnell (Keynes collection, Fitzwilliam Museum; Butlin 1981, No. 666). These designs are similar to the "Scene" Blake sets forth at the beginning of his brief drama of 1822, *The Ghost of Abel*: "A rocky Country. Eve fainted over the dead body of Abel which lays near a Grave. Adam kneels by her Jehovah stands above" (Blake 1982, 270).

84. Blake 1982, 272. Tannenbaum 1978, 23–34, discusses the pictorial conventions associated with the subject and the relationships between leaves 10–11 of the Genesis

manuscript and *The Ghost of Abel*. Damon 1924, 221, and 1965, 152, states that the hovering figure is Abel's "ghost."

85. Blake 1982, 273 (based on Genesis 6:6). Blake's association of "Adamah" with the feminine is probably based on the gender of the "ah" ending in Hebrew. For Blake's use of Hebrew in his own texts, see Arnold Cheskin, "The Echoing Greenhorn: Blake as Hebraist," *Blake: An Illustrated Quarterly* 12 (1978–79):178–83.

86. In 1810, Blake told Henry Crabb Robinson that the creator of the material world "was not Jehovah, but the Elohim" (Robinson's *Reminiscences*, Bentley 1969, 545). Jehovah, as the bearer of a "Covenant of the Forgiveness of Sins," is contrasted with the vengeance-seeking Elohim at the end of *The Ghost of Abel* (Blake 1982, 272). See also H. Summerfield, "Blake and the Names Divine," *Blake: An Illustrated Quarterly* 15 (1981):14–22.

87. This possibility was brought to my attention by Robert R. Wark's introduction to an unpublished facsimile of Blake's Genesis manuscript. I am grateful to Dr. Wark for allowing me to read his typescript.

88. See David Bindman, "Blake's 'Gothicised Imagination' and the History of England," in *William Blake* 1973 (see note 40), 29–49.

89. Blake engraved a copy of the Farnese Hercules for the second plate of "Sculpture" in Abraham Rees, *The Cyclopaedia*, plates volume 4, in 1816, but he was no doubt familiar with casts or engravings of the statue from his early days as a student at the Royal Academy. For the subject of Hercules between Vice and Virtue, Butlin 1981, 319, refers specifically to the engraving after Paolo de Mattheis in the Earl of Shaftesbury's *Characteristics of Man*, 1714, volume 3.

90. See Bindman 1977, 117–18, and Essick 1980, 122–23.

91. According to T. H. Cromek's "Memorials of R. H. Cromek" of 1865; see Essick 1982 in *Literature*, below.

92. The relevant documents, on which the brief summary of this complex history given here is based, are cited or reprinted in Bentley 1969 and Essick and Paley 1982.

93. A precedent for a title page of this type was established by the 1753 illustrated edition of Thomas Gray's poems, entitled *Designs by Mr. R. Bentley for Six Poems by Mr. T. Gray*.

94. Cromek's prospectus of November 1805 and the *Birmingham Gazette* and Birmingham *Commercial Herald* of 28 July 1806 (see Essick and Paley 1982, 196–97).

95. A prospectus indicates that publication plans, and very probably Blake's engraving, were well underway in 1824 (Bentley 1977, 606). Todd 1971, 127, suggests that an entry in John Linnell's account book for 6 July 1823, "Cash by Dr Thornton's order WB £5.5s." (Bentley 1969, 604), may be payment for the plate. For the plate, see Part III, section B, No. 40.

96. Baker 1957, 37, suggests that "the drawing may have been made several years ear-lier" than the engraving. Klonsky 1977, 68, dates the watercolor to ca. 1800, but gives no reasons for what may be simply an error.

97. *Jerusalem* (ca. 1804–20), Pl. 89, lines 17–18 (Blake 1982, 248).

98. Relevant passages are *Jerusalem*, Pl. 11, lines 6–7, and Pl. 41, reverse inscription (Blake 1982, 154, 184).

II. WRITINGS

A. The Illuminated Books

In the late 1780s, Blake developed a unique method for publishing his illustrated poems. We do not have any description of the technique, now generally called "relief etching," written by Blake himself, but the broad outlines of the process have been reconstructed by modern researchers.[1] Most authorities now agree that Blake painted his designs and text (the latter necessarily in reverse) on a copperplate in a glutinous, acid-resistant liquid. By pouring acid on the plate, Blake could etch away the uncovered metal surfaces and leave the painted areas in shallow relief. After cleaning the relief plateaus, Blake applied ink to them, leaving the etched valleys free of ink, and printed the plate with light pressure in an engraver's rolling press. He also scratched lines through the acid-resist on many plates and etched them in, or engraved them with a tool, to create white-line effects in printed areas. Many of the "Illuminated Books"[2] were subsequently hand tinted with watercolors by Blake, perhaps with the assistance of his wife. He also color printed some copies, mostly ca. 1794–96, using "size color"–that is, pigments with glue or low-solubility gum as the vehicle. This medium created thick, opaque colors with reticulated surfaces.

Blake's earliest illuminated books were printed from very small plates and show the sort of elementary design and crude execution

one would expect in an experimental medium. In a surprisingly short period, however, Blake moved to much larger plates, bold and dramatic designs representative of his best work as a pictorial artist, and symbolic narratives culminating in two epic poems, *Milton* and *Jerusalem*, of 50 and 100 plates respectively. But Blake also continued to print and hand color even his earliest illuminated books over many years. The unique features of each impression of the same plate, the result of differences in inking and coloring, reflect Blake's changing talents, sensibilities, and attitudes toward his books—as well as the countless minor variations intrinsic to the relief printing process itself.

The illuminated books are the form in which Blake brought together the three main realms of his artistic endeavors: poetry, painting, and engraving. All these books are very rare today, for Blake could never find enough customers to justify large printings. But in the view of many of his modern admirers, they are Blake's greatest accomplishment.

A vast number of books and articles comment from every critical perspective on the poems Blake published in his illuminated books. In the last dozen years, scholars have also devoted increasing attention to the relationships between text and design, stimulated by the fact that the latter are far more than straightforward picturings of things and events described in the poetry. I have made no attempt to record this extensive body of commentary under *Literature* for each title below, but have noted important bibliographic descriptions of the Huntington copies. *Reproduction* includes only illustrations of the specific copies at the Huntington. *Coloring* includes brief notes on hand work of all kinds executed on the impressions themselves. Pencil inscriptions (call number, vault location, etc.) added by the Library in recent years are not recorded. The comments on *Design Variants* record the states of the plates, when more than one is known, and modifications in inking or hand work on the impression which add motifs to, or subtract them from, the image we can reasonably assume to have been etched in the copper. All plate numbers follow Bentley 1977.

1. ALL/ RELIGIONS/ are/ ONE

Call No. 57445. Relief etching with small amounts of white-line etching on some plates. Etched ca. 1788. Pls. 1 (frontispiece), 3–10 on nine leaves, lacking the title page. Plate sizes range between 4.5 x 2.9

cm. and 5.7 x 3.9 cm. Printed in light green ink, perhaps with olive brown ink on some plates, on wove paper approx. 37.8 x 27 cm. Pl. 6 watermarked "1794 [and to the right 6.8 cm.] I TAYLOR." The left and bottom or top edges of most leaves are deckled, indicating that they are quarter pieces from a sheet approx. 75.6 x 54 cm.

Coloring: Most plates have small amounts of gray wash and pen and black ink work, often applied to outline motifs or to fill in poorly printed areas of text and design. Several plates, particularly 1 and 9, show small amounts of olive brown with a reticulated surface structure. The olive brown may be ink printed from the plate, size-color printed from the plate (i.e., Blake's "color printing" technique), or watercolors applied to the paper and blotted. Watercolors painted over damp ink can also produce the same type of reticulated textures, and some of the olive brown does appear to be on top of areas printed in green. This suggests that the two colors were applied in two separate operations, either two printings (which seems unlikely) or one printing followed by hand work on the impression. There are six framing lines drawn in black ink around Pl. 1 and five around all others. The inner frame on each plate follows the plate mark; the outer frame forms a rectangle averaging 12.1 x 10 cm.

Design Variants: Some of the ground below the sheep on Pl. 5 and part of the dark background behind the figure on Pl. 9 may not be part of the image on the plate.

Binding: Loose in blue cloth portfolio, labeled on the spine "BLAKE—ALL RELIGIONS ARE ONE—1788-94." No evidence of any previous binding. The order of the plates is established by the numbered sequence of "Principle[s]" and the reasonable assumptions that Pl. 1 is a frontispiece and that Pl. 3, "The Argument," follows the title page.

Provenance: John Linnell; trustees of the Linnell estate, sold Christie's, 15 March 1918, lot 203, with Pl. a2 of *There is No Natural Religion* (£84 to George D. Smith for Henry E. Huntington).

Exhibition: Grolier Club, 1919–20, in No. 20; Fogg Art Museum, 1924.

Literature:
Keynes 1921, 96.
Keynes and Wolf 1953, 8.
Bentley 1977, 81, 85–86 (copy A).

Reproduction:
Complete: Keynes 1921, Pls. 14–15; *All Religions are One* (London: Frederick Hollyer, 1926); *All Religions are One*, note by Geoffrey Keynes (London:

Trianon Press for the Blake Trust, 1970), in color; David V. Erdman, *The Illuminated Blake* (Garden City: Anchor/ Doubleday, 1974), 24–26; *William Blake's Writings*, ed. G. E. Bentley, Jr. (Oxford: Clarendon Press, 1978), 1:15–21; Bindman 1978, Pls. 30–39; Paley 1978, 15.

Pl. 1: Ruthven Todd, *William Blake the Artist* (London: Studio Vista, 1971), 21; Bindman 1977, Fig. 41; Milton Klonsky, *William Blake: The Seer and His Visions* (New York: Harmony Books, 1977), 23.

Pls. 4, 5: Essick 1980, Figs. 79, 98.

Pl. 4: *Blake's Visionary Forms Dramatic*, ed. David V. Erdman and John E. Grant (Princeton: Princeton Univ. Press, 1970), 180; *Blake in His Time* 1978, Pl. 1.

Pls. 6, 9: Hagstrum 1964, Pl. V.

The sizes of the plates and their lack of technical sophistication indicate that *All Religions are One* is among Blake's earliest works in relief etching. The awkward letter forms and the uneven lines of text on some plates suggest that it is Blake's first extant work in the medium, slightly earlier than the similar sequence of aphorisms, *There is No Natural Religion*, although perhaps by no more than a few months. At the end of *The Ghost of Abel* (1822), Blake wrote that "W Blakes Original Stereotype [no doubt a reference to his relief etchings] was 1788,"[3] and this has been taken as the approximate date of *All Religions are One*. The printing date of the Huntington impressions, the only known examples of Pls. 1 and 3–10, is somewhat less certain, but the watermark provides a *terminus a quo* of 1794. If indeed the reticulated olive brown coloring can be associated with Blake's color printing experiments, then a date of ca. 1794–96 seems probable since Blake did most of his color printing from relief plates during that period. It is most unlikely that Linnell acquired the impressions prior to his meeting Blake in 1818.

The title page, lacking from the Huntington copy, is known in two impressions, now in the Victoria and Albert Museum and the Keynes collection, Fitzwilliam Museum. The ink color, framing lines, and paper (watermarked "I TAYLOR") indicate that the Keynes impression was originally printed as part of the Huntington copy.[4]

A drawing of ca. 1785–90 (British Museum; Butlin 1981, No. 86) shows a man and woman seated in a posture almost identical to the two figures at the top of Pl. 5. A pencil sketch of the traveler pictured on Pl. 7 appears in Blake's *Notebook* (British Library; Butlin 1981, No. 201.15). This, however, was composed as part of an emblem series,

later engraved as Pl. 16 in *For Children: The Gates of Paradise* (1793), and may not be a direct preliminary for the relief etching.

2. THERE/ is NO/ NATURAL/ RELIGION

Call No. 57445. Relief etching, ca. 1788. Pl. a2, the title page, only. Plate 5.2 x 4.3 cm. printed in black ink on wove paper, 34.6 x 24.3 cm., with deckled top and left edges.

Coloring: None.

Design Variants: None.

Binding: Loose in portfolio with *All Religions are One*. No evidence of prior binding.

Provenance: As for *All Religions are One* (see No. 1, above). Bentley 1977, 446, suggests that this may be the same impression offered by Francis Harvey, ca. 1864, and/or the impression sold by the earl of Crewe at Sotheby's, 30 March 1903, lot 18. However, it seems unlikely that Linnell would be acquiring single Blake items so many years after he had acquired a great many directly from Blake, or that his heirs or trustees would be acquiring Blake materials as late as 1903, 21 years after Linnell's death. It is more probable that Linnell acquired the print directly from Blake or Mrs. Blake before the latter's death in 1831.

Exhibition: As for *All Religions are One* (No. 1, above).

Literature:
Keynes 1921, 96.
Keynes and Wolf 1953, 8.
Bentley 1977, 81, 446.

Reproduction:
All Religions are One (London: Frederick Hollyer, 1926), Pl. [1].
Robert N. Essick, *William Blake's Relief Inventions* (Los Angeles: W. & V. Dailey, 1978), title page.

For the date of etching, see *All Religions are One* (No. 1, above). The printing date is uncertain. Another impression, now in the Pierpont Morgan Library, is also printed in black on wove paper of about the same size. These could even have been printed as late as the 1820s, when Blake was printing copies of his last relief etchings in black ink.

3. SONGS/ of/ *INNOCENCE/ 1789/* The Author & Printer W Blake

Call No. 54040. Relief etching, 1789, with white-line etching and/or engraving on some plates. 31 plates (2–27, 34–36, 53–54) on 17 leaves: Pl. 2 (frontispiece) with recto blank, Pls. 3 (title page) and 4 ("Introduction") with versos blank, Pls. 5–27, 34–36, 53–54 printed recto/ verso. Plates range in size between 11 x 6.3 cm. and 12.3 x 7.8 cm. Printed in an ink ranging from light green to light blue with many intermediate tones, the etching borders not printed except for Pl. 2. Wove paper, 18.1 x 13 cm., Pls. 23/53 (printed recto/verso) watermarked "E & P." Pls. 2 and 3, 36 and 8 (both openings), evenly browned.

Coloring: Delicately tinted with pale watercolors, predominantly shades of blue, green, and rose on most plates. Thin washes cover the text areas on some plates. A black wash, perhaps India ink, creates shadows in the foreground of many designs. Some forms outlined in black, probably applied with a brush rather than pen.

Design Variants:
Pl. 10 ("The Little Black Boy," second plate): Both children tinted pink.
Pl. 13 ("The Little Boy lost"): Brim of a hat painted around boy's head.
Pl. 14 ("The Little Boy found"): Etched halo above adult's head in design above text left uncolored. Brim of a hat painted around boy's head.
Pl. 34 ("The Little Girl Lost," first plate): Man nude, colored pink.

Binding: Disbound in August 1984 and now loose in folder. The left edges are reinforced with rice paper. The former binding, retained, is (contemporary?) full brown calf, gilt stamped circular device on both covers. Gilt spine, stamped "BLAKE'S/SONGS." Robert Hoe's leather bookplate on inside front cover. Second front flyleaf and first back flyleaf watermarked "1796." Housed in a quarter brown leather folder, stamped in gilt on spine, "BLAKE'S SONGS OF INNOCENCE 1789." Former binding order: Pls. 2–4, 5/9, 10/54, 16/17, 11/34, 35/36, 8/24, 25/27, 13/14, 12/22, 23/53, 15/26, 19/18, 6/7, 20/21. Three stab holes from the immediately preceding binding, 4.5 and 4.8 cm. apart from the top, obscure on most leaves a previous set 4.5 and 4.5 cm. apart.

Provenance: John Linnell; Robert Hoe before 1895 (£4.4s.), sold Anderson Auction Co., 25 April 1911, lot 390, "formerly in the possession of John Linnell" ($700 to George D. Smith for Henry E. Huntington).

Exhibition: Grolier Club, 1905, No. 4 (giving the wrong provenance), and 1919–20, in No. 2; Fogg Art Museum, 1924; Huntington Art Gallery, 1979, No. 21 ("The Lamb" only).

Literature:
O. A. Bierstadt, *The Library of Robert Hoe* (New York: Duprat & Co., 1895), 198, noting "copies of the 'Songs of Innocence' and 'Songs of Experience' " in Hoe's collection.[5]
A Catalogue of Books in English later than 1700, Forming a Portion of the Library of Robert Hoe New York 1905 (N.p., 1905), 1:55, "John Linnell's copy."
Keynes 1921, 100 (copy F).
Keynes and Wolf 1953, 11, 14 (copy I).
Bentley 1977, 365, 382, 407 (copy I).

Reproduction:
Pl. 3 ("Introduction"): *Blake: An Illustrated Quarterly* 17 (1983):18.
Pl. 13 ("The Little Boy lost"): Essick 1980, Fig. 138, upper design only.
Pl. 22 ("Spring"): *Blake in His Time* 1978, Pl. 11.

The recto/verso printing, unprinted etching borders, and delicate washes suggest that this copy was printed and colored before 1800. However, the washes over text areas associate it with later copies. The Huntington copy may have been among the first executed with this feature.

The verso of the front free endpaper is inscribed in ink, in an unidentified hand, "This Copy was coloured by W. Blake himself." Below in pencil, Hoe has written "A copy of this vol. brought at Beckford's (Hamilton) sale one hundred & forty six pounds W. Tites copy brought £61.. Lord Beconsfields brought £85.—Ellis copy brought £700.0.0 in 1901." The recto of the first flyleaf is inscribed in pencil, "I paid £4.4.0 for this book. R.H. [Robert Hoe]." The plates are numbered in pencil 1–31, not by Blake. The rectos bearing the even numbers 6–18 in this sequence are also inscribed in pencil with the odd numbers 9–21.

For drafts and preliminary drawings, see *Songs of Innocence and of Experience* (No. 9, below).

4. THE/ BOOK/ of/ THEL/ *The Author & Printer Will.m Blake. 1789.*

Call No. 57434. Relief etching, 1789. Pls. 1–8 on 8 leaves. Pl. 1 measures 10.1 x 6 cm.; Pls. 2–8 range between 14.1 x 10.5 cm. and 15.5 x 10.6 cm. Printed in green ink on wove paper, 30.3 x 23.9 cm., with the etching borders not printed. Pl. 1 and verso of Pl. 8 foxed.

Coloring: Tinted with bold watercolor washes, predominantly blue, rose, and

yellow. Some motifs are outlined with pen and black ink. Pl. 1 ("Thel's Motto") and text areas of Pls. 3–8 are not colored.

Design Variants:
Pl. 3: Second state ("gentle" in line 13).
Pl. 6: Yellow cloud added to sky.

Binding: Full green leather with gilt decorations on covers by F. Bedford (for Frederick Locker?). Stamped in gilt on spine, "THE BOOK OF THEL— BLAKE 1789." All edges gilt. Bookplate of Frederick Locker on inside front cover. There are three stab holes, 10.5 and 9.5 cm. apart from the top hole. Binding order: Pls. 1–8.

Provenance: Thomas Butts; Thomas Butts, Jr., sold Sotheby's, 26 March 1852, lot 51 (£2.15s. to Francis Turner Palgrave); Frederick Locker by 1886; Dodd, Mead & Company, offered in their sale catalogue, *The Rowfant Books,* of 1905, item 1, bound as described above ($375); Dodd & Livingston; Rosenbach and Co., sold to Henry E. Huntington, May 1911 ($1000).[6]

Exhibition: Burlington Fine Arts Club, 1876, No. 316; Grolier Club, 1919–20, in No. 5; Fogg Art Museum, 1924; Huntington Art Gallery, 1953.

Literature:
The Rowfant Library. A Catalogue of the Printed Books...Collected by Frederick Locker-Lampson (London: Bernard Quaritch, 1886), 138, bound as described above. "Mr. Locker is indebted to Mr. Francis Palgrave for this volume."
Keynes 1921, 106 (copy I).
Keynes and Wolf 1953, 24 (copy L).
The Book of Thel, ed. Nancy Bogen (Providence: Brown Univ. Press, 1971), 54 (copy II-10).
Bentley 1977, 120, 129 (copy L).

Reproduction:
Pl. 1: James Thorpe, *William Blake: The Power of the Imagination* (San Marino: Huntington Library, 1975), 5; Thorpe, *Gifts of Genius* (San Marino: Huntington Library, 1980), 111.
Pls. 2, 8: Hagstrum 1964, Pls. XLVIII, XLIX.
Pl. 2: *Huntington Library Calendar* (November–December 1965):[3]; *Blake in His Time* 1978, Pl. 62.
Pls. 6, 8: John Howard, *Infernal Poetics: Poetic Structures in Blake's Lambeth Prophecies* (Rutherford: Fairleigh Dickinson Univ. Press, 1984), 54, 55.
Pl. 8: *Blake: An Illustrated Quarterly* 11 (1978):244.

The style of coloring, unprinted etching borders, and initial owner-

ship of this copy suggest a printing date of ca. 1796–1803, the period in which Butts made his first purchases of Blake's work. Pl. 1 is inscribed in pencil, upper right, "F. T. Palgrave/ 1852./ preserve." Each plate, except the first, is numbered in pencil, 2–8, not by Blake.

Pencil sketches in Blake's *Notebook* are similar to the small figures and flower of Pl. 2 (British Library; Butlin 1981, Nos. 201.21, 201.60), but these are part of an emblem series and probably not direct preliminaries for the relief etching. A pencil mock-up sketch for variants of Pls. 7–8 (the latter with motifs used on Pl. 6) is now in the British Museum (Butlin 1981, No. 218). A pencil sketch of ca. 1789 may be a rejected design for *The Book of Thel* (British Museum; Butlin 1981, No. 219).

5. *VISIONS/ of/ the Daughters of/ Albion/ The Eye sees more than the Heart knows./ Printed by Will^m: Blake: 1793.*

Call No. 42625. Relief etching, 1793. Pls. 1–11, ranging in size between 14.3 x 11.2 cm. and 17.1 x 13 cm. Pl. 1 with recto blank, Pls. 2–11 printed recto/verso on five leaves of wove paper, 27.3 x 21 cm. Pls. 2/3 watermarked "J WHATMAN." Printed in golden brown ink, with the etching borders not printed except for a few smudges. Three edges gilt, with the inner edge frayed and uneven from prior binding, but remargined in 1983 with strips of rice paper 2.7 cm. wide.

Coloring: Delicately tinted with transparent watercolor washes, blue, rose, green, and purple predominating. Text areas uncolored. Some outlining and shading in black (India ink?), probably applied with a brush.

Design Variants:
Pl. 2 : Rainbow painted in, rising from left to right across center of plate. A few cloud outlines added within the etched outlines.
Pl. 6: Cloud lower left has been extended to the left beyond its etched outline.
Pl. 7: Heavy clouds painted in the sky. A quadrant of the sun added just above the water and left of the right margin.
Pl. 9: Cloud outline below the figures is created by the edge of the sky color.
Pl. 10: Dark cloud painted in between the figures and the right margin.
Pl. 11: Heavy, sloping eyebrows added to the figure in the sky, giving her a particularly sad visage. Cloud outline added to the right of the huddled figures and below the etched cloud.

Binding: Disbound in 1983, now loose in a paper folder. The former binding, retained, is full red morocco by Riviere, gilt frames on covers. Stamped in gilt

on the spine is "VISIONS/ OF THE/ DAUGHT-/ ERS/ OF/ ALBION./-/
BLAKE./ 1793." Bookplate of Ralph Brocklebank on inside front cover.

Provenance: Ralph Brocklebank, sold Christie's, 10 July 1922, lot 69 (£185 to
Frank T. Sabin); offered Maggs Bros. catalogue 428 of 1922, item 184 (£315);
Thomas J. Gannon, sold January 1923 to Henry E. Huntington for $1750,
according to letters of 4 and 10 January 1923 from Gannon to Huntington (for-
merly laid in the volume, now housed separately).

Exhibition: Grolier Club, 1919–20, in No. 10; Fogg Art Museum, 1924; Hun-
tington Art Gallery, 1953.

Literature:
Keynes and Wolf 1953, 29 (copy E).
Bentley 1977, 466, 473 (copy E).

Reproduction:
Pls. 1–2, major designs on 3–11: *William Blake's Writings*, ed. G. E. Bentley, Jr.
 (Oxford: Clarendon Press, 1978), 1:100–17.
Pls. 1–2, 11: Hagstrum 1964, Pls. LII-LIII.
Pl. 1: *Blake in His Time* 1978, Pl. 61; *Sparks of Fire: Blake in a New Age*, ed. James
 Bogan and Fred Goss (Richmond: North Atlantic Books, 1982), 163.
Pl. 2: Illus. 45.
Pl. 6: *Blake Studies* 6 (Fall 1973): Fig. 13a.

The coloring, recto/verso printing, and paper type associate the
Huntington copy with four other complete copies probably printed
and colored ca. 1793–95. The plates are numbered in pencil, 1–11,
and the rectos foliated, 1–6, in pencil. Neither series of numbers was
written by Blake.

Blake's *Notebook* (British Library) includes preliminary sketches for
the following designs in *Visions of the Daughters of Albion:*

Pl. 2: Ring of dancers in sky lower left, in reverse (Butlin 1981, No. 201.30);
 figures running over waves, variant in reverse (No. 201.72); face of winged
 figure, related sketch lacking beard (No. 201.74); top right figure with arms
 extended, reversed (No. 201.81). For the last, see also "The Evil Demon," a
 pencil sketch of ca. 1793 (Houghton Library, Harvard University; Butlin
 1981, No. 209).
Pl. 3: Full design, reversed (No. 201.28).
Pl. 6: Full design, reversed (No. 201.32).
Pl. 7: Both figures, reversed (Nos. 201.50 and 201.92); crouching figure (No.
 201.74).

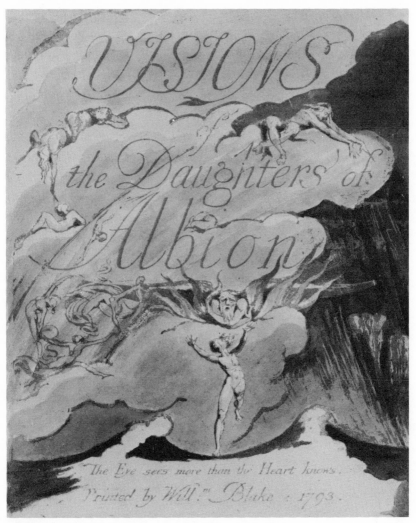

45. Visions of the Daughters of Albion, *Title Page*

Pl. 10: Possibly related to figure top right and to center figure in foreground seen from the side (No. 201.74).
Pl. 11: Full design, reversed (No. 201.78).

For a possible variant of the design on Pl. 9, see sketch on the verso of Blake's drawing of "Pity" (British Museum; Butlin 1981, No. 314).

6. AMERICA/ a/ PROPHECY/ LAMBETH/ Printed by William Blake in the year 1793.

Call No. 54044. Relief etching with white-line etching and engraving, 1793. 19 plates (including Pl. e, the word "Preludium" only, printed above Pl. 3) on 10 leaves: Pl. 1 (frontispiece) with recto blank, Pl. 2 (title page) with verso blank, Pls. 3–18 printed recto/verso. Pl. e approx. 2.3 x 8 cm.; all others range between 23 x 16.3 cm. and 23.8 x 17.3 cm. Wove paper, 36.3 x 25.5 cm., Pls. 3/4, 5/6, 13/14 watermarked "E & P." Printed in green ink, ranging from blue-green to olive, with the etching borders not printed.

Coloring: Uncolored. No clear evidence of hand work of any sort.

Design Variants:
Pl. 2: First state? Cloud upper left corner filled in, not just an outline as printed in later copies.
Pl. 4: All four lines below design masked in printing (see Bentley 1966 under *Reproduction,* below).
Pl. 13: First state (serpent with 3 tails).

Binding: Full green morocco with gilt frames on covers by F. Bedford (for Frederick Locker?). Stamped in gilt on the spine, "AMERICA/ A/ PROPHECY/-/ BLAKE/ 1793." All edges gilt. Bookplate of Frederick Locker on inside front cover. Binding order: Pls. 1–18.

Provenance: Frederick Locker by 1876, sold through Dodd, Mead, & Co. in 1905 to E. Dwight Church (according to Keynes and Wolf 1953, 46); sold to Henry E. Huntington in April 1911 as part of the Church collection (according to Bentley 1977, 103).[7]

Exhibition: Burlington Fine Arts Club, 1876, No. 317; Grolier Club, 1919–20, in No. 11; Fogg Art Museum, 1924.

Literature:
The Rowfant Library. A Catalogue of the Printed Books...Collected by Frederick Locker-Lampson (London: Bernard Quaritch, 1886), 139.
Keynes 1921, 137 (copy H).
Keynes and Wolf 1953, 46 (copy I).
Bentley 1977, 87–88, 103 (copy I).

Reproduction:
Pls. 1–2, 10, 18 (tailpiece only): *Blake in His Time* 1978, Pls. 2, 7, 9, 54.

Pls. 1, 12: Robert N. Essick, *William Blake's Relief Inventions* (Los Angeles: W. & V. Dailey, 1978), frontispiece, Pl. 5.

Pls. 3, 11, 16, 18: Hagstrum 1964, Pls. LIV-LV.

Pl. 4: G. E. Bentley, Jr., "The Printing of Blake's *America*," *Studies in Romanticism* 6 (1966):Pl. VII, lower design only.

Pl. 9: *Huntington Library Quarterly* 46 (1983):74.

Pls. 10, 11, 12: Essick 1980, Figs. 78, 99, 140.

Pls. 10 (upper design only), 11: *Blake Studies* 5 (Fall 1972):Pls. 10, 12; *The Visionary Hand*, ed. Robert N. Essick (Los Angeles: Hennessey & Ingalls, 1973), Figs. 158, 160.

Pl. 12: Morton D. Paley, *Energy and the Imagination* (Oxford: Clarendon Press, 1970), Pl. 1.

The ink color, recto/verso printing, masking of lines on Pl. 4, paper, and first state of Pl. 13 associate the Huntington copy of *America* with at least five others probably printed ca. 1793–94, perhaps in one press run.

A sketch in Blake's *Notebook* (British Library; Butlin 1981, No. 201.71) shows an old man entering a door, as on Pl. 14, but this drawing is part of an emblem series and may not be a direct preliminary for *America*. Blake also used this design on Pl. 17 of *For Children: The Gates of Paradise* (see No. 14, below), engraved in the same year as *America*. Another sketch in the *Notebook* (Butlin 1981, No. 201.75) is related to the figure descending above the serpent's coils on Pl. 7. Three pencil drawings in the British Museum may be a rejected title-page design for *America* (Butlin 1981, No. 223A), a preliminary version of the figures below "PROPHECY" on Pl. 2 (Butlin 1981, No. 224), and a variant for the design above the text on Pl. 3 (Butlin 1981, No. 225). There is also a watercolor of ca. 1792–93 closely related to the two males above the text on Pl. 3 (Tate Gallery; Butlin 1981, No. 255). A sheet of sketches in the collection of Charles Ryskamp (Butlin 1981, No. 226) includes motifs for Pl. 5 (man in chains, top left, and running woman, lower left, reversed) and perhaps Pl. 8 (figure's legs). Blake had first used the design on Pl. 8 on Pl. 21 of *The Marriage of Heaven and Hell*, ca. 1790–93. Another sheet of sketches (untraced since ca. 1912; Butlin 1981, No. 227) includes the figures on Pls. 8, 10, and 14. Blake had earlier used the bearded figure on Pl. 10 above the text of Pl. 4 of *All Religions are One* (No. 1, above). A pencil drawing in the Keynes collection, Fitzwilliam Museum, may be an early version of the figure on Pl. 12 (Butlin 1981, No. 228).

Blake executed three plates for *America* known only in proof impressions: Pls. a (an early version of Pl. 5), b, and c. A fragment of the original copperplate of Pl. a is in the National Gallery of Art, Washington. A fourth cancelled plate (d), probably intended for *America*, is known only through two color-printed impressions of the design after some of the text was cut away (see "A Dream of Thiralatha" in Essick 1983, 38–40).

7. *America, a Prophecy.* Pl. 3 only.

Housed in "Blake: Miscellaneous Prints" box in the Library; no call number. Relief etching with white line etching and/or engraving, 1793. Plate 23.1 x 16.4 cm. Lightly printed in blue-green ink, with weak areas of printing top right and above the lower margin. Fragments of the etching border are printed, particularly at the top and upper left edge. Wove paper, 24.8 x 18. 1 cm., mounted in a window cut in a sheet 54.4 x 34 cm. with two red framing lines and gilt on the top edge. Pl. e (the word "Preludium") is not present, although it may have been printed more than 1 cm. above Pl. 3 and trimmed from the sheet.

Coloring: Uncolored. No clear evidence of hand work of any sort.

Design Variants: None.

Binding: Formerly bound as leaf 572 in volume 2 of the extra-illustrated Kitto Bible. Disbound at an unknown time.

Provenance: Acquired at an unknown time by either J. Gibbs or Theodore Irwin and bound in the Kitto Bible, for the provenance of which see "The Conversion of Saul" (Part I, section D, No. 3).

Literature:
Wittreich 1970, 52.
Bentley 1977, 89, 107.

The date of printing is uncertain, but the ink color associates this impression with complete copies of *America* printed ca. 1793–96. The mounting sheet is stamped upper right "572" and inscribed in ink below the left corner of the print "W^m Blake" and below the right corner "Rare." Inscribed in pencil "66," upper right on the mounting

sheet, "39," bottom center, and "This is the proeludium to America: A prophecy/ Proof State" below the print. In spite of this last note, the plate is in the same state as that published in complete copies. For preliminary and associated drawings, see the complete copy of *America*, No. 6, above.

8. *EUROPE/ a/* **PROPHECY/** *LAMBETH/ Printed by Will: Blake: 1794*

Call No. 57435. Relief and white line etching and engraving, 1794. 17 plates on 17 leaves, lacking Pl. 3 (a "Preface" included in only 2 copies). Printed in black ink, including the etching borders. The plates range in size between 23 x 16.4 cm. and 23.8 x 17.3 cm. Wove paper, 29.5 x 22 cm., watermarked "T STAINS" on Pls. 1–2, 4–7, 9–11, 13–18, and "1813" on Pl. 12.

Coloring: Elaborately hand tinted with watercolors, body colors, and liquid gold, not by Blake. According to Keynes and Wolf 1953, 83, the coloring was added by Walter T. Spencer, the London bookdealer, soon after the February 1913 sale of the volume.

Design Variants: All plates in final state.

Binding: Formerly bound in gray calf (according to the 1913 auction catalogue) with *America* copy Q, now at Princeton University. Disbound, probably by Spencer shortly after the 1913 sale, and rebound separately in the present full red morocco by Riviere, with gilt frames on the covers. The front cover is stamped in gilt, "W. BLAKE/-/ EUROPE/ A PROPHECY/ W. BLAKE/ LAMBETH 1794." Stamped in gilt on the spine, "EUROPE/ A/ PROPHECY/ W. BLAKE/ LAMBETH/ 1794." Leather bookplate of Herschel V. Jones on inside front cover. Interleaved with thin laid sheets with a fleur-de-lis watermark. All edges gilt. Binding order: Pls. 1–2, 4–5, 10, 9, 6–8, 11–18. Pls. 9 and 10 are full-page designs, and thus they do not disrupt the text sequence regardless of their position.

Provenance: R. A. Potts, sold Sotheby's, 20 February 1913, lot 59, bound with *America* copy Q, no mention of coloring (£66 to Frank T. Sabin); Walter T. Spencer; Herschel V. Jones, sold Anderson Galleries, 2 December 1918, lot 184, "richly executed in gold and colors by himself [i.e., Blake]" ($4600 to George D. Smith for Henry E. Huntington).

Exhibition: Grolier Club, 1919–20, in No. 12; Fogg Art Museum, 1924.

Literature:
Keynes 1921, 143 (copy H).
Keynes and Wolf 1953, 83 (copy L).
Bentley 1977, 142, 146, 160 (copy L).

Reproduction:
Pl. 15, lower right corner only: *Blake Studies* 5 (Fall 1972): Pl. 13; *The Visionary Hand*, ed. Robert N. Essick (Los Angeles: Hennessey & Ingalls, 1973), Fig. 161.

The flat, even texture of the (relief rather than intaglio?) ink and the printed etching borders suggest that these are posthumous impressions printed from Blake's plates ca. 1831–33 by Frederick Tatham. The only other illuminated book on T STAINS paper, *America* copy Q (with which this copy of *Europe* was long associated), is probably also posthumous, even though both books have one leaf watermarked "1813." Each plate is numbered above the top right corner, 1–17.

Blake's *Notebook* (British Library) includes pencil studies for Pls. 1, 4 (figure below text), 5 (figures below text, on a separate fragment formerly pasted to page 10 of the *Notebook*), and 10 (three figures, one reversed)—see Butlin 1981, Nos. 201.96, 201.74, 201.10A, 201.25. Blake first used the crouching figure on Pl. 9, lower left, and the man and woman on Pl. 11, reversed and with other figures, in a pencil sketch and in one of his pen and wash illustrations to his poem *Tiriel*, both ca. 1789 (Keynes collection, Fitzwilliam Museum, and Whitworth Art Gallery; Butlin 1981, Nos. 198.8 and 199). The two figures lower left on Pl. 10 also appear in two early versions of "Pestilence" (see Part I, section D, No. 1). There are impressions of Pl. 2 (title page) with motifs added by hand in a British private collection, the National Gallery of Australia, and two versions in the Pierpont Morgan Library (Butlin 1981, Nos. 272–74A). All four bear impressions from *Jerusalem* (ca. 1804–20) on their versos, but they may have been executed as studies for etching an alternative plate.

9. SONGS/ of/ INNOCENCE/ and of/ EXPERIENCE/ Shewing the Two Contrary States/ of the Human Soul

Call No. 54039. Relief etching with white-line etching and engraving. Pls. 2–27, 34–36, 53–54 etched 1789; Pls. 1, 28–33, 37–52 etched 1794. 54 plates (1–31, 33–54) on 31 leaves, including 2 impressions of Pl. 15 ("Laughing Song"). Lacking Pl. 32 ("The Clod & the

Pebble''), a posthumous impression of which has been bound at the end (see No. 11, below). Pls. 1–4, 26, 28–29, 52 with versos blank; Pls. 5–25, 27, 30–31, 33–51, 53–54 printed recto/verso. Pls. 13–14, 20–21, 34–36, 50, and the second impression of Pl. 15 (inscribed "34") printed in green ink, Pl. 26 in olive brown, and the remainder in shades ranging between reddish brown and golden brown. The borders are not printed. Pls. 1, 28–31, 33, 37, 40–43, 45–51 show small amounts of color printing in brown, black, and/or green. There is more extensive color printing on Pls. 38 (red, green), 44 (green, brown, black), and 48 (brown). The plates range in size between 10.9 x 6.3 cm. and 12.4 x 7.9 cm. Wove paper, 17.6 x 11.4 cm. Pls. 33/43 watermarked "WHA[TMAN]''; Pls. 50/37 watermarked "[WHAT]MAN." Pl. 42 ("The Tyger") evenly stained brown.

Coloring: Richly hand tinted with watercolors, predominantly blues, greens, yellows, pinks, and rose red. Extensive outlining of motifs with pen and ink, including a thin ink border drawn around the outer edges of many plates. Many letters written over with pen and black ink. Each plate is numbered by Blake in black ink, 1–54, above the top right corner.

Design Variants:
Pl. 1 (general title page): Lower figure's face painted out as though covered with hair.
Pl. 8 ("The Lamb"): Dark area (a cloud?) painted in above the house.
Pl. 10 ("The Little Black Boy," second plate): The boy on the left is colored black and the boy on the right is white.
Pl. 12 ("The Chimney Sweeper" in *Innocence*): Slight halo of white around the head of the figure lower right.
Pl. 13 ("The Little Boy lost"): Brim of a hat painted around boy's head.
Pl. 14 ("The Little Boy found"): Etched halo above the adult's head in the design above the text has been left uncolored, but large, dark rays have been painted in. These appear to emanate from the figure's head. Brim of a hat painted around boy's head.
Pl. 15 ("Laughing Song," first impression, inscribed "9"): Garland drawn around head of girl second from left.
Pl. 17 ("A Cradle Song," second plate): Carpet-like pattern of white lines in the foreground has been painted out, mostly with a large, dark shadow cutting across the floor left to right.
Pl. 18 ("The Divine Image"): Paper left uncolored around head of standing figure, lower right, to form a halo.
Pl. 19 ("Holy Thursday" in *Innocence*): Book painted in hands of figure lower left.
Pl. 21 ("Night," second plate): Areas left uncolored around heads of all five

figures standing on the ground, thereby forming a halo around each.

Pl. 22 ("Spring," first plate): Red added to sky far right, indicating a sunrise or sunset.

Pl. 28 (frontispiece to *Experience*): Burst of yellow light top left; remainder of sky red.

Pl. 29 (*Experience* title page): Face of boy behind bier turned slightly toward us. Hair of standing girl redrawn to eliminate the etched knot on the back of her head.

Pl. 34 ("The Little Girl Lost," first plate): The man is colored pink and appears to be nude. Large dark area (a cloud?) added behind figures.

Pl. 38 ("Nurses Song" in *Experience*): Apparently printed twice, once in golden brown ink and once in green size-color, as indicated by faulty register of tendrils and leaves in the text area.[8]

Pl. 41 ("The Angel"): No crown on woman.

Binding: Full green morocco by F. Bedford for Frederick Locker. Gilt frames on covers, stamped in gold on spine, "BLAKE'S/ SONGS OF/ INNOCENCE/ AND/ EXPERIENCE/ 1789 * 1794." All edges gilt. Binding order: Pls. 1–4, 5/ 25, 11/8, 15/19, 10/54, 18/12, 16/17, 6/7, 27/22, 23/53, 24/19, 13/14, 20/21, 26, 28–29, 30/31, 15/34, 35/36, 50/37, 42/46, 44/39, 38/41, 45/47, 40/49, 48/ 51, 33/43, 52. Interleaved, some leaves showing a "WHAT[MAN]/ 186 [trimmed off]" watermark. Bookplates of Frederick Locker and Beverly Chew on inside front cover. The *Innocence* plates have three stab holes 3.6 cm. and 3.3 cm. apart from the top. Some *Innocence* plates show two further holes, 12.7 cm. apart, perhaps once used with one or more holes from the first group. Pls. 40/49, 44/39, and 48/51 show three stab holes, 3.2 cm. and 3.9 cm. apart from the top. These differences result from the two sections having been bound separately until at least 1866 (see *Provenance* and *The Rowfant Library* under *Literature*, below).

Provenance: Probably the copy purchased from Blake by Thomas Butts for £6.6s. on 9 September 1806[9]; sold from Butts' collection, Sotheby's, 26 March 1852, lot 50, "fifty-four designs...with the printed Poem [a copy of the 1839 Pickering edition of the *Songs*]," and the parody described below, all in three volumes (£12.12s. to Robert Arthington); sold from Arthington's collection, Sotheby's, 17 May 1866, lot 17, 3 volumes, with the letter from Gilchrist described below (£13.15s. to Basil M. Pickering); Frederick Locker; Dodd, Mead & Company, offered in their sale catalogue of 1905, *The Rowfant Books*, item 2, bound as at present, with "The Clod & the Pebble," the parody, and the Gilchrist letter "inserted," the extract from Swinburne "laid in" ($750); perhaps E. Dwight Church[10]; Beverly Chew, sold with his collection in December 1912 to Henry E. Huntington.

Exhibition: Burlington Fine Arts Club, 1876, No. 309; Grolier Club, 1919–20, in No. 3; Fogg Art Museum, 1924.

Literature:
The Rowfant Library. A Catalogue of the Printed Books...Collected by Frederick Locker-Lampson (London: Bernard Quaritch, 1886), 138: "Formerly in the possession of Mr. Butts, Blake's friend. The volume was cut down by an earlier owner to meet the dimensions of an old weekly washing book, from the covers of which Mr. Locker has rescued it." Pl. 32 at the end of the list of contents.
Keynes 1921, 120 (copy D).
Keynes and Wolf 1953, 57 (copy E).
Bentley 1977, 367, 382, 414 (copy E).

Reproduction:
Pls. 1 (general title page), 2 (frontispiece to *Innocence*), 3 (*Innocence* title page), 4 ("Introduction" to *Innocence*), 7 ("The Lamb"), 15 ("Laughing Song"), 24 ("Nurses Song" of *Innocence*), 25 ("Infant Joy"), 29 (*Experience* title page), 30 ("Introduction" to *Experience*), 38 ("Nurses Song" of *Experience*), 39 ("The Sick Rose"), 48 ("Infant Sorrow"), 49 ("A Poison Tree"): *Songs of Innocence and of Experience*, Introduction by James Thorpe (San Marino: Huntington Library, n.d.), in color.
Pl. 1, general title page: Illus. 46; *Blake: An Illustrated Quarterly* 11 (1978):245.
Pl. 8 ("The Lamb"): *A Handbook to the Huntington Library Exhibition* (San Marino: Huntington Library, 1978), 86, in color.
Pls. 15 ("Laughing Song"), 19 ("Holy Thursday" of *Innocence*), 38 ("Nurses Song" of *Experience*): Essick 1980, Fig. 113, 135, 137.
Pl. 28 (*Experience* frontispiece): *William Blake: Essays in Honour of Sir Geoffrey Keynes*, ed. Morton D. Paley and Michael Phillips (Oxford: Clarendon Press, 1973), Pl. 33.
Pl. 42 ("The Tyger"): James Thorpe, *William Blake: The Power of the Imagination* (San Marino: Huntington Library, 1979), 22 right, in color; Thorpe, *Gifts of Genius* (San Marino: Huntington Library, 1980), 128 right, in color.
Pl. 43 ("My Pretty Rose Tree," "Ah! Sun-Flower," "The Lilly"): *Blake Studies* 5 No. 2 (1974):Fig. 2.

This copy of *Songs of Innocence and of Experience* appears to have been printed in several different press runs, perhaps widely separated in time, and then assembled and numbered as a unit by Blake at a later date. The two distinct ink colors, brown and green, were very probably printed at different times. The plates in brown may also represent two press runs, as suggested by the range of browns from reddish to golden. The absence of printed etching borders and the recto/verso printing of most plates indicate printing dates before ca. 1800. Those plates with color printing represent yet another press run, probably ca. 1794–96 when Blake did most of his color printing from copper-

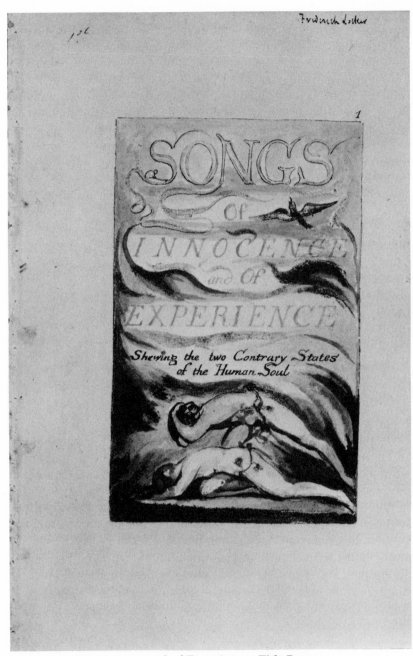

46. Songs of Innocence and of Experience, *Title Page*

plates. Pl. 38 (see *Design Variants*, above) may first have been printed in golden brown and then color printed in a separate operation at a later time. The inclusion of a second impression of Pl. 15, probably caused only because it was printed on the recto of Pl. 34, and the absence of Pl. 32 also bespeak an assemblage of impressions on hand, probably put together shortly before their sale to Butts in September 1806. The numbering of the plates, inclusion of Pls. 34–36 in the *Experience* rather than *Innocence* section, and the coloring of the children on Pl. 10 are characteristic of later copies. Most, if not all, of the hand coloring was probably executed in 1806.[11]

The verso of the front free endpaper is stamped "B.M. PICKERING" and inscribed in pencil, "F. Locker L[ampson]/ 30 Lower Sloane Street/ Chelsea/ [word illegible]." Recto of first front flyleaf faintly inscribed in pencil with information on sales of another copy. Pls. 1 and 28 inscribed in ink, upper right, "Frederick Locker," with "1st" upper left in pencil on Pl. 1 and "2d" upper left in pencil on Pl. 28. Pl. 15 (inscribed "9") also inscribed in pencil by Locker upper right, "Duplicate on P. 34." Pl. 15 (inscribed "34") also inscribed upper right in pencil by Locker, "Duplicate on P. 9," with "not[?]" written below in large pencil letters. Pl. 50 inscribed in pencil above the plate by Locker, "Emerson likes this." Bound at the end is a posthumous impression of Pl. 32 (see No. 11, below), followed by a two-page manuscript parody of the "Introduction" to *Innocence* (titled "A Song of Innonsense"),[12] followed by a three-page letter of 25 October 1861 from Alexander Gilchrist (apparently to Robert Arthington, then the owner) seeking information about the volume. Attached to the letter is a note in ink by Locker explaining that he had the letter "removed to the end of the Vol." when rebound. Formerly laid in, but now kept separately, is a two-page transcript by Locker from Algernon Charles Swinburne, *William Blake: A Critical Essay* (London: J. C. Hotten, 1868).

Drafts for the poems on Pls. 13, 19, and 24 appear in Blake's *Island in the Moon* manuscript of ca. 1784 (Fitzwilliam Museum). Blake wrote an early version of Pl. 15 in a copy of his *Poetical Sketches* in the Turnbull Library, Wellington, New Zealand. Drafts for Pls. 31–33, 38–50 are on pages 101, 103, 105, 107–109, 111, 113–15 of Blake's *Notebook* (British Library). The *Notebook* also contains pencil sketches related to the piper and dog lower left on Pl. 27, the figures on Pls. 28–30 and 41, the woman and child above the title on Pl. 33, perhaps the rose and figure

at the bottom of Pl. 39, and the figures above the title on Pl. 46 (Butlin 1981, Nos. 201.15, 201.21, 201.43, 201.54, 201.57, 201.75). Some of these sketches are part of an emblem series and were not executed as direct preliminaries for the illuminated book. In 1879, Quaritch offered for sale watercolors of Pls. 2 and 4, but these may have been colored impressions from the plates (see Butlin 1981, No. 215).

10. SONGS/ *of/* EXPERIENCE/ 1794/ The Author & Printer W Blake

Call No. 54038. Relief etching, with touches of white-line etching and/or engraving on a few plates. 25 plates (29–53) on 25 leaves. Pls. 34–36, 53 etched 1789; Pls. 29–33, 37–52 etched 1794. The plates range in size between 11 x 6.3 cm. and 12.4 x 7.3 cm. Printed in dark brown, with the designs and etching borders very lightly printed, perhaps in anticipation of hand coloring. Wove paper, 19.6 x 13.6 cm., three edges gilt, with the left edge uneven from prior binding but reinforced with rice paper. The matting with corner mounts prevents inspection for watermarks, but according to Keynes and Wolf 1953, 60, and Bentley 1977, 368, there are none. Pl. 42 ("The Tyger") evenly stained brown.

Coloring: Richly painted with watercolors, with pen and ink work and touches of liquid gold on some plates. Somber tones of gray, brown, blue, and green predominate, but there are also lighter shades of rose, pink, beige, and yellow. Most text areas are tinted with transparent watercolors. The plates are numbered by Blake in ink, 30–54, just above the top right corner.

Design Variants:
Pl. 30 ("Introduction"): 15 stars added to the dark sky surrounding the text cloud.
Pl. 31 ("Earth's Answer"): Tendrils drawn in over top etching border.
Pl. 33 ("Holy Thursday"): Sky colored rose and yellow to suggest clouds in a sunset or sunrise.
Pl. 34 ("The Little Girl Lost," first plate): Man clothed in blue. Catchword painted out.
Pl. 35 ("The Little Girl Lost," second plate): Sky above girl colored in rose bars to suggest a sunset (see the advent of "night," lines 29–30 on Pl. 34). Pen and ink outline and green watercolor form land sloping toward the lower left corner below the lioness.
Pl. 39 ("The Sick Rose"): Base of tree, lower left, painted in narrower than the printed image. Slight etched indications of vegetation right of the tree base painted out with yellow. Two tendrils added to top left corner.

Pl. 41 ("The Angel"): No crown on woman.

Pl. 44 ("The Garden of Love"): Slight indications of a leafless tree painted in upper left.

Pl. 46 ("London"): Etched wavy line in lower margin developed with hand work into a serpent with his head on the right and a long forked tongue.

Pl. 47 ("The Human Abstract"): Pen and ink work has converted the left etching border into a tree or cluster of tendrils.

Pl. 48 ("Infant Sorrow"): Horizontal tendrils drawn in above the title, with leaves in the top left corner.

Pl. 50 ("A Little Boy Lost"): Some of the wavy lines in left margin have been colored red, thereby extending the flames below.

Binding: Recently disbound and individually matted. The former binding, retained, is full maroon morocco, gilt frames on the covers, and stamped in gilt on the spine, "BLAKE.—SONGS OF EXPERIENCE.—1794." Leather bookplate of Robert Hoe on inside front cover. Three stab holes, 3.9 cm. and 3.8 cm. apart from the top, may have been made for an earlier binding (see *Provenance,* below).

Provenance: Perhaps part of a copy with 40 plates, including 15 duplicates,[13] offered by Quaritch, catalogue 147 of 15 May 1859, bound in half red morocco with *The World Turned Upside Down* (£10.10s.), and in catalogue 156 of 24 February 1860, bound with several other works, including *The World Turned Upside Down* (£8.10s.); offered separately, with the 15 duplicates removed, in Quaritch general catalogues of 1877, item 974, "red morocco extra" (£48), and 1880, item 3407 (£42); Howell Wills, sold Sotheby's, 11 July 1894, lot 92 (£40 to Quaritch); Robert Hoe by 1895, sold Anderson Auction Co., 25 April 1911, lot 392 ($700 to George D. Smith for Henry E. Huntington).

Exhibition: Grolier Club, 1905, No. 9, and 1919–20, No. 4; Fogg Art Museum, 1924.

Literature:
O. A. Bierstadt, *The Library of Robert Hoe* (New York: Duprat & Co., 1895), 198.
A Catalogue of Books in English later than 1700, Forming a Portion of the Library of Robert Hoe New York 1905 (N.p., 1905), 1:56.
Keynes 1921, 123 (copy M).
Keynes and Wolf 1953, 60 (copy N).
Bentley 1977, 368, 379, 382, 418 (copy N).

Reproduction:
Pls. 32 ("The Clod & the Pebble"), 42 ("The Tyger"): *Songs of Innocence and of Experience,* Introduction by James Thorpe (San Marino: Huntington Library, n.d.), in color.
Pl. 35 ("The Little Girl Lost," second plate, lower design only): *Blake: An Illus-*

trated Quarterly 12 (1979):260.
Pl. 42 ("The Tyger"): *A Handbook to the Huntington Library Exhibition* (San
Marino: Huntington Library, 1978), 87, in color; James Thorpe, *William
Blake: The Power of the Imagination* (San Marino: Huntington Library, 1979),
22 left, in color; Thorpe, *Gifts of Genius* (San Marino: Huntington Library,
1980), 128 left, in color; Elizabeth Pomeroy, *The Huntington Library, Art Gal-
lery, [and] Botanical Gardens* (London: Philip Wilson, 1983), 34, in color.
Pl. 48 ("Infant Sorrow"): *Blake in His Time* 1978, Pl. 12; *ELH* 50 (1983):309.

Blake's numbering of the plates, 30–54, yields the following
sequence of plates: 29–32, 37, 49, 48, 42, 40, 39, 47, 51, 34–36, 44, 41,
43, 50, 52, 46, 45, 33, 38, 53.[14] The numbering indicates that this copy
of *Experience* was issued by Blake as part of a combined copy of the
Songs of Innocence and of Experience. Such a copy probably included the
first and last plates of *Experience*, 28 (frontispiece) and 54 ("The Voice
of the Ancient Bard"), perhaps removed as part of the rebinding pro-
cess. Neither of these plates was included as part of the copy in 40
plates offered by Quaritch in 1859 (see *Provenance*); but an impression
of the frontispiece, formerly in the collection of Anthony Blunt, is
numbered 29 and originally may have been part of the hypothetical
complete copy. Pl. 54 may have been part of the *Innocence* section, as in
many copies of the combined *Songs*.

The presence of Pl. 53 among the *Experience* plates and the plate
numbering led Keynes and Wolf 1953, 55, to date the printing of the
Huntington copy to ca. 1799–1801. Bentley 1977, 382, places it in a
group he dates 1800–1806, based on the same evidence noted by
Keynes and Wolf but also because the text areas are tinted and Pls. 34–
36 are present in *Experience*. The light, very reticulated inking, the
printing of the borders, and the general character of the coloring sup-
port the later dating. Blake's numbers are repeated in pencil near the
inner margins of the first 4 leaves, probably added as part of a
rebinding operation.

For drafts and preliminary drawings, see *Songs of Innocence and of
Experience* (No. 9, above).

11. *The CLOD & the PEBBLE*
Call No. 54039. Relief etching, 1794. Pl. 32 of *Songs of Innocence and of
Experience*, 11.4 x 7.3 cm., printed in black ink on wove paper, 17.6 x
11.4 cm. Etching borders printed.

Coloring: Simply tinted with thin watercolor washes (gray, brown, blue, rose, yellow, green).

Design Variants: None.

Binding: Bound as the last plate in *Songs of Innocence and of Experience* (No. 9, above).

Provenance: Frederick Locker; inserted into his copy of *Songs of Innocence and of Experience* between 1866 and 1886. See No. 9, above, for the subsequent history of the volume.

Exhibition and *Literature:* See No. 9, above.

Inscribed by Locker in pencil above the plate, "I inserted this—? colouring more/ modern." The quality of the rather flat and dull printing indicates that this is without doubt an impression printed after Blake's death on 12 August 1827, probably pulled by his widow or by Frederick Tatham, ca. 1827–32. Tatham acquired Blake's copperplates after Mrs. Blake's death on 18 October 1831 and took impressions from them, many on paper watermarked 1831 and 1832. Locker probably added this print because his copy of the *Songs* printed and colored by Blake lacked Pl. 32.

12. *THE/ SONG of/ LOS/ Lambeth Printed by W Blake 1795*

Call No. 54043. Planographic copperplates (Pls. 1, 2, 5, 8?) and relief etching (Pls. 3, 4, 6–7), 1795. 8 plates on 8 leaves, with Pl. 1 (frontispiece) facing Pl. 2 (title page). The plate sizes range between 21.5 x 13.5 cm. and 23.5 x 17.5 cm. Pls. 3–4, 6–7 printed in gray ink. The etching borders are not printed except where they constitute design elements. All plates elaborately color printed, predominantly in black, brown, blue, pink, gray, green, orange, and red. Wove paper, 36.4 x 26 cm. The lower edges of Pls. 2–8 are deckled. There is considerable offsetting of Pl. 1 onto Pl. 2 and Pls. 3–8 onto the facing versos. The offsetting of Pl. 8 onto the verso of Pl. 3 and Pl. 5 onto the verso of Pl. 6 includes color transferred from the impressions when still damp. Small pieces of paper from the verso of Pl. 3 are stuck to the dense colors in the lower part of Pl. 8.

Coloring: The color printing has been supplemented with watercolors and the

definition of some forms, such as faces, with pen (or small brush) and ink. Some of the hand coloring may have been applied with a stubble brush or blotted to match the reticulations of color printing.[15]

Design Variants: The planographic printing of some plates renders inapplicable the concept of variations from an image etched or engraved on the plate. See comments below on graphic technique.
Pl. 3: Etched butterfly right of lines 6–8 not printed or hand colored.

Binding: Full red morocco by Riviere (for Halsey?), top edge gilt. Gilt frames on covers and stamped in gilt on the spine, "THE/ SONG/ OF/ LOS/-/ BLAKE/ LAMBETH/ 1795." Interleaved. Binding order: Pls. 1–3, 8, 4, 6, 5, 7. The offsetting indicates that this was very probably the original binding order. Pls. 5 and 8 are full-page designs, and thus their placement does not affect the text sequence. Blake's print of "Albion rose" (see Part III, section A, No. 5) was formerly bound at the end of the volume, as offsetting onto a flyleaf indicates, but removed in 1953. There are three stab holes 10.4 cm. and 10.4 cm. apart.

Provenance: The earl of Crewe, sold Sotheby's, 30 March 1903, lot 9, "unbound...consisting of 8 leaves in colours...4 of which are full-page figures without text"[16] (£174 to Frank T. Sabin); Frederic Robert Halsey (in 1903?); sold in December 1915 as part of the Halsey collection to Henry E. Huntington.

Exhibition: Grolier Club, 1919–20, in No. 15; Fogg Art Museum, 1924.

Literature:
Keynes 1921, 155 (copy E).
Keynes and Wolf 1953, 93 (copy E).
Bentley 1977, 358, 362 (copy E).

Reproduction:
Pls. 1–2, 5, 8: *William Blake's Writings*, ed. G. E. Bentley, Jr. (Oxford: Clarendon Press, 1978), 1:284–85, 289, 294; John Howard, *Infernal Poetics: Poetic Structures in Blake's Lambeth Prophecies* (Rutherford: Fairleigh Dickinson Univ. Press, 1984), 183–84.
Pls. 1, 5, 8: *Blake in His Time* 1978, Pls. 63–65; *Colby Library Quarterly* 20 (1984):24, 29, 31.
Pl. 1: *Blake: An Illustrated Quarterly* 11 (1978):245.
Pls. 2, 3, 6: David V. Erdman, *The Illuminated Blake* (Garden City: Anchor/ Doubleday, 1974), 175–76, 179.
Pls. 2, 3, 8: Essick 1980, color frontispiece (Pl. 8), Figs. 111, 116–17.
Pls. 2, 6: Hagstrum 1964, Pls. VI–VII.
Pl. 2: Illus. 47.

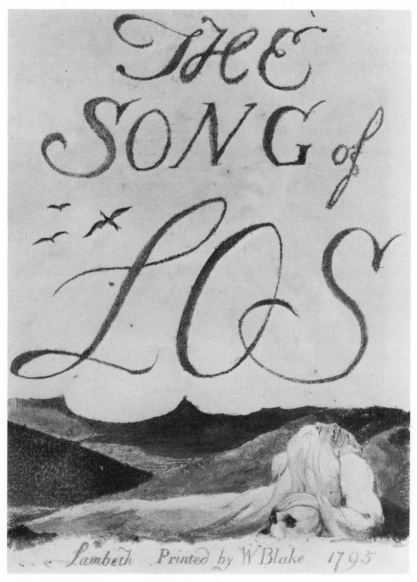

47. The Song of Los, *Title Page*

Pl. 8: Elizabeth Pomeroy, *The Huntington Library, Art Gallery,* [*and*] *Botanical Gardens* (London: Philip Wilson, 1983), 35, in color.

The absence of a distinct border to the printed areas of Pl. 2 or any evidence that the edges of relief plateaus were impressed into the paper indicate that the title page was printed planographically from a copperplate that bore no more than a scratched outline of the letters and design.[17] Pls. 1, 5, and 8 were probably executed in the same way, although the thick coloring obscures definite evidence. All 5 copies of the book were probably printed ca. 1795–96. Differences among the title pages suggest that copies A and B (British Museum and Library of Congress) were printed in immediate succession, then C and D (Pierpont Morgan Library and British Museum) after some repainting of the plate, and finally the Huntington copy (E) after further repainting.

Pl. 1 is numbered in pencil on the blank recto, lower left, "1," and inscribed upper left "fol 495." The remaining plates are numbered, not by Blake, 2–8 in pencil below the lower left corner. The verso of the front free endpaper is inscribed in pencil, "folio 537" and "book fol 495." The recto of the back free endpaper is inscribed (by Halsey?) in pencil, "1903/ £ cnt./ binding £ce.x.x."

A slight pencil sketch for the figure on Pl. 2 is in the collection of Robert N. Essick (Butlin 1982, No. 232). Pl. 5 is loosely modeled on a drawing in Blake's *Notebook* (British Library; Butlin 1981, No. 201.5) executed by his brother Robert (1767?–1787). Blake also based a watercolor of ca. 1790–93 (Philip Hofer collection; Butlin 1981, No. 245) on this drawing, modifying it in several ways that bring it closer to Pl. 5, reversed.

13. *MIL/ TON a Poem/ in 12[2?] Books/ The Author/ & Printer W Blake/ 1804/ To Justify the Ways of God to Men*

Call No. 54041. Relief etching (Pls. 2–12, 14–37, 39–40, 42–45) and white-line etching/engraving (Pls. 1, 13, 38, 41), ca. 1804–1808. 45 plates on 45 leaves: Pls. 1–45, lacking Pls. a–f.[18] Printed in grainy black ink, including the etching borders. The plates range in size between 13.5 x 9.5 cm. and 16.9 x 12 cm. Wove paper: Pl. 38 on a sheet 23.1 x 16.4 cm., all others 23.3 x 17 cm. Pls. 3, 8, 10, 29, 31, 36, 40 watermarked "J WHATMAN/ 1808"; Pls. 6, 24 watermarked "WH[ATMAN]/ 1[cut off]"; Pl. 23 watermarked "[WHA]TMAN/ [18]01."

Coloring: Designs and text areas tinted in bright, transparent watercolor washes (predominantly blue, yellow, pink, rose, brown, and green) with opaque black painted over some of the larger inked surfaces. Several plates (e.g., Pl. 2) are outlined around their etching borders in pen and ink. A few letters on some plates have been reinforced with pen and ink. Most plates are highlighted with small amounts of liquid gold. The lettering on Pls. 1, 29, and 33, and *"MILTON"* on Pl. 3, are painted in with gold. The plates are numbered, 1–45, by Blake in black ink above the top right corner.

Design Variants:
Pl. 1: The first digit of the number "12," etched in white line, is partly touched with gold, as is one of the swirling white lines right of the number. Since the second digit, like all letters on the plate, is completely filled in with gold, Blake may have intended to cancel the first digit by merging it into surrounding design elements. All copies of *Milton* are in 2 books.
Pl. 3: Second state ("That" in line 21 of copy A changed in the plate to "What"). Band of green (earth?) painted in between design and the text below.
Pl. 4: Eight stars drawn in sky with pen and ink.
Pl. 10: Rainbow painted over text (see "a bow/ Of varying colours," lines 14–15).
Pl. 16: Sky upper left painted orange and yellow, as though in flames or a sunset.
Pl. 23: "raving" in line 66 printed (accidentally?) as "roaring."
Pl. 24: Line 60 printed but then rubbed off the paper, leaving small fragments of the letters.
Pl. 29: Ink lines define the top and legs of transparent short pants on the figure.
Pl. 33: Pants added, as on Pl. 29.
Pl. 35: Yellow and rose burst of light emanates from the lower right corner and spreads over most of the text.
Pl. 36: Orange and yellow colors behind the trees lower right suggest, but do not clearly delineate, a rising sun (see "the dawn of day," line 6).
Pl. 39: Burst of yellow light descends from the top left corner.
Pl. 41: The eyes of the standing figure are retouched so that he seems to be looking down at the figure he supports rather than off to the right.
Pl. 43: First state? A line, printed from the plate, defines the left elbow of the woman far right and crosses over the left arm of the woman second from the right. This makes it appear that the woman far right is holding her own hands rather than extending her right hand to grasp the hand of her companion third from the right, as in all other impressions. Either this line was removed from the plate or not inked in other impressions.
Pl. 45: The center woman's eyes lack pupils, drawn in on all other impressions.

Binding: Disbound, but housed loose in the former binding of full brown calf, rebacked. Gilt frame on covers, stamped in gilt on front cover "MILTON/ BLAKE/-/ 1804." Leather bookplate of Robert Hoe on inside front cover. Quarter brown leather covering case, marbled boards, stamped in gold on spine, "BLAKE'S/ MILTON/ 1804." Binding order: Pls. 1–45.

Provenance: Perhaps the copy Thomas Griffiths Wainewright claimed on 28 March 1826 that he had "lately purchased,"[19] or the copy sold from the collection of Thomas Butts, Sotheby's, 26 March 1852, lot 53 (£9 to Toovey); Robert Hoe by 1895, sold Anderson Auction Co., 25 April 1911, lot 393 ($9000 to George D. Smith for Henry E. Huntington).

Exhibition: Grolier Club, 1905, No. 34, and 1919–20, No. 17; Fogg Art Museum, 1924; Huntington Art Gallery, 1953, 1978 (16 plates), 1979 (No. 5, Pls. 21 and 42).

Literature:
O. A. Bierstadt, *The Library of Robert Hoe* (New York: Duprat & Co., 1895), 199.
A Catalogue of Books in English later than 1700, Forming a Portion of the Library of Robert Hoe New York 1905 (N.p., 1905), 1:57.
Keynes 1921, 160–61 (copy B).
Keynes and Wolf 1953, 102–103 (copy B).
Bentley 1977, 305, 319 (copy B).

Reproduction:
Complete: *Milton,* ed. Kay Parkhurst Easson and Roger R. Easson (Boulder: Shambala Press, 1978), in color.
Pls. 1, 13, 15, 38: *Huntington Library Quarterly* 38 (1975):132–35.
Pls. 1, 13, 29, 38: Joseph Anthony Wittreich, Jr., *Angel of Apocalypse* (Madison: Univ. of Wisconsin Press, 1975), Figs. 6, 10, 14, 16.
Pls. 1, 15, 38: Paley 1978, Pls. 52 (Pl. 15 in color), 53, 56.
Pls. 1, 29, 36: *Essays in History and Literature,* ed. Heinz Bluhm (Chicago: Newberry Library, 1965), Pls. IV, VII.
Pls. 1, 13: *Blake in His Time* 1978, Pls. 99–100.
Pls. 1, 32: Raymond Lister, *William Blake* (London: Bell and Sons, 1968), Pls. 16–17.
Pl. 1: Hagstrum 1964, Pl. XXIV; *Blake Studies* 5 (Fall 1972):Pl. 11, and 6 (Fall 1973):Fig. 1; *The Visionary Hand,* ed. Robert N. Essick (Los Angeles: Hennessey & Ingalls, 1973), Fig. 159; *Blake: An Illustrated Quarterly* 11 (1978):244; *A Handbook to the Huntington Library Exhibition* (San Marino: Huntington Library, 1978), 84: *Sparks of Fire: Blake in a New Age,* ed. James Bogan and Fred Goss (Richmond: North Atlantic Press, 1982), 203.
Pl. 15: *Catalogue of the Library of Robert Hoe,* Anderson Auction Co., 24 April 1911, facing page 73; *Colby Library Quarterly* 17 (1981):159.

Pl. 21: Shelley Bennett and Patricia Crown, *English Book Illustration circa 1800*, catalogue of an exhibition (San Marino: Huntington Library, 1979), 12.

Blake typically dated his works according to their initial conception and/or execution rather than their printing or publication. Thus, the 1804 date etched on the title page of *Milton* probably records the beginning of Blake's work on the plates, or even some earlier stage of composition, not the completion date of the whole book. A work of 45–50 plates must have taken quite some time to finish, particularly since Blake was also working on *Jerusalem*, etched on 100 plates, during the same period. Indeed, Blake introduces the evil character "Hand" on Pls. 17 and 22 of his symbolic narrative, and this veiled reference to Robert Hunt must have followed his vicious review of Blake's illustrations to Blair's *Grave* on 7 August 1808.[20] Thus, the etching of *Milton* was in all probability not finished until the fall of 1808 at the earliest. The British Museum (A) and Huntington (B) copies were probably printed and colored shortly thereafter.

The recto of the front free endpaper of the Huntington copy is signed in pencil, "Robert Hoe." Hoe also inscribed the recto of the front flyleaf in pencil: "Blake is believed to have made twelve copies in all of this book. Three only are known to exist. This copy, one in the British Museum and one in the Lenox Library." Pasted below is a printed description of *Milton*, copy C, clipped from a Quaritch catalogue of 30 July 1882. A one-page list of the plates in the British Museum copy, probably written by William Muir, was formerly laid in the volume, but is now kept separately.

A group of four pen and ink sketches on one sheet, probably executed ca. 1785–90 (British Museum; Butlin 1981, No. 85), includes two figures later used on Pl. 38 of *Milton*. A pencil sketch of ca. 1804–1806 (Butlin 1981, No. 560) for Pl. 41, lacking only the rays of light around the standing figure's head and the hillock on the right, is in the Victoria and Albert Museum.

14. *For the Sexes/ The/ Gates/ of/ Paradise*

Call No. 57439. Intaglio etching/engraving, Pls. 1–18 first executed 1793 as *For Children: The Gates of Paradise*, revised ca. 1818–26 and Pls. 19–21 added. 19 plates on 19 leaves, lacking Pls. 19–20 ("The Keys of the Gates"). The plate marks range in size between 6.1 x 4.2 cm. and

9.5 x 7.4 cm.; the designs on Pls. 1, 3–18 range between 5 x 4.1 cm.
and 8.1 x 6.6 cm. Pls. 1, 3–10, 12–14, 16–18 bear an imprint, *"Pub-
lished by W Blake 17 May 1793"* or some version thereof, with *"Lambeth"*
added to the end of the imprint on Pls. 6, 9–10, 13–14, 16–17. Pls. 3–
18 are numbered in the plate lower left, 1–16. Printed in black ink on
wove paper, 34.3 x 24 cm. Pls. 2, 5, 7, 11–13, 16 watermarked "J
WHATMAN/ 1826."

Coloring: Touches of gray wash (diluted India ink?) have been added to Pls. 3
(between the tree and the woman's right arm), 4 (in the rain), 5 (rocks above
figure), 7 (in the flames and on both sides of the figure), 9 (background foliage
and ground between the largest figure's legs), 10 (sky and hill far left), 12
(water lower right), 13 (bearded man's knees and foliage left of him), 16 (fo-
liage upper left), 18 (upper left and right of center), and 21 (back of winged
figure).

Design Variants: All plates in final (second, third, fourth, or fifth) state.

Binding: Loose in original green paper wrapper. Three stab holes 4.3 cm. and
3.5 cm. apart from the top in both wrapper and plates. The holes indicate that
Pl. 2 (title page) was bound with the blank side as a recto, very probably with
the plate facing Pl. 1 (frontispiece).

Provenance: Frederick Tatham, given to "Mr. Bird" (see cover inscription,
below) on 23 October 1831; Thomas G. Arthur, sold Sotheby's, 15 July 1914,
lot 260 (£72 to George D. Smith for Henry E. Huntington).

Exhibition: Grolier Club, 1919–20, in No. 9; Fogg Art Museum, 1924.

Literature:
Keynes 1921, 177 (copy F).
Binyon 1926, Nos. 18–36.
The Gates of Paradise, Introductory volume by Geoffrey Keynes (London:
 Trianon Press for the Blake Trust, 1968), 1:50 (copy F).
Bentley 1977, 194, 202–203 (copy F).

Reproduction:
Complete: *The Gates of Paradise* (London: Trianon Press for the Blake Trust,
 1968), volume 3. Pls. 19–20 added from another copy.
Pls. 5, 7: Essick 1980, Figs. 186–87.
Pl. 8: W. J. T. Mitchell, *Blake's Composite Art* (Princeton: Princeton Univ. Press,
 1978), Fig. 57.

Pl. 13: *Huntington Library Quarterly* 37 (1947):157.
Pls. 17, 21: Hagstrum 1964, Pls. II, V.

Blake appears to have first reworked his 1793 plates of *For Children: The Gates of Paradise*, and added Pls. 19–21, in about 1818, the date of the watermarks in a copy of *For the Sexes* in the British Museum (B). The multiple states of the plates and the 1825 and 1826 watermarks in all other copies suggest that Blake continued to work on the plates over a considerable period shortly before his death in August 1827. Elizabeth Mongan has claimed that it is "highly probable that the re-engraving, in many cases showing a crudity hardly to be expected from Blake himself, was done by Tatham or at his request."[21] I can find no evidence to substantiate this view. Bentley 1977, 196–97, argues that all copies on large sheets of 1826 paper, including the Huntington's, were printed shortly after Blake's death by his widow or by Frederick Tatham, who acquired Blake's copperplates and printed from them. These copies (F-L) also lack at least one plate. Posthumous impressions of Blake's relief etchings can usually be identified by their flat, smooth ink and heavy printing pressure which distinguish them from Blake's characteristically reticulated, granular ink and delicate printing. It is very difficult, however, to identify the printer of an intaglio plate. Nor can one confidently identify a colorist based only on small patches of gray wash (see *Coloring*, above). Yet nothing in the physical evidence of the Huntington impressions or their recorded history would exclude the possibility that they (and others on 1826 paper) were pulled by Blake in the last year or two of his life and assembled into incomplete copies by Mrs. Blake or Tatham.

The outside front wrapper of the Huntington copy is inscribed in ink, "Frederick Tatham/ from[deleted]/ To Mr. Bird./ on his attendance at the Funeral/ Oct. 23.rd 1831-/ being the day on which the/ widow of the author was/ Buried in Bunhill Fields/ Church Yard." Pls. 2–18, 21 are numbered in pencil, upper right, 2–19, with the title page (Pl. 2) numbered "1" on the blank side (formerly bound as the recto).

For Children: The Gates of Paradise began as a series of sketches Blake made ca. 1790–92 in his *Notebook* (British Library; Butlin 1981, No. 201), from which he selected 17 designs for engraving and added a

title page. The relevant sketches are on pages 15, 19, 34, 40, 45, 52, 58–
59, 61, 63, 68–69, 71, 91, 93–95. There are as well a variant drawing of,
but perhaps a preliminary for, Pl. 10 (British Museum; Butlin 1981,
No. 206), two early drawings of Pl. 14 (Victoria and Albert Museum
and Hamburg Kunsthalle; Butlin 1981, Nos. 207–208), a wash draw-
ing of ca. 1780–85 similar to Pl. 15 (Royal Collection, Windsor; Butlin
1981, No. 135), a pencil sketch of the figure on Pl. 17 (Liverpool City
Libraries; Butlin 1981, No. 131), and two early drawings related to Pl.
18 (Pierpont Morgan Library and collection of Anthony Wolf; Butlin
1981, Nos. 133–34). The old man entering a doorway on Pl. 17 appears
in *America*, Pl. 14 (see No. 6, above).

15. For the Sexes: The Gates of Paradise, Pl. 12.

Call No. 49000, volume 5. Intaglio etching/engraving, first executed
1793, revised ca. 1818–26. Inscribed in the plate below the design,
"Help! Help!/ Publishd by W Blake 17 May 1793" and numbered "10"
in the plate, lower left. Image 5.7 x 4.3 cm., plate mark 6.6 x 5 cm.
Printed in black ink on wove paper, 10.6 x 8.5 cm.

Coloring: None.

Design Variants: Third (final) state, with the last few strokes added to the
water, lower left and right.

Binding: Pasted in a window cut in leaf 715 of volume 5 of the extra-illustrated
Kitto Bible.

Provenance: Acquired at an unknown time by either J. Gibbs or Theodore Irwin
and bound in the Kitto Bible, for the provenance of which see "The Conver-
sion of Saul" (Part I, section D, No. 3).

Literature:
Wittreich 1970, 52, wrongly described as a plate from *For Children: The Gates of
Paradise*.
Bentley 1977, 195, 204.

Reproduction: None.

For a discussion of dating, see No. 14, above. The mounting sheet of
this single impression is inscribed in red ink, "Blake fecit," below the
bottom left corner of the print.

16. THE GHOST of ABEL/ *A Revelation In the Visions of Jehovah/ Seen by William Blake*

Call No. 55345. Relief etching, 1822. Pls. 1–2, both 16.7 x 12.4 cm. Printed, including the etching borders, in black ink on two leaves of wove paper, 34.5 x 24.1 cm., top edges deckled.

Coloring: Perhaps touched with black (India?) ink to improve weakly printed areas on the top and bottom etching borders of Pl. 1, and upper right and lower left in the design below the text on Pl. 2.

Design Variants: None.

Binding: Loose in full green morocco folder, stamped in gilt on upper cover, "THE GHOST OF ABEL /-/ WILLIAM BLAKE." No evidence of prior binding.

Provenance: John Linnell[22], trustees of the Linnell estate, sold Christie's, 15 March 1918, lot 200 (£29.8s. to Francis Edwards); "a Prominent Pennsylvania Collector" (Col. Henry D. Hughes, according to Keynes and Wolf 1953, 119), sold American Art Association, 22 April 1924, lot 70 ($400 to James F. Drake for Henry E. Huntington).

Exhibition: This or the copy (B) in the Keynes collection, Fitzwilliam Museum, lent to The National Gallery [of] British Art, 1913, No. 103; Manchester Whitworth Institute, 1914, No. 93; Nottingham Art Museum, 1914, No. 70; National Gallery of Scotland, 1914, No. 50. Both copies (B, C) were then in the possession of the Linnell trustees; only Pl. 2 was shown in all four exhibitions.

Literature:
Keynes 1921, (copy C).
Keynes and Wolf 1953, 119 (copy C).
Bentley 1977, 207, 209 (copy C).

Reproduction:
Complete: *Blake in His Time* 1978, Pls. 48–49.
Pls. 1, 2 (tailpiece only): *William Blake's Writings,* ed. G. E. Bentley, Jr. (Oxford: Clarendon Press, 1978), 1:669, 674.
Pl. 2: Robert N. Essick, *William Blake's Relief Inventions* (Los Angeles: W. & V. Dailey, 1978), Pl. 7.

Blake probably printed all copies of *The Ghost of Abel* shortly after its etching in 1822, the date etched at the bottom of Pl. 2. He seems to have given or sold a few copies to friends and patrons, such as Linnell and Thomas Butts, usually in conjunction with *On Homers Poetry* [and]

on Virgil, a single relief plate etched at about the same time.

A sheet of pencil drawings in the British Museum includes preliminary sketches for the running figure, reversed, in the second small vignette from the top in the left margin of Pl. 2 and for the two lowest vignettes on Pl. 2 (Butlin 1981, No. 585). For designs related, at least in subject, to the illustration below the text on Pl. 2, see Part I, section C, No. 10.

B. Typographic Publications

Described in this section are first editions of Blake's writings originally published in conventional typography in Blake's lifetime. Reprints of his writings originally published as etched and/or engraved works (section A, above) are not included. *Literature* here and in section C includes only bibliographic descriptions.

1. POETICAL/ SKETCHES./ - / By W. B./ - / LONDON:/ Printed in the Year M DCC LXXXIII.
Call No. 57432.

Collation: 4° printed in half sheets: [A]²B-K⁴.

Contents: P. [i], title. P. [ii], *blank*. P. [iii], advertisement. P. [iv], *blank*. Pp. [1]-70, text. Pp. [71–72], *blank*.

Paper: Laid, 21.3 x 12.9 cm., chain lines 2.8 cm. apart.

Binding: Full citron morocco by "the Club Bindery 1908" (according to a stamp at the foot of the inside front cover) for Robert Hoe.[23] Gilt frames on the covers, stamped in gilt on the spine, "BLAKE/ - / POETICAL SKETCHES/ LOND./ 1783." All edges gilt. With the leather bookplate of Robert Hoe on the inside front cover.

Provenance: Charles Tulk; Edward Duperner, sold Sotheby's, 20 June 1906, lot 937, "original light blue cloth boards, with red leather label at back" (£109 to B. F. Stevens); Robert Hoe by 1908, sold Anderson Auction Co., 25 April 1911, lot 389 ($725 to George D. Smith for Henry E. Huntington).

Literature:
Keynes 1921, 76–81 (copy C).
Margaret Ruth Lowery, "A Census of Copies of William Blake's *Poetical*

Sketches, 1783," *Library* 17 (1936):354–60 (copy C).
Michael Phillips, "Blake's Corrections in *Poetical Sketches*," *Blake Newsletter* 4 (1970):40–47 (copy C).
Keynes 1971, 31–45 (copy C).
Bentley 1977, 343–54 (copy C).

The title page is inscribed by Blake in ink, "To Charles Tulke Esq^re / from William Blake." He also emended the text of this copy by hand as follows:

"To Winter," page 4, line 11: "in" deleted from "in his hand" by crossing it through with pen strokes.
"Fair Elenor," page 7, line 6: "s" of "cheeks" deleted by crossing it through with vertical pen strokes.
"Fair Elenor," page 9, line 19: "y" of "thy" partly rubbed away. Perhaps the beginning of an emendation or a later accident not connected with Blake's corrections.
"Song," page 12, line 16: "her" changed to "his" by writing over the printed letters in pen and ink.
"Mad Song," page 15, line 7: "beds" deleted with horizontal strokes and "birds" written above in ink.

According to J. T. Smith, Blake's friends John Flaxman and the Rev. Anthony Stephen Mathew paid for printing this first volume of Blake's poetry.[24] Michael Phillips has argued convincingly, on the basis of typographic similarities, that the printer was John Nichols.[25] Complete facsimiles were published by William Griggs in 1890, based on an unidentified copy, and by Noel Douglas in 1926, reproducing a copy (A) in the British Museum.

2. *Poetical Sketches*, 1783, a second copy.
Call No. Dev. 8vo. 30.

Collation and *Contents:* See No. 1, above.

Paper: As for No. 1, 19.1 x 10.4 cm.

Binding: Bound as the first of five unrelated works in full calf with "PLAYS/ VOL. 30" and the duke of Devonshire's monogram (WS in a D) stamped in gilt on the spine. Bookplate of the duke of Devonshire on the inside front cover. Front free flyleaves and flyleaf following *Poetical Sketches* watermarked "G & R TURNER/ 1825." Manuscript table of contents listing the six works bound together on second front flyleaf.

Provenance: John Flaxman, who sent it as a gift to William Hayley on 26 April 1784[26]; the duke of Devonshire by ca. 1825; the ninth duke of Devonshire, sold with his library in January 1914 to Henry E. Huntington.

Literature: Copy S in the second through the fifth works listed for No. 1, above.

The title page is inscribed, in very faded ink, "For [?] William Hale[y?]/From J Flax[man]," partly trimmed off as indicated. Following "W.B." in the printed title are the letters "lake" in pencil by another (much later?) hand. Blake emended the text of this copy by hand as follows:

"To Winter," page 4, and "Mad Song," page 15: As for No. 1, above.
"Fair Elenor," page 7, line 6: "s" of "cheeks" rubbed off the paper.
"Fair Elenor," page 9, line 19: "I am" scraped away and "behold" substituted in ink in imitation of the text font.
"Mad Song," page 15, line 4: "unfold" changed to "infold" by scraping away the left vertical of "u" and placing a dot over the right vertical.
"King Edward the Third," page 29: *"before/it"* deleted with horizontal pen strokes from the description of the scene.

For publication information, see No. 1, above. The title page of this copy is reproduced in *William Blake's Writings*, ed. G.E. Bentley, Jr. (Oxford: Clarendon Press, 1978), 2: facing 874.

3. THE/ FRENCH REVOLUTION./ A POEM,/ IN SEVEN BOOKS./ BOOK THE FIRST./ LONDON:/ PRINTED FOR J. JOHNSON, N$^{\text{O}}$ 72, ST PAUL'S CHURCH-YARD./ MDCCXCI./ [PRICE ONE SHILLING.]
Call No. 57440. The only copy known.

Collation: 4°:[A]²B-C⁴

Contents: P. [i], title. P. [ii], *blank*. P. [iii], advertisement. P. [iv], *blank*. Pp. [1]-16, text.

Paper: Wove, 28.3 x 22.9 cm., uncut. Some foxing, mostly in margins.

Binding: Blue paper wrappers, detached but retained with the leaves sown through three holes, 2.9 cm. and 2.9 cm. apart. Housed in blue cloth box, labelled on the spine "BLAKE—THE FRENCH REVOLUTION—1791."

Provenance: John Linnell; trustees of the Linnell estate, sold Christie's, 15 March 1918, lot 191 (£131.5s. to George D. Smith for Henry E. Huntington).

Exhibition: Grolier Club, 1919–20, No. 7; Fogg Art Museum, 1924.

Literature:
Keynes 1921, 81–83, title page reproduced with inscriptions deleted.
Bentley 1977, 205–207.
William Blake's Works in Conventional Typography, ed. Bentley (Delmar: Scholars' Facsimiles, 1984), complete reproduction.

The title page is inscribed in ink, upper left, "John Linnell. Red Hill [his residence] 1860." "By W^m BLAKE" is written in ink between the third and fourth lines of the printed title, perhaps as a mock-up for inclusion in a revised setting. This copy appears to be page proofs because of its uniqueness, the number of typographic errors, the faulty register of some forms, and the uneven inking and extremely heavy printing that almost cuts some letters through the thin paper.[27] The last line of the advertisement, page [iii], and the last line of the text ("END OF THE FIRST BOOK," page 16) are not properly centered. There is no evidence that any further copies were printed. The advertisement states that "the remaining Books of this Poem are finished, and will be published in their Order," but there is no further record of any such additional books. The reason for the withdrawal of the work is not known, nor do we know if that decision was made by Blake or his publisher, Joseph Johnson.[28]

4. EXHIBITION/ oF/ Paintings in Fresco,/ Poetical and Historical Inventions,/ By. Wm. BLAKE. / - / / . . . for Public Inspection and for Sale by Private/ Contract, at / *No. 28, Corner of BROAD STREET, Golden-Square.* / - / *"Fit Audience find tho' few"* MILTON./ - / Admittance 2s. 6d. each Person, a discriptive Catalogue included/ = / Watts & Co. Printers, Southmolton St.
Call No. 78637.

Collation: folio pamphlet.

Contents: P. [1], title. P. [2], text, P. [3], *blank.* P. [4], *blank.*

Paper: Wove, full unfolded sheet 24 x 36.2 cm.

Binding: Unbound. Folded to make an envelope for Blake's letter of 1809 to Ozias Humphry.[29] Remnants of sealing wax are on the left margins of pages [1] and [4]. Housed in a green imitation leather folder, stamped in gilt on the front cover, "EXHIBITION OF PAINTINGS IN FRESCO/ - / WILLIAM BLAKE/ - / 1809."

Provenance: Ozias Humphry in 1809; Alexander C. Weston by 1876; Mrs. Anderdon Weston[30]; "a noted Philadelphia Collector" (Col. Henry D. Hughes, according to Bentley 1977, 165), apparently sold with Blake's letter to Humphry, American Art Association, 12 April 1923, lot 128[31]; acquired by April 1926 from an unknown source by the Huntington Library.

Exhibition: Burlington Fine Arts Club, 1876, No. 320, lent by Alexander Weston.

Literature:
Keynes 1921, 84, copy (B) in the Bodleian Library reproduced.
Bentley 1977, 164–65 (copy A).
William Blake's Works in Conventional Typography, ed. Bentley (Delmar: Scholars' Facsimiles, 1984), complete reproduction of the Huntington copy.

Following the penultimate line of text on the title page, Blake has added in ink a comma and "Containing/ Ample Illustrations/ on Art." He has also added "May 15. 1809" in ink at the end of the text on page [2], lower left. These same annotations appear in the only other known copy (B, Bodleian Library). Blake has addressed page [4], forming the outside of the envelope, "Ozias Humphrey Esqre/ Sloane Street" sideways in ink. "Wm Blake" is written in pencil by an unidentified hand on the title page, upper left.

See No. 5, below, for the catalogue to the exhibition for which this work is a prospectus.

5. A/ DESCRIPTIVE CATALOGUE/ OF/ PICTURES,/ *Poetical and Historical Inventions,/* PAINTED BY/ WILLIAM BLAKE,/ IN/ WATER COLOURS,/ BEING THE ANCIENT METHOD OF/ *FRESCO PAINTING RESTORED:/* AND/ DRAWINGS,/ *FOR PUBLIC INSPEC-TION,/* AND FOR/ Sale by Private Contract,/ = / *LONDON:/* Printed by D. N. Shury, 7, Berwick-Street, Soho,/ For J. BLAKE, 28, Broad-Street, Golden-Square. / - /1809.
Call No. 57433.

Collation: 12° gathered and signed in sixes: [A]²(= G₅,₆)B-G⁶(-G₅,₆)

Contents: P. [i], title. P. [ii], Conditions of Sale. Pp. [iii]-iv, Preface. Pp. [1]-66, text. Pp. [67–68], index. Colophon, P. 66: "D. N. SHURY, PRINTER, BERWICK-STREET,/ SOHO, LONDON."

Paper: Wove, 17.7 x 10.3 cm. B₁,D₁ watermarked "1807"; B₃,D₃ watermarked "A P."

Binding: Full brown morocco by F. Bedford, gilt frames on covers, and stamped in gilt on the spine, "CATALOG/ OF/ BLAKE'S/ PICTURES/ LOND./ 1809."

Provenance: Perhaps Robert Arthington, sold Sotheby's, 17 May 1866, lot 21 (£1.9s. to James); Thomas Glen Arthur, sold Sotheby's, 15 July 1914, lot 45, bound as above (£24.10s. to George D. Smith); sold by Smith for $350 to Henry E. Huntington, probably shortly after the 1914 auction and certainly no later than 1920.

Literature:
Keynes 1921, 85–89 (copy D), title page of an unidentified copy reproduced.
Keynes 1971, 66–73 (copy D).
Bentley 1977, 134–41 (copy D).

Blake has written in ink just above the double rule on the title page, "At N 28 Corner of Broad Street Golden Square." On page 64, Blake has crossed through "of/ want" in "the idea of/ want in the artist's mind" and written "want of" in ink above "the idea," thus correcting the misprint to "the want of idea/ in the artist's mind." Laid in the volume is a carbon of a typed dealer's description (probably Smith's) of the work priced at $350. The exhibition was held at the home of Blake's brother, the "J[ames] Blake" named in the title.

C. Annotations in Books

1. John Caspar Lavater. *Aphorism on Man: Translated* [by Henry Fuseli] *from the Original Manuscript.* London: J. Johnson, 1788. Pages vi + [ii] + 224.
Call No. 57431.

Blake has signed his name in ink on the title page and drawn a heart around it and "LAVATER" in the printed title. Blake has annotated

approx. 210 of the 643 aphorisms with brief comments, X marks (as suggested by the last aphorism), underlining, and longer comments on two concluding flyleaves. Aphorisms 20–21, 25, 36, 54, 59, 61, 66–67, 96, 151, 165, 248, 285, 287, 503, 532, 562, 604–605, 609, 612, and 629 have marks or comments in pencil—or perhaps poorly written ink in the case of some of the simple diagonal marks. All other annotations are in ink, probably written with two different pens—or one pen allowed to become dull and then sharpened. These differences suggest that Blake annotated the book on more than one occasion. Many of the pen strokes Blake used to underline printed passages did not deposit ink along their entire length, and thus register only as slight indentations in the paper. Blake has also corrected the text according to the errata page. There are notes written in brown ink in an unidentified hand next to aphorisms 21, 280, and 384. The pencil addition to aphorism 503 looks like Blake's later handwriting, similar to the examples in Nos. 2 and 3, below. The pencil inscription at the top of page 220 is probably not by Blake.

Some of the offsets from Blake's annotations indicate that he wrote them when the book was still in unbound sheets. He was involved in the production of the volume, having engraved the frontispiece after a design by his friend Henry Fuseli. Blake probably wrote at least the ink annotations shortly after the book's publication.

Binding: Full ocher morocco by R. W. Smith for Robert Hoe, whose leather bookplate is pasted to the inside front cover. Top edge gilt, others uncut. Stamped in gilt on the spine, "APHORISMS/ ON/ MAN/ LAVATER/ LONDON/ 1788." A note by Hoe is pasted to the front flyleaf: "This copy which was Blake's, had to be rebound; it was in broken sheepskin, & more than dirty. All the writing by Blake on the fly leaves is carefully preserved. R.H."

Provenance: Samuel Palmer[32]; a descendant of Palmer(?); Robert Hoe, sold Anderson Auction Co., 25 April 1911, lot 396 ($1525 to George D. Smith for Henry E. Huntington).

Literature:
Keynes 1921, 49.
Bentley 1977, 690–91.
Johann Caspar Lavater, *Aphorisms on Man: A Facsimile Reproduction of William Blake's Copy of the First Edition,* ed. R. J. Shroyer (Delmar: Scholars' Facsimiles, 1980). Some of Blake's annotations are not fully reproduced; see

the review by Jenijoy La Belle in *Blake: An Illustrated Quarterly* 16 (1982): 126–28.

2. Richard Watson. *An Apology for the Bible, in a Series of Letters, Addressed to Thomas Paine.* Eighth Edition. London: T. Evans, 1797. Pages [iv] + 120.
Call No. 110260.

Blake has written extensive annotations in the margins, particularly on the first 22 pages. The comments above the beginning of the preface and on pages 31, 34, and 95 are in pencil, the remainder in ink. This difference suggests that Blake annotated the volume on two different occasions. Blake's reference to "this year 1798" on the verso of the title page provides a definitive date for at least the ink annotations. The only inscription not by Blake is the signature "S. Palmer" on the title page. The title page and verso of the last leaf are very soiled, suggesting that the volume was unbound for some years.

Binding: Full blue morocco by F. Bedford. Top edge gilt, others uncut. Stamped in gilt on the spine, "WATSON'S/ APOLOGY/ FOR THE/ BIBLE/ W./ BLAKES/ MS./ NOTES."

Provenance: Samuel Palmer; a descendant of Palmer(?); Thomas Glen Arthur, sold Sotheby's, 15 July 1914, lot 44 (£47 to George D. Smith for Henry E. Huntington).

Exhibition: Grolier Club, 1919–20, No. 55a; Fogg Art Museum, 1924.

Literature:
Keynes 1921, 50–51.
Bentley 1977, 699–700.
William Blake, *Annotations to Richard Watson*, ed. G. Ingli James, Regency Reprints III (Cardiff: University College, 1984.) A complete facsimile with transcription.

3. Robert John Thornton. *The Lord's Prayer, Newly Translated from the Original Greek, with Critical and Explanatory Notes.* London: Sherwood and Co., Cox, and Thornton, 1827. Pages [ii] + 9.
Call No. 113086.

Most of Blake's marginal annotations in this pamphlet were first

written in pencil and then written over in ink. The exceptions are 5 lines in pencil only and 2 in ink only on the verso of the title page, a long annotation on page 3 in pencil only, and much of the annotation on the blank verso of page 9 in pencil only. The inscriptions on the verso of page 9 were partly copied out by an unidentified hand on the inside of the back wrapper. The frontispiece is dated in the imprint 31 March 1827. If that was the actual date of publication, then Blake must have written the annotations between April 1827 and his death on 12 August 1827. The pencil note on the verso of the frontispiece is not by Blake.

The annotations have often been published out of proper sequence. They are properly arranged in Blake 1982, 667–70, and in *William Blake's Writings*, ed. G.E. Bentley, Jr. (Oxford: Clarendon Press, 1978), 2:1514–18.

Binding: Loose in original blue paper wrappers with the title label on front cover. Housed in a blue cloth box stamped in gilt on the spine, "LORD'S PRAYER. ENGLISH—DR. THORNTON'S TRANSLATION—1827."

Provenance: John Linnell by 1828[33]; trustees of the Linnell estate, sold Christie's, 15 March 1918, lot 204 (£50.8s. to George D. Smith for Henry E. Huntington).

Exhibition: Grolier Club, 1919–20, No. 55b; Fogg Art Museum, 1924.

Literature:
Keynes 1921, 55.
Bentley 1977, 698–99.

D. Letters

All letters in the collection are described in Keynes 1921, 58, 68–73, and Bentley 1977, 270–83; and described and printed in *The Letters of William Blake*, ed. Geoffrey Keynes, 3rd ed. (Oxford: Clarendon Press, 1980). Nos. 3–16 were sold by the trustees of the John Linnell estate, Christie's, 15 March 1918, lots 208–209, 213–14 (£30.10s., £25.4s., £26.5s., and £84 respectively to George D. Smith for Henry E. Huntington). Nos. 1 and 17, although not listed in the Linnell auction catalogue, were acquired at the same time and probably from the same source.[34] Nos. 3–17 were exhibited at the Grolier Club, 1919–20, in

No. 56, and at the Fogg Art Museum, 1924. Letter No. 3 is in pencil; all others are in ink. For the envelope Blake addressed to Ozias Humphry in 1809, see Part II, section B, No. 4.

1. To Willey Reveley. Call No. HM 20020. Not dated; no postmark. One sheet, 18.9 x 23.2 cm., folded into 2 leaves, with Blake's letter on the second recto and a letter by Reveley to Blake, dated "Oct 18," on the second verso. Watermarked "CURTEIS & SON," mostly trimmed off. The first leaf, bearing the address to Blake on its recto, is torn and with missing pieces, not affecting the text. Reveley's letter is postmarked "C OCT/7," with the remainder cut off.

Blake refers to his willingness to engrave for Reveley "by the end of January" some illustrations for James Stuart and Nicholas Revett, *The Antiquities of Athens.* Volume 3 (1794) of that work (see Part III, section B, No. 48) includes 4 plates by Blake dated 3 April 1792 in the imprints. Thus, Blake must have written his note, a direct reply to Reveley's letter, shortly after 18 October 1791.

2. To William Hayley. Call No. HM 20063. Dated "Sept 16. 1800"; postmarked "BRIDGE/ WESTMINSTER A.S.E./ 16/ 800." One sheet, 19.5 x 32.1 cm., folded into 2 leaves, with Blake's letter on the first recto and the address on the second verso. Watermarked "179[remainder cut off]." Mounted in a window cut in a sheet of paper watermarked "J WHATMAN/ 187[?]3." The letter is reproduced in James Thorpe, *William Blake: The Power of the Imagination* (San Marino: Huntington Library, 1979), 12; and in Thorpe, *Gifts of Genius* (San Marino: Huntington Library, 1980), 118.

Provenance: Sold from "the Hayley Correspondence," Sotheby's, 20 May 1878, lot 3 (£2.17s. to Webster); Louis J. Haber, sold Anderson Auction Co., 9 December 1909, lot 47 ($55 to G. H. Richmond); acquired by the Huntington Library no later than March 1936.

3. To John Linnell. Call No. HM 20019. Inscribed "12 O Clock/ Wednesday"; no postmark. One leaf, 16 x 16.3 cm., with Blake's letter on one side and the address on the other. Watermarked "1818." Blake's reference to visiting Lahee, the printer of Blake's Job engravings, suggests a date between March 1825, when Lahee first

pulled proofs of the plates, and early in 1826, when he printed the first set for general sale.[35] The letter is reproduced in the two books listed under No. 2, above, 14 and 120 respectively.

4. To John Linnell. Call No. HM 20013. Inscribed "Mon[deleted] Tuesday Night"; no postmark. One leaf, 13.4 x 16.7 cm., with Blake's letter on one side and the address on the other. Blake refers to "The D of C" (apparently Gerrard Andrewes, Dean of Canterbury, who died 2 June 1825) and to either the death or ill health of "Ld L." (probably Lord Lilford, who died 4 July 1825). Blake also thanks Linnell for "Two Pounds," apparently recently received. We know from Linnell's account book that he paid £2 to Blake on 6 June 1825 (Bentley 1969, 588). Thus the most probable date for this letter is the first Tuesday after the dean's death, 7 June 1825.[36]

5. To Mrs. John Linnell (nee Mary Ann Palmer). Call No. HM 20017. Dated "11 October 1825"; postmarked "TP STRAND CO," "8.MORN.8/ 12.OC/ 1825," and "10.F.NO [remainder obscured]/ OC.12/ 1825." One sheet, 19.8 x 31.3 cm., folded into 2 leaves, with Blake's letter on the first recto and the address on the second verso. Now unfolded and mounted on linen.

6. To John Linnell. Call No. HM 20011. Dated "10 Novr 1825"; postmark "TP/ STRAND CO" and "8.MORN.8/ 11.NO/ 1825." One leaf, 16.3 x 20.3 cm., with Blake's letter on one side and the address on the other. Crown watermark, mostly trimmed off.

7. To John Linnell. Call No. HM 20005. Dated "Feby 1. 1826"; postmark "T.P/ STRAND CO" and "4.EVEN/ 31/ JN/ 18[remainder obscured]"—i.e., 31 January 1826. One sheet, 21.1 x 33.1 cm., folded into 2 leaves with Blake's letter on the first recto and verso and the address on the second verso. Watermarked "RUSE & TURNERS/ 1810."[37]

8. To Mrs. John Linnell (nee Mary Ann Palmer). Call No. HM 20016. Inscribed "Sunday Morning"; no postmark. One leaf, 21.1 x 16.5 cm., with Blake's letter on one side. The left margin is torn, suggesting that the sheet was originally folded into 2 leaves and addressed on the

second verso, now missing. In his letter of 31 January 1826 (No. 7, above), Blake states that he "will go to Hampstead to see Mrs Linnell on Sunday." This letter was evidently written in lieu of such a visit, informing Mrs. Linnell of her husband's departure on a coach journey mentioned prospectively in the letter of 31 January. Thus, the date of this letter is probably Sunday, 5 February 1826.

9. To John Linnell. Call No. HM 20015. Dated "May 19 1826"; postmark "T.P/ STRAND CO" and "10.F.NOON.10/ [central letters obscured]/ 1826." One leaf, 20.1 x 16.6 cm., with Blake's letter on one side and the address on the other.

10. To John Linnell. Call No. HM 20007. Dated "5 July 1826"; no postmark. One leaf, 21.1 x 16.6 cm., with Blake's letter on one side and the address on the other.

11. To John Linnell. Call No. HM 20010. Dated "July 16. 1826"; postmark "T.P/ STRAND CO" and "[number obscured].NOON.10/ 17.JY/ 1826." One leaf, 21 x 16.7 cm., with Blake's letter on one side and the address on the other. Watermarked "RUSE & TURNERS/ 1810." Repaired tear in left margin.

12. To John Linnell. Call No. HM 20008. Dated "29 July 1826"; postmark "T.P/ STRAND CO" and "2.A.NOON.2/ 29.JY/ 1826." One leaf, 20.9 x 16.6 cm., with Blake's letter on one side and the address on the other.

13. To John Linnell. Call No. HM 20006. Dated "Augst 1. 1826"; postmark "T.P/ STRAND CO" and "10.F.NOON.10/ 2.AU/ 1826." One leaf, 20.8 x 16.5 cm., with Blake's letter on one side and the address on the other.

14. To John Linnell. Call No. HM 20009. Dated "Jany 27 1827"; no postmark. One leaf, 20.7 x 16.6 cm., with Blake's letter on one side and the address on the other.

15. To John Linnell. Call No. HM 20018. Not dated; no postmark. Written on one side of a slip of wove paper, 4 x 28.5 cm., with "J

Linnell Esq^{re}" on the verso. Blake's comment that he "calld this Morning for a Walk" suggests that he left this brief note at Linnell's home while he was out. Blake refers to "4 Plates," evidently the 4 Dante engravings he mentions in a letter probably of February 1827. This note has been tentatively dated by all recent authorities to the same month and year.

16. To John Linnell. Call No. HM 20012. Dated "25 April 1827"; no postmark. One leaf, 20.7 x 16.6 cm., with Blake's letter on one side and the address on the other.

17. To John Linnell. Call No. HM 20014. Dated "3 July 1827"; no postmark. One sheet, 16.7 x 20.6 cm., folded into 2 leaves with Blake's letter on the second recto and the address on the first recto.

Notes

1. See Essick 1980, 85–135; Joseph Viscomi, *The Art of William Blake's Illuminated Prints* ([Manchester]: Manchester Etching Workshop, 1983).

2. As Blake called them in a prospectus "To the Public" of 10 October 1793 (Blake 1982, 693). Two later illuminated works, *The Book of Los* and *The Book of Ahania* (both 1795), were executed in conventional intaglio etching. *For Children: The Gates of Paradise* (1793; revised and reissued as *For the Sexes: The Gates of Paradise*, ca. 1818) is another intaglio work generally grouped with the illuminated books.

3. Blake 1982, 272.

4. The Keynes impression is reproduced in the complete reproductions of 1970, 1974, and all three of 1978.

5. This could not be Hoe's other copy (A) of *Songs of Innocence*, acquired no earlier than 1897.

6. The date and price are recorded in Edwin Wolf 2nd and John F. Fleming, *Rosenbach: A Biography* (Cleveland: World Publishing, 1960), 74, which also reports that Rosenbach found the book "on Dodd & Livingston's shelves priced at $280." Keynes 1921, 106, Keynes and Wolf 1953, 24, and Bentley 1977, 129, report that the volume belonged to E. Dwight Church before Rosenbach acquired it, but I can find no independent confirmation of this. There are no Blake materials listed in *A Catalogue of Books Consisting of English Literature . . . Forming a Part of The Library of E. D. Church*, ed. George Watson Cole, 2 volumes (New York: Dodd, Mead and Company, 1909). Rosenbach's receipt, formerly laid in the volume but now kept separately, is undated and unpriced.

7. I can find no independent confirmation of Church's ownership, first noted in Keynes 1921, 137. See also note 6. A one-page dealer's description of the book (by Rosenbach?) was formerly laid in, but is now kept separately.

8. See Essick 1980, 127.

9. Blake's receipt, now in a private collection, is reprinted in Bentley 1969, 575.

10. According to Keynes and Wolf 1953, 57, but I can find no independent confirmation of this. See also note 6.

11. Bentley 1977, 382 note 2, suggests that the Huntington copy (E) and another (F, collection of Paul Mellon) printed in more than one color "seem to have been printed early but coloured late."

12. The anonymous parody is printed in G. E. Bentley, Jr., "A Piper Passes: The Earliest Parody of Blake's 'Songs of Innocence'," *Notes and Queries* 209 (1964):418–19.

13. Described in Bentley 1977, 415, as part of copy G (dispersed).

14. This is given as the binding order in Hoe's 1905 collection catalogue (see *Literature*, above), by Keynes and Wolf 1953, 60, and by Bentley 1977, 379, all recorded before the leaves were disbound.

15. See Essick 1980, 129–30.

16. Since there are only 3 full-page designs in *The Song of Los*, the cataloguer miscounted either these or the total number of leaves. If the latter, then "Albion rose" (see *Binding*, above) may have been part of this lot.

17. See Essick 1980, 128–29.

18. Pls. a–e are found in only the New York Public Library (C) and Library of Congress (D) copies; Pl. f is present only in the latter. The Huntington copy is complete as numbered and issued by Blake.

19. See Bentley 1969, 327.

20. Reprinted from Hunt's *Examiner* in Bentley 1969, 195–97. My comments on dating accord with the discussion in Bentley 1977, 306–308.

21. *William Blake 1757–1827*. A Descriptive Catalogue [by Edwin Wolf 2nd and Elizabeth Mongan] of an Exhibition of the Works of William Blake Selected from Collections in the United States (Philadelphia: Museum of Art, 1939), 63.

22. Bentley 1977, 209, writes that this may be the copy lent by Herbert H. Gilchrist to the Pennsylvania Academy of the Fine Arts exhibition of 1892, No. 146, Pl. 1 only, but it seems most unlikely that Linnell's heirs or trustees would have acquired Blake materials ten or more years after Linnell's death. It is far more likely that Linnell acquired *The Ghost of Abel* directly from Blake or Mrs. Blake.

23. According to a brief description of the volume Hoe wrote in his copy (now in the Huntington Library) of the 1905 catalogue of his collection, he paid $33.58 in 1909 for this binding.

24. *Nollekens and His Times* (London: Henry Colburn, 1828), 2:455–56 (reprinted in Bentley 1969, 456). Smith incorrectly wrote "the Rev. Henry Mathew," the son of Blake's patron.

25. "William Blake and the 'Unincreasable Club': The Printing of *Poetical Sketches*," *Bulletin of the New York Public Library* 80 (1976):6–18.

26. The inscription (see below) on the title page suggests that this is the "Pamphlet of Poems" which Flaxman said in his letter of 26 April 1784 he was sending to Hayley via a "Mr Long." See Bentley 1969, 27.

27. Bentley 1977, 206, also notes "thumb marks, presumably of the printer, . . . on some pages," but I can find no evidence of these.

28. David V. Erdman, *Blake: Prophet Against Empire*, 3d ed. (Princeton: Princeton Univ. Press, 1977), 152 note 10, argues against the notion that Johnson withdrew the work out of fear of prosecution for publishing a pro-revolutionary work.

29. Very probably the letter to Humphry now at Trinity College, Hartford (Blake 1982, 770).

30. According to A. G. B. Russell's annotated copy of the Burlington Fine Arts Club exhibition catalogue, 1876, now in my collection.

31. The auction catalogue does not explicitly describe the prospectus/envelope, but the comment that "the back of [the] second leaf" of the letter is "addressed in Blake's autograph" must be a reference to it.

32. A copy of Lavater's *Aphorisms* in the Beinecke Library, Yale University, contains transcriptions of Blake's annotations and a note by John Linnell, Jr., son of Blake's patron, that the original belonged to Palmer.

33. In a letter to Linnell of 29 August 1828, Samuel Palmer noted that his father "would be very much amused by a sight of Mr. Blake's annotations to Dr. T.s Lord's Prayer" (Bentley 1969, 369).

34. The Linnell auction catalogue, like Smith's invoice now in the Huntington archive, accounts for only 14 letters. But Keynes 1921, 68, 73, describes Nos. 1 and 17 as part of lot 214 in the Linnell auction, each "with twelve others" even though the catalogue indicates that the lot contained 11 (mostly undescribed) items. The letters in question were accessioned by the Huntington in sequence with those unquestionably from the Linnell sale.

35. See Bentley 1969, 300, 321, for dated references to these printings. The publication printing was probably completed by March 1826.

36. All recent editions of Blake's letters, including Blake 1982, 773, suggest this date. I am grateful to Professor Bentley for his help with the dating of this letter.

37. The chain lines, only .9 cm. apart, in Nos. 4, 8–10, 12–14, 16–17 match the lines in this 1810 paper, and thus may have been written on the same stock.

III. PRINTS

A. Separate Plates

In this category are Blake's engravings, etchings, and planographic prints executed as individual works or as pairs. These include both plates designed and executed by Blake and plates executed by him after the designs of other artists. References under *Literature* are limited to standard catalogues and works dealing specifically with the impressions at the Huntington. Unbound impressions of plates published as book illustrations or as illustrative series of more than two prints are listed in section B, below, under the appropriate author and title. All plates from Blake's illuminated books are included in Part II, section A.

1. "A Lady Embracing a Bust." Call No. 282164, volume 2. Intaglio etching/engraving, first state before letters, signed in the second state by Blake as the engraver and Thomas Stothard as the designer. Image 12.8 x 8.1 cm. printed in black on laid paper trimmed within the plate mark to 13 x 8.2 cm. Formerly pasted down, but now loose, at page 28 of volume 2 of a collection of prints after Stothard. From the collection of Samuel Boddington, whose engraved bookplate is printed on the inside front cover; given to the Library by Mr. and Mrs. Carl F. Braun, February 1951.

Very probably intended as a book illustration but not known to have been published. Probably executed ca. 1780–93.

Literature:
Russell 1912, No. 70.
Essick 1983, 242–43 (impression 1A).

2. "Evening Amusement." Library print box 300/33. Intaglio stipple etching/engraving, signed by Blake as the engraver and Jean Antoine Watteau as the designer. Second state, with the title letters filled with hatching strokes. Imprint: "Pub.d, as the Act directs August 21,, 1782 by T,, Macklin, No,, 39 Fleet Street.." Oval image, 25.2 x 30.3 cm., printed in black on laid paper trimmed on or just within the plate mark to 32.9 x 35.9 cm. A well-printed, probably early, impression. Two small inking flaws in the wall on the left. Recently cleaned and backed with tissue. This previously unrecorded impression was acquired in December 1984 from a private collector who inherited it from her father.

"Evening Amusement" and its companion, "Morning Amusement," were prepared for the leading print publisher Thomas Macklin. They are the first separate plates Blake is known to have executed after his release from apprenticeship in August 1779. An inscription below the title indicates that the plate is "From an Original Picture in the Collection of Mr,, A,, Maskin," but this was very probably a copy after Watteau's "Les Champs Elysées" now in the Wallace Collection, London.

Literature:
Keynes 1956, 64.
Essick 1983, 130–31.

3. "Calisto." Call No. 152250, volume 3. Intaglio stipple etching/engraving, signed by Blake as the engraver and Thomas Stothard as the designer. First state, with scratched letters. Imprint: "Published as the Act directs, Decr 17: 1784. by Blake & Parker No. 27 Broad St Golden square." Oval image, 17.2 x 20.3 cm., printed in black on laid paper trimmed on or just within the plate mark to 25.2 x 22.4 cm. The faint watermark, probably composed of letters, has not been deciphered. Mounted in a window cut in leaf 51 in volume 3 of an extra-illustrated copy of Mrs. [A. E.] Bray, *Life of Thomas Stothard* (London: John Murray, 1851). From the collection of Robert Hoe, sold Anderson Auction Co., 25 April 1911, lot 494 ($1350). Acquired shortly after the auction by Henry E. Huntington.

"Calisto" and its companion, "Zephyrus and Flora," are the only prints known to have been published by the partnership of Blake and James Parker.

Literature:
Rossetti 1863, 259; 1880, 282.
Russell 1912, No. 60.
Keynes 1956, 68.
Essick 1983, 142–44 (impression 1A, reproduced).

4. "Head of a Damned Soul in Dante's *Inferno.*" Housed in "Blake: Miscellaneous Prints" box in the Library; no call number. Intaglio line etching/engraving, Blake after Henry Fuseli, unsigned. First state, ca. 1789. Image 34.8 x 26.4 cm. printed in black on wove paper trimmed inside the plate mark to 38.8 x 30.8 cm. Right edge a bit ragged, three edges gilt, no doubt as a result of having been bound in the Library's hand-colored copy of Edward Young's *Night Thoughts*, 1797 (see Part III, section B, No. 55A for provenance). The print was removed from the volume by 1929. Small mark on figure's left cheekbone. A typed description of the print (written by a dealer?) is taped to the verso.

The attribution of the plate to Blake and Fuseli is based on pencil inscriptions on several impressions and the similarities between the print and their work of the late 1780s and early 1790s. The head is particularly similar to an engraving after Fuseli in John Caspar Lavater's *Essays on Physiognomy*, volume 2 (1792), page 290 (see Part III, section B, No. 31A). The print may have been associated in some way with that publication, although the image is almost as large as uncut copies of the book. Blake used similar heads seen from below in several of his designs, including one just left of the Pope's feet in "Lucifer and the Pope in Hell" (No. 7, below).

Literature:
Rossetti 1863, 261; 1880, 283.
Russell 1912, No. 74.
Keynes 1956, 76.
Bindman 1978, 469.
Essick 1983, 170–72 (impression 1C).

5. "Albion rose" (or "Glad Day" or "The Dance of Albion"). Illus. 48. Art Gallery; no accession number. Intaglio etching/engraving, plate 27.2 x 19.9 cm. Engraved by Blake ca. 1793 after his own design, first

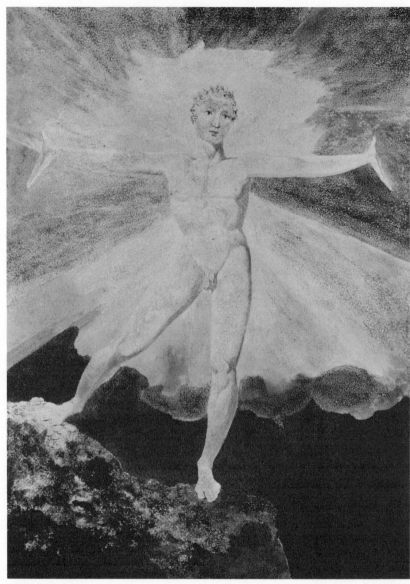

48. Albion rose

executed as a pencil drawing ca. 1780 (Victoria and Albert Museum;
Butlin 1981, No. 73). This impression color printed (predominantly

black, rose, yellow, blue, green) by Blake from the surface of the plate with gum or glue based pigments, ca. 1794–96, and hand finished with watercolors and pen and ink. Wove paper, 36.8 x 26.3 cm., watermarked "1794/ J WHATMAN."

There is no recorded impression of the first state printed in intaglio. Indeed, the first state is known only through the residual indications of intaglio lines in the Huntington impression. Another color printed impression is in the British Museum. In comparison to it, the Huntington impression is much more thinly printed, and thus it may be the second pull taken immediately after the British Museum print with little, if any, color added. Blake seems to have done most of his color printing from copperplates ca. 1794–96. In about 1804 or later, Blake reworked the plate, adding a worm just left of the figure's left foot, a bat-winged moth between his legs, and a caption: "Albion rose from where he labourd at the Mill with Slaves/Giving himself for the Nations he danc'd the dance of Eternal Death." Like the second state, the first may also be signed in the plate "WB inv 1780" (probably the date Blake "invented" his design on paper), but the color printing makes it impossible to see these letters if present. The print was removed in 1953 from the copy of *The Song of Los* in the Library (See Part II, section A, No. 12). While part of that book, the print was gilt along its top edge, inscribed in pencil "an additional plate," and numbered "9" in pencil as the last plate in the volume. Also inscribed "end" and "14" in pencil on the verso.

Provenance: Perhaps one of the prints acquired in August 1797 by Dr. James Curry[1]; bound with *The Song of Los* between 1903 and 1915—see Part II, section A, No. 12 and note 16 thereto for further provenance.

Exhibition: Huntington Art Gallery, 1953, 1984.

Literature:
Rossetti 1863, 257; 1880, 279.
Russell 1912, No. 3.
Binyon 1926, Nos. 9, 346.
David V. Erdman, "The Date of William Blake's Engravings," *Philological Quarterly* 31 (1952):337–43; reprinted with revisions in *The Visionary Hand*, ed. Robert N. Essick (Los Angeles: Hennessey & Ingalls, 1973), 161–71.
Keynes 1956, 6–9.
Joseph Anthony Wittreich, Jr., *Angel of Apocalypse: Blake's Idea of Milton* (Madi-

son: Univ. of Wisconsin Press, 1975), 48–69, reproduced.
Bentley 1977, 78–79 (impression D).
Bindman 1977, 97, reproduced.
Bindman 1978, 479–80, reproduced.
Essick 1980, 70–78, 182–83, 257, reproduced.
Butlin 1981, No. 284, both color printed impressions reproduced in color.
Essick 1983, 24–29 (impression 1B), both color printed impressions reproduced in color.

6. "Edmund Pitts, Esq$^{r.}$" Call No. 272584, volume 10. Intaglio stipple etching/engraving, signed by Blake as the engraver and J. Earle as the designer. Second state, ca. 1793–96. Oval image, 18.5 xc 14.2 cm.; plate mark 24.2 x 17.5 cm. Printed in black on wove paper, 28.5 x 21.5 cm., with three framing lines drawn in pencil outside the plate mark, the outer line partly cut off. Bound as the third print following page 562 in volume 10 of an extra-illustrated copy of Daniel Lysons, *Historical Account of the Environs of London* (London: Cadell and Davies, 1796). The book may have been extra-illustrated by William Augustus Fraser, whose bookplate is pasted to the inside front cover of all volumes. Acquired by the Huntington Library in February 1949 from Keith Spalding for $572.39.

The portraitist was probably Sir James Earle (1755–1817), like his subject an eminent surgeon of St. Bartholomew's Hospital, London.[2] Earle signed the plate "Armig," indicating that he was the bearer of a coat of arms. Thus the second state may not have been executed until 1802 when he was knighted.

Literature:
Russell 1912, No. 76.
Keynes 1956, 78.
Essick 1983, 178–80 (impression 2C).

7. "Lucifer and the Pope in Hell" (Illus. 49). Housed in "Blake: Miscellaneous Prints" box in the Library; no call number. Intaglio etching/engraving, ca. 1794, color printed by Blake from the surface of the plate and some intaglio lines in gum or glue based pigments (predominantly blue, olive brown, green, mustard yellow), ca. 1794–96. Extensively hand finished in watercolors (reddish orange, black, light blue, flesh pink, touches of opaque white) and pen and ink. Wove(?) paper, 19.9 x 27.4 cm., which may be about the size of the

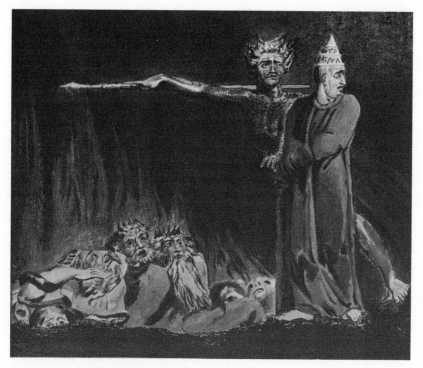

49. Lucifer and the Pope in Hell

copperplate. Mounted on a backing sheet of the same size which in turn is pasted to the mat.

The only other traced impression (British Museum) is printed in intaglio and uncolored. The date of etching/engraving is based on the graphic style and the thematic similarities between the print and Blake's illuminated books of 1793–95. Blake seems to have done most of his color printing from copperplates ca. 1794–96. He first executed a version of this design ca. 1780–85 as a pen and wash drawing, "The King of Babylon in Hell" (Royal Collection, Windsor; Butlin 1981, No. 145).

Provenance: Frederick Tatham(?), sold anonymously at Sotheby's, 29 April 1862, perhaps in lot 185, 2 works "in colours" (15s. to Francis Harvey); Harvey in 1863; George A. Smith by 1876, sold Christie's, 16 July 1880, lot 101 (£2.10s. to John Pearson); Thomas Glen Arthur by 1890, sold Christie's, 20 March 1914, lot 52 (£14.14s. to Frank T. Sabin); Robson and Co., sold to Sessler's, July

1923, for $407; sold by Sessler's to Henry E. Huntington, August 1923, for $1500.[3]

Exhibition: Burlington Fine Arts Club, 1876, No. 167, lent by George Smith; Huntington Art Gallery, 1953.

Literature:
Rossetti 1863, 238, No. 222 ("Mr. Harvey"); 1880, 253, No. 253, and 254, No. 267 (repeating the earlier entry?).
Catalogue, for Private Use, of Books, Autographs, Pictures, Drawings, Etchings and Engravings Collected by Thomas Glen Arthur (Glasgow: J. Maclehose, 1890), 1.
Russell 1912, No. 37A.
Keynes 1956, 36–37, reproduced.
Baker 1957, 44, reproduced.
Bindman 1978, 477, reproduced.
Essick 1980, 75–76, 58, reproduced.
Butlin 1981, No. 287, reproduced in color.
Essick 1983, 41–43 (impression 1B), reproduced in color.

8. "Hecate" (Illus. 50). Housed in "Blake: Miscellaneous Prints" box in the Library; no call number. Printed planographically, ca. 1795, with gum or glue based pigments (brown, green, mustard yellow) and finished with pen and ink outlining and watercolors. Printed on paper, 41.5 x 55.9 cm., varnished and pasted to thick cardboard. Inscribed in pencil on the back of the cardboard, "B[?] B." Corners chipped, and with many damaged areas clumsily repaired (with oil paint?).

There are two other impressions of this design, now in the Tate Gallery and the National Gallery of Scotland (Butlin 1981, Nos. 316–17). In comparison to the much more highly finished Tate version, the Huntington example is considerably trimmed, particularly along the bottom edge. The eyes of the front-most figure on the right are more downcast than in the other versions, and there are numerous minor differences in details of the hair and hand positions. The left foreleg of the ass is more clearly delineated in the other versions. A pencil sketch of the design, in reverse, is in the collection of Ian Phillips, London (Butlin 1981, No. 319). The Huntington version was probably part of the group of Blake's drawings George Richmond showed to John Ruskin in the early 1840s. Ruskin briefly took possession of them and then returned the lot to its owner, the dealer Joseph Hogarth.[4]

The technique Blake used to print "Hecate" and his other color-printed drawings was first described by Frederick Tatham.[5] He stated

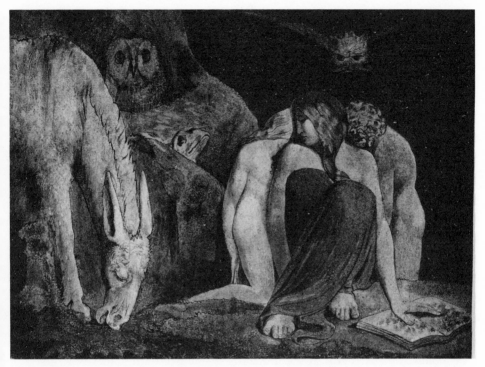

50. *Hecate*

that the medium was oil and the printing body "thick millboard." The first assertion is clearly wrong, and we now know that one color print, "God Judging Adam," was printed from a copperplate etched in relief.[6] None of the versions of "Hecate" shows indentations from the edges of relief plateaus, and thus they were probably printed from either an unincised copperplate or millboard. Several of the color-printed drawings were dated 1795 by Blake, and this is probably the date of printing (although not necessarily of hand finishing) of at least one version of each of the 12 subjects. However, one example of the three known impressions of "Newton" (Tate Gallery; Butlin 1981, No. 306) is on paper watermarked 1804.[7]

It is a moot point as to whether Blake's color-printed drawings should be classified as prints or drawings, but the discovery that "God Judging Adam" is a relief etching indicates that these works evolved out of his activities as a printmaker.

Provenance: Mrs. Blake(?); Frederick Tatham(?); Joseph Hogarth; John Ruskin, ca. 1843, returned to Hogarth; Arthur Burgess from ca. 1878–80 to his death in 1887; J. W. Pease, bequeathed in 1901 to Miss S. H. Pease, bequeathed 1938 to Mrs. Valentine Dodgson; John Dodgson, sold anonymously at Christie's, 21 November 1952, lot 35 (£220.10s. to Frank T. Sabin); sold by Sabin in 1954 to the Huntington Library.

Exhibition: Nottingham Art Museum, 1914, No. 32.

Literature:
Anon., "The Triple Hecate," *Huntington Library Quarterly* 18 (May 1955): supplement, reproduced.
Baker 1957, 44–45, reproduced.
Butlin 1981, No. 318, all 3 versions reproduced.

9. "Chaucers Canterbury Pilgrims." Framed and matted within the plate mark; no call number. Intaglio etching/engraving, image 30.5 x 94.9 cm. Printed in black on wove(?) paper now evenly browned with age. Imprint: "Painted in Fresco by William Blake & by him Engraved & Published October 8. 1810." Fourth state, as revised ca. 1820–23, with the drypoint inscriptions either side of the title. There are no records of the provenance, but the print has been in the Library's collection for many years. Perhaps the impression sold from the collection of Frederic R. Halsey, Anderson Galleries, 26 February 1917, lot 20 ($32.50 to George D. Smith—for Huntington?).

The print is based closely on Blake's tempera painting (Pollock House, Glasgow; Butlin 1981, No. 653) which he exhibited in 1809. The reduced pencil sketch for the engraving is now in the British Museum (Butlin 1981, No. 654). The drawing may have been transferred directly to the copperplate (35.7 x 97 cm.) by one of the standard counterproofing techniques. The copperplate is now in the Yale Art Gallery, New Haven. For a related publication, see Part III, section B, Nos. 8A–B.

Literature:
Rossetti 1863, 257; 1880, 278.
Russell 1912, No. 24.
Binyon 1926, No. 100.
Keynes 1956, 45–49.
A Handbook to the Huntington Library Exhibition (San Marino: Huntington Library, 1978), 85, reproduced.

Betsy Bowden, "The Artistic and Interpretive Context of Blake's 'Canterbury Pilgrims'," *Blake: An Illustrated Quarterly* 13 (1980):164–90, reproduced, with enlarged details of several figures.

Essick 1983, 60–89 (impression 4BB), reproduced, with enlarged details of the drypoint inscriptions.

10A. "Wilson Lowry." Call No. 262456, volume 7. Intaglio etching/engraving, signed by John Linnell as the designer and Blake and Linnell as the engravers. Fifth state, with the *"Proof"* inscription lower right. Imprint: "Published as the Act directs Jan 1, 1825; by Hurst, Robinson, & C^O. Cheapside, London." Image approx. 14.5 x 10.5 cm.; plate mark 25.4 x 19.9 cm. Printed in black on laid paper, 37.4 x 27.9 cm., with a fragment of a Dupuy Auvergne countermark. Top edge gilt. Bound preceding page 265 in volume 7 of an extra-illustrated copy of Samuel Redgrave, *A Dictionary of Artists of the English School* (London: Longmans, Green, and Co., 1874). The book was acquired by the Library in April 1937 for $200 from "Breslow," according to accession records.

10B. "Wilson Lowry," another impression. Library print box 715/44. Sixth (final) state, printed in black on India paper laid on a wove sheet, 44.5 x 30.5 cm. Tear in the right margin extending into the plate mark. Sold anonymously at Sotheby's, 14 June 1984, lot 195A, with another impression (No. 10C, below) and a third print perhaps by Blake (£88 to Donald Heald for Robert N. Essick). Acquired by the Library in August 1984.

10C. "Wilson Lowry," another impression. Library print box 715/43. Sixth (final) state, printed in black on laid paper, 44 x 29.6 cm. Same provenance as No. 10B, above.

Wilson Lowry (1762–1824) was an engraver who specialized in architectural and mechanical illustrations. Linnell's brown wash and ink portrait of Lowry, reproduced in this engraving, is in the collection of McGill University, Montreal.

Literature:
Rossetti 1863, 261; 1880, 283.
Russell 1912, No. 109.
Keynes 1956, 86–87.
Essick 1983, 201–208 (No. 10A listed as impression 4I, reproduced).

Robert N. Essick, "A Supplement to *The Separate Plates of William Blake: A Catalogue*," *Blake: An Illustrated Quarterly* 17 (1984):143 (corrects state designations in Essick 1983).

B. Commercial Book Illustrations and Prints in Series

Throughout his working life, Blake etched and engraved illustrations for books published in conventional typography. The Library's collection of these commercial productions is listed here in alphabetical order by the author and title of the book in which they appear. Also included are typographic publications with plates designed by Blake and print series originally issued without accompanying text. The states of the plates are noted when more than one published state is known. Information on provenance is given only for the more important works. *Literature* includes only standard bibliographies and catalogues. Unless stated otherwise, all plates are intaglio etchings/engravings printed in black and uncolored. Blake's plates are numbered (as in Bentley 1977) according to the order in which they are normally bound.

1. Allen, Charles. *A New and Improved Roman History.* London: J. Johnson, 1798.

Call No. 108270. Four plates by Blake after designs attributed to Henry Fuseli. The plates are printed on 2 sheets (originally 1?) and bound at the front. Bound in (original?) cloth-backed boards.

Literature:
Rossetti 1863, 260; 1880, 282.
Russell 1912, No. 88.
Bentley 1977, No. 416.

2A. Ariosto, Lodovico. *Orlando Furioso: Translated...by John Hoole.* London: C. Bathurst, et al., 1783. 5 volumes.

Call No. 292845. One plate by Blake after Thomas Stothard in volume 3. First state, stained.

2B. *Idem.* London: George Nicol, 1785. 5 volumes. Call No. 344210. First state.

2C. *Idem.* London: J. Dodsley, 1791. 2 volumes. Call No. 105642. Blake's plate in volume 1, second state.

2D. *Idem.* London: Otridge and Son, et al., 1799. 5 volumes. Call No. 441517. Third state.

Literature:
Rossetti 1863, 260; 1880, 282.
Russell 1912, No. 53.
Keynes 1921, No. 96.
Bentley 1977, Nos. 417A–D.
Easson and Essick 1979, 42–43.

3. *Bellamy's Picturesque Magazine, and Literary Museum. Vol. I. For the Year MDCCXCIII.* London: T. Bellamy, 1793.
Call No. 389830. One plate by Blake after Charles Reuben Ryley.

Literature:
Bentley 1977, No. 418.
Easson and Essick 1979, 96.

4A. Blair, Robert. *The Grave, a Poem.* London: R. H. Cromek, 1808.
Call No. 113093. Folio issue, uncut. First states of the 12 plates by Louis Schiavonetti after Blake. Pl. 8 spotted. Bookplate of Robert Hoe; sold from his collection at Anderson Auction Co., 25 April 1911, lot 395 ($125).

4B. *Idem.* Call No. 263699. 1808 quarto issue, second states of the plates. Extra-illustrated with first states of Pls. 1, 3–12 (from the 1808 folio issue) and a pre-publication proof of Pl. 2, letters unfinished and dated 1 June 1806 in the imprint. A title-page drawing (see Part I, section D, No. 4) and a portrait drawing of Blake (see Part V, No. 1) formerly laid in.

Provenance: William Beckford, sold from his collection at Sotheby's, 3 July 1882, lot 950 (£12.5s. to Bain); Bernard Buchanan Macgeorge by 1892, with the title-page drawing inserted; see Part I, section D, No. 4 for further history.

4C. *Idem.* Call No. 54049. 1808 quarto issue, the plates (second states) skillfully hand tinted with watercolors, predominantly brown, yellow,

rose red, pale orange, purple, blue, and green. Inscribed "Edw^d Aubrey/ 1809" on the engraved title page and with the bookplate of Caleb S. Mann. Accessioned October 1924, but probably acquired some years earlier. No information available on provenance. See also 4G, below, for hand colored impressions.

Exhibition: Grolier Club, 1919–20, in No. 39; Fogg Art Museum, 1924.

4D. *Idem.* Call No. 54048. 1808 quarto issue, second states of the plates. Top edge gilt, others uncut. Original front wrapper with cover label bound at end.

Provenance: C. Glucksmann, sold to Frederic R. Halsey, 19 April 1900; acquired by Henry E. Huntington, December 1915, as part of the Halsey collection.

4E. *Idem.* London: R. Ackermann, 1813. Call No. 292762. The typographic facsimile folio issued by John Camden Hotten in 1870 (see Essick and Paley 1975 under *Literature*). Fifth states of the plates. Original publisher's cloth, rebacked.

4F. *Idem.* New York; Stanford & Delisser, 1858. Call No. 80559. Plates re-engraved by A. L. Dick.

4G. *Idem.* Pls. 8–9 only, two impressions of each, first states, in extra-illustrated Daly Bible, call No. 112823. Bound as follows: Pl. 8, hand colored (blue, rose, yellow, purple)—volume 41, frontispiece; Pl. 8—37: following page 121; Pl. 9, hand colored (blue, green, rose, purple)—29:15; Pl. 9—41:215. The 2 colored impressions have much the same range of tones and general style of coloring as in No. 4C. Both groups, however, are fairly conventional (albeit skillful) in coloring technique, and thus it is not possible to attribute them to the same hand. It is very unlikely that Blake was one of the colorists.

4H. *Idem.* Pls. 2, 4, 8 only, second states, in extra-illustrated Kitto Bible, call No. 49000. Bound as follows: Pl. 2—volume 60, leaf 11034; Pl. 4—24:4643; Pl. 8—52:9414 (imprint and title cut off).

4I. *Idem.* Pl. 9 only, second state, bound following page 42 in volume 1 of an extra-illustrated copy of Samuel Redgrave, *A Dictionary of Artists*

of the English School (London: Longmans, Green, and Co., 1874), call
No. 262456.

4J. *Idem.* Pls. 2–8, 10–12, fifth states from the 1870 edition, in extra-
illustrated Daly Bible, call No. 112823. Bound as follows: Pls. 2, 7, 11—
volume 24, following page 705; Pls. 3, 4—24:696; Pls. 5, 10—30:24; Pl.
6—24:686; Pls. 8, 12—29:12.

For drawings related to the *Grave* illustrations, see Part I, section D,
No. 4, and Part V, Nos. 1–2.

Literature:
Rossetti 1863, 261; 1880, 283.
Russell 1912, No. 40.
Keynes 1921, Nos. 81–82.
Wittreich 1970, 53.
Robert N. Essick and Morton D. Paley, "The Printings of Blake's Designs for
 Blair's *Grave,*" *The Book Collector* 24 (1975):535–52.
Bentley 1977, Nos. 435A–B, E, G.
Bindman 1978, 483.
Robert N. Essick and Morton D. Paley, *Robert Blair's* The Grave *Illustrated by
 William Blake* (London: Scolar Press, 1982).

**5. *Boydell's Graphic Illustrations of the Dramatic Works of
Shakspeare.*** London: Boydell and Co., n.d. [1803?].

Call No. 27435. The 95th plate is engraved by Blake after John Opie.
See also No. 45, below, for the same plate.

Literature:
Keynes 1921, No. 123.
Bentley 1977, No. 437.

6. Bryant, Jacob. *A New System, or, An Analysis of Ancient
Mythology.* London: T. Payne, et al., 1774–75. 3 volumes.

Call No. 338987. Blake may have had a hand in engraving some of
the 28 plates signed by his master, James Basire. The vignette on page
537 of volume 2, sometimes attributed to Blake, is in the first state.

Literature:
Russell 1912, No. 110.
Bentley 1977, No. 439A.
Easson and Essick 1979, 1–7.

7. Bürger, Gottfried Augustus. *Leonora. A Tale, Translated and Altered from the German...by J. T. Stanley.* London: William Miller, 1796.

Call No. 421592. Three plates engraved by "Perry" after Blake's designs. Contemporary paper wrappers, with Blake's plates 2–3 repeated (uniquely?) in the German text often bound with the translation.

Literature:
Rossetti 1863, 261; 1880, 283.
Russell 1912, No. 38.
Keynes 1921, No. 79.
Bentley 1977, No. 440.
Bindman 1978, 478.
Easson and Essick 1979, 107–108.

8A. Chaucer, Geoffrey. *The Prologue and Characters of Chaucer's Pilgrims, Selected from His Canterbury Tales; Intended to Illustrate a Particular Design of Mr. William Blake.* [London]: Harris, 1812.

Call No. 57453. Frontispiece designed and engraved by Blake and an unsigned vignette very probably by him. Extra-illustrated with prints not related to Blake; text pages outlined in red ink.

Provenance: Edelheim sale, American Art Association, 7–10 March 1900; Frederic R. Halsey; acquired by Henry E. Huntington as part of the Halsey collection, December 1915.

8B. *Idem.* Call No. 108269. Top edge gilt, others uncut. Bookplate of Robert Hoe, sold from his collection at Anderson Auction Co., 16 April 1912, lot 376 ($80).

In part an advertisement for Blake's large plate of "Chaucers Canterbury Pilgrims" (see Part III, section A, No. 9).

Literature:
Rossetti 1863, 257; 1880, 279.
Russell 1912, No. 25.
Keynes 1921, No. 75, title page reproduced.
Binyon 1926, No. 101.
Easson and Essick 1972, 45–47.
Bentley 1977, No. 443.
Bindman 1978, 482.

9. Cumberland, George. *Thoughts on Outline, Sculpture, and the System that Guided the Ancient Artists.* London: Robinson and Egerton, 1796.

Call No. 312010. Eight plates by Blake after Cumberland, first states. Title page uncorrected (see Bentley 1977, 543). Plates spotted.

Literature:
Rossetti 1863, 261; 1880, 283.
Russell 1912, No. 85.
Keynes 1921, No. 112.
G. E. Bentley, Jr., *A Bibliography of George Cumberland* (New York: Garland, 1975), 15–20.
Bentley 1977, No. 447.
Easson and Essick 1979, 109–12.

10A. Dante Alighieri. *Blake's Illustrations of Dante. Seven Plates, Designed and Engraved by W. Blake.* [London: John Linnell, 1838].

Call No. 57437. India paper laid on wove, Pls. 1, 5, 6, 7 watermarked "1822"; Pl. 4 watermarked "S & [cut off]." Bound. Pls. 1, 5 badly foxed, others lightly foxed.

10B. *Idem.* Call No. 283403. Loose in portfolio, with the original cover label in an envelope. India paper laid on wove. Perhaps the restrikes of ca. 1892, but not the same very heavy backing paper of No. 10C. Given to the Library by Mrs. Donald Mac Isaac, August 1951. Exhibited in the Huntington Art Gallery in 1953.

10C. *Idem.* Call No. 57438. India paper laid on very heavy wove. Probably the restrikes of ca. 1892. Bound, with the descriptions of the plates cut from the original cover label and pasted below each image.

10D. *Idem.* Call No. 471375. Restrikes of 1953–54 on heavy wove paper, each plate inscribed in pencil, "Impression taken from the copper-plate in my collection 1953–4. Lessing J. Rosenwald 4/19/55." Matted, loose in portfolio. Given to the Library by Rosenwald, May 1955.

For Blake's preliminary drawing for the fourth plate, see Part I, section D, No. 6.

Literature:
Rossetti 1863, 258; 1880, 281.
Russell 1912, No. 34.
Keynes 1921, No. 56.
Binyon 1926, Nos. 127–33.
Bentley 1977, Nos. 448A–C.
Bindman 1978, 487.
Geoffrey Keynes, "The Dante Engravings," in *Blake's Illustrations of Dante* (London: Trianon Press for the Blake Trust, 1978).

11A. Darwin, Erasmus. *The Botanic Garden.* Part I. *Containing the Economy of Vegetation. The Second Edition.* London: J. Johnson, 1791. *Part II. The Loves of the Plants. The Fourth Edition.* London: J. Johnson, 1794.

Call No. 387423. One plate engraved by Blake after Henry Fuseli and 4 plates of the Portland Vase attributed to Blake, all in Part I. Plates stained; imprint cut from Pl. 2.

11B. *Idem.* Pl. 1 only, "Fertilization of Egypt," Blake after Fuseli, bound as leaf 1831 in volume 12 of the extra-illustrated Kitto Bible, call No. 49000. Imprint cut off.

Literature:
Rossetti 1863, 260; 1880, 282 (Pl. 1 only).
Russell 1912, No. 79.
Keynes 1921, No. 103.
Wittreich 1970, 52.
Bentley 1977, No. 450A-B.
Easson and Essick 1979, 87–91.

12. Darwin, Erasmus. *The Poetical Works.* London: J. Johnson, 1806. 3 volumes.

Call No. 421361. Reduced re-engravings by Blake of the plates in *The Botanic Garden* (No. 11A, above), all in volume 1.

Literature:
Bentley 1977, No. 450E.
Easson and Essick 1979, 87–91.

13. Flaxman, John. *Compositions from the Works Days and Theogony of Hesiod.* London: Longman, Hurst, Rees, Orme & Brown, 1817.

Call No. 220796. Thirty-seven plates by Blake after Flaxman, first states. Some plates heavily spotted. One of Flaxman's pen and pencil preliminary sketches for Pl. 12, and perhaps a variant sketch for Pl. 16, are in the Art Gallery collection.[8]

Literature:
Rossetti 1863, 261; 1880, 283.
Russell 1912, No. 107.
Keynes 1921, No. 131.
G. E. Bentley, Jr., *The Early Engravings of Flaxman's Classical Designs* (New York: New York Public Library, 1964), 53, No. 1.
Bentley 1977, No. 456A.

14. Flaxman, John. *The Iliad of Homer Engraved from the Compositions of John Flaxman.* London: Longman, Hurst, Rees, and Orme, et al., 1805.

Call No. 220798. Three of the 40 plates are engraved by Blake. Slightly spotted. Five of Flaxman's pen and pencil preliminary sketches for Blake's second plate ("Minerva Repressing the Fury of Achilles") are in the Art Gallery collection, which also has a finished wash drawing by Flaxman of the same subject.[9]

Literature:
Russell 1912, No. 100.
Keynes 1921, No. 127.
Bentley 1964 (see No. 13, above), 34, No. 6.
Bentley 1977, No. 457A.

15. Flaxman, John. *A Letter to the Committee for Raising the Naval Pillar.* London: Cadell, et al., 1799.

Call No. 313060. Three plates by Blake after Flaxman. Original blue paper wrappers.

Literature:
Rossetti 1863, 260; 1880, 282 (Pl. 1 only).
Russell 1912, No. 91.
Keynes 1921, No. 119.
Bentley 1977, No. 458.

16. Fuseli, John Henry. *Lectures on Painting, Delivered at the Royal Academy.* London: J. Johnson, 1801.

Call No. 292894. One plate by Blake after Fuseli, stained and spotted. Signatures of Rembrandt Peale, John Neagle, James Hamilton, and F. E. Marshall on title page.

Literature:
Rossetti 1863, 260; 1880, 282.
Russell 1912, No. 95.
Keynes 1921, No. 122.
Bentley 1977, No. 459.

17A. Gay, John. *Fables.* London: John Stockdale, 1793. 2 volumes.

Call No. 123698. Twelve of the 71 plates are engraved by Blake. They are based on the plates after William Kent and John Wootton in the first (1727) edition of volume 1 and the plates after Henry Gravelot in the first (1738) edition of volume 2.[10]

17B. *Idem.* 2d ed. [1811]. 2 volumes. Call No. 123700. Original boards, uncut. Backstrips and spine labels detached but retained.

Literature:
Rossetti 1863, 257; 1880, 279.
Russell 1912, No. 80.
Keynes 1921, No. 106.
Bentley 1977, Nos. 460A–B.
Easson and Essick 1979, 99–102.

18. Gough, Richard. *Sepulchral Monuments in Great Britain. Part I. Vol. II. Containing the Four First Centuries.* London: for the author, 1786.

Call No. 145686, volume 2. Twenty-two plates, signed by Blake's master, James Basire, are based on drawings which have been attributed to Blake (see Butlin 1981, Nos. 19–47). One further plate ("Pl. LX. P. 159") may also be based on a drawing by Blake. He probably also engraved the 6 portrait plates and may have had a hand in the execution of all 23. This copy presented by Gough to John Nichols, the printer of the volume. Uncut, and extra-illustrated with materials unrelated to the plates possibly by Blake. From the collection of Henry Huth.

Literature:
Rossetti 1863, 259; 1880, 281.

Russell 1912, No. 117.
Keynes 1921, No. 67.
Binyon 1926, Nos. 2–7.
Keynes 1971, 17–18 (19 plates attributed to Blake).
Bentley 1977, No. 461 (16 plates attributed to Blake).
Easson and Essick 1979, 55–61 (23 plates tentatively attributed to Blake).

19A. Hartley, David. *Observations on Man, His Frame, His Duty, and His Expectations.* London: J. Johnson, 1791. Quarto issue.

Call No. 345172. Frontispiece by Blake after John Shackleton. Spotted.

19B. *Idem.* Plate only, bound following page 426 in volume 4 of an extra-illustrated copy of Daniel Lysons, *Historical Account of the Environs of London* (London: Cadell and Davies, 1796), call No. 272584.

Literature:
Russell 1912, No. 78.
Keynes 1921, No. 105.
Bentley 1977, No. 464A.
Easson and Essick 1979, 92–93.

20. Hayley, William. *Ballads...Founded on Anecdotes Relating to Animals.* London: Richard Phillips, 1805.

Call No. 57452. Five plates designed and engraved by Blake, first states. From the collection of Ross Winans, with his bookplate. Top edge gilt, others uncut.

Literature:
Rossetti 1863, 257; 1880, 279.
Russell 1912, No. 20.
Keynes 1921, No. 74.
Binyon 1926, Nos. 95–99.
Easson and Essick 1972, 41–44.
Bentley 1977, No. 465.
Bindman 1978, 480.

21A. Hayley, William. *Designs to a Series of Ballads...Founded on Anecdotes Relating to Animals.* Chichester: William Blake, 1802.

Call No. 57448. Twelve plates designed and engraved by Blake, plus 2 plates engraved by him after antique gems (1 signed "T. H.

[Thomas Hayley] del."). Original wrappers for Ballads 2–4 bound at end. Top edge gilt, others uncut.

Provenance: Sold by Frank T. Sabin to Frederic R. Halsey, May 1903; acquired with the Halsey collection by Henry E. Huntington, December 1915.

21B. *Idem.* Call No. 138848. "Swinburne's copy" inscribed in pencil on the verso of the front free endpaper. Pls. 12, 14 slightly spotted. Acquired from George D. Smith at an unknown time; catalogued October 1928.

Literature:
Rossetti 1863, 257; 1880, 279.
Russell 1912, No. 19.
Keynes 1921, No. 72.
Binyon 1926, Nos. 83–94.
Easson and Essick 1972, 31–35.
Bentley 1977, No. 466.
Bindman 1978, 479.

22. Hayley, William. *An Essay on Sculpture: In a Series of Epistles to John Flaxman.* London: Cadell and Davies, 1800.

Call No. 87743. Three plates by Blake after a sculpted bust, a medallion by Flaxman, and a drawing by Thomas Hayley. Plates spotted; Pl. 2 cropped on right margin.

Literature:
Russell 1912, No. 94.
Keynes 1921, No. 120.
Bentley 1977, No. 467.

23A. Hayley, William. *The Life, and Posthumous Writings, of William Cowper.* Chichester: J. Johnson, 1803 (volumes 1–2), 1804 (volume 3). 3 volumes plus supplement of 1806.

Call No. 141610. Four plates engraved by Blake after George Romney, D. Heins, Thomas Lawrence, and Francis Stone; Pl. 4 (first state) by Blake after his own design. Lacking Pl. 6 after Flaxman. Top edges gilt, others uncut. Pls. 1–3 apparently tipped in from another copy.

23B. *Idem.* 3 volumes, 2d ed. of volumes 1–2. Call No. 292929. Pl. 4 in second state; imprint partly cropped from Pl. 3.

23C. *Idem.* Plates only, Pl. 4 in first state, bound in an extra-illustrated copy of Goldwin Smith, *Cowper* (London: Macmillan, 1880), call No. 131211. Plates bound following page 2 and facing pages 67, 81, 96, 130. Imprints cut from Pls. 1 and 5.

23D. *Idem.* Pls. 1–2, 3 (2 impressions), 5, 6 only. Library print box 450/ 2–4, 6–8. Imprints trimmed from Pl. 1 and one impression of Pl. 3.

Literature:
Rossetti 1863, 257, 260–61; 1880, 279, 283.
Russell 1912, No. 96.
Keynes 1921, Nos. 73, 124.
Easson and Essick 1972, 36–40.
Bentley 1977, No. 96.
Bindman 1978, 479 (Pl. 4 only).

24A. Hayley, William. *The Life of George Romney.* Chichester: T. Payne, 1809.
Call No. 135333. One plate by Blake after Romney. Top edge gilt, others uncut.

24B. *Idem.* Classification No. ND497.R7H3, Art Gallery. Imprint bound in spine.

24C. *Idem.* Classification No. ND497.R7H3, copy 2, Art Gallery.

24D. *Idem.* Blake's plate only, imprint cropped, bound following page 348 in volume 9 of an extra-illustrated copy of Samuel Redgrave, *A Dictionary of Artists of the English School* (London: Longmans, Green, and Co., 1874), call No. 262456.

Literature:
Rossetti 1863, 261; 1880, 283.
Russell 1912, No. 102.
Keynes 1921, No. 130.
Bentley 1977, No. 469.

25A. Hayley, William. *The Triumphs of Temper.* 12th ed. Chichester: Cadell and Davies, 1803.
Call No. 108267. Six plates by Blake after Maria Flaxman. Large pa-

per copy from the collection of Henry William Poor.

25B. *Idem.* Call No. 108268. The plates (showing wear, and perhaps taken from a small paper copy) have been cut just within the plate mark and pasted to leaves the size of the text pages in this large paper copy, also from the Poor collection.

Literature:
Rossetti 1863, 260; 1880, 282.
Russell 1912, No. 97.
Keynes 1921, No. 125.
Bentley 1977, No. 471A.

26. Hoare, Prince. *An Inquiry into the Requisite Cultivation and Present State of the Arts of Design in England.* London: Richard Phillips, 1806.

Call No. 332367. Frontispiece (slightly stained) by Blake after Sir Joshua Reynolds.

Literature:
Russell 1912, No. 101.
Keynes 1921, No. 129.
Bentley 1977, No. 474.

27A. Hogarth, William. *The Works of William Hogarth, from the Original Plates Restored by James Heath.* London: Baldwin, Cradock, and Joy, 1822.

Call No. 439135. One plate ("Beggar's Opera, Act III") by Blake after Hogarth, the fourth of five states (second published).

27B. *Idem.* N.d. [ca. 1830–38?]. Call No. 244216. Fifth state, worn.

27C. *Idem.* Blake's plate only, first (etched) proof state, marginal spotting. Hogarth Print Portfolio II in Library.

27D. *Idem.* Blake's plate only, 2 impressions of the fourth state. Hogarth Print Portfolio II in Library.

27E. *"The Beggar's Opera" by Hogarth and Blake. A Portfolio Compiled by Wilmarth S. Lewis and Philip Hofer.* New Haven: Harvard

Univ. Press and Yale Univ. Press, 1965. Call No. 380766. Modern restrike from Blake's very worn plate.

Literature:
Rossetti 1863, 260; 1880, 282.
Russell 1912, No. 71.
Bentley 1977, Nos. 475C, E–G, I.
Easson and Essick 1979, 66–68.

28. Hunter, John. *An Historical Journal of the Transactions at Port Jackson and Norfolk Island.* London: John Stockdale, 1793. Quarto edition.
 Call No. 337262. One plate by Blake after Governor King, first state.

Literature:
Bentley 1977, No. 476A.
Easson and Essick 1979, 94–95.

29A. Job. *Illustrations of the Book of Job Invented & Engraved by William Blake.* [London]: William Blake, 1825 [i.e., 1826].
 Art Gallery, accession No. 72.62.53. Twenty-two plates designed and engraved by Blake, loose in portfolio. First (published "Proof") issue on laid India paper. Backing sheets 43.2 x 33.5 cm. Six plates watermarked "J WHATMAN/ TURKEY MILL/ 1825."

Provenance: Perhaps John Linnell, one of the sets sold by the trustees of his estate, Christie's, 15 March 1918, lots 183–89; Lionel Robinson, London bookseller, sold to Edward W. Bodman, September 1938 (according to a note kept with the prints); given by Mr. and Mrs. Bodman to the Huntington Art Gallery, 1972.

Exhibition: Huntington Art Gallery, 1972 (selection), 1978, 1979 (Nos. 4 and 23, plates 11 and 20 only).

29B. *Idem.* Call No. 54045. Second issue, "Proof" inscription removed. Original paper covers and label bound in. Leaves 37.2 x 27.2 cm. Four plates watermarked "J WHATMAN/ TURKEY MILL/ 1825."

29C. *Idem.* Second issue, "Proof" inscription removed, 8 plates watermarked "J WHATMAN/ TURKEY MILL/ 1825" or some part thereof. Leaves approx. 33 x 26.5 cm. and smaller. Bound in volume 22

of the extra-illustrated Kitto Bible, call No. 49000. See Part I, section D, No. 3 for provenance. Title page and plates numbered 1–21 bound as follows: leaves 4020, 4044–45, 4047, 4051, 4056, 4058, 4100, 4107, 4114, 4128, 4133, 4139, 4168, 4180, 4190, 4152, 4181, 4202–203, 4205–206.

Literature:
Rossetti 1863, 258; 1880, 281.
Russell 1912, No. 33.
Keynes 1921, No. 55
Binyon 1926, Nos. 105–26.
Illustrations of the Book of Job by William Blake, introduction and catalogue by Laurence Binyon and Geoffrey Keynes (New York: Pierpont Morgan Library, 1935).
Wittreich 1970, 52–53.
Keynes 1971, 176–86.
Bo Lindberg, *William Blake's Illustrations to the Book of Job* (Abo: Abo Akademi, 1973).
Bentley 1977, No. 421A.
Bindman 1978, 486–87.
William Blake's Illustrations of the Book of Job (London: Blake Trust, forthcoming), with a complete catalogue of the engravings.

30A. Lavater, John Caspar. *Aphorisms on Man: Translated* **[by John Henry Fuseli]** *from the Original Manuscript.* London: J. Johnson, 1788.

Call No. 57431. Frontispiece by Blake after Fuseli, first state. Blake's annotated copy; see Part II, section C, No. 1.

30B. *Idem.* 3d ed., 1794. Call no. 146617. First state of the plate.

Literature:
Rossetti 1863, 260; 1880, 282.
Russell 1912, No. 68.
Keynes 1921, No. 101.
Bentley 1977, Nos. 480A, C.
Easson and Essick 1979, 62–63.

31A. Lavater, John Caspar. *Essays on Physiognomy, Designed to Promote the Knowledge and the Love of Mankind.* Trans. by Henry Hunter. London: John Murray, et al., 1789 (volume 1), 1792 (volume 2), 1798 (volume 3). 3 volumes bound in 5.

Call No. 224203. Four plates by Blake, 1 after Rubens and 3 not

signed by a designer, all in volume 1.

31B. *Idem.* 1810 edition. Call No. 439103. 3 volumes bound in 5.

31C. *Idem.* Pl. 2 ("Democritus") only, bound following page 42 in volume 1 of an extra-illustrated copy of Samuel Redgrave, *A Dictionary of Artists of the English School* (London: Longmans, Green, and Co., 1874), call No. 262456. Engraved number lower right cut off.

Literature:
Rossetti 1863, 260; 1880, 282.
Russell 1912, No. 69.
Keynes 1921, No. 102.
Bentley 1977, Nos. 481A, C.
Easson and Essick 1979, 64–65.

32A. Malkin, Benjamin Heath. *A Father's Memoirs of His Child.* London: Longman, Hurst, Rees, and Orme, 1806.

Call No. 313124. Frontispiece by Robert H. Cromek after Blake. Uncut in original boards with printed label on spine.

32B. *Idem.* Frontispiece only on laid paper 27.1 x 20.3 cm., a proof with the design completed but before all letters. Library print box 450/1. Collection stamp of Frederic R. Halsey on verso; perhaps the print sold from his collection at Anderson Galleries, 8 January 1917, lot 162, " 'Master Austin'[?], proof before all letters" ($50 to George D. Smith—for Huntington?).

Literature:
Russell 1912, No. 39.
Keynes 1921, No. 80.
Bentley 1977, No. 282.
Bindman 1978, 410.
Essick 1983, 244–45 (Blake's own engraving of the design).

33A. *The Monthly Magazine, and British Register.* Volume 4, No. 23, October 1797. London: R. Phillips, 1797.
Call No. 83018, volume 2. Portrait of Joseph Wright of Derby engraved by Blake; no designer named. Uncut.

33B. *Idem.* Plate only, bound following page 624 in volume 2, part 5, of an extra-illustrated copy of Michael Bryan, *A Biographical and Critical Dictionary of Painters and Engravers* (London: Carpenter and Son, et al., 1816), call No. 113812. Plate slightly spotted.

33C. *Idem.* Plate only, bound facing page 337 in volume 32 of an extra-illustrated copy of *The General Biographical Dictionary*, ed. Alexander Chalmers (London: J. Nichols and Son, et al., 1817), call No. 152290.

Literature:
Russell 1912, No. 87.
Keynes 1921, No. 114.
Bentley 1977, No. 483.

34. Nicholson, William. *An Introduction to Natural Philosophy.* London: J. Johnson, 1782. 2 volumes.
 Call No. 436240. One vignette, printed on both title pages, engraved by Blake; no designer named.

Literature:
Christopher Heppner, "Another 'New' Blake Engraving: More About Blake & William Nicholson," *Blake: An Illustrated Quarterly* 12 (1978–79):193–97.

35. *The Novelist's Magazine. Vol. VIII. Containing Don Quixote.* London: Harrison and Co., 1792 engraved title page and 1784 typographic title page.
 Call No. 148622. Two plates by Blake after Thomas Stothard. Second states, with the engraved plate numbers scraped off the impressions.

Literature:
Rossetti 1863, 259; 1880, 281.
Russell 1912, No. 49A.
Keynes 1921, No. 92.
Bentley 1977, No. 485C.
Easson and Essick 1979, 31–37.

36A. *The Novelist's Magazine. Vol. IX. Containing Sentimental Journey, Gulliver's Travels, David Simple, Sir Launcelot Greaves, The Peruvian Princess, and Jonathan Wild.* London: Harrison and Co., 1793 engraved title page and individual typographic title pages of 1785, 1792, 1792, 1787, 1792, 1788, respectively.

Call No. 148622. Three plates by Blake after Thomas Stothard. Second states, with the engraved plate numbers scraped off the impressions.

36B. *Idem.* Pl. 1 (for *Sentimental Journey*) only, first state, trimmed to the central design and mounted on leaf [24] of a volume labelled *Stothard Book Plates*, call No. 128970.

36C. *Idem.* Pl. 1 only, second state, bound facing page 10 in volume 1 of an extra-illustrated copy of Mrs. [A. E.] Bray, *Life of Thomas Stothard* (London: John Murray, 1851), call No. 113091. Imprint and plate number cut off.

36D. *Idem.* Pl. 2 (for *David Simple*) only, second state, bound facing page 86 in volume 1 of an extra-illustrated copy of Mrs. [A. E.] Bray, *Life of Thomas Stothard* (London: John Murray, 1851), call No. 109569.

Literature:
Russell 1912, No. 49B–D.
Bentley 1977, No. 486C.
See also No. 35, above.

37A. *The Novelist's Magazine. Vol X. Containing the First, Second, Third, and Fourth Volumes of Sir Charles Grandison.* London: Harrison and Co., 1783 engraved title page, 1793 typographic title page.
Call No. 148622. Three plates by Blake after Thomas Stothard, second states, with the engraved plate numbers scraped off the impressions.

37B. *Idem.* Pl. 3 only, second state, trimmed to the inner design and bound facing page 137 in volume 2 of an extra-illustrated copy of Bray, *Stothard* (see No. 36D, above), call No. 109569.

Literature:
Russell 1912, No. 49E.
Bentley 1977, No. 487A.
See also No. 35, above.

38. Olivier, [J.]. *Fencing Familiarized: or a New Treatise on the Art of Small Sword.* London: John Bell, 1780.
Call No. 376070. One plate engraved by Blake after "J. Roberts."

Plate folded and with some offsetting.

Literature:
Russell 1912, No. 49E.
Keynes 1921, No. 87.
Bentley 1977, No. 488.
Easson and Essick 1979, 11.

39. Rees, Abraham, ed. *The Cyclopaedia; or, Universal Dictionary of Arts, Sciences, and Literature.* London: Longman, Hurst, Rees, Orme, & Brown, et al., 1820. 39 text volumes and 6 volumes of plates.

Classification No. AE5.R4, volumes 40–44 (plates volumes 1–4). Five plates engraved by Blake, 1 signed by him as designer and engraver, and 1 engraved by Blake and Wilson Lowry. Pl. 1 lightly stained. Imprints cut from Pls. 2, 5–7. Pl. 3 ("Miscellany. Gem Engraving") is an impression from what may be the earlier (and rarer?) of 2 copperplates of the same image.[11] It is distinguished from the other version by small but numerous differences in shading in the 3 portrait gems.

Literature:
Rossetti 1863, 261; 1880, 283.
Russell 1912, No. 105.
Keynes 1921, No. 132.
Bentley 1977, No. 489.

40. *Remember Me! A New Years Gift or Christmas Present.* London: I. Poole, 1825.

Plate only, "Hiding of Moses," designed and engraved by Blake. Bound as leaf 10822 in volume 60 of the extra-illustrated Kitto Bible, call No. 49000. For Blake's watercolor of this design, see Part I, section D, No. 5.

Literature:
Rossetti 1863, 257; 1880, 280.
Russell 1912, No. 32.
Keynes 1921, No. 78.
Binyon 1926, No. 104.
Wittreich 1970, 53.
Easson and Essick 1972, 53–55.
Bentley 1977, No. 490.

Bindman 1978, 486.

41A. Ritson, Joseph, ed. *A Select Collection of English Songs.* London: J. Johnson, 1783. 3 volumes.

Call No. 108216. Eight plates (2 unsigned) by Blake after Thomas Stothard in volumes 1–2.

41B. *Idem.* Pls. 1, 3–4 only, mounted on page 42 of volume 3 of a collection of prints after Stothard, call No. 282164.

Literature:
Rossetti 1863, 259; 1880, 281.
Russell 1912, No. 55.
Keynes 1921, No. 97.
Bentley 1977, No. 491.
Easson and Essick 1979, 45–46.

42. Salzmann, Christian Gotthilf. *Elements of Morality, for the Use of Children. Translated from the German* [by Mary Wollstonecraft]. London: J. Johnson, 1791. 3 volumes.

Call No. 108262. Fifty plates, first states, perhaps as many as 45 attributable to Blake as the engraver. All but the plate inscribed "Pl. 28, Vol. II" (perhaps designed as well as engraved by Blake[12]) are based on the designs by Daniel Chodowiecki, published separately in 1784 and in the 1785 German edition of the *Elements*.

Literature:
Rossetti 1863, 260; 1880, 282.
Russell 1912, No. 77 (14 plates attributed to Blake).
Keynes 1921, No. 104 (16 plates attributed to Blake).
Bentley 1977, No. 492A (17 plates attributed to Blake).
Easson and Essick 1979, 69–86 (45 plates attributed to Blake).

43. Salzmann, Christian Gotthilf. *Gymnastics for Youth.* London: J. Johnson, 1800.

Call No. 291638. Ten unsigned plates generally attributed to Blake. Plates slightly stained.

Literature:
Russell 1912, No. 123 (questioning the attribution to Blake).

Keynes 1921, No. 121.
Bentley 1977, No. 493.

44A. Scott, John. *The Poetical Works.* London: J. Buckland, 1782.
Call No. 68285. Four plates by Blake after Thomas Stothard. In-
scribed on the inside front cover, "From the Author to Fred. Barlow."

44B. *Idem.* 2d ed., 1786. Call No. 440036. Inscribed in pencil on the
front free endpaper, "G L Keynes."

44C. *Idem.* Pls. 1 and 4 only, mounted on page 22 in volume 5 of a
collection of prints after Stothard, call No. 282164.

Literature:
Rossetti 1863, 258–59; 1880, 280–81.
Russell 1912, No. 48.
Keynes 1921, No. 94.
Bentley 1977, Nos. 494A–B.
Easson and Essick 1979, 38–39.

45A. Shakespeare, William. *The Dramatic Works of Shakspeare Re-
vised by George Steevens.* London: John and Josiah Boydell, 1802 [i.e.,
1803?]. 9 volumes.
Call No. 181067. Extra-illustrated and extended to 45 volumes.
Blake's plate after John Opie is bound as leaf 218 in volume 41. See
also No. 5, above, for the same plate.

45B. *Idem.* Blake's plate only (folded in half, worn, and probably from
the 1832 edition of No. 45A), bound following page 62 in volume 56 of
an extra-illustrated copy of *The Pictorial Edition of the Works of Shakspere,*
ed. Charles Knight (London: Knight, 1839-43), call No. 140091.

Literature:
Bentley 1977, No. 497A.

46A. Shakespeare, William. *The Plays of William Shakespeare.* Ed.
Alexander Chalmers. London: F. C. and J. Rivington, et al., 1805. 10
volumes.
Call No. 140092. Two of the 38 plates designed by Henry Fuseli
were engraved by Blake, volumes 7 and 10. Extra-illustrated, includ-

ing a proof of Blake's Pl. 2 with signatures but lacking all other letters (volume 10, facing page 107).

46B. *Idem.* Blake's plates only in the extra-illustrated volumes listed under No. 45B, above, call No. 140091. Bound as follows: Pl. 1—volume 53, following page 376; Pl. 2 (imprint cut off)—56:68. Both plates worn; probably from the 9 volume issue of No. 46A.

46C. *Idem.* Blake's plates only in the extra-illustrated volumes listed under No. 45A, above, call No. 181067. Bound as follows: Pl. 1—volume 32, leaf 130; Pl. 2—41:225.

Literature:
Rossetti 1863, 261; 1880, 283.
Russell 1912, No. 99.
Keynes 1921, No. 128.
Bentley 1977, No. 498B.

47A. Stedman, John Gabriel. *Narrative, of a Five Years' Expedition, against the Revolted Negroes of Surinam.* London: J. Johnson, 1796. 2 volumes.

Call No. 23654. Thirteen plates signed by Blake as the engraver. A further 3 plates have been attributed to him as the engraver by Keynes 1921 and Bentley 1977. All plates, apparently based on designs by Stedman, with contemporary hand coloring, including liquid silver.

47B. *Idem.* Call No. 23614. Some plates slightly stained.

Literature:
Rossetti 1863, 260; 1880, 282.
Russell 1912, No. 84.
Keynes 1921, No. 111.
Bentley 1977, No. 499A.

48. Stuart, James, and Nicholas Revett. *The Antiquities of Athens. Volume the Third.* London: N.p., 1794.

Call No. 382720, volume 3. Four plates engraved by Blake after William Pars. Uncut. For a letter from Willey Reveley, editor of the book, asking Blake to engrave plates for it, and for Blake's reply, see Part II, section D, No.1.

Literature:
Bentley 1977, No. 500.
Easson and Essick 1979, 103–104.

49. Varley, John. *A Treatise on Zodiacal Physiognomy.* London: Varley, 1828.

Call No. 354770. Three plates engraved by John Linnell which include images based on Blake's drawings. Second states of Pls. 2 (bound as the frontispiece) and 3. Original wrappers bound in. Bookplate of H. Buxton Forman; sold from his collection at Anderson Galleries, 26 April 1920, lot 56 ($11). Purchased by the Library from Brick Row Bookshop, April 1962 ($40).

Literature:
Russell 1912, No. 41.
Keynes 1921, No. 85.
Bentley 1977, No. 501.

50. *Vetusta Monumenta.* **Volume 2.** [London: Society of Antiquaries, ca. 1789?]

Call No. 229484, volume 2. Includes Sir Joseph Ayloffe, *An Account of Some Ancient Monuments in Westminster Abbey* (London: Society of Antiquaries, 1780), illustrated with 7 plates based on drawings attributed to Blake (see Butlin 1981, Nos. 3–11). All 7 plates are signed by James Basire, Blake's master, as the engraver.

Literature:
Russell 1912, Nos. 113–14.
Bentley 1977, No. 503.
Easson and Essick 1979, 15–18.

51A. Virgil. *The Pastorals of Virgil, with a Course of English Reading, Adapted for Schools.* Ed. Robert John Thornton. London: F. C. & J. Rivingtons, et al., 1821. 2 volumes.

Call No. 137046. Seventeen wood engravings designed and cut by Blake, 3 wood engravings cut by an anonymous journeyman after Blake's designs, 6 intaglio plates engraved by Blake (apparently after his own drawings of classical busts), and 1 wood engraving drawn by Blake (on the block?) after Nicolas Poussin's painting and cut by John Byfield. Pl. 4, usually bound in volume 1, is placed facing page 400 in

volume 2. Acquired from the Library of Frederic Rowland Marvin, April 1919.

51B. *Idem.* Call No. 57436. Pls. 5–17, 21–24 (i.e., the 17 wood engravings designed and cut by Blake) mounted in an album. Not from the published book. Pencil inscription below the first cut states that the blocks were "printed by John Linnell"; a pencil inscription on the verso of the front free endpaper states that they were "printed by the Linnell family" (but see Bentley 1977, 630, on Edward Calvert's printing of the blocks). Bound in full red morocco.

Provenance: John Linnell; Rosenbach and Co., sold June 1911 to Henry E. Huntington for $470.

Exhibition: Grolier Club, 1919–20, in No. 32; Fogg Art Museum, 1924.

51C. *Idem.* Art Gallery, accession No. 72.62.54. Pls. 6–13, 16–17, 24 (i.e., 11 of the wood engravings designed and cut by Blake) mounted in an album. Not from the published book; very probably Linnell impressions. Given to the Art Gallery in 1972 by Mr. and Mrs. Edward W. Bodman.

Exhibition: Huntington Art Gallery, 1972–73, No. 1, 8 cuts only; 1979, No. 30, 4 cuts only.

51D. *Idem.* Art Gallery, accession No. 000.60. Pl. 7 (1 of the wood engravings designed and cut by Blake) only. Not from the published book; very probably a Linnell impression.

51E. *The Wood Engravings of William Blake. Seventeen Subjects...Newly Printed from the Original Blocks now in the British Museum.* Introduction by Andrew Wilton. London: British Museum Publications, 1977. Call No. 470384. Restrikes of Pls. 5–17, 21–24, each on a separate leaf, unbound.

Literature:
Rossetti 1863, 258; 1880, 280.
Russell 1912, No. 30.
Keynes 1921, No. 77.
Binyon 1926, Nos. 137–53.

Keynes 1971, 136–42.
Easson and Essick 1972, 48–52.
Bentley 1977, No. 504.
Bindman 1978, 485.

52. *Wedgwood's Catalogue of Earthenware and Porcelain,* ca. **1816.**

Call No. 479271. Proofs of the plates engraved by Blake inscribed "P 10" (slightly stained) and "P 12." Both proofs lacking "WEDG-WOOD" inscription, top left, and some shading lines on the creamware. "P 12" before the substitution of a plate warmer, numbered "812," for the dish numbered "917," lower right. Wove paper, 22.7 x 17 cm., "P 10" watermarked "J WH[ATMAN]/ 18[cut off]." Apparently based on Blake's drawings of Wedgwood's crockery.

Provenance: Frederick Tatham; W. Graham Robertson, sold from his estate at Christie's, 22 July 1949, lot 90, with 2 other proofs of the Wedgwood plates and a leaf inscribed by Tatham[13] (£31.10s. to Charles J. Sawyer); offered by Sawyer in catalogues 200 of 1950, item 27 (£25); 208; 212; and finally 220 of 1956, item 168 (£25), from which acquired by the Huntington Library.

Literature:
Russell 1912, No. 106.
Keynes 1921, No. 76.
Keynes 1971, 59–65.
Bentley 1977, No. 511.

53A. *The Wit's Magazine; or, Library of Momus. Vol. I.* London: Harrison and Co., 1784.

Call No. 148541. Five plates engraved by Blake, 4 after Samuel Collings and 1 after Thomas Stothard. Pl. 1, "The Temple of Mirth" after Stothard, is an impression from the second of 2 copperplates of the design (Pl. 2 in Bentley 1977, 635).

53B. *Idem.* Proof of pl. 1 (from the second of 2 plates of "The Temple of Mirth") only, lacking signatures and with other inscription areas trimmed off, bound as leaf 11 in volume 5 of an extra-illustrated copy of Mrs. [A. E.] Bray, *Life of Thomas Stothard* (London: John Murray, 1851), call No. 152250. See Part III, section A, No. 3 for provenance.

Literature:
Rossetti 1863, 259; 1880, 282.

Notes

1. A friend of Ozias Humphry, who acquired a number of Blake's color prints, including the British Museum impression of "Albion rose." See G. E. Bentley, Jr., "Dr. James Curry as a Patron of Blake," *Notes and Queries* 27 (1980):71–73.

2. See Geoffrey Keynes, "William Blake & Bart's," *Blake Newsletter* 7 (1973):9–10.

3. This is the asking price given in Sessler's letter to Huntington of 2 August 1923, now in the Huntington archives.

4. See Ruskin, "Arthur Burgess," *The Century Guild Hobby Horse* 2 (1887):51–52. Ruskin describes one of the works, no doubt the "Hecate," as "a wonderful witch with attendant owls and grandly hovering birds of night unknown to ornithology." Ruskin discusses his return of the drawings to Hogarth in a letter to Richmond of ca. 1843; see *The Works of John Ruskin*, ed. E. T. Cook and Alexander Wedderburn (London: Allen, 1909), 36:32–33.

5. Letter to William Michael Rossetti of 6 November 1862, quoted by Rossetti in his supplementary chapter in Alexander Gilchrist, *Life of William Blake* (London: Macmillan, 1863), 1:376. Tatham was a friend of Blake, but they did not meet until many years after Blake's color printing experiments.

6. See David Bindman, "An Afterword on *William Blake: His Art and Times*," *Blake: An Illustrated Quarterly* 16 (1983):224.

7. See Martin Butlin, "A Newly Discovered Watermark and a Visionary's Way with His Dates," *Blake: An Illustrated Quarterly* 15 (1981):101–103.

8. See Robert R. Wark, *Drawings by John Flaxman in the Huntington Collection* (San Marino: Huntington Library, 1970), Nos. 23–24, reproduced.

9. Wark (see note 8), Nos. 7–8, 12, 16, all but the verso of No. 7 reproduced.

10. See Geoffrey Keynes, "Blake's Engravings for Gay's Fables," *The Book Collector* 21 (1972):59–64.

11. See Essick 1983, 262.

12. See Robert N. Essick, "The Figure in the Carpet: Blake's Engravings in Salzmann's *Elements of Morality*," *Blake: An Illustrated Quarterly* 12 (1978):10–14.

13. These three items were offered by Sawyer in catalogue 200 of 1950, item 26 (£38), and are now in a private American collection.

IV. WORKS OF QUESTIONABLE ATTRIBUTION

1. "Figure from Michelangelo's 'Last Judgment'." Accession No. 000.56. Oil on paper, 51.5 x 31.9 cm., pasted to cardboard. Inscribed in ink lower right, perhaps applied with a brush, "W: Blake 1776." Inscribed on the back of the cardboard mount in an unidentified hand, "William Blake. Study for the Last Judgment Signed & dated 1776./ From Mr. Flaxmans collection." The backing cardboard is also inscribed "Fairburn" in pencil.

As Butlin 1981, 15, notes, this copy of a figure in the lower left portion of Michelangelo's "Last Judgment" fresco in the Sistine Chapel is "completely uncharacteristic of Blake's style and technique." Both the medium and the broad, sketchy brush strokes set this work apart from Blake's earliest known works of the late 1770s which show the studied draftsmanship one would expect from a young man being trained as a professional copy engraver. There would be no reason for associating this work with Blake in any way if it were not for the large, bold signature. Butlin 1981, 15, considers this signature "sufficiently unlike Blake's usual forms to be inadequate evidence for his authorship." However, it is sufficiently like the forged Blake signatures added to several of the works listed below, No. 2, to make the authenticity of the signature suspect. Four of these drawings also bear inscribed dates following the signatures. According to Baker 1957, 53, the painting was acquired "in New York, 1916." He gives the same year and

place for Huntington's acquisition of the *Comus* designs (Part I, section A, No. a), and these were accompanied by the group of misattributed drawings. Huntington purchased both portfolios of drawings late in 1916 from Rosenbach, who then had a shop in New York as well as his main Philadelphia office. The oil sketch came to the Huntington in a French mat (retained) identical in materials and style to those in which the misattributed drawings (No. 2) are mounted. Thus, what little information we have about the provenance of the painting suggests a common source with works bearing forged signatures. There is no evidence other than the verso inscription that the painting was ever in the possession of Blake's friend John Flaxman (1755–1826).

In my opinion, this painting is not by William Blake and the signature was written by the same forger who added Blake inscriptions to the drawings described below, No. 2.

Literature:
Baker 1957, 52–53.
Ruthven Todd, *William Blake the Artist* (London: Studio Vista, 1971), 9–11, reproduced.
Butlin 1981, No. 50.
Robert N. Essick in *Blake: An Illustrated Quarterly* 16 (1982):25, reproduced.
Irene H. Chayes, "Blake's Ways with Art Sources: Michelangelo's *The Last Judgment*," *Colby Library Quarterly* 20 (1984):80–83.

2. A group of 7 drawings, all but one inscribed with Blake's name. These were apparently among the miscellaneous group of supposed Blake drawings offered in Rosenbach's catalogue 18 of 1916, item 17, with Blake's *Comus* illustrations (see Part I, section A, No. a for further provenance). The earlier history of these drawings, listed below, is not known. The group acquired from Rosenbach may have also included Blake's "The Six-Footed Serpent Attacking Agnolo Brunelleschi" (see Part I, section D, No. 6).

a. "Joseph and Potiphar's Wife," perhaps by Theodore von Holst (1810–44). Accession No. 000.96. Inscribed lower left in pencil, "W. Blake/1779," and on the verso in pencil, "William Blake 1797."
b. Three figures in flames, probably one of the so-called "Camden Hotten forgeries."[1] Labelled on the mat, "Design for 'America'," but not directly related to any design by Blake. Accession No. 000.97. Not signed.

c. "Acis and Galatea." Accession No. 000.95. Inscribed lower left in ink, "W. Blake." Just to the right is a partly rubbed-out signature, "H. P. Bone" (Henry Pierce Bone, 1779–1855), probably the true author of the work.

d. "Hercules and the Cretan Bull," attributed to John Henry Fuseli.[2] Accession No. 000.61. Inscribed in ink lower right, "W. Blake 17[cut off]," over a very light pencil inscription, perhaps "W S." Inscribed lower left in pencil, "Blake/ 1779."

e. "Atlas Supporting the Globe," probably an Italian drawing. Accession No. 000.99. Inscribed in ink lower left, "W. Blake." The verso of the old backing sheet bears the "NH" collection mark of N. F. Haym (1679–1729).

f. "Amazonian Conflict." Accession No. 000.100. Inscribed lower right in ink, "WB," written over a monogram signature, perhaps "WA." Inscribed "W. Blake 1797" in ink on the backing mat, lower right.

g. "Samson Slaying the Philistines," probably an Italian drawing. Accession No. 000.101. Inscribed in ink lower right, "WB," and "W. Blake 1780" on the mount written over another, illegible, signature.

None of these works is by Blake. The addition of a "Blake" inscription on drawing c, also bearing another artist's name, strongly suggests an intention to deceive. See also No. 1, above, for another work probably associated with this group.

Literature:
C. H. Collins Baker, *Catalogue of William Blake's Drawings and Paintings in the Huntington Library* (San Marino: Huntington Library, 1938), 39–42.
Baker 1957, 55.

3. A sketchbook sometimes attributed to Robert Blake (1767?–1787), William Blake's brother. Accession Nos. 000.54.1 through 000.54.54. 34 leaves, including some blank replacements for excised leaves, with drawings in pencil, red chalk, and pen and watercolors on 50 pages. Leaves 32.2 x 20.5 cm. bound in rough paper covers also bearing sketches. Inscribed "Robert Blake's/ 1777 Book" on the front cover, "Robt/ Blake" on the inside front cover, and "Blake," "Robertus," and "R Blake" on the back cover. 7 pages are dated "1778." A long note in an unidentified hand on the inside front cover claims that "this Sketch-book belonged to Robert Blake," that it was purchased "some years since among the Collection of the late Thomas Stothard R.A.," and that it contains sketches by William as well as Robert Blake.

The attribution of these drawings to Robert Blake is lent some credence by the similarities between a few of the profiles in the sketchbook and several heads he drew on the verso of one of his drawings in the British Museum (Butlin 1981, No. R 11). Yet it is un-

likely that the sketchbook would be associated with either Blake if it were not for the inscriptions. There is no independent evidence supporting the claim that the sketchbook was once in Stothard's collection. It must be admitted, however, that there are few extant works by Robert Blake upon which to base a sense of his style as a draftsman, and very few extant works by William Blake datable prior to 1779–80. Butlin 1981, 617, accepts the sketchbook as Robert Blake's, but also notes David Bindman's doubts about the involvement of either artist, particularly William Blake's.

Provenance: Thomas Stothard(?); Sir Alexander Spearman, sold Puttick and Simpson's, 9 January 1878 (according to the note on the cover); George S. Hellman, sold Anderson's, 25 November 1919, lot 51 ($625 to George D. Smith for Henry E. Huntington).

Exhibition: Grolier Club, 1919–20, No. 49; Fogg Art Museum, 1924.

Literature:
Baker 1957, 50–51, 2 pages reproduced.
Butlin 1981, 617–20, No. R1, 50 pages and the inside of both covers reproduced.

4. Blake's watercolor illustration to Young's *Night Thoughts*, page 11, copied on vellum. Accession No. 000.31. Pen and watercolor, 38.8 x 30 cm., surrounding the type-printed text of page 3 from the 1797 edition of the poem published by Richard Edwards with Blake's engraved illustrations (see Part III, section B, No. 55). Variations in capitalization, punctuation, spacing, and leading indicate that the text was not printed from the same setting of type as the published book. However, the typeface is the same, and it is possible that the vellum leaf was printed before revision from the same form as the published book. The printed and painted sheet is backed by another piece of vellum, but show-through on the recto indicates that the text of page 4 was printed on the verso—without Blake's engraved illustration but with the asterisk indicating the line illustrated. The design on the recto is the reverse of Blake's original (British Museum; Butlin 1981, No. 330.11). It may have been counterproofed on to the vellum, as pencil reinforcements of outlines in the original suggest. The drawing on vellum lacks the staff held by the large figure, thus making the

gesture of his right hand meaningless. There are several minor variations between the two versions of the design. In the published text, page 3 is not illustrated.

The weak handling of the outlines and rather flat and even watercolor washes in the drawing on vellum are uncharacteristic of Blake's work from ca. 1795 to the end of his life. Butlin 1981, 255, takes a similar view and suggests "that it was executed by someone in Edwards's business." Richard Edwards was a member of a Halifax family which specialized in fine vellum bindings, including a special technique of painting on the back of transparent vellum.[3] Edwards may have printed this vellum leaf, and had one page colored by a journeyman in facsimile of one of Blake's designs not selected for engraving, as part of his plans for promoting his publication.

The vellum leaf was formerly inserted in the Library's hand-colored copy of the 1797 *Night Thoughts* (see Part III, section B, No. 55A for provenance), at which time it was gilt on three edges.

Literature:
Baker 1957, 39–40, reproduced.
Robert R. Wark, "A Minor Blake Conundrum," *Huntington Library Quarterly* 21 (1957):83–86, reproduced.
Butlin 1981, No. 334.

5. A sketchbook with copies of Blake's drawings in the manuscript of *Vala, or The Four Zoas.* Art Gallery; no accession number. 11 leaves, 17.3 x 13.4 cm., with 10 pages bearing pencil copies of Blake's drawings. A pictorial title page in purple ink is inscribed "Drawings/ From/ Vala." The front free endpaper is inscribed "From D. H. G. 1922." With pencil notations on the verso of the last leaf, apparently unrelated to the drawings. Given to the Art Gallery in June 1939 by Homer D. Crotty. The unidentified copiest probably made the sketches after the *Vala* manuscript was given to the British Museum (now British Library) in 1918 (Butlin 1981, No. 337).

6. *Archaeologia: or Miscellaneous Tracts, Relating to Antiquity.* London: Society of Antiquaries, 1770–.

Classification No. DA20.A65. In 1863, Alexander Gilchrist wrote that Blake's apprentice "work as assistant to Basire of these years (1773–78) may be traced under Basire's name in the *Archaeologia*, in

some of the engraved coins, &c., to the *Memoirs of Hollis* (1780), and in Gough's *Sepulchral Monuments* [Part III, section B, No. 18], not published till 1786 and 1796."[4] Many plates in the *Archaeologia* are signed by Basire, official engraver to the Society of Antiquaries. It appears to have been common practice in the eighteenth century for the master to sign all plates produced by his firm, even if they were in large part the work of his journeymen or apprentices. By the very nature of shop practice, it is impossible to distingush the work of Blake the apprentice, August 1772–1779, from that of his master. But it is certainly possible that, as Gilchrist claims, Blake played some role (however minor and subordinate to a corporate style) in the production of many of Basire's plates during the term of apprenticeship. The same possibilities pertain to No. 7, below. The volumes of the *Archaeologia* most likely to contain such plates are the second through the fifth of 1773, 1776 (misdated 1786), 1777, and 1779.

7. Thomas Hollis, *Memoirs of.* London: N.p., 1780.

Call No. 138995, with 9 plates signed by James Basire. Another copy, called No. 18385, bound in two volumes, lacks many plates but has all 9 by Basire. See No. 6, above, for Gilchrist's attribution and discussion of it.

Notes

1. For information about these facsimiles/forgeries, see Morton D. Paley, "John Camden Hotten, A. C. Swinburne, and the Blake Facsimiles of 1868," *Bulletin of the New York Public Library* 79 (1979):259–96.

2. By Gert Schiff, *Johann Heinrich Füssli* (Zürich: Verlag Berichthaus, 1973), 1:535, No. 988 (reproduced in volume 2).

3. See T. W. Hanson, " 'Edwards of Halifax.' A Family of Book-Sellers, Collectors and Book-Binders," *Papers, Reports, &c Read before the Halifax Antiquarian Society, 1912* (Halifax, [1912]):142–200.

4. *Life of William Blake* (London: Macmillan, 1863), 1:19.

V. PORTRAITS OF BLAKE

1. Gray wash and pencil, accession No. 000.57A. Image 26.3 x 20.7 cm. on wove paper 28 x 21.5 cm., the corners cut off at a diagonal. Watermarked "J WHATMAN/ 1810." Inscribed in pencil below image, "Por. of Wm Blake/ T. P. [i.e., Thomas Phillips]." Indecipherable pencil inscription on verso. Repair on right margin; stained on left elbow and just below left lapel.

This portrait is basically the same as the oil painting by Thomas Phillips (National Portrait Gallery, London) and the engraving after it by Louis Schiavonetti, published in R. H. Cromek's 1808 edition of Robert Blair's *The Grave* with Blake's illustrations (see Part III, section B, Nos. 4A–D). There are several slight differences in pose and characterization between the painting and this drawing, and in the latter Blake holds a quill pen rather than a crayon. The watermark indicates that this drawing could not be part of the compositional process leading to the painting or the print. Baker 1946 (both works under *Literature*, below) accepts this portrait as Phillips' own work in spite of the watermark. Keynes 1977 (see *Literature*, below) states "it is very unlikely that [this] copy was from" Phillips' hand, but suggests that it was probably "made during Blake's lifetime" after Schiavonetti's engraving.

Provenance: Bernard Buchanan Macgeorge by 1906, inserted in a copy of Blair's *Grave* (Part III, section B, No. 4B) with a drawing of an alternative title page (see Part I, section D, No. 4 for futher history).

Literature:

Catalogue of the Library of Bernard B. Macgeorge (Glasgow: James Maclehose, 1906), 15, "original drawings inserted of a title page which was not adopted, formerly belonging to Mr. Cromek, and of Blake's Portrait by T. Phillips."

C. H. Collins Baker, "A Gift of Blake Material," *The Friends of the Huntington Library* 3 (October 1946):1–3, reproduced.

Baker, "Thomas Phillips' Portrait of Blake," *Huntington Library Quarterly* 10 (1946):115–18, reproduced.

Geoffrey Keynes, *The Complete Portraiture of William & Catherine Blake* (London: Trianon Press for the Blake Trust, 1977), 126, reproduced.

2. Pencil and watercolor copy of the portrait by Thomas Phillips (see No. 1, above). Accession No. 000.57B. Image 29.2 x 22.5 cm. on (wove?) sheet 34.1 x 26.6 cm., pasted to the backing mat. Inscribed in pencil below the image, "W Blake Esqr." The mat is inscribed in pencil, "T. Phillips pinx" (lower left) and "L. Schiavonetti del." (lower right). Also inscribed on the mat, "$253.00," and with the printed number "414" pasted to the mat. The verso of the backing mat inscribed in pencil, "folio 362/ FTS 1904/ £ i.i.x." Rather amateurish in execution; probably a copy of Schiavonetti's engraving.

Provenance: Frederic R. Halsey (acquired 1904 from "FTS"?), whose collection mark is stamped on the verso of the backing mat; probably acquired as part of the Halsey library by Henry E. Huntington, December 1915.

Literature:

Baker, "Thomas Phillips' Portrait of Blake" (see No. 1, above), 116.

Keynes 1977 (see No. 1, above), 126, reproduced.

VI. A NOTE ON RELATED MATERIALS

In addition to the original works by Blake listed in this catalogue, the Huntington Library has an extensive collection of editions of Blake's writings, reproductions of the illuminated books (including the William Muir and Blake Trust facsimiles), standard criticism, and journal articles. Authors who provide a context for the study of Blake, such as Milton and Jacob Boehme, and the writings of his contemporaries, such as William Hayley, are thoroughly represented. The manuscript collection includes letters from Charles Lamb and John Linnell containing references to Blake (HM 7079 and HM 26325), the bill for Blake's funeral expenses and the receipt issued to Linnell (HM 26324), and parts of A. C. Swinburne's manuscript for his 1868 book on Blake (HM 2778, HM 20609) and for the "Prefatory Note" to the 1906 edition (HM 2785). There are also several large collections of prints designed by Blake's friend Thomas Stothard and books with plates after John Flaxman, Henry Fuseli, and Stothard. The Art Gallery holds important collections of drawings by these three artists and others of Blake's generation. The handlist of the Huntington Blake collection published in *Blake: An Illustrated Quarterly* 11 (1978):236–59, includes summary lists of drawings and prints by Flaxman and Fuseli and of drawings by Stothard and George Romney. More detailed information on the Flaxman collection can be found in Robert R. Wark, *Drawings by John Flaxman in the Huntington Collection* (San

Marino: Huntington Library, 1970). The illustrated catalogues for two Huntington exhibitions include selected works by Blake's British contemporaries: *William Blake and His Circle*, catalogue by Robert R. Wark, November 1965–February 1966; *English Book Illustration circa 1800*, catalogue by Shelley Bennett and Patricia Crown, January–February 1979.

The collection of Blake's circle is completed by the prints and drawings by his so-called "followers"—John Linnell, Edward Calvert, George Richmond, and Samuel Palmer. The Huntington's holdings of their work are noted in the handlist in *Blake: An Illustrated Quarterly*, cited above. *The Followers of William Blake*, a catalogue by Larry Gleeson for an exhibition at the Huntington from November 1972 through January 1973, includes selections from all four artists. A complete listing of their prints in the collection, including several by Palmer absent from the *Quarterly* handlist, appears in *Prints by the Blake Followers*, a catalogue by Shelley Bennett for the exhibition of November 1981 through February 1982.

INDEX

245

247

"Il Penseroso" illustrations, 1, 57, 60
"Infant Joy," 159
"Infant Sorrow," 159, 163-64
"Introduction" to *Songs of Experience*, 159, 162
"Introduction" to *Songs of Innocence*, 147, 159, 161
Iris, 19
Irwin, Theodore, 121, 154, 174
Irwin, Theodore, Jr., 121
Isaac, Mrs. Donald Mac, 209
Isis, 47
Island in the Moon, An, 161
Ithuriel, 34

Jahweh, 104-105, 115
James (dealer), 181
James, G. Ingli, 78, 80
Jehovah, 114-15, 138n83, 139n86
Jerusalem, 127
Jerusalem, 19, 22, 31, 44, 52, 69, 79, 80, 96, 97, 132ns9, 12; 134n33, 135n42, 140ns97, 98; 142, 156, 171
Jesus, 51, 58, 60, 61, 63, 66, 71, 73, 74, 85, 111, 135n46, 137n63. *See also* Christ
Job illustrations: engravings, ix, 88, 101, 104, 106-107, 185, 217-18; watercolors, 5, 24, 26, 31, 40, 42, 49, 61, 101, 104, 125, 132n12
"Job's Evil Dream," 104
Jochebed, 127
Johns Hopkins University, 27
Johnson, Joseph, 178-79, 181, 190n28, 204, 210-11, 213-14, 218, 220, 223, 225, 229
Johnson, Richard, 128
John the Baptist, 58, 60, 61
Jonathan Wild, 220
Jones, Herschel V., 155
Joseph, husband of Mary, 58, 60, 61, 63, 65, 66, 73, 74, 85, 127; son of Jacob, 234
"Joseph and Mary, and the Room

They were Seen in," 85-86
"Joseph and Potiphar's Wife," 234
Jove, 5
"Judgment of Adam and Eve, The," 47
"Judgment of Solomon, The," 83
Juno, 134n29
Jupiter, 134n29; Pluvius, 34

Kaplan, Alice M., 54
Kent, William, 212
Keynes, Geoffrey, 136n59, 138n83, 144, 153, 156, 175, 188n4, 224
King, Governor, 217
King David, 84
King Edward I, 80, 83, 84
"King Edward the Third," 178
King Henry II, 80
King John, 80
"King of Babylon in Hell, The," 199
Kitto Bible, xi, 121, 154, 174, 206, 210, 218, 222
Knight, Charles, 224

Lady, the (in *Comus*), 5, 7-9, 11, 14-15, 17-21
"Lady Embracing a Bust, A," 193-94
"Lady Restored to Her Parents, The," 19-21
Lahee, J., 185
"L'Allegro" illustrations, 1, 57, 60
Lamb, Charles, 126, 241
"Lamb, The," 146, 157, 159
"Laocoön," 68, 114
"Last Judgment, The," 26
"Laughing Song," 156-57, 159
Lavater, John Caspar, 218; annotations to his *Aphorisms*, x, 132n11, 181-83, 190n32; *Essays on Physiognomy*, 75, 79, 85-86, 195, 218-19
Lawrence, Thomas, 24, 214
Lenox Library, 171

249